TABLE OF CONTENTS

EDITOR
LEON WIESELTIER

MANAGING EDITOR
CELESTE MARCUS

———————

PUBLISHER
BILL REICHBLUM

———————

JOURNAL DESIGN
WILLIAM VAN RODEN

WEB DESIGN
HOT BRAIN

Liberties is a publication of the Liberties Journal Foundation, a nonpartisan 501(c)(3) organization based in Washington, D.C. devoted to educating the general public about the history, current trends, and possibilities of culture and politics. The Foundation seeks to inform today's cultural and political leaders, deepen the understanding of citizens, and inspire the next generation to participate in the democratic process and public service.

Engage
To learn more please go to libertiesjournal.com

Subscribe
To subscribe or with any questions about your subscription, please go to libertiesjournal.com

ISBN 978-1-7357187-4-3
ISSN 2692-3904

———————

EDITORIAL OFFICES
1604 New Hampshire Avenue NW
Washington, DC 20009

———————

DIGITAL
@READLIBERTIES
LIBERTIESJOURNAL.COM

Liberties

MAMTIMIN ALA

The Death Trap of Difference, or What the Uyghurs Understand

In that tower built of skulls you will find my skull as well
they cut my head off just to test the sharpness of a sword.
When before the sword our beloved cause-and-effect relationship
is ruined like a wild lover
Do you know that I am with you

PERHAT TURSUN, "ELEGY"

June 1988 was an unforgettable month for the Uyghurs. A group of Uyghur students noticed an insulting slogan, presumably written by a Chinese person, on one of the walls of a public toilet in Xinjiang University: "We will turn your men into slaves and your women into whores!" This incident quickly triggered a mass protest of Uyghur students against the Xinjiang authorities, which just as quickly suppressed it. The protest was described by the Chinese government as an act of secession, a serious crime against the sovereignty of the Chinese state. The Uyghurs considered the inscription a gross insult, foreshadowing many insults and calamities to come.

Politically, for the Uyghurs, the incident heralded the end of the quasi-liberal atmosphere under the leadership of Hu Yaobang, the General Secretary of the Chinese Communist Party (CCP) in the 1980s, who tried, but ultimately failed, to implement the autonomous laws that were promised by the CCP to the Uyghurs, along with the Mongols, the Hui, the Zhuangzu, and the Tibetans, in the 1950s. With this humiliation and the others that they experienced daily, the Uyghurs were roughly awakened from the illusions of socialism's promise of autonomy to face a merciless colonial reality that offered them a stark choice — notional autonomy or nothing at all. Since then, the scope of the notional autonomy for the Uyghurs has gradually dwindled, leaving room for more confusion, frustration, and resistance against Chinese rule, and then for much worse.

For some Uyghurs, the graffiti incident in June 1988 was experienced as a kind of historical *déjà vu,* a repetition of the experience of their ancestors who lived in what is now Mongolia, where Bilgë Qaghan, the fourth king of the second Turkic khaganate in the eighth century, issued a serious warning for the Turkic tribes about the Chinese. The warning

7

was inscribed on stone monuments known as the Eternal Stones: "The Chinese made slaves of your noble sons, and slaves of your beautiful daughters." This warning captured, and anticipated, the essence of the ongoing conflict between the Uyghurs and the Chinese, on and off, over a millennium — to be or not to be the slaves of the Chinese.

Almost thirty years after the incident at Xinjiang University, the Uyghurs have been visited by another horrific nightmare, another continuation of the one that they may never awaken from: they have been incarcerated in Chinese concentration camps, where their sons have been tortured and killed, their daughters have been raped and humiliated, and their children have been orphaned and abused. (The poet Perhat Tursun, whose lyrics are cited above, is a prisoner in one of those camps.) By an irony of fate, what Bilgë Qaghan feared most has finally happened to his descendants in its worst form possible. To a Uyghur, history feels as inescapable as those camps.

Is this the fate of the Uyghurs? Or is it a cruel mockery of history? How can the current Uyghur crisis best be understood? What is often missing in the discourse about this contemporary genocide is its cultural dimension. Without a proper grasp of culture, it is impossible to understand the origin, or the nature, of this conflict and this crime. After all, we have learned from earlier episodes of genocidal behavior that culture can lead to concentration camps.

The Uyghurs and the Chinese possess different cultures and mentalities, largely in contradiction with each other but still exhibiting certain commonalities, not because they share the same ancestral origins but because they are driven by the same

human desires and life-forces to realize their aspirations and to cope with the pressures of their realities as human beings. Both cultures, first and foremost, owe their origin to the nurturing rivers in their historical terrain — for the Chinese, the Huanghe (Yellow) River and the Changjiang (Yangtze) River are vital for the formation of their culture, sustaining their survival, growth, connectedness, and prosperity, whereas for the Uyghurs, the Tarim River is their mother river and the source of their life. If Chinese culture originated historically between those two famous rivers, so did Uyghur culture originate in the Tarim Basin in East Turkestan, the heart of the Uyghur homeland, called Xinjiang by the Chinese.

Historically, the region of East Turkestan makes its first appearances in historical narratives beginning in the second millennium BC. The region was known to the ancient Chinese Kingdoms as Xiyu, or the Western Territories or Regions. At the heart of Xiyu lies the Tarim Basin, which was home to many races, peoples, and tribes — from Indo-European settlers to non-European ones. The extraordinary demographic mixture of the peoples in the area has been confirmed by modern genetic analysis, which has shown that the local inhabitants have a high proportion of DNA of European origin with the mixture of non-European ones. Owing to the geopolitical importance of its location, East Turkestan has caught the attention of many empires that sought control over it, including the Chinese, Turkish, Mongol, and Manchu (Qing) empires. Among them, the political interest of the Chinese dynasties to colonize it was especially strong, and it intensified after the annexation of the region by the Qing dynasty in the eighteenth century.

After the ancestors of the Uyghurs living in present-day Mongolia were defeated by Kyrgyz troops in the ninth

century, they migrated *en masse* to the Tarim Basin, where they, along with other Uyghur and Turkic tribes in the area, contributed to the Uyghurization of the local Indo-European peoples, resulting in the creation of a local identity defined by oasis regions, consisting mainly of Islamic and Buddhist areas. The Uyghur tribes, which moved into the Kashgar region, established the Qarakhanid kingdom and embraced Islam in 940 in a peaceful manner, whereas other cities in the Koqu Uyghur Khaganate embraced Buddhism. Both Kashgar, the capital of the Qarakhanid kingdom, and Turpan, the capital of the Koqu Uyghur Khaganate, quickly became centers of learning for Islam and Buddhism, respectively. If there was any significant cultural exchange between the peoples in the Tarim Basin and mainland China, it was due to the spread and flourishing of Buddhism. Buddhism facilitated the nurturing exchanges of religious and other knowledge between Chang'an (now Xi'an) and Turpan, which were recorded in travel diaries and discovered in excavated documents.

East Turkestan was ruled by the Kara Khitays (alternatively known as "Black Khitan" or the Western Liao, which was a successor state to the Liao dynasty ruled by the Khitan Yelü clan) in the twelfth century, and was overwhelmed by the Mongols in the thirteenth century, who continued the Turkification process until the seventeenth century. The East Turkestan region was surrounded by the Manchus in the next century, who met with the relentless resistance of the Uyghurs as a response to several incidents of misrule and abuse that caused considerable anger and resentment. Later, in 1865, under the leadership of Yaqub Beg, the kingdom of Kashgaria (centerd at Kashgar in East Turkestan) was established, and it lasted until 1877. In 1884, the Qing empire colonized East Turkestan and called it Xinjiang, which

itself meant, literally, "colony." In the twentieth century, Uyghurs staged several uprisings against the rule of Chinese warlords and established the East Turkestan Islamic Republic in Kashgar in 1933, and again, as the Second East Turkestan Republic, in Ghulja in 1944. This was a multi-ethnic republic that included other Turkic nationalities such as Kazaks, Kyrgyz, Uzbeks, and more. This republic was finally defeated by the Chinese Communists, with the tacit support of Stalin, in 1949.

During this long historical process, which I have summarized here in broad strokes, Uyghur and Chinese cultures evolved to reflect the ideas, customs, beliefs, and social behaviors of their respective societies. These cultures began to display their differences. Again, I will describe them broadly. To an exaggerated degree, Chinese culture is time-oriented. It is a culture that has a deep respect for the past in the form of ancestry worship. It regards future progress as nothing but the useful application of the wisdom canonized by the sages in the past as timeless rules for everything. The future is merely the extended past. For such a historical consciousness, excellence is imitation. In extreme cases, it is the sign of a collective sense of self-worth and self-excellence, which currently takes the form of Chinese supremacy. In his book *On China*, Henry Kissinger appositely observed that "the Chinese never generated a myth of cosmic creation. Their universe was created by the Chinese themselves, whose values, even when declared of universal applicability, were conceived of as Chinese in origin." The Chinese universe is exclusively Chinese in nature — self-centered and self-sufficient, exclusive to other cultures and ways of life. This sense of self-centeredness and self-sufficiency is not immune from the sin of collective narcissism, which was the theme of Lu Xun's novel *The*

11

True Story of Ah Q, a masterpiece of modern Chinese literature in which he traced the life of a narcissistic individual who "rationally" interprets his every loss and failure as a psychological triumph, as a "spiritual victory."

Uyghur culture, to an exaggerated degree, is space-oriented. Nowhere is this characteristic of Uyghur culture more evident than in its exposure to a variety of civilizational influences along the Silk Road, the great Eurasian crossroad connecting East (China) with West through the vast area of Central Asia where the Uyghurs lived. On the Silk Road, the Uyghurs were one of the most active peoples as traders, and as middlemen between different cultures, interests, and trades. The geographical position of East Turkestan served as a hub for the exchange not only of goods, but also of religions, ideas, and cultures. This position enabled the Uyghurs and the adjacent peoples to absorb and to interact with alien influences, so as to establish their own cultural ideas, practices, and identities. There exists, for example, a Uyghur version of Aesop's fables, which is an essential part of Uyghur oral literature. Moreover, Uyghurs are perhaps the only people on earth who have worshipped almost all the major world religions throughout their history, including totemism, shamanism, Zoroastrianism, Manicheanism, Buddhism, the Nestorian Church, and Islam. As a consequence of these rich and diverse religious heritages, of this profound syncretism, Uyghur culture developed its unique mixture of variety, tolerance, and complexity.

As a syncretistic culture it may suffer from a lack of originality; it is especially good at absorbing and compressing the ideas and the arts of other cultures, by means of long dialectical processes of influence and adaptation, into a new arrangement. Of course no culture is pure, or perfectly insular,

12

or completely self-sufficient. Every culture is the result of a constant interaction with, and acceptance of, the achievements of other cultures into itself in a nourishing way. What we see in Uyghur culture is a prodigious, and indeed radical, example of this great human integration. Uyghur medicine, for example, was historically influenced by the knowledge of Greek humoral medicine, Arab-Persian medicine, and Buddhist medicine. As such, it developed into folk medicine with Uyghur characteristics. Even though Uyghur culture is largely syncretistic, it is more than just the sum of its influences; it creates its own unique forms and practices, the combination of which is distinct to itself.

While Chinese culture is proud of its inward-looking, or better, backward-looking, greatness, and boasts of its immunity to external influences, Uyghur culture dwells upon its outward-looking, or in-between-looking, achievements, owing largely to its history as a crossroads. While the former seeks purity and originality, the latter seeks unity in diversity. It should never take us by surprise when Chinese culture pulls everything, all resistance, novelty, and otherness; back into the gravitational zones of the past, relentlessly and uncompromisingly, and tolerates no alterity. For Chinese speakers, for example, a foreign name must be pronounced not in its native way but in a Chinese way — it must be domesticated and Sinicized. Uyghur culture, on the other hand, thrives on alterity. It has learned over the mottled centuries to tolerate novelty and difference, aspiring to blend with other cultures graciously.

Strictly speaking, there is no direct and deep influence of Chinese culture upon Uyghur culture or vice versa, despite the historical fact that they both mutually benefitted from short exchanges of ideas, customs, and music during

13

the Tang dynasty. The differences between them are more striking than their similarities. The ideas of the eleventh-century Uyghur thinker Yusuf Khas Hajib remind us more of Plato and of Ferdowsi than of any thinkers in China, including Confucius and Mencius. In his magnum opus, *Kutadgu Bilig,* or *Wisdom of Royal Glory: A Turko-Islamic Mirror for Princes,* composed in 1069-1070, he exhibited the deep influence of Greco-Roman thought on his own thinking, the topics of which ranged from the virtues of kings and rulers in an imaginary utopia appropriated for a newly established religious context — Islam — to the multiple ways of being a good person in ordinary life. At the heart of this work lies the subject of goodness — how it should permeate society from top to bottom — and the good life. Unlike Chinese thinkers such as Sun Tzu, who advocated the use of deception — of evil — for victory at all costs, or Hsün-tzu, for whom human nature is inherently evil, Khas Hajib advocated for the use of goodness even in circumstances of destitution and hardship for greater social justice and harmony. He differs even from Confucius, whose ideas rest on the belief in the goodness of the human heart in immanent manifestations of kindness, loyalty, and harmony, for the purpose of a morally constructed world. For Khas Hajib, as for Plato, the notion of goodness is not immanent but transcendent, for which everything strives as an ultimate goal of human existence. This concept of goodness is one of the founding pillars of Uyghur thought. With the spread of Sufism in the East Turkestan region in the sixteenth century, the idea of the good was deeply irradiated by the idea of love — divine love — as an eternally binding force connecting man to man and man to God. This view was elevated to a new and sophisticated level in the poetry of Ali-shir Nava'i, one of the great poets of Central Asia. For him, human love is enriched

14

with the vision of the divine love as the ultimate source of human existence, to which we all eventually return.

In the fifteenth century the great Silk Road was closed, and ocean transportation became considerably easier than overland transportation. This was a devastating blow to China and to Central Asia, the innermost, almost landlocked, part of Asia with no access to the seas. With the decline of the Silk Road, Uyghur culture became afflicted, to a certain extent, by a kind of depressive mood. Incurring cultural isolation, which was the antithesis of its historical experience, it lost many of its vital resources and inspirations. This isolation continued until the beginning of the twentieth century, when it was disrupted by the spread of the movement of cultural reform and secularization known as Jadidism in the Muslim territories of the Russian empire and in Central Asia and beyond. This movement created a new group of intellectuals and leaders who regarded themselves as modernizers and enlighteners.

The re-appropriation of the ethnonym "Uyghur" at a Soviet conference in Tashkent in 1921, and its subsequent widespread use, was a turning point in the social, cultural, and political awareness of Uyghurs. Uyghur intellectuals played a crucial role in bringing Uyghurs out of isolation into a wider world — a dazzling, frightening, and unavoidable change. Ever since, Uyghur intellectuals have consciously participated in nation-building activities with a focus on the urgent need to shape the collective self-consciousness of the Uyghurs as a prerequisite to the realization of a unified national identity. For this purpose, Uyghur intellectuals in the 1930s and 1940s turned to a variety of ideologies — Islam, Pan-Turkism, and communism — to pursue their religious, cultural, and political aspirations. These various currents of modern Uyghur

identity proved to be deeply irreconcilable, and they resulted in factional and ideological conflict during and after the Second East Turkestan Republic.

For the Chinese, the nineteenth century was full of miseries in the confrontation with a culture — Western culture — far more advanced than theirs. This encounter shattered their collective narcissism, forcing them to choose between modernization and humiliation. Like the Uyghurs, they were exposed to a variety of ideas and ideologies, ranging from Social Darwinism to communism, for the purpose of national revival. Moreover, they began to look toward the scientific achievements of the West as the crucial way to overcome their isolation, backwardness, and illusion — the great disgrace of being the "Sick Man of Asia." Sun Yat-sen, the founding father of modern China, vowed to make it strong and respected again. He paved the foundations for a Chinese republic, which was inherited by the Kuomintang as a party, which governed most of China until it was defeated in the civil war by the Communists in 1949.

16

The political culture of China is unique, and indigenous to itself, in many ways. The most important aspects of Chinese political culture derive from an ancient Chinese conception of the political. It consists of a binary system: center and periphery. According to the time-honored traditions of Chinese political thought, there exists in the historical world a horizontal hierarchy, which specifies a Chinese state as the central kingdom vis-à-vis other areas, kingdoms, and peoples who make up the regions of the periphery. This statecraft promotes the center as the source of order, civility, advancement, and

power, with the periphery standing for disorder, incivility, backwardness, and weakness. Moreover, this world-picture is the essential feature of the core system of the centralized bureaucracy, which manages power-sharing, the distribution of resources, the systems of tribute, and the mechanisms of alliances and enmities. In such a conception of politics, in such a political structure, the Western Regions were inevitably considered by the Chinese dynasties as chaotic, backward, and difficult to control. They were the badlands.

If politics was defined as an art of deception as by Sun Tzu, this deception required a clear knowledge of who are foes and who are friends. For him, this knowledge was the very prerequisite for winning a war: "If you know the enemy and know yourself, you need not fear the result of a hundred battles." Echoing his ancient master, Mao Zedong famously asked in his writings, solemnly but also anxiously, "Who are our enemies? Who are our friends?" Chinese propaganda has always used the phrases "enemy forces" and "hostile forces" and "foreign forces" to inflame Chinese nationalism, to express Chinese anger, or to play the victim. This construal of power is very much in the spirit of Carl Schmitt, the Weimar German political philosopher now revered by right-wing Chinese political theorists and lawyers, who once proclaimed that "all political actions and motives can be reduced [to the distinction] between friends and enemies" — a theory of politics that was influential in the Third Reich, where the recognition and eradication of the enemy was a political duty and a necessary part of the collective identity.

This knowledge was physically manifest in the greatest monument to Chinese political thought — the Great Wall, built over many centuries by many rulers and dynasties as a fortification against the northern and western barbarians. Its

panoramic beauty notwithstanding, the length and the height of the Great Wall testify to how profoundly the Chinese feared those barbarians and how strongly they hated them. The complex combination of both fear and hatred was projected onto an everlasting wall of enmity — separating "us" from "them," revealing the core of the Chinese political mentality. A wall fits well into the paradigm of center and periphery, in which the ancestors of the Uyghurs were regarded as enemies. This fear had already been reinforced by the ingenuity of the Chinese language, which uses, deliberately and strategically, certain derogatory characters to mark their enemies. The Huns, for example, whom the Uyghurs call their ancestors, were given the name "savage slaves" in Chinese, implicitly indicating that they must be destroyed.

Such a rigid and clearly delineated political world is, to a certain extent, foreign to Uyghurs, whose idea of difference was more religious than political. The Chinese were infidels, but they were rarely considered political enemies. The political slogans of the anti-Chinese resistance organized by religious leaders in East Turkestan in the nineteenth century were mainly focused on expelling the infidels from the land of Muslims. For the Uyghurs, who were not even identified as Uyghurs until the beginning of the twentieth century, perceived themselves only as Muslims, vaguely aligning themselves with the Ottoman Empire as a legitimate caliphate until its collapse. Uyghur identity was never fundamentally political. But the increased prominence of Islam in the political life of Uyghurs during the era of Sufism heralded the end of the more tolerant nature of the Uyghurs' syncretistic culture. This tendency brought about the formation of a more monolithic identity of Uyghurs who perceived themselves in a binary opposition of Muslims and non-Muslims.

The political teachings of the Uyghur tradition were summarized in a scattered way and inscribed on the Eternal Stones in Mongolia by their kings, until they gained a more systematic medieval elaboration by Khas Hajib. On those Stones, the Chinese were perceived both as a dangerous and cunning foe and as a skillful and attractive friend. This contradiction foreshadowed the fatal crack in the political future of the Uyghurs — the impossibility of living together with their dangerous enemy without proper caution. It also revealed that for the Uyghurs the enemy was not as clearly, rigidly, and everlastingly defined as in Chinese political thought. The sense of political enmity was embodied by both peoples externally, in the Great Wall and the Eternal Stones; but if the Great Wall reenforced the cultural and political identity of the Chinese as sedentary city-dwellers with a static demarcation line, the Eternal Stones suited the lifestyle of a nomadic people such as the Uyghurs whose vitality rests on mobility.

Yet the Eternal Stones were left behind and forgotten after Uyghurs abandoned their kingdom, following their defeat by the Kyrgyz forces, to join other Uyghurs in the Tarim Basin. The Great Wall that kept the Chinese inside and the barbarians outside failed in its mission of exclusion as Mongols and Manchus, northern barbarians both, invaded China and established their dynasties. But the identification of the Uyghurs as enemies and outsiders never disappeared from the collective consciousness of China. The historical hatred of the savages was stored and became latent in their collective imagination, until it was stimulated by Sun Yat-sen when he mobilized the Chinese against the Manchu rulers in Honolulu in 1894 with the following oath: "Expel the northern barbarians, revive *Zhonghua* [China, in the cultural and literary sense], and

The Death Trap of Difference, or What the Uyghurs Understand

establish a unified government."

At the time of Manchu rule in the eighteenth and nineteenth centuries, some Chinese merchants, military personnel, and administrative staff settled in East Turkestan. The Uyghurs and the Chinese had first come to know each other after their tense interaction during the Tang dynasty, after which they developed negative perceptions of each other. Though the Uyghurs did not see the Chinese as a permanent political enemy, in the way that the Chinese viewed them, they did regard the Chinese as morally inferior. This perception was reciprocated by the Chinese, not about the morality of the Uyghurs but about their intelligence. The Uyghurs popularly view the Chinese as dirty, dishonest, stubborn, and stupid. These nasty caricatures are captured in the way Uyghurs call them *"Khitay,"* which is a derogatory and contemptuous term. These negative perceptions of the Chinese enabled the Uyghurs to maintain their sense of moral superiority while helping them to dilute the humiliation of being enslaved to them. It also gave them cultural strength as the source of their pride, self-confidence, and national identity, even though it sometimes made it too easy for them to slip into something dangerously self-delusional and self-serving.

Without this inner strength, the Uyghurs would not have survived the century-long onslaught of the Chinese colonialists. They have paid a terrible price for refusing to become Chinese, which could have saved them from oppression and extermination — from the genocide that is now being mercilessly carried out by the Chinese regime of Xi Jinping. The psychological dynamics of the colonized and the colonizers are complicated: the inner strength, the pride, that makes Uyghur survival possible is sometimes interpreted by the Chinese as a provocation, a challenge to their own concep-

tion of themselves. For them, it is utterly unthinkable that a "backward" people such as the Uyghurs have refused to become a part of one of the great nations on earth, to join a country whose economic boom is now drawing awe and amazement from all corners of the world.

The Chinese do not perceive the Uyghurs positively either. They call them *"Huizi"* and *"Chantou"* or *"Chanhui,"* a derogatory word for being mentally disadvantaged or stupid. In 1845, in a letter to one of his relatives, Lin Zexu, Governor General and scholar-officer under the Emperor of Qing dynasty who was exiled to Xinjiang owing to his forceful opposition to the opium trade, described Uyghurs as "the most foolish, cowardly, and extremely pitiful." Many other examples could be cited of the perennial Chinese belief that the Uyghurs are essentially outside the sphere of Chinese civilization because they are intrinsically unworthy of inclusion within it.

After the Chinese Communists took power in 1949, they intended to establish social harmony in China in part by banning the negative names that different nationalities used against each other. Most Uyghurs started to call the Chinese not *"Khitay"* but "Chinese comrades" or "a big brother nationality." (Orwell's novel was published in the same year!) For a while the Chinese did the same to the Uyghurs, by calling them more courteously "Uyghur comrades" or "a minority brother." In private discourse, however, in secret, the mutual contempt and hatred were never eradicated completely. In the 1980s, travel between East Turkestan and inland China improved significantly, with some Uyghurs moving inland to try their luck in the new Chinese economy. As the presence of Uyghurs in mainland China became more visible and active, it provoked curiosity at first, then mockery, and finally vilification. Chen Peisi, a famous Chinese comedian, called Uyghurs

21

"kebab-sellers" in one of his popular comedies in 1986, which set a precedent for the stereotyping of Uyghurs in Chinese vernacular culture, breaking the political taboos set up by the CCP. This opened the floodgates of Chinese xenophobia: since then Uyghurs have been called pickpockets, drug dealers, savages, and, finally, terrorists. These negative stereotypes fueled the gradual marginalization of Uyghurs from the Chinese-dominant world and encouraged the Chinese perception of themselves as culturally superior to non-Chinese nationalities.

The invasion of East Turkestan in 1949 was a momentous event in Chinese history, as it marked the first time that they felt confident enough to move beyond the Great Wall into the barbarian land — the land that their ancestors sought to occupy many times in vain. The Uyghurs, deprived of their nationality by the Chinese occupation, found themselves in a new political framework: they were to constitute an autonomous region, which promised them a significant degree of self-governance. But their dreams of self-determination, which were nourished by memories of the Second East Turkestan Republic, turned out to be a nightmare. In 1951, some Uyghur intellectuals and political figures who served in the government of the Second East Turkestan Republic wrote a letter to Zhou Enlai, the Premier of the Chinese government, to request the establishment of the Uyghuristan Autonomous Republic. In the letter, they rejected the ongoing Chinese plan for the establishment of an autonomous region for the Uyghurs, in which independence would be impossible. This letter did not please the Chinese Communist leaders, both in Beijing and

Urumqi, resulting in the mass purge of these Uyghurs in the name of fighting local nationalism and revisionism. Since then, the dream of Uyghurs for political independence has been mercilessly quashed by the Chinese government, for whom it denotes secessionism.

Actually, the Chinese had already planned to colonize the Uyghurs and then to assimilate them. This plan had been a priority of Sun Yat-sen's and was achieved by Mao Zedong and Zhou Enlai. In 1924, Sun had already discussed the colonization of Mongolia and Xinjiang in his book *The International Development of China*, while advocating the urgent creation of a unified nation as a necessary step for China to prosper. In 1957, following in Sun's footsteps, Premier Zhou Enlai described assimilation as "a progressive act if it means the natural merger of nations [i.e. ethnic groups] advancing towards prosperity. Assimilation as such has the significance of promoting progress." This assimilationist program has been a government policy, carried out slowly but surely, since the beginning of the 1950s.

This assimilationist program has focused on the three key areas — the history, the language, and the religion of the Uyghurs, which together comprise the foundations of Uyghur identity. The Chinese authorities re-wrote the history of the Uyghurs, claiming that Xinjiang has been an integral part of China since antiquity, while forgetting that there was no state called China and that they themselves were colonized by non-Chinese rulers, such as Mongols and Manchus, until recently. This deceitful historical literature claimed that Xinjiang has always been ruled by Chinese and not by Uyghurs, who came to it only after the ninth century. This view aimed to separate the Uyghurs from their ancestral land — or more precisely, to make them wanderers, stateless on their own land.

23

The Uyghur language was targeted by the Chinese authorities because it is one of the most vital and living aspects of Uyghur culture. In the 1980s, the Uyghurs were gradually robbed of the linguistic rights spelled out in the Regional Ethnic Autonomy Law, which allowed ethnic autonomous areas to decide on educational plans in those areas, including the language used in instruction and enrolment procedures. These rights were eroded because of the central and the regional government's unwillingness to implement them, either fully or partially, in the early 1990s. In 1995, Wang Lequan, who was then Party Secretary of Xinjiang, discredited the languages of the minority nationalities, claiming that these languages have exceedingly small capacities to express the key concepts of modern science and technology, which makes education in those concepts impossible. By the beginning of the 2000s, the Chinese government implemented a bilingual education policy which was in fact a monolingual policy, a Chinese-centric language policy, leading to the complete exclusion of the Uyghur language from all levels of education in 2017.

Since 1949, the Uyghurs have faced one of the deepest dilemmas of their colonial life: how to reconcile their Islamic identity with an atheistic and anti-religious party, the CCP. At first the Uyghurs were allowed by the CCP to practice their Islamic faith on the condition that it not be harmful to the rule of the CCP. Yet the communists' tolerance of Islam was less about the mercy of the CCP and more about the utility of religion as an ideological tool, so that local religious figures would help the regime govern the Uyghurs more effectively. The Uyghurs were given no option other than reconciling an atheistic belief in socialism with their theistic faith in Islam. Of course, they cannot be reconciled. This strange era of tense

but peaceful contradiction proved to be short-lived.

Despite this pressure, the Uyghurs' faith in Islam has played a great role in maintaining their own identity in a fiercely secular Chinese culture. It has created a dichotomy of "us and them" — "us" as Uyghur Muslims whose lifestyle is shaped by Islamic principles and rules, and "them" whose lifestyle is non-Islamic and non-Uyghur. The strict demarcation between halal and non-halal created a demarcation between the world of the Uyghurs and the world of the Han Chinese. They interact with each other only at work, and on other occasions in a superficial way. This religious demarcation prevented the Uyghurs from being blended with the Chinese and created a social barrier from which they could maintain their difference. It also placed huge internal restrictions on the Uyghurs about inter-ethnic marriages with the Chinese. Generally speaking, marriage to a Chinese is as unthinkable for a devout Uyghur as it is for an atheist Uyghur and even a Christian Uyghur, out of a deep fear of being assimilated into Chinese culture. All that the Uyghurs demanded was the right to be apart, the right to be themselves.

In the 1990s, the Uyghurs struggled to maintain their culture against the constantly intensifying assimilationist policies of the Chinese authorities. In this resistance, Uyghurs gradually made Islam the core part of their identity, as a spiritual shield in the face of cultural marginalization, social violence, and systematic injustices. Since the terrorist attacks of September 11 in the United States and the aftermath of the American-led war on terror, China has indiscriminately branded any type of Uyghur dissent as terrorism. This has dangerously blurred the line between legitimate grievances consistent with the Chinese Constitution and violence, between normal religious practices and terrorism.

It has systematically violated the rights of the Uyghurs to free expression, forcing them into silence about the violations of their rights.

During this time, Chinese nationalism came gradually to the forefront of Chinese government and politics, mirroring the growing self-assertiveness that seemed warranted by China's spectacularly successful economic reforms. This resurgence of Chinese nationalism was guided and manipulated by the Chinese regime. The re-appearance in textbooks and in public discourse of the notion of national humiliation, which is always perceived to be caused by foreign invasion and interference, gave a new life to the old feelings of self-pity and victimhood, which frequently accompany nationalist exhilaration. Chinese nationalism gained unprecedented popularity among the Chinese middle class, and like many nationalisms it frequently took the forms of anger, contempt, and hatred.

And so, China intensified its crackdown on Uyghurs and Uyghur nationalism in the name of nationalism and anti-separatism. The Uyghurs became a convenient screen upon which Chinese nationalists could project their fantasy of invincible power and their ultimate aim to create a unitary Chinese nation-state. Uyghurs, along with Tibetans, were an obstacle to this program of coercive integration, as they resisted being absorbed into the Chinese state at the cost of losing their culture. For Chinese nationalist intellectuals, inside and outside of government, being a unitary nation-state is the only guarantee of China's future. In pursuit of this imperialistic aim, China has been ruthlessly determined to eliminate Uyghur resistance.

On July 5, 2009, the relationship between the Uyghurs and the Chinese went from bad to worse, when Uyghurs took to the streets of Urumqi, the capital of Xinjiang, to honor the Uyghur workers who had been beaten to death by Chinese workers in Shaoguan, Guangdong a few days earlier, and to demand changes. Their demands fell on deaf ears. The peaceful demonstration turned quickly into uncontrollable mayhem. The century-long clash of cultures finally became violent, beneath the veneer of the communist propaganda about ethnic harmony and national unity. The physical, political, and psychological damage to the already fragile relationship between the Uyghurs and the Chinese was irreparable. A foul image of the Uyghurs was rapidly and widely disseminated by a variety of state propaganda channels. It became just a matter of time before the CCP decided to wipe out this enemy — the enemy of the people, the party, and the state.

Responding to the Urumqi riots in 2009, Chinese authorities introduced many hostile measures to curb expressions of Uyghur identity in the name of The Three Evils, defined by the Chinese government as "terrorism, separatism, and religious extremism." China took another critical step further to intensify their racist policies, so as to subdue the wild and stubborn Uyghurs once and for all: it played the Uyghur terrorism card successfully. Since 2014, thousands of Uyghurs had escaped mysteriously from China through southeast Asian countries, with some assistance from Turkey, and they ended up in Syria. The presence of Uyghurs in Syria provided the excuse for China to label Uyghurs indiscriminately as actual and potential terrorists, and to call Islam "an ideological virus." (That latter inuendo has not provoked any alarm or indignation in the Muslim world, including Turkey.) This provided the alibi for the creation of a network of concentration camps

deceptively described by the regime as re-education centers. The crackdown on Uyghur identity on all fronts was carried out within the context of waging a "Strike Hard Campaign Against Violent Extremism" in Xinjiang in 2014. But the level of repression increased dramatically after Communist Party Secretary Chen Quanguo was transferred from the Tibet Autonomous Region to assume the leadership of Xinjiang in late 2016. In Tibet he had been notorious for suppressing the human rights of the Tibetans.

In 2017, the genocide of the Uyghurs began.

The Uyghur genocide, which aims to put an end to the Uyghur question once and for all, includes the incarceration of millions of Uyghurs in the camps, systematic campaigns of brainwashing and humiliation through torture, the forced sterilization and rape of Uyghur women both inside and outside the camps, industrialized organ harvesting, the "orphanization" of hundreds of thousands of Uyghur children forcibly separated from their parents and assimilated into Chinese culture, the systematic prevention and reduction of Uyghur population growth, as well as others means for the eradication of Uyghur identity. All these practices satisfy the definition of genocide as formulated in the UN Genocide Convention. In a recent article called "Beijing Plans a Slow Genocide in Xinjiang" in *Foreign Policy*, Erin Rosenberg and Adrian Zenz, the latter a well known expert on the Uyghur issue, summarized the crisis: "The newly published research provides states and the international community with compelling evidence that a genocide is slowly being carried out. Of particular concern is China's perception of concentrated Uyghur populations as a national security

threat. Other signs of genocidal intent under the U.N. framework are also clearly present. However, even those states that may not share this conclusion cannot deny that, at a minimum, there is a serious risk of genocide occurring. We argue states are therefore obligated to act urgently on that knowledge."

On June 7, 2021, in testimony in Britain at the Uyghur Tribunal, which was convened with a nine-member panel to probe whether China's alleged crimes against the Uyghurs amount to genocide, Wang Leizhan, a former police officer in China who is currently applying for asylum in Germany, stated that

> as part of the national policy of seeing Uyghurs as
> automatically enemies/terrorists, as part of my police
> training, I was taught to see Uyghurs as "the enemy."
> If a Chinese police officer decided to arrest Uyghurs,
> we were told to invent reasons and to make the arrest
> appear as legal and plausible as possible. This is why
> torture and electrocutions were also routinely adminis-
> tered to Uyghurs.

The categorization of all Uyghurs as a collective enemy of China has long been an element of the Chinese strategy to justify the Uyghur genocide. To borrow a phrase from Carl Schmitt, the collectivization of enmity is the essence of Chinese politics on the Uyghur issue.

In the implementation of the Uyghur genocide, the role of the CCP is essential, and in the CCP it is the leader, Xi Jinping, who is paramount. The Communist Party of China is a party that has maintained its legitimacy and its power by mercilessly suppressing any opposition to its rule. The method of this genocide, like its intent, is shocking and inhuman.

Leaked Chinese documents have revealed clear governmental instructions for the camp administrators to "show absolutely no mercy" and "allow no escape." The reports of Uyghur and Kazak camp survivors — who were released from the ordeal of the camps to Pakistan, Kazakhstan, Egypt, and Turkey, where they held dual citizenship as a Chinese citizen, on condition of their absolute silence over their horrific experience in the camps — paint a grim and harrowing picture. The CCP has been systematically and cold-bloodedly eliminating, that is, killing, camp inmates.

How could such a culture, Chinese culture, which has been admired for its Confucian values advocating for the common good, allow such evil? There are many possible answers to this question. One of them is that, in a group as in an individual, morality may conflict with psychology, and when such a conflict occurs morality may yield to psychology. The centuries-old insecurities of the Chinese have led them to develop certain mechanisms of survival. These mechanisms are masked by the high ideals of Confucianism, which allow their presentation in a safe and satisfactory way. Fear and hatred are some of these survival mechanisms, as manifested in the great negative vision of the Great Wall — as perfect a symbol of a collective psyche as any people ever devised. These traditional instincts of fear and hatred have served as the inner psychological and cultural force behind this genocide. Even though they live within the borders of the Chinese state, the Uyghurs are still the enemy beyond the Wall, the abiding trans-historical enemy that changes form over time but remains always the same.

This fear and this hatred are not dead after a millennium, for their object is still very much alive and has refused to be defeated — to be enslaved by the Chinese. And this has created

an evil circle: the more resistant and resilient the enemy has been, the stronger the fear and the hatred has grown. In the current genocide we are witnessing the extension of the Chinese fear of the Uyghurs who during the Tang dynasty "threatened" them from without to the Uyghurs within the Chinese state who now "threaten" them from within. Until this enemy is eradicated, no Chinese can feel safe. Liao Zhaoyu, dean of the Institute of Frontier History and Geography at Xinjiang's Tarim University, has declared that "the imbalance of the ethnic minority and Han population composition in southern Xinjiang has reached an unbelievably serious degree." He contends that southern Xinjiang must "change the population structure and distribution [to] end the dominance of the Uyghur ethnic group." That is why Rosenberg and Zenz argue that "the perception of Uyghurs as a human threat to China's national security suggests birth prevention targets could increase over time, increasing the threat to the continued existence of the group as a whole."

All this is madness. How could a nuclear-armed military power and an economic superpower be afraid of a people who have nothing but their bare lives left to be destroyed? Why would a mighty and sophisticated state such as China wage a war of destruction against one of the weakest peoples on earth, save that the Uyghurs are hated by them viscerally and beyond all reason? No genocide happens without hatred, and animalistic hatred especially. The annihilation of another human person must be preceded by his de-humanization, which numbs all the perpetrators' moral sensibilities, blinding them to the meanings and the consequences of their action. Hatred fuels this dehumanization and fear sanctions it.

Recent Chinese propaganda has shown singing and dancing Uyghurs in East Turkestan, a colorful folksy mask to

31

hide the horror of what is being done to them. These official videos and photographs ratify the old Chinese stereotype of the Uyghurs, the eugenicist belief that they are simpletons and idiots who know only how to sing and dance, whose primitive minds must be re-engineered. The government propaganda even suggests that the Uyghurs do not feel humiliated by their treatment: after all, they do not have the intellectual capacity to understand what is happening to them. What they seek is only sensual pleasure. Their apparent smile is the proof that they are happy with the conduct of their Chinese masters. They deserve inhumane treatment because they are not quite human.

The modern world has seen genocide before, and it is seeing genocide again. This genocide is enabled by cutting-edge technologies, global economic power, aggressive diplomatic influence, and domestic political support. And, of course, by the passivity and the indifference of the bystanders beyond China's borders. In committing this vast crime, China is scorning the conscience of humanity, if such a thing still exists. And so, the question that was asked before must now be asked again. What is the world going to do about it?

RICHARD THOMPSON FORD

Slavery's Wages

I was in grade school when the television show *Roots,* based on Alex Haley's famous book, first aired. It was a big deal, at least among adults, and my parents insisted that my sister and I watch it. We dutifully sat down in the front the walnut-veneered TV cabinet as my father adjusted the rabbit ear antennas to get a good signal. For an eight-year-old, *Roots* was disorienting, often boring, and occasionally very disturbing. The images of LeVar Burton's Kunta Kinte enduring the brutal Middle Passage and of the slavers throwing the sick Africans overboard are still with me today. Sitting in an air-conditioned living room in a California track house, I didn't quite grasp

what it had to do with me. This all happened a long time ago, I thought. It seemed like another one of the period costume dramas that my mother watched on PBS, but with many more examples of vicious behavior, a lot more black people, and much better production values. I identified with the black slaves as the protagonists of the story, but I felt little connection with any of the people depicted. The landscapes, accents, clothing, and architecture were all unfamiliar. Most of the white people were inexplicably cruel and heartless. The black people were as unlike me and my family as the slaves in *Spartacus* (and I kept waiting for what I naively assumed would be the inevitable slave uprising that would provide the story with its cathartic ending).

When I went to school, where I was one of three or four other black students, some of the kids started calling me Kunta Kinte. I was annoyed but brushed it off, until I was cornered by a group of older white kids. *Kunta Kinte! Kunta Kinte! Go back to Africa where you belong!* I ran away, cursing the bullies — and silently cursing Alex Haley for writing that damn book. When I told my father, he offered the advice that was typical of his generation: "They'll never leave you alone if they think you're scared of them." He had taken me and my sister to karate lessons, seemingly in preparation for just such a problem. The next day, when the same kids cornered me, I picked the smallest of them and tried to do as much damage as I could. I still got the worst of it, of course, but the one unlucky kid I targeted left the scene with his face bloodied and his wrist sprained. In the principal's office I said that I didn't start the fight, and I promised to stay away from the other boys. But if they hassled me again, I added, I would make sure that at least one of them left bloody every single time and I didn't care what happened to me in the process. They stopped calling me

Kunta Kinte and started whispering behind my back. It would have to do.

Those grade school bullies showed me exactly what I had in common with the characters in *Roots*. A straight and unbroken line connected me to my despised and exploited ancestors who had made the brutal Middle Passage from Africa. Or at least that's how it felt at the time.

Before *Roots*, the archetypical slavery story was probably *Up from Slavery* by Booker T. Washington. Indeed, *Roots* was a late-twentieth-century century answer to *Up from Slavery*: more radical in its politics, more ambitious in its scope, more scholarly in its historical research, more dramatic and novelistic in style. For me, and I expect for many other Americans of a certain age, *Roots* is still the archetypical representation of slavery. Although there have been many others since, Haley's account established the genre. Ever since, all decent slavery narratives have shared some common elements. Most obviously, a respectable slavery narrative must unflinchingly depict the horrors and cruelties of slavery: the unspeakably hellish passage across the ocean, the dehumanizing slave auctions, the grueling, thankless, and unremunerated toil, the capricious rule of the master, the separation of mothers from their children, the whippings, the rapes, the lynchings. It must also establish the experience of slavery as the foundation of the black experience. A slavery narrative cannot simply be the story of an individual; it must carry the symbolic weight of slavery for black people as a group. Either overtly or indirectly, it must depict slavery as a sort of pedigree, a shared ancestral experience that joins black people to each other.

Quentin Tarrantino's film *Django Unchained* is not a respectable slavery narrative, but it is instructive because it successfully treats the slavery narrative as a stylized genre. It is a cross between a slavery narrative and a spaghetti Western. The film operates, as many Tarrantino films do, by quoting familiar elements of a well-established genre and slyly but convincingly tweaking or inverting them. *Django Unchained,* in what has become a signature Tarrantino flourish, offers a cathartic alternative to the classic archetype, wherein the downtrodden gets even with the oppressor in a highly stylized orgy of righteous violent retribution. It does for the slavery narrative what *Inglorious Bastards* (wherein a team of Jewish-American military officers outwit and fight Nazi soldiers in occupied France) does for the Holocaust narrative and what *Kill Bill* (in which a woman gets bloody revenge on a host of sexually predatory and exploitative men, the worst of whom had killed her bridegroom and her unborn child on her wedding day) does for the story of the sexually victimized woman. Django suffers all the classic injuries of enslavement: grueling toil, routine humiliation, regular beatings. His wife is raped by a sadistic plantation owner. Instead of staging an unsuccessful rebellion or making an unsatisfying escape as would be historically plausible, Django becomes an expert gunslinger and returns to slaughter every white person on the plantation before he rescues his wife and burns the plantation house to the ground, while the stereotypical "House Negro" looks on in horror.

Django Unchained makes sense as a film only because the slavery narrative is so familiar. We already know the story and how it has to end, which makes the unexpected, impossible *denouement* both shocking and exhilarating, as if cinema offers the chance to alter the past and redeem history itself.

36

(Tarantino played the same benevolent counterfactual trick on the Manson killings in *Once Upon a Time...in Hollywood*.) The film left many black viewers uneasy, I suspect because it disrupted the line of subjugation and suffering that joins the history of slavery to the present day. Django seems to escape not only slavery but history itself. Like a spaghetti Western hero, he rides off into the sunset and into a depthless present: we do not ask whether his descendants will suffer as sharecroppers or live in segregated impoverished neighborhoods, endure Jim Crow policies, be incarcerated for petty offenses, or be killed by racist police. Django puts it all behind him. We cannot.

Not only can we not put slavery behind us; it has become the lens through which many people of all races see the black experience in America. Consider a few examples:

- As Americans reckon with the horrors of police violence and mass incarceration, many people have insisted that the racial inequities of the criminal justice system have their roots in slavery. Mass incarceration is "the new Jim Crow," which was, of course, a continuation of the racial economy of slavery in a new form. Extending the analogy, some argue that modern policing writ large is an outgrowth of patrols organized to track down runaway slaves.

- A black person who attempts to get ahead by distancing herself from other black people or ingratiating herself to whites is known as a "House Negro" — a reference to the distinctions between slaves on the plantation.

- A common criticism of romantic or intimate relationships between blacks and whites — especially those

involving black women and white men — is that they
mirror, and in some way recapitulate, the rape of black
slaves by white masters.

- A recent controversy in high tech involves the use of the
terms "master" and "slave" to describe the relationship
between circuits and elements of programming. Some
contend that this terminology is racially insensitive
because it callously evokes the traumas of slavery.

This return to slavery grounds our conversations about
race and racism in a discrete history. Virtually all educated
people have rejected the myth of biological race, but without it
race is an infamously slippery concept; it defies definition even
as it defines a social hierarchy. Slavery, by contrast, provides
a concrete historical referent: a black person is a person who
could have been enslaved. The return to slavery also pays
homage to our ancestors, connecting black people to a legacy
of oppression and survival and spiritual resistance. Most
black people cannot trace our lineage back to a specific place
— instead, we find it in slavery and the struggle for freedom.
The memory of slavery substitutes for the memory of an
ancestral homeland, of the "old country" that other groups in
America define as their origins — a connection that the histor-
ical practice of slavery ruthlessly cut off. Slavery, then, both
explains our present circumstances and joins black people
to today to black people in the past. If our suffering today
is a legacy of and a reflection of slavery, then our suffering is
continuous with and analogous to the suffering of slaves.
Like an ancestral homeland that one has never visited,
however, or an ancient ethnic tradition that has been modified
and idealized as it passes from one generation to the next, the

38

legacy of slavery is not completely straightforward or identical to the historical practice. Slavery's contemporary significance is both practical and symbolic; it is real but it is obscure, the lingering consequences of laws, customs and events, and the poetic and emotional force of past trauma.

The distinctive evil of slavery lay not only in the practice itself but also in the racism that justified it and eventually outlived it. The ideology of race has kept this country in the shadow of slavery, dooming us to reproduce racial injustice in new mutations: sharecropping, Jim Crow, the chain gang, the isolation of the ghetto, the confinement of the prison. In this way, racial ideology compounded the initial theft of labor, denying opportunities for gainful employment and remunerative investment to the descendants of slaves long after Emancipation. Employment discrimination kept most blacks in low wage jobs and blocked the advancement of even those who managed to pursue a skilled trade or profession. Housing segregation and discrimination ensured that black neighborhoods would be plagued by blight, crime, environmental hazards, and unstable property values.

The modern idea of race is a byproduct of modern chattel slavery. Chattel slavery differed from slavery in the ancient world, where the status was often temporary and typically was justified as a consequence of conquest. The conflict between the ideals of Enlightenment liberalism and the realities of the slave economy inspired a new and more pernicious justification of human bondage: a natural hierarchy of races. There were older ideas of race, but they were quite different. Europeans had an idea of distinctive human races before the slave trade, but it was vague and politically contingent. In *Society Must be Defended,* a book based on a series of lectures given at the College de France, Michel Foucault noted that

the idea of race appears in early modern Europe, where it refers to geo-political conflict between groups distinguished by language, culture, and geographical origin (Normans, Angles and Saxons in England; Franks and Gauls in France.) In these instances, race organizes a historical account of political community, power, and legitimacy. The idea of the "race war" describes the conquest of one group by another, and is used as a counter-narrative to a story of unity under a legitimate sovereign. Race is a sort of rallying cry whereby one faction contests the legitimacy of political dynasty. The Norman monarch had the right to rule the Normans but not the Saxons, who must reclaim their proud independence as a distinct race and throw off the tyranny of alien dominion. This idea of race shares some features with modern racism, but it lacks the crucial notion of inherited hierarchical status.

The notion of race that appears in Shakespeare's *Othello* is more familiar but still not quite the same as ours. The Moor of Venice is an outsider, marked by his skin color, which has already taken on some of the now-familiar symbolism assigned to it by atavistic white supremacy. Desdemona's father Brabantio, objecting to the marriage, complains, "For if such actions have passage free, bond-slaves and pagans shall our statesmen be." The Duke, in approving the marriage, suggests that Othello's race does not signify low status — or at least that his other qualities make up for it: "if virtue no delighted beauty lack, your son in law is far more fair than black." And, most infamously, Iago, in an effort to provoke Brabantio, taunts, "Even now, very now, an old black ram is tupping your white ewe."

Yet Othello's race is a subject of ambivalence in the play. There is no iron law against miscegenation, as there was in most of the American south until 1967. Othello is regularly

described as honorable and noble. Those who would disparage his relationship with Desdemona accuse him of drugging or casting a spell on her — not of raping her, as they certainly would have in the United States for much of its history. Othello is obliquely compared to a "bond-slave" but also a "pagan," suggesting that the slur refers as much to his exoticism and acculturation as to his status or color. Shakespeare's Venetians use Othello's color as a metaphor for status; Brabantio's objections to his union with Desdemona reflect concerns about a loss or degradation of status, and — most tellingly — the Duke's answer to those objections consists of an assurance that Othello's color is not in fact a sign of his status.

All this is not yet the race and racism that came to dominate and to corrupt the United States. Slavery took these more fluid and contingent ideas of race and hardened them into an immutable biological condition that was used to justify intergenerational subjugation. This idea of race survived the demise of slavery itself and came to take on a life of its own. What we might call modern racism first developed as propaganda for slavery.

But modern racism is not a fixed ideology: it is an opportunistic discourse, changing to suit the times. Just as the race of Foucault's "race war" was not the same race as that of Shakespeare's Othello which in turn was not the same race as Thomas Jefferson and Sally Hemmings, today's race is not identical to that of the eighteenth-century plantation. Racism changed as slavery matured into its most uncompromising form. As the tension between American democratic ideals and slavery became more and more conspicuous, racial ideology became more extreme and more shrill: in a sense, it was not racism that inspired and intensified slavery but slavery that inspired and intensified racism. Tragically, racist propaganda

has flourished and spread well beyond its original function and has inspired new types of evil. We do not passively inherit the prejudices of our ancestors; each generation makes its own prejudices, building on but also modifying that of the past. Likewise, new racial injustices metastasize from old bad habits, while new institutions and practices offer new opportunities for selfish ambition, bigotry, exploitation, and callousness.

The history of racism's mutations begs an important and delicate question. What can slavery explain about contemporary black life and what can it not explain? It cannot be the case that it explains nothing, but it also cannot be the case that it explains everything. Is collective memory enough to account for present experience? Did the same racism that tied black people to humid plantations south of the Mason-Dixon Line also provoke grade-school bullies to taunt and pummel me in the arid heat of California's Big Valley over a century later?

It is worth noting that those kids didn't think to hassle me until *Roots* was aired on network television. They were, of course, racists, but it took the publicity surrounding *Roots* to trigger their racism. Their aggression was not the smug assertion of dominance that one encounters from people secure in their position or convinced of their superiority — I would encounter this too, but only later and much more frequently at the elite universities that I attended and in the elite law firms and government offices in which I worked. This was different: it was a shrill and defensive aggression provoked by the shifting cultural landscape that allowed a radical retelling of the American story from the black perspective to air on prime-time television. *Roots* sullied the innocent, sunny

version of the American story and replaced it with a grim and unvarnished account that placed slavery at its center. For black people, this story was familiar and seeing it in popular national media was a long overdue vindication. But for many whites, it must have felt like an accusation and the prelude to a loss in status.

The defensive reaction to *Roots* was a racism of *ressentiment,* a distinctive form of late twentieth-century racism. Of course, it finds it origins in the racism of slavery, but it is also an outgrowth of its own historical moment. It is a reinvented racism, a sour remake of a bitter American standard. Racism has been reinvented many times over its strange history. It became more strident and uncompromising as slavery came under more forceful attack in the nineteenth century. It acquired new justifications, such as the allegedly inherent rapaciousness and laziness of blacks after Emancipation. It adapted to the mass urbanization of blacks during the long Great Migration from the rural Jim Crow south to the cities of the north. It morphed again during the upheavals of the civil rights struggle, when black liberation was linked to the menace of communist sedition and countercultural radicalism. During my youth it took the form of the stereotypes of the urban thug, the welfare queen, and the affirmative action hire who gamed naïve liberals to snatch unearned advantages.

Each of these racism reboots is based on the original atavistic racism developed to justify slavery. But they are not the same. These reinterpretations now justify other practices and attitudes; they are spread by new political coalitions for new purposes. As racism mutates, it serves new purposes and acquires new themes, attenuating its connection to slavery. How much does today's racism owe to slavery and how much to the years that came after slavery? Do we learn more about

our current racial injustices by looking to the plantation economy of the eighteenth century or to the urban markets of the twentieth century?

It would be remiss to discuss the legacy of slavery and fail to mention the *New York Times'* renowned and controversial 1619 Project. A common theme of many of the 1619 Project essays is that slavery was — and its legacy remains — central to almost every institution, custom, and practice in America. The racism born of slavery is, according to the project's lead essayist Nikole Hannah-Jones, part of the "the very DNA of this country." The 1619 Project asks, provocatively, what might be illuminated if we thought of slavery rather than liberty as America's foundation. It is certainly useful to re-center racial justice in the American story, and thereby correct a certain Whiggish interpretation of the American racial narrative.

The 1619 Project reminds us that slavery was also a long-lived practice of central importance to national economies. It is well known that slavery was indispensable to the agricultural industries of the American South, the Caribbean, and Latin America. But it is less often acknowledged that slavery defined transatlantic trade for centuries. Slavery was an indispensable leg in the infamous triangular trades of the Age of Discovery: slaves brought from Africa to the Caribbean and North America, where they worked to harvest sugar and rum, which was brought to Europe and later the North American colonies and traded for manufactured goods, which were traded in Africa for slaves. It was a perpetual circuit. Without slavery, trans-Atlantic trade would have been much smaller and much less profitable. Slavery sustained empires and bankrolled entire cities in Europe. Monticello and Richmond in Virginia were built on the backs of African slaves; so were Liverpool and Manchester in England. Slavery

was more than an evil practice with discrete injuries; it was an integral part of the modern world for centuries.

Now add to this the racial prejudice, the discrimination and exclusion that slavery left in its wake. Like a major techno-logical innovation or scientific breakthrough, the economy of slavery inspired a mythology. An epic of Progress celebrated machine-age breakthroughs. A parable of racial hierarchy justified slavery. This mythology is one of slavery's most durable legacies, and surely its most toxic. As a consequence, the design of cities, the location of housing, the administra-tion of criminal justice — all have been shaped, distorted, and corrupted by slavery. In these respects, the 1619 Project helped to correct a distorted and incomplete popular understanding of history by emphasizing the significance of slavery during this formative period in America's history.

A group of prominent professional historians fairly criticized the 1619 Project for ignoring or downplaying the opposition to slavery during the nation's founding. They argued that the tone and emphasis of the articles "suggest a displacement of historical understanding by ideology." They pointed to exaggerations and errors of fact and interpre-tation — most notably, that the revolution was fought by slaveowners so as to keep their slaves. But to many readers this seemed beside the point: the 1619 Project insists upon confronting the centrality of slavery to American wealth and influence and to ask whether the influence of slavery might be more profound than the influence of noble ideals too often honored in the breach, such as liberty and equality. Those are fair questions, whatever the answers.

Slavery's influence has been so widespread, so lasting, and so profound that it seems reasonable for black people to attribute almost any disadvantage or misfortune to it. Fewer black people

45

would be poor and more of them would be rich, if genera-
tions of wages had not been stolen from our ancestors; had
our parents and grandparents not been denied equal employ-
ment opportunities and equal access to housing investments in
desirable neighborhoods. We would have longer, happier, and
healthier lives if we were free of the constant stigma of racial
bigotry, the steady diet of insults, snubs and condescension, the
episodic but still regular explosion of violent repression from
racist thugs, mobs and police abusing the color of law.

Yet the causality is very imprecise and can be easily abused.
The very pervasiveness of slavery's influence is also why it is
hard to identify its discrete consequences with precision.
A cause of everything is also a cause of nothing in partic-
ular. Death affects every aspect of human psychology, every
institution, custom, and ambition, which is precisely why
no one tries to account historically for its influence. It is real
and ubiquitous, but too tangled and diffuse to constitute a
historical cause. For black people in America, the legacy of
slavery is in this way like the anticipation of death: an unavoid-
able and looming monolith so overwhelming that it cannot
be reckoned with even as it demands to be acknowledged.
Perhaps that is why we are better at addressing slavery figura-
tively and narratively rather than analytically. In book and
films, we can describe slavery's gruesome horrors and relent-
less indignities, but we cannot account for them in the sense
of tracing their consequences or measuring their costs. A
monocausal emphasis on slavery would simplify history, and
lead us to believe in phantom continuities, and falsely reduce
the present to the past, and deny the many things that really
have changed in America.

Given the impossibility of causal analysis, we resort to
metaphor; and sometimes that leads to intellectual sloppiness

as well. A biological metaphor in particular, the metaphor of DNA, evoking an image of a body politic with an inescapable genetic legacy. Thus Matthew Desmond argues in his essay for the 1619 Project that "American slavery is necessarily imprinted on the DNA of American capitalism." Desmond notes, for example, that depreciating mortgages and double-entry bookkeeping were developed to organize the slave economy. He clearly means to discredit modern capitalism by revealing its debt to the slave economy. But this alone does not discredit the institutions and practices by association, any more than it would discredit the field of mathematics if we were to discover that it was first developed to aid an avaricious dictator in calculating the tribute due from his vanquished subjects. Given its importance to global trade and the easy circulation of wealth and resources in a rapidly developing nation, it was inevitable that some of the practices that developed to support slavery might later be put to better uses. Indeed, one would be hard pressed to find a modern institution or practice that was not influenced by slavery at least indirectly, either benefiting from the wealth it created or influenced by the pernicious ideas it propagated. But do we understand these things adequately if we dwell only, or mainly, on their link to slavery?

To discredit various practices, we would have to believe that they still effectively carry on the ugly work of slavery today in a different guise. Certainly, one could make the case that some parts of the wage economy resemble slavery — indeed someone did, hence the old idea of "wage slavery." But it is important to insist that the institution of slavery was much more than very hard work in very hard conditions. It was a social system. Anyway, Desmond does not really argue for this; instead he lets the metaphor of DNA imply that these practices

somehow carry the genetic code of slavery into today's financial system, such that slavery explains the exploitations of modern capitalism in the same way the chronic depression of a parent might explain the crankiness of a child. This is more likely to convince capitalism's critics than its admirers. And even the fiercest anti-capitalist might insist that today's economy has its own distinctively contemporary evils. To say that slavery *explains* starvation wages and sweatshop working conditions today is *post hoc ergo prompter hoc* speculation. It is plausible that some of the habits of callousness formed during slavery have contributed to the particularly harsh character of American capitalism; but callousness is older even than slavery. It is much more likely that both slavery and sweatshops are independently explained by the universal phenomenon of human avarice.

The DNA metaphor suggests a mysterious and inscrutable causality. When my mother notices that I like cashews and says it must be because my father liked nuts before dinner, or when someone points out that heart disease runs in the family, they mean to say that there is no need to parse the relationship any further — that we have hit upon the one true explanation. It doesn't really matter whether I like cashews because such a preference is in the DNA that I inherited from my father, or because I remember sharing them with him as a kid, or because the bar at the Duke's Hotel in London, which he never visited but which I love for other reasons, serves them with their excellent martinis. On the other hand, it does matter if the supposedly genetically encoded trait is something I would like to change. The biological metaphor, the notion of inherited social or cultural imprinting, is a pessimistic, even fatalistic idea. If heart disease is in my DNA, I am in trouble no matter what I do: my ancestry is my destiny. If, on the other hand, it

48

runs in the family because of lifestyle choices such as smoking cigarettes and a high-fat diet, it is up to me, my sister, and my cousins whether it continues to run in the family for another generation. We have agency, and therefore change, a different fate, is possible.

For slavery to define black racial identity, there must be some way it is transmitted inter-generationally to those born long after the institution itself was abolished. The idea that slavery is in the nation's DNA echoes the idea that race is in the individual's DNA. We have replaced the discredited idea of inherited race passed from generation to generation encoded in biological DNA with a different type of genetic inheritance: the experience of slavery, passed down from generation to generation. Not the memory; the experience.

The centrality of slavery in today's racial consciousness is explained as much by its distinctiveness to the black American experience as by its causal significance. Capitalism, caste, punitiveness, and technocracy affect everyone and create a multi-racial group of victims; but the legacy of slavery makes the experience of black suffering unique. What happened to black people in America happened to no other Americans. About this there can be no doubt. But while it may be true that slavery accounts for the uniqueness of black subordination, it does not account for all or even most of the history of black subordination. There are too many intervening historical contingencies for that to be the case. Slavery, one might argue, is a cause of racially segregated urban poverty, but so is the pattern of industrialization and deindustrialization, American metropolitan development, and the construction

49

of the interstate highway system. A slavery-centered narrative conflates the psychological meaning of an especially salient instance of oppression with the causal significance of those events for contemporary inequality. But we will not eliminate inequality unless we are empirical about its causes.

Moreover, since racism has mutated to serve new nefarious purposes over its long and strange career, practices may be racially unjust but largely discontinuous with the legacy of slavery. For example, today it is almost a commonplace that modern policing practices evolved from the tactics of patrols that sought to capture and return escaped slaves — a clear and unbroken line from slave patrols to today's racial disparities in aggressive policing. This serves as an unequivocal indictment of both the motivations for policing and its effects. (It also, perhaps unintentionally, suggests an optimistic prognosis for reform: we can change or abolish policing at little social cost because its primary function is unambiguously abhorrent.) To say that a twenty-first century police officer who shoots an unarmed black person is perpetuating the legacy of slavery implies a continuous and consistent social practice: policing and incarceration is simply the plantation in a new guise.

50

This is bad history. Racism certainly played a role in the development of modern policing, but policing was largely a reaction to urbanization and industrialization. It took a similar form on the European continent at a time when slavery was either unlawful or quite rare, and in American cities in the north as well as the south. In America, as in Europe, the modern project of pervasive and systematic crime prevention was largely a reaction to the norms and habits of a rural peasant class entering industrialized urban environments in large numbers. Police were one of many organizations designed to socialize people used to village and rural

life into the rhythms of the factory, the habits of the city, and the norms of bourgeois society. The American historian Hendrik Hartog describes this pattern in his classic essay "Pigs and Positivism," where he details the efforts to prohibit pig farming in New York City; and the French historian Eugen Weber describes it in *Peasants into Frenchmen*, which recounts the largely, if often inadvertently, successful efforts to impose a Parisian French dialect, a Parisian French history, and a Parisian French national identity on the provinces.

Black Americans fleeing the degradations and the exploitations of the Jim Crow system were the last of such a peasant class to enter American cities. The famous Great Migration of the early twentieth century in fact continued until the early 1970s. Peasant migrants to cities in the nineteenth century met with harsh conditions and vicious policing, but also with economic opportunity. They acculturated to bourgeois norms, to greater and lesser degrees, and eventually they began to blend into a less differentiated mass culture. This development, with its rough edges shaved away, was the basis for the sanitizing myth of the American melting pot. This was Weber's story of how peasants became Frenchmen. It is also, to a large extent, the historian Noel Ignatiev's American story of *How the Irish Became White*. It is tale of widespread ethnic prejudice, compulsory assimilation at its most objectionable, and a great deal of violence. It is, perhaps most of all, a story of the culturally homogenizing effects of liberal capitalism. In Weber's account, for example, the harshest discipline could not convince the residents of villages in Languedoc or Provencal to abandon local dialects, customs, and identity for a generic French national culture as defined by the elites of Paris. What did convince them was economic opportunity, and the well-known liberties and seductions of the big city.

The black American urban migrants met with all of the hardships suffered by every other farming laborer who entered the city, plus the distinctive ones of racial animus. Worse, they did not come into a welcoming job market. Blacks were shunted into the most menial jobs. By the 1960s they entered a slowing urban economy where industrial jobs were leaving cities for suburban industrial parks. Unemployment was rising everywhere, but it was worse in cities where industry had fled, and it was chronic among black men, who faced discrimination as well as a weak labor market. Joblessness was as pressing an issue as civil rights — the famous March on Washington in 1963 was for Jobs and Freedom.

Some of the large number of jobless people of all races did what some jobless people everywhere have always done: they turned to crime, both serious and petty. In the late 1960s and 1970s, American cities faced one of the most significant crime waves in history. In an understandable zeal to condemn the criminal justice crackdown that followed, some ignore or even deny this. But people of all races at the time agreed that crime was a serious menace and many people of all races eventually supported aggressive policing as a response. An aggressive jobs creation policy on the order of the New Deal, combined with a generous and expanded social safety net as a backstop would have been both wiser and more humane. Federal officials saw this clearly at the time: Lyndon Johnson's Great Society was the response. But that initiative withered under budgetary pressures and competing priorities, most notably the war in Vietnam. Intensified law enforcement, by contrast, was cheap — at least in the short run. Moreover, it was a local solution. Crime was a national problem, but every big city mayor had to deal with it, and in the absence of a federal response they used the tools that were available. Law enforcement is under local

administration; social welfare is not. So, the nation as whole, city by city, police department by police department, district attorney by district attorney, got tough on crime.

Of course, the response was warped and intensified by racism. But rich and powerful political interests opposed social welfare programs and the redistribution they would require out of self-interest, while many others opposed them in principle as inconsistent with the work ethic. In any case, today's punitive and violent law enforcement was not simply the continuation of racist practices such as Jim Crow or slavery. It was created and shaped by factors that have little or nothing to do with race or slavery, such as the structure of American government and the changing industrial economy.

Slavery is the defining trauma of black identity. It occupies the place that the Holocaust does for modern Jews; and that rape does for a certain type of radical feminist. If slavery seems like the archetype of all race relations, it is because the modern idea of race itself is a legacy of slavery. The black race *as a race* was born into slavery. To understand the black experience, then, we must begin with slavery. But must we end with it? Must we also return to it repeatedly, evoke it constantly, advance it as an explanation for all of the evils and the injustices that now fall under the capacious banner of "racial injustice"? Must we always keep our eyes focused on it? What will we fail to see if we do?

The horrors of slavery were real and objective facts. But the community defined by slavery, like all communities defined by maps, flags, anthems, museums, political institutions, and military might, is imagined. This does not mean it is insignifi-

53

cant or fantastical, only that it cannot be experienced directly *as such* — it must be imaginatively reconstructed from the fragments of smaller encounters, symbols, and stories, across significant differences and circumstances, across centuries. And imagination can be an unreliable narrator. An account of contemporary racial inequality relentlessly focused on slavery is incomplete and distorted. In such an account, which is really a mythology, slavery becomes a transhistorical force that reaches out, unmediated, too easily seeming to explain social patterns that have complex and multiple causes. If the legacy of slavery defines racial oppression today, what room is left for the more universal evils of exploitative capitalism, social caste-like hierarchy, punitive moralism, and the banal technocratic viciousness of modern civilization as explored by Hannah Arendt and the philosophers of the Frankfurt School in contexts far removed from the evils of slavery but steeped in other unspeakable evils?

What slavery is to black people today, moreover, is not always the same as what it was to the slaves. Consider the reaction to Annette Gordon-Reed's fine book, *The Hemingses of Monticello,* which documents the intimate relationship between Thomas Jefferson and his slave and paramour Sally Hemmings. The book unsurprisingly upset conventional Jefferson historians, who with few exceptions jealously guarded a tradition of hagiography reserved for the "founding fathers." Not only was Jefferson's relationship with Sally Hemmings illegitimate and exploitative, it also violated taboos on interracial intimacy that, while anachronistic, doubtless still informed the sensibilities of some of the historians in question.

What is perhaps more surprising is that some black readers also objected to Gordon-Reed's subtle analysis of the Jeffer-

son-Hemmings relationship. Some were incredulous at the implication (unavoidable given the historical record) that Sally Hemings had genuine affection for Jefferson and lived what was in many ways a privileged life, not only in comparison to other black slaves but also in comparison to most white people of her era. When Jefferson traveled to France with Hemings and her brother, the two could have sued for their freedom and refused to return to America with him. Apparently she considered doing so, but returned with him after getting Jefferson's assurance that their children and her brother would be freed upon his death.

This paints a more complicated picture of slavery than its current symbolic position allows. Perhaps life as a destitute black woman in a patriarchal foreign country was worse than slavery, or the equal of it. Gordon-Reed reminds the reader that no women were truly free in Jefferson's and Hemings' era. Moreover, slavery itself was not a monolith: it was worse for some slaves than for others, and it got worse for all slaves over time as the absolutism of racial status hardened into place in the decades after Sally Hemings' death. Gordon-Reed notes that the Hemingses enjoyed a favored status in the Jefferson household — they were exempt from manual labor, they dressed in sumptuous aristocratic attire, and they ate as well as Jefferson himself. Chattel slavery was a unique moral abomination. But for some, the alternatives, in a society stratified by a rigid class hierarchy and defined by patriarchy, were no better.

Today such observations may seem like an apology for slavery, minimizing or denying its cruelties and horrors. But we cannot understand slavery's historical legacy without taking into account not only how it was singular and unique, but also how it was continuous with many other contemporaneous injustices in American society. Slavery was, among

other things, a monumental theft of human labor. But there were other customs and practices that also effectively stole human labor: for instance, many feminists credibly insist that marriage and the patriarchal limitations on the liberty of unmarried women constituted a theft of women's labor, not to mention of their other property, which accrued to the husband after marriage. Such were the circumstances that Sally Hemings would have faced had she left Jefferson to stay in Paris. These other injustices have also cast long shadows and have also warped our society.

The symbolic weight of slavery for the black race can blind us to injustices that do not involve the racial legacy of slavery, even when they mirror it in important respects. To give one striking example: from the perspective of political economy, today's undocumented workers are the most obvious descendants of the slaves — they have quite literally taken the place of slaves, doing the same type of work in domestic service and in an agricultural economy that remains organized to require a powerless and exploitable workforce. Yet they are not, for the most part, black, and this disrupts the familiar link between anti-black racism and slavery. As a consequence, most discussions of the legacy of slavery fail to mention them.

There is a risk in overstating or oversimplifying the importance of slavery to both the American experiment and to the African American experience — not only in overlooking or trivializing the real virtues that contributed to the national character, but also in ignoring a host of other evils and morally ambiguous features that account for this large, vibrant, chaotic society. A genuine confrontation with our history entails not only condemning evil but also embracing virtue, and grappling with moral ambiguity, complexity, and contradiction. I am a black American who believes that my

true legacy is rich, nuanced, and layered — as is the legacy of any great people. It cannot be reduced to a simple linear story of oppression and resistance, the fundamentals of which were determined before the discovery of electricity. I reject the idea that nothing of fundamental significance has changed in race relations in four hundred years — that we are really just fighting the same fight against slavery in new forms, like some nightmare of eternal recurrence.

Slavery looms out of our past and it haunts our present in myriad indirect forms. And we can reinvent slavery in new forms if we choose to do so. Yet the legacy of slavery does not get passed down through the generations like detached earlobes. If we are cruel and exploitative today, it is because *we* are cruel and exploitative — not because someone in 1619 was. Thankfully, we can also reinvent liberty and equality in our time; and to the extent we do so, that will be to *our* credit — not that of the Founding Fathers or even Fredrick Douglass or Fannie Lou Hamer, much as their examples might inspire us. Slavery is our history, but it is not our roots.

MARIO VARGAS LLOSA

The Winds

58

I went to the demonstration against the closure of the Cines Ideal at the Plaza de Jacinto Benavente, and no sooner had it begun than I inopportunely broke wind; it's been happening more and more these days. But no one around me noticed. I regretted going there, because the crowd was negligible and those who did show up were mainly human rubble like myself. No young person in Madrid cares that the last cinemas in the city are vanishing. They have never set foot in them. Since childhood they've been used to watching the films devised — if you can use the word *film* to describe those images that the present generation find amusing — for the screens of their

22ty

computers, tablets, and mobile phones.

Osorio, in his optimist mode, says that since the cinemas are gone, I will have to get used to seeing films on the small screen. But I won't get used to them; in this, too, I will remain faithful to my tendencies of old. I have lived too long to care if they call me a fossil, a Luddite, or, as Osorio says to tease me, a "conservative irredentist." I am all that, and will continue to be so as long as my body holds out (which I doubt will be much longer). I break wind again; but no one has noticed it this time either, to judge by the indifference on people's faces.

Osorio must be the last friend I have. We talk on the phone every day, to be sure that we are still alive. "Good morning. What's up? You still standing?" "Apparently. At least it looks that way." "Shall we meet for a coffee later?" "Yup." I don't remember when we first met; certainly not when we were young. The hazy swamp of my memory tells me that it was twenty or thirty years ago. I know I was a journalist in my youth; Osorio says he taught philosophy in secondary school, but I'm not at all certain that he was a teacher, and even less of philosophy, since he knows little of the profession or the subject. He has never read Pascal, for example, whom I like a lot. Maybe he has forgotten how he made his living, and his memory is as shot as mine. Maybe he is trying to dupe me and himself by inventing a past. And he is well within his rights to do so. We have agreed to call each other every morning to see if one of us has departed this world in his sleep, and to notify the competent authorities to incinerate us, so that we may disappear completely.

"The last of the cinemas may be closed, but they've opened a new bookstore," Osorio says to lift my spirits once the sorry farewell ceremony for the Ideal has ended. "There are now four in Madrid. I don't guess you'll complain. Four bookstores!

More than in Paris and London, I assure you. It's an outright luxury."

Another tall tale, the product of Osorio's pathological optimism. What he calls a "bookstore" is actually a simulacrum, a firefly that lights up at night and dies out almost simultaneously. This so-called bookstore — I dropped by there yesterday or the day before — was the property of an old codger from Malasaña who put his library on sale before retiring to the next world: a motley collection of ragged volumes pawed at, leafed through, and put back on their dusty shelves by the handful of shoppers present when Osorio and I went in to take a look around. I bought a slim tract by Azorín, a compilation of articles on Argentine literature, mainly *Martín Fierro*. I had never heard of it, and it cost me just a few cents. Naturally, in the shop, amid the old codger's books, I broke wind again, and there was nothing I could do to cover it up. No one cared, except for Osorio, of course, who smiled one of his devilish smiles and briefly flared the wings of his nose in disgust.

I didn't find any of those old-fashioned novels I like nowadays. Since the practice arose of ordering up novels custom-written by computer, I gave up reading any of the ones produced — it would be absurd to say "written" — in our time. When the system was invented, it seemed like another of those diversions that appear in such profusion from day to day, one destined to fade away like any other passing fad. Who can take seriously a novel generated by a computer in accordance with the client's instructions? "I want a story that takes place in the nineteenth century, with duels, tragic loves, lots of sex, a dwarf, a King Charles spaniel, and a pedophile priest." The same way you order a hamburger or a hot dog with mustard and extra ketchup. But the fad caught on, then it stuck, and now people — the few people who read at all — read nothing

but novels that they order from metal or plastic skeletons. You can't say there is even such a thing as a novelist anymore; or better said, all of us are novelists now. But that's not true either. The only novelist on the planet still alive and kicking is the computer. Which is why readers wedded to tradition, to the real novel, the novel of Cervantes, Tolstoy, Woolf, and Faulkner, are left reading dead writers with our backs stiffly turned to the living.

This so-called bookstore in Malasaña will last as long as it takes to sell the relics piled on its shelves, unless the state succeeds first in its campaign to expropriate printed paper of all kinds, which it plans to incinerate in order to be rid of those allegedly harmful bacteria that the militants of that godforsaken *Paper-Free Society!* campaign have been yammering about in slogans and on placards for some time now. I think it's all bunk, regardless of how many scientists — among them more than one Nobel winner — assert that they have proven repeatedly in laboratory tests that the combination of paper and printer's ink is as harmful as paper and tobacco were back when cigarettes were killing generations of smokers with cancer of the lungs and throat. My sense is this is just the latest craze, something for the idle masses to get up in arms about. My worry is that they will win, and like Singapore, the first paper-free city in the world, Spain and all of Europe will turn their books, libraries, and private and public archives into ash.

"What do you care if it all burns up?" Osorio asks, ever defensive of what he assumes is our era's political vanguard. "All those books, magazines, and newspapers are digitalized, and you can consult them comfortably, in antiseptic conditions, onscreen at your house." But I don't have a "house," just a tiny room with a bathroom, and anyway my computer is no bigger than an old book. So his argument doesn't hold for

me. For that matter, I don't think even he believes what he is saying. He does it to get under my skin. If he didn't, we would get bored.

Osorio says he feels not the least nostalgia for those faraway years when people like myself went to the library to read. But I do. I liked the tranquil atmosphere, a bit like a convent, of the Biblioteca Nacional on the Paseo de Recoletos, the religious silence of its reading rooms, the secret complicity among those of us there, with our folders, reading by the bluish glow of the lamps. When the Biblioteca Nacional in Madrid closed its doors there was a protest, and I swear I saw people shed tears. In Madrid, it was a peaceful farewell. Not so in Paris, where a violent demonstration took place on the day they shuttered the Bibliothèque Nationale. There were violent protests, a fire, and I believe some dead and wounded.

It is true that they have digitalized the former holdings of that immense building on Recoletos, and that they are now accessible onscreen. But for people like myself, people from another era, life without bookstores, without libraries, without cinemas, is a life without a soul. If this is progress, they can stick it where the sun don't shine. "You're a pterodactyl, a dinosaur, an antediluvian," Osorio tells me. He may be right.

Far as I know, Osorio never had a family. He must have had parents, but he doesn't remember them, and he doesn't recall whether he had brothers or sisters, and he will tell you with certainty that he has never been married. I do have some recollections of my parents, whom I don't think I ever really got along with. I do not know if I had siblings; if I did, they have been erased from my memories. But Carmencita, my wife of many years, I remember well. I never talk to Osorio about her, though. Every night since I was stupid enough to leave her, I think about her, and I am tortured by regrets. I think I have

only done one wrong thing in my life: leaving Carmencita for a woman who wasn't worth it. She never forgave me, we never managed to be friends again, and to top it off Carmencita married Roberto Sanabria, my best friend at the time. It is the only episode from the distant past to which my memory still clings, and it torments me even today. At night, before I go to sleep, I think of Carmencita and ask her to forgive me. She doesn't know this, of course, unless there is another life after this one and the dead amuse themselves by spying on the living. I never saw her again, and only many years later did I get word of the accident that ended her life. I no longer remember the name of the woman I left Carmencita for; it will probably come back to me, but if it doesn't, I don't care. I never loved her. Ours was a fierce and fleeting affair, one of those rash incidents that turn your life upside down. After doing what I did, my world exploded, and I was never happy again.

It's not true that I'm a pterodactyl. At least not in most senses of the word. I can recognize that in many ways the world of today is better than the one of my youth. There is less poverty than before, and that matters. According to the statistics, eighty percent of humanity is now middle class. A great achievement, and I hope it is really true. That leaves a fifth or a sixth of the planet poor and miserable, which means that we are still far from eradicating the problem. Defeating cancer and AIDS seemed impossible, but the scientists did it. Even I survived a cancer of the blood. We never thought it would be common for people to live a hundred years, and yet a good number of us bipeds are still standing to show that this isn't out of reach. More than a few centenarians retain their lucidity and are able to enjoy life and even sex. Not me, but many people more or less my age still enjoy making love, or so I hear. As for freedom, I believe today — tomorrow I may change my

mind — that it has disappeared entirely from our lives. This is a permanent source of arguments between Osorio and myself. He believes — or says he believes — that we are freer than ever, and is scandalized when I tell him that ours is a world of happy, obsequious slaves. But sometimes, when he is in a bad mood, he admits that I am right.

I was thinking about all this — Osorio, the vanished movie theaters, the young people with their laptops — when I felt something strange in my head, something that coursed through my entire body, like a chill. A strange sensation. Discreetly, I patted myself all over, and noticed nothing strange on my head or body. What was it then? For the first time, with growing anxiety, I understood: I didn't know how to get home. I had forgotten my address. I had often thought that I should write it down on a piece of paper and carry it everywhere I went, but I never did. Now something worse was happening: I had forgotten which streets to take to reach my house, or rather to my room with its bathroom. I looked around frantically: all the people who had attended the protest at the closing of the Ideal had left. Osorio was one of the first to go, saying he had to drop off papers at some ministry or other.

And so I was alone on that corner of the Plaza Benavente, even as people, cars, buses, and trucks surrounded me. I had no idea what direction to take. I had been breaking wind a long time, as I always do when I get nervous. Dissimulating, as though the few passersby might notice my indisposition, I walked to the corner and looked closely at the sign hanging high up on the wall: Plaza Jacinto Benavente. It meant nothing to me, though I knew that if I rummaged through my memory it would reveal itself bit by bit, gradually growing brighter like a spotlight.

Pretending that all was well, I walked around the square, scrutinizing the names of the streets. I felt a slight tremor when I read the street sign that said Plaza del Ángel, which I was certain was familiar and meant something to me, even if I didn't know what. At last, having come full circle, I sat on a bench, trying to calm my nerves. I was frightened. Nothing like this had ever happened to me before. And at this accursed hour my friend had left me there, forgotten and alone. My friend — what was his name — ah, yes, Osorio. Sometimes I even forget my own name — like a jerk I broke wind as I tried to recall it. What must it smell like around me? I lost my sense of smell some time ago. I had better walk, maybe that will stir up my memories. Yes, they'll come back to me when the scene changes and my serenity returns.

I chose a street called Carretas that ran downhill. I had the feeling, almost the certainty, that my home was not far away. It hadn't taken me long to walk to the protest that morning. A half an hour, or maybe less, it could have been just fifteen or twenty minutes. No time at all. I walked slowly to keep from tripping and falling. As I did, I remembered things and people, and my address would undoubtedly return to me soon. One by one, the streets that separate me from the little room full of books and papers will appear, and the little bathroom where I piss and shit and shower and comb my few remaining hairs every day before going out for a coffee and a conversation with Osorio.

But I recognized nothing and nobody, certainly not the streets whose names I paused to read on every corner. Another expulsion, this time long and noisy. Why did I have so much gas? Because I was anxious. It always happens. When I remembered my address, I would relax. Finally I reached a public square, the Puerta del Sol. I had the feeling that this

The Winds

place must be important, with its crowds, its plaques, a clock, flags, police, and Metro tunnels. But I recognized nothing. And why bother asking questions of passersby? What would I ask? I didn't have any identification. Seeing me so confused they would most likely call the police, who would haul me off to the station and stick me in a cell while they figured out who I was and where I lived. And I was certain that I wouldn't make it through the experience alive. Again, a shiver shook me from head to toe. I thought I'd better stop and rest a while, and continue walking later, but slowly, taking my time, waiting for the movement to rouse my memories, until I at last remembered what street I lived on. When I got there, I would have to climb a long staircase for several stories. That much, at least, I still knew.

There were no benches in the Puerta del Sol, so I sat down on the edge of a fountain, along with a group of young people of both sexes. Now and then a few drops of water struck our heads and shoulders. I felt a bit weary, but my mind was active, struggling to remember my address. I looked around again. Had I come this way? Probably, but I didn't remember. Was this the first time I had a memory lapse so severe? I thought so, but I wasn't sure even of that.

I watched the girls and boys I was sharing the fountain with get up, hold their nose, and glare at me. "I've broken wind," I thought. And I hadn't even realized it. How long ago had I lost my sense of smell? Years ago. I got up, too. My back ached, and I took a slow turn around the Puerta del Sol. I had the vague impression that I had been there that morning, when fewer people were around, but I couldn't imagine which street I ought to take to return home. And many streets branch off from the Puerta del Sol, leading into every part of Madrid. The sun was high in the sky. It must have been early afternoon.

Liberties

It is true that all the holdings in the building on Recoletos are now digitized, within reach of any screen. But for me, a man from another era, life without libraries is a living death. Just then — walking slowly, I had made it around the Puerta del Sol — I was certain that the Calle del Arenal, which lay before me, would take me home. My heart was pounding in my chest. Yes, I could turn there and I would make it back to my room.

Incidentally, I'm not an antediluvian, not entirely. I can recognize that in many ways the world of today is better than the one of my youth. There is less poverty than before, and that matters. According to the statistics, eighty percent of humanity is now middle class. A great achievement, and I hope it's really true. That leaves a fifth or a sixth of the planet poor and miserable, which means we are far from eradicating the problem. Today there are African countries — South Africa is one of them — that rival those of the first world in terms of modernization and development, and that is remarkable. Defeating cancer and AIDS seemed impossible, but the scientists did it. And myeloma, as it's called, which made me lose almost fifty pounds and still flares up now and again, because myeloma is a strange disease, no one knows what causes it or how long it will last, and it rarely kills its patients, but it never goes away entirely. (Still, for two years now I have been free of blood cancer.) We never imagined it would be common for people to live so long, and yet here we are, hundred-year-old bipeds, showing it was no mere fantasy. Let alone that men and women could last this long with their lucidity intact — but not, *hélas,* their memory — and enjoy their lives. (The last time I made love without chemical assistance was ten years ago or so, I believe.)

But despite all this progress, we haven't gotten rid of war or nuclear accidents, and this means that however far the world

67

advances, it may disappear at any time. The slaughter of Israelis by Palestinians and vice-versa continues, a daily testament to our self-destructive vocation. It's curious that Jews, persecuted throughout their history, have turned cruel, at least with regard to the ill-fated Palestinians. The nuclear accident in Lahore — which might have been a terrorist plot, the true cause was never established — brought about more than a million deaths in a matter of minutes. And yet an international treaty to deactivate our nuclear arsenals is still a fantasy. No one can ignore the likelihood of war between China and India, which seems to creep closer every day. Pessimists say that if one does happen, the nuclear cataclysm will blow the world to pieces. Osorio, of course, isn't one of them. "If it occurs, believe me, only Asia will disappear. The scientists and the military have studied it. All of us this over here will survive, don't worry. And once the disaster's over, perhaps common sense will prevail, and peace will reign over whatever's left of the earth. The world will be a museum, like the kind you love so much." At times my friend Osorio utters this kind of idiocy, just to irritate me. And he inevitably succeeds.

I had reached the end of the Calle del Arenal and was now in the Plaza de Isabel II, in front of the Teatro Real, which was advertising a run of five operas by Verdi. I felt weary and on edge and had broken wind at length and I suppose malodorously the entire time. My legs were shaking. I sat on one of those small benches scattered across the Plaza de Isabel II, in the heart of the old Madrid of the Austrias, to see if my memories would return and I would find my home, which should be nearby. I missed it.

Osorio must be the last friend I have. I don't remember when we met; certainly not when we were young. The hazy swamp that is my memory seems to say twenty or thirty

68

years ago. I know I was a journalist in my youth; Osorio says he taught philosophy in secondary school, but I'm not at all certain he was a teacher, and even less of philosophy, since he knows little of the profession or the subject. He has never read Pascal, for example, whom I studied a great deal at one time and who nearly convinced me to return to the Catholicism in which I grew up. Maybe Osorio has forgotten what he was in life, and his memory is as shot as mine; maybe he is trying to dupe me and himself by inventing a past. And he is well within his rights to do so. We have agreed to call each other every morning to see if one of us has departed this world in his sleep and to notify the competent authorities to incinerate us, so we may disappear completely. I think I've thought this, and said this, already.

I went through my pockets again, as I did many times that morning, believing I would finally find my cellphone so I could call Osorio and ask him my address. But I had gone out to the ill-starred protest against the closure of the Cines Ideal in such a rush, I had forgotten it. Damn it.

Far as I know, Osorio never had a family. He must have had parents, but he doesn't remember them, he doesn't recall whether he had brothers or sisters, and he will tell you with certainty that he has never been married. I do have some recollections of my parents, whom I don't think I ever really got along with. I do not know if I had siblings; if I did, they have been erased from my memories. But Carmencita, my wife of many years, I remember well. I never talk to Osorio about her, though. Every night since I was stupid enough to leave her, I think about her, and am tormented by regrets. I think I have only done one wrong thing in my life: leaving Carmencita for a woman who wasn't worth it. She never forgave me, we never managed to be friends again, and to top it off, Carmencita

69

married Roberto Sanabria, a good friend from the neighborhood. It is the only episode from the distant past to which my memory still clings, and it torments me even today. I fell in love with my dick, not my heart. A dick that's no good for anything anymore except peeing. When I think of my dick, the word that occurs to me is the Peruvian one, *pichula,* but why, if no one here in Spain uses it? Force of habit, I suppose. It still pains me that I left Carmencita. I never saw her again, and only much later did I learn that she had been run over by a car and killed. I have never managed to remember the name of the woman I left her for. It has vanished from my mind, same as my address, which was gone just when I needed it most. It would probably come back to me when it no longer mattered. A long fart escaped me, but so softly I hardly noticed. How long had I been sitting in the Plaza de Isabel II? A long time, an hour maybe, maybe two. My legs were heavy, and I thought a walk would do me good. I was still lost, utterly lost, but I felt more relaxed now. It had to be past midday, and although I couldn't be sure, I doubted that I had eaten breakfast or lunch or even drunk a glass of water that whole day. I asked a passerby what time it was and he said, "Around three."

Three in the afternoon! Would I ever find my house? Or would I have to go to the police and ask for their help? I'd have to show them my papers — which I obviously didn't have on me — and the whole thing would be a mess and a horrible waste of time. I had reached a large square past which lay a building which I immediately identified as the Royal Palace. Was this the Plaza de Oriente? Yes. I remembered this place, and in the old days I think I even passed by here when I used to stroll or even jog along the Paseo del Pintor Rosales, which was just past here, in that direction. If I kept going, I would see to my left the Parque del Oeste, which was full of foreign

prostitutes, Dominicans and Haitians especially, at night. Not far from where I stood, I saw a fountain where people were filling their bottles or taking sips of the cool water. I got in line and drank long and deep, and it felt good. When I was done I broke wind quickly, discreetly, and it bothered no one.

As I walked along the Paseo del Pintor Rosales, I thought what a good thing it was that the museums still hadn't disappeared. Weren't we headed in that direction? Aren't the paintings and sculptures in them already digitized? That is why so few people visit them, in all likelihood. Even the Prado, which always used to be full, especially in summer. Many people, like Osorio, prefer to look at the paintings on their screens. As if it were the same, seeing a Goya, a Velázquez, a Rembrandt, in person as on a computer! What is extraordinary is that there are critics and professors who maintain this idiocy, claiming that the digital image is not only more comfortable for spectators, but also more exact than the original. According to them, an artwork viewed on screen can be examined minutely and in its totality for an extended period of time in a way that just looking at it does not allow. Many people swallow this flimflam and as a result the museums are neglected. I need to go back to the Prado one of these days, I haven't been for a good while. Thinning crowds mean tighter budgets, and they open for fewer hours a day, fewer days a week, and fewer weeks a year. Eventually the absence of a public will force them to close. And soon enough some scientist will discover that the blend of oil and linen is dreadful for people's health, and we will have to burn all the paintings for the sake of public safety. I hope I'm no longer here when the tragedy occurs.

My god, I'm a pessimist these days! I had reached the Parque de Debod, I vaguely recognized the Egyptian temple

there, and since I was tired and there was nowhere to sit, I plopped down in the grass. I felt my heart beating in my chest, and wondered if I was having a heart attack. But I calmed down a few minutes later: false alarm.

Still, I didn't get up yet. I felt good there. There weren't many people in the park. A few tourists snapping photos of the Egyptian monument. Someone had told me that during the Civil War, the Montaña Barracks were here. When Franco rose up, the soldiers from these barracks rose up too, but the people of Madrid came out in full force, pried the doors open, and massacred the soldiers inside. What times those were! Now nothing moves anymore in Spain, and there won't be another civil war. Just as well. What they call Francoism now is something different: without caudillos or radical partisans, without firing squads or torture, all very scientific, based on physics and mathematics, and, above all, on the absolute dominion of screens and images over reason and ideas.

I laid back in the grass and I felt serene. Maybe I would take a nap, and when I slept I would remember my address.

I thought about the serious museums, not the galleries, which were no longer, at least in aesthetic terms, what they once were. Now they were little circuses, less interesting than the big ones — the only institutions, I might add, that have progressed in this era and have turned into proper artistic spectacles. I had recognized as much some time ago, but I kept my opinions to myself. I would never tell Osorio, because it would make him jump for joy, and shout: "You've sold out to the modern age!" But I haven't sold out, and I haven't made any concessions. I am simply confirming an objective fact. While everything that was artistic in the past — painting, sculpture, literature, high music, the humanities — has deteriorated to such an extreme as to either disappear or change permanently

for the worse, the circus, which used to be entertainment for children or older adults who yearned for their lost childhood, and which no one would ever have called art half a century earlier, has been reborn with a rigor, elegance, audacity, and perfection that suffuses many of its routines with the grandeur of artworks from long ago. Technological developments have helped make the circus an artistic spectacle of the highest order. Young people, who once wanted to be architects, then directors, then singers, then chefs or soccer stars, now dream of being ringmasters, acrobats, clowns, trapeze artists, or magicians. How the times change.

Did I fall asleep? If not, I was close. I felt good. There was a pleasant breeze. I did sense that the bugs might be biting me, especially the ants. My stomach had calmed down. I no longer had that uncomfortable gassy feeling that brought me so much shame.

A few weeks ago — or months? — after a long time of waiting, I got a ticket to see the celebrated Adonis Mantra. A prodigy, that magician from Silesia: he could make members of the public vanish before the spectators' eyes, or levitate them, or fly to the ceiling of the auditorium, and then a second later the lights would dim, and when they came back up, he would be tied with rope in the bottom of a trunk. Those tricks were pure genius, absolutely incredible.

The same is true of cartoons. And surely for the same reason: technological advances. It's funny, as a boy, unlike my classmates, I didn't care for the circus. Especially the animals, which frightened me. When my parents took me I would go along, but I wasn't dying to go the way my friends were. And I cared even less for cartoons. When we argued about what we should go see, I was always against watching anything with Donald Duck, Mickey Mouse, or Popeye and Olive Oil. They

73

bored me. And yet now they are the only films on television I can stand to watch. The effects they achieve are incredible. The figures emerge from the screen, stare at you straight in the eyes, sit on your knees, hide under the sofa. Or so it seems. It must be true what they say, that old age is a second childhood. Now an old man, I had turned back to the circus and to animation, the only fields in which I am prepared to admit that the culture — is it culture? — of today had surpassed that of yesterday.

Still, it's sad that in a period that could never give birth to Cervantes, to Michelangelo, to Beethoven, the only thing comparable to those giants in originality and beauty are the funambulists from the circus and the puppets of the cartoons. It's unfair of me to think of it this way, because in truth those are the only two things now that bring me the same sensation of absolute satisfaction that I felt as a young man reading *War and Peace* or seeing *Primavera* in the Uffizi or the *Giaconda* in the Louvre.

I felt good, and I went on sleeping on the grass of the Parque de Debod. I don't remember my address and I don't care. What they call art galleries now strike me as failed circuses in the vast majority of instances. Or theaters playing out a ridiculous farce. The last one I visited, a few months — or years? — ago, the Marlborough in Madrid, was putting on an exhibition of insignificant pieces by the famous Emil Boshinsky entitled *Art for Fantasy and Imagination*. I can't say at present why this con man is so famous. His monstrous creations were projected on large screens. They had flashy titles like *Tiburtius, Bringer of Storms* or *The Hood of the Monk Romualdo*. They consisted of fireworks, like the figures in a kaleidoscope, those tubes of cardboard filled with shifting colored glass that were meant to amuse children back when I was small.

No one knows what a kaleidoscope is anymore. Children don't play with them; they can work a computer as soon as they are born. The other day I was arguing with Osorio, who swore to me that he had never seen a tube of colored glass that changed its appearance as it moved. I thought they were entertaining, a pretty thing, and I seem to remember spending hours with them, turning my right wrist to make the images dance. I think I did that, but maybe it's a false memory.

The trick with Emil Boshinsky's exhibitions is that his paintings do not exist: the titles do, but the works themselves are digital. Still, you can buy them at the Marlborough, which furnishes its clients with a certificate of authenticity. That seemed like a silly joke to me, and I cared for it even less when the gallerist offered me a socio-political explanation to justify the charade. She assured me that this invention of Boshinsky's had resolved the ancient problem of private property and those who were opposed to it. Property had always been considered a form of theft, an injustice committed by the rich against the poor. "Immaterial" artworks, however, have owners, and therefore respect the principle of private property, but everyone can enjoy the artworks on the net without stealing them. She assured me they had already sold several "immaterial paintings" for a very modest fee — just twenty to twenty-five thousand euros — and that the gallery considered them a success. I told her — I don't know how I remembered — that a Peruvian poet and painter, Jorge Eduardo Eielson, had invented "imaginary sculptures" eighty (or many more) years ago. He installed them in such storied settings as the Tower of Pisa, the Arc de Triomphe, and the Statue of Liberty; he even sent one to the moon on a NASA spaceship. Without ever making a cent from it. I thought that the gallerist would be amused to learn that Boshinsky had a

predecessor, but she looked at me incredulously and slightly dismayed. Twice I broke wind as I spoke to her, but I covered it up, with some measure of success, by hunching over, as though I needed to scratch my leg.

When I woke I was shivering, and the natural light had dimmed. I had the horrible feeling that as I slept I had not only passed gas, but had lost control of my bowels and soiled myself. My goddamn stomach! This wasn't the first time it had occurred. It happened once before when I was in the cinema watching a film by John Ford, a director I admire a great deal. I would have to do now what I had done then: carefully clean myself and wash my shit-stained briefs and pants with bleach. How revolting. And that was if I ever found my home.

There was just a bit of light left. I was shaking, and the bugs, especially the ants, had eaten me alive while I was sleeping. I didn't remember my building number or the name of my street, but I wasn't as scared as before. I felt resigned to my fate. I struggled to get up and asked a passerby the time. It was five-ten in the afternoon. I still had time to remember my address. If I didn't — but I felt optimistic, I had a hunch that it was close, this neighborhood looked familiar to me — I would go to the police to avoid spending the night out in the open. Perhaps I would be jailed and never get back out. But at least with the police, while they tried to figure out who I was, I would have a roof over my head. What would I do if it started to rain? I set out slowly down the Paseo del Pintor Rosales.

A few months — or maybe weeks? — ago, Osorio dragged me to a new gallery, "cutting edge," he told me, in Lavapiés. The title of the exhibition was *Sculptures for the Sense of Smell.* There were twenty-odd mannequins vomiting, urinating, defecating, or suppurating liquids — let's be frank: mucus — from their ears and nostrils, and to appreciate fully the significance of the

works on display the visitor had to smell the containers where these figures deposited their discharge. As soon as I entered, I felt such disgust that I myself wanted to vomit in one of those slop buckets. And of course I emitted a series of farts. It always happens when I get out of sorts. But Osorio assured me that after a moment of initial difficulties, the nose would cease to be repelled and would begin to grasp the deeper sense of the exhibition. And, he added, "its metaphysical significance." The poor fool thought that I was intimidated. "I never imagined metaphysics would smell like farts," I responded. "I've got enough of my own." At the end of the series, the artist himself, a hairy young man with the eyes of a madman, who seemed never to have bathed and who called himself Gregor Samsa, gratified the heroic visitor with a translated text from Baudelaire about the artistic value of odors.

I barely go to the theater or the opera now, though I liked them a great deal before. Or rather, it's for that reason that I don't go. Because they too have become a joke, a pretext for putting things on screens, like everything in this electronic digital world that we've wound up in thanks to progress.

Just imagine, this was celebrated as a grand invention — I remember it well, forty years ago, or twenty, or ten — this thing they call a guided multimedia spectacle. It seemed like an advance, being able to hear the opera while you received information on a screen about the work, the composer, the librettist, the conductor, and the historical context of the piece, especially as you could comment on the performance with fellow spectators or others far from the action onstage. Bravo, bravissimo. Except that attention is unitary, and we have only one brain, and this kind of simultaneous operation ends with the spectator concentrating on the little glimmers on the portable screen and completely distracted from the

The Winds

opera which, in principle, he has come to hear and to watch. The entire theater is packed with a multitude that, instead of listening to or savoring the music, is totally absorbed in its screens, informing itself about a work that it neither sees nor hears except in snippets, commenting — or rather, blabbing — with other nitwits like themselves, magnetized by the glowing pixels. A guided multimedia spectacle. It is impossible to enjoy a concert or an opera or even a light comedy surrounded by people who can do nothing but tap or caress the tablets before their eyes and gawk incessantly at the poor spectator who went to the theater with the idiotic plan of watching and listening to the things happening onstage. The only serious spectator of today is the image that the biped produces of himself on his portable appliance, that incinerator of all that is genuine and authentic, all that has gone basically extinct in this world reigned over by the glimmer of the prosthetic and the artificial.

Was this not the Teatro Real? Was I not once more before the Palacio de Oriente? Yes, of course. Here was the Royal Palace, where the ambassadors presented their credentials to the kings. How had I gotten here? I thought I had been walking in the opposite direction. At some point I had turned around and retraced my steps from that morning. Yes, this was the Teatro Real. I was tired, and depressed again. I felt something strange on my face, touched my eyes, and found that they were full of tears. I managed to stop myself from screaming and sobbing. Would I never get home? I was fatigued, my body was quivering, I wanted to lie down. How nice it would be, to cover up and sleep knowing I would wake to natural light a few hours later, and I would be in my house, or rather my room, with its tiny bathroom. How nice. It terrifies me to think of spending an entire night on a bench, dying from the cold. If I

had to spend the entire night outside, I would certainly die like a dog. I was tired and looked for a bench to sit down on and pass the time.

When I sat down on a corner of the Plaza de Oriente, half turned away from the Royal Palace, I felt more relaxed. I touched my eyes, and discovered that I had stopped crying. I looked at the sky, and it was clear and radiant. A few stars were visible.

Sometimes, without realizing it, I imagine that what is happening around me has contaminated me as well, and I don't really know how to distinguish between culture and its stand-ins in this mad world we now live in. I say this because of my argument the other day with Osorio at the home of the Arismendis, the millionaires. The dinner impressed me greatly, not because of the food, which was nothing out of this world, but because of the holograms. They were truly the stuff of fairytales. We were two of a half-dozen guests who were surprised and amazed from the beginning of the night to its end. I had already seen holograms at fairs, exhibitions, and museums, but those three-dimensional figures had never before astonished me. That night, they did. I didn't know that hologram technology had evolved to such a point that it could produce the kind of wonders we saw at the Arismendis.

I was stunned as soon as the butler opened the door to help me remove my coat and scarf and I saw his holographic double, a butler with his same face and attire, repeating his gestures, his smile, and his bow. And that was just the beginning. All night we were surrounded by ghosts, duplicates of waiters or waitresses, serving the table, passing trays of canapés and drinks, absolutely identical to their real counterparts. We were delirious: all of us had the sensation of entering an oneiric world, of living in a surrealist poem, witnessing what you might call the quotidian

marvelous, a world in which it was hard to distinguish the edge of reality, the real people from their doubles, flesh and blood from puppets wrought by technological illusions. For the grand finale, when we were at the entrance saying our goodbyes, duplicates of our hosts, fictional Arismendis, appeared to say goodnight and wish us well.

My argument with Osorio began when I told him about the impressions that the holographic spectacle had made on me. He interrupted me with a kind of ironic scorn, as if he had caught me masturbating or doing something else untoward. "Tell me, then, was what we saw not art?" No, I told him, it wasn't. It was simply a remarkable technological feat. He replied: "Well, that's what art has always been, a technological feat. That's what art in our day consists of." We argued for hours, and I refused to accept his theory that the true artists of our time are electronic engineers, programmers, specialists in art and image, and network professionals. I never told him that he was right, but there was a depressing truth in Osorio's point: we live in a world where what we used to call art, literature, and culture is no longer the work of the imagination and the skill of individual creators, but the product of laboratories, workshops, and factories. Of the fucking machines, in other words. (Am I a Luddite? I might well be.)

I felt myself getting drowsy again. If I fell asleep, the sky would be full of stars when I woke. A whole day looking for my home, my room, certain that it was around here, but not being able to find it. Now, at this moment, I didn't care. I knew my underwear was full of shit, it happened when I dozed off by the Avenida del Pintor Rosales, but I didn't really care. I huddled up and realized I felt good and decided to sleep a bit more.

Is it possible that culture no longer serves a function in our lives? That its former justifications — sharpening

the sensibility and the imagination, bringing to life the pleasure of beauty, developing a person's critical spirit — no longer matter for human beings today, when science and technology can do everything better? That must be why there are no more philosophy departments in any of the universities of the cultured countries on the planet. I did an internet search the other day and found that the only surviving philosophy departments are those of the University of Cochabamba in Bolivia and in the School of Humanities in the Marquesas Islands. But the latter shares the department with Theology and the Culinary Studies programs. What a mix! I imagine getting a doctorate in Philosophy, Theology, and Gastronomy, and I die laughing.

But yes, if ideas as such, ideas divorced from immediate practical ends, had disappeared, then every form of dissidence and opposition would consequently have evaporated from our societies as well. Fortunately, it isn't so, though I do fear we are headed in that direction, toward a society of automata. My hope lies in the movement of the "imbalanced," which is spreading across Spain and the rest of the world. I say this despite my ambivalence toward the "imbalanced." At times they awaken my sympathy, because they dislike the world as it is, and their way of life reveals their clear desire to change it. They have a disinterested attitude of purity and spirituality, all the things that seem to have been wiped out in our societies, which are frantically oriented toward work, productivity, making money, and piling up entertainment appliances.

But I am far from an advocate for their creeds and their obsessions, and their fanatical contempt for things such as sex and meat, without which my youth and mature years would have lacked for certain pleasures that sometimes I recall with so much emotion that my eyes cloud with tears.

The Winds

(I've turned into something of a crybaby in my dotage.) I'm not saying that lovemaking or dining on a succulent *churrasco* are the same thing, I'm not that stupid. I do believe that making love was something marvelous, especially when I was younger. I remembered Carmencita. Wasn't it luscious, stripping down and twining in bed for hours and making love around the corner from the news bureau where I worked? Seeing a woman's naked body for the first time, making love to her with the delicacy of a poet writing a poem, reveling, drunk on desire and happiness, feeling time abolished in the immortality of that instant that carnal ecstasy gives rise to: what a wonder! I am certain that sex no longer represents all it did in those faraway years when I slowly overcame the taboos and the sanctimonies surrounding physical love and finally engaged in the act itself, like a person setting foot in paradise. But I must say, in those days, putting away a good filet, a ribeye, or kidneys soaked in wine, was a delight a common man could indulge in with a clear conscience, free from those moral and political problems that arise today, when everyone jokes about it awkwardly, and follows the dictates of their nutritionists and dishes increasingly resemble medicines or some kind of vitamin supplement. How repulsive it is to eat and drink nowadays. And this is coming from someone who hardly ever eats to excess and rarely drinks a drop of those pharmaceutical liquids that now go by the name of wine.

I fell asleep and dreamed serenely, in perfect peace with myself. The fear, the cold, were gone. I felt fine that way.

They say that the movement of the "imbalanced" started in Japan half a century ago. It has slowly spread across the world. naturally, the way rivers open new tributaries, not through propaganda and proselytism; and with its rank individualism, the last thing its adepts would do is become apostles and

messengers of its philosophy of life. They aren't a new religion or anything of the kind. What are they, then? Something like a fraternity of passivists or iconoclasts, within or beyond their countries' borders, one that attracts the young above all. I use the term "fraternity" because "ideology" would be an anachronism. Nobody knows anymore what it is, or what it was. There are no more ideologies worthy of the name. Everything in life has become practical, politics included. Maybe the movement of the "imbalanced" is a reaction to the universal materialist pragmatism that has imposed itself as the one possible way of life — a singular protest against a world of people who seem to be in agreement with almost everything and cannot see around their blinders — our blinders, why should I exclude myself?

The "imbalanced" have no doctrines or apostles, so far as I know. They teach by example. And this example has spread and gathered force. They are everywhere now, though the screens that have sprouted up on every street corner to give us the news don't talk about them much. Their way of life has touched a nerve for the younger generation today. They are passive, they don't have reunions or set up camps, they avoid the media and crowds, and for that reason they go largely unnoticed. But they are there, all around us. Thousands, tens of thousands, perhaps millions of them. All of them young. I suppose that as the years pass and they get older, they will retire. Or maybe still younger ones will kill them. I laugh in my sleep at the notion. Absurd. The "imbalanced" are pacifists. I don't think they kill even flies.

What do they want? How would they like to change the world? I talked once with a group of them here in Madrid. They were sunning themselves on the grass beside the Egyptian Temple of Debod, looking up at a clear sky, the Parque de Oeste all around them.

The Winds

At first they looked at me mistrustfully, but without hostility. When I told them I just wanted to know a bit more about what they were doing, what their beliefs were, what they wanted for society, they were unnerved. After an exchange of glances, they agreed. One of them asked me if I was with the police. And they all laughed, because I looked like a beggar. We talked for about an hour, lying there in the grass, me like a great-grandfather or great-great-grandfather surrounded by great-grandchildren or great-great-grandchildren. There were a few foreigners who could barely manage a couple of words in Spanish, with occasional phrases in English, Italian, or French.

I was confused by their contradictions and ambiguities. Reflecting later on the "imbalanced," I concluded that they acted more from instinct than conviction. What drives them is not ideas — which are shunned in today's world — but impulses, intentions, actions. Manifestly, they all agree on one thing: our system doesn't leave people with enough time to waste. They are passionate defenders of leisure. Wasting time as they do there, lying on the grass, seems to them a great privilege, because it is something rare in these times. Doing nothing, lying there and dreaming, soaking in the warm sun, singing or telling jokes. "This is life," one of them affirmed, "not spending the whole day from morning to night clicking around on your computer surrounded by walls and boredom." A redheaded girl added persuasively, "Not everything can be work, we need to value other things." The rest of them nodded.

When I asked them how they ate, how they made a living, they were surprised, as though none of that mattered. They worked the odd occasional job and shared everything they had. Some had managed to get a pension from the state. They divided up their income and expenses. Everything was for everyone. Anyway, they didn't eat much.

When I asked them why they seemed so infatuated with lotions, ointments, and cosmetics, I noticed that they were uncomfortable, as if I had tread on intimate terrain. After a long pause one of them murmured, "Our body is sacred, and we have to take care of it." For them, the sacred is found in perfumeries and pharmacies. They asked me if I had put on anything for the sun and when I said no, I never use sunscreen, they were scandalized. They confessed that whatever money they made with their precarious employment and the checks they get simply for being alive went toward buying pills, lotions, tonics, anything to impede the deterioration of the skin, the eyes, the teeth. For aesthetic reasons, but above all for their health. Though there are many bad things in our time, they said, there is one that is a cause for celebration, and it is all that science has invented to protect us against physical decline: disinfectants, reconstituting creams, balsams, hydrotherapy, thermal baths, massages, a whole arsenal of drugs and natural products which, used judiciously, keep human beings healthy, handsome, and in full possession of their faculties down to their final day.

One of the boys, of a slender ascetic build, told me that the most important thing was always to keep the stomach clean, and that curing constipation was the greatest glory of contemporary science. (But all this costs money, and they are idlers and don't have it, so what do they do?) Possession of a stomach that worked as precisely as a Swiss watch kept people from succumbing to neurosis, which was the main cause of the suicides recorded every day all across Europe. Another argued that more important still was the discovery of a gel that maintains the memory fresh and alert. Others refuted both of them, asserting that more remarkable still was a pill that relieves the libido and allows men and women to avoid the sexual worries that beset them in the old days.

I used this opportunity to ask them why the "imbalanced" were opposed to sex and why so many of them practiced abstinence. I noticed some of the group blushing and looking away. Finally, the redheaded girl spoke up: "We believe in cleanliness in body and spirit." "As do I," I said, "but that can't mean a person never makes love. Sex is healthy as well as pleasurable." They looked at me as if I were what I am — a caveman. "Isn't it enough that we have to defecate every day?" a belligerent young man, almost a boy, intervened. It was the first time he had spoken a word. "Now we're supposed to expel our semen every day, too?"

I didn't understand what he meant, but it seems that his companions did, because all of them smiled upon hearing him, as though he had routed me completely. When I was a boy, I told him, that was exactly what the priests told us: that sex was dirty, ugly, sinful, something a person could easily dispense with. None of these people practiced any sort of religion. There was just one girl who admitted that, without adhering to any specific faith, she couldn't be an atheist either, because she believed in "a first principle for all things." She defended asceticism with reference not to religious faith, but to lay morality and, strangely enough, to hygiene.

This was the most flagrant example I had seen of the contempt for sex among the young at a time when we have achieved something that just half a century ago seemed impossible: the unrestricted freedom to have sex in any and all ways, with anyone and anywhere. Perhaps this much-celebrated freedom is the cause of their disdain. Sex used to excite people when it was surrounded by prohibitions and taboos; now that they are gone, it has lost its magic, and the young people find it repulsive. Who could have imagined?

When I whispered that if everyone followed their example

and chose chastity, humanity would disappear, one of them replied: "Science will take care of that, they'll make people in laboratories." But the group delighted more still in another's contribution: "And who cares if we disappear? The plants and the animals certainly won't mind."

I asked them why they were called "imbalanced," and they didn't know. One of them mused: "Maybe the people who saw us as a danger to society gave us that name. They later realized we were no such thing, but the name stuck. We don't care, or at least I don't." One of the girls said, "Those words, *we, us*, we have defanged them." Her neighbor agreed: "That word used to be an insult, now we've turned it into a compliment."

They love cosmetics and pharmaceuticals, they disdain sex, and they are dyed-in-the-wool vegetarians. The only part of the conversation that excited them was when I said that the prohibition against meat-eating struck me as absurd, as a violation of liberty and human rights, specifically the right to pleasure. The worst thing is the way the state, the government, supports their prejudices in this regard. I said I thought it monstrous that people found violating the ban were fined or sent off to jail. They lost their composure at this point, raising their voices and waving their hands as they criticized me. What would have happened if I had told them I was appalled by the ban on bullfighting? They might have lynched me then and there. I chose to say goodbye before they started in with the insults. I remembered when youth rebellion was inspired by creating paradise on earth, inaugurating an egalitarian society, banishing inequality, free love, feminism, abortion, dying with dignity (we called it euthanasia). Now what adolescent nonconformists want is for the whole world to survive on fruits and vegetables. If this isn't decadence, I don't know what is.

The Winds

The curious thing is that the hatred for meat on the part of the "imbalanced" has less to do with their love for animals than with a supposed medical certainty that made the rounds when they outlawed bullfighting: that meat is harmful, gives rise to illness, "pollutes" the human body, makes men and women "ugly" and "violent." Ridiculous rumors spread at that time —for example, that when the bulls ran into the ring, aficionados sometimes lynched people. (I am repeating this exactly as I heard it.) These young people's ideas of cleanliness are sick, neurotic, and their obsession has given rise to an entire category of sanitary fantasies.

The "imbalanced" would not be rebels if they did not put some distance between themselves and that perverse pro-animal sentiment that has overtaken the entire globe. I liked animals a great deal in my youth, and even as an adult I had a dog to whom I used to read poems by Cernuda and García Lorca. But things being as they are, I have developed a sort of phobia about the animal world. I wouldn't be surprised if it did away with us, the humans. Without telling anyone — certainly not Osorio — I have started to take a kinder view of those anti-animal commandoes cropping up here and there committing terrorist acts against dogs, cats, rats, skunks, flies, and other so-called domestic animals. The other day a court in Madrid condemned a ten-year-old boy to a year in a reformatory because the police found him shooting stones at swallows with a slingshot. Now I don't think you should shoot rocks at swallows, and I didn't do it in the days before a slingshot was considered a "deadly weapon," but sending this boy to a correctional facility strikes me as the height of sectarian stupidity, and it was grotesque when the judge declared that swallows were, as the bureaucratic jargon has it, "living, warm-blooded beings whose right to life must be respected."

What did away with much of my sympathy for animals was when the veterinarians said that in our times rats were no longer vectors of disease, that scientists had managed to eradicate the germs and microbes that they formerly carried, and that they would thenceforth be considered domestic animals, as many animal rights organizations had pleaded. I had nightmares then and I still do; I detest those horrible rodents. My hair stands on end when I realize that they live in so many houses now, fed and cuddled by their owners, who stuff food into their mouths and probably let them into bed so that they don't get cold on winter nights. Fortunately, they haven't managed to extirpate the killer instinct of cats toward rodents, and the cats continue to eviscerate them every time they come within reach. Long live cats! I stopped taking walks in Retiro in the early morning because of the rats, and it was something I used to love to do. They have taken over that beautiful park; they are everywhere, climbing the trees, swimming in the pond, crawling over pedestrians' feet, and wagging their grey tails so that people will throw them food. If you want to get rid of them, you have to scare them away softly, otherwise you will draw the attention of the guards or you will get slapped with a fine for being inconsiderate to your "warm-blooded" neighbors. What does warm blood matter?

That is why I believe that I was one of the few people not frightened when the foxes invaded Madrid. In fact, I was happy to see packs of them taking over the parks, the arbors, and the trails of Madrid. For as long as those silvery immigrants were here, the rats disappeared from the city streets: they hid or the foxes ate them. Osorio was terrified and went along with others to the Puerta del Sol to protest the campaigns of all those NGOs which ran slogans such as "Welcome to Madrid, our fox brothers," "Madrid, homeland of the foxes," and so on,

which aimed to retain the canine invaders and to condition the city to become their permanent home. I wasn't at all bothered by the foxes' presence in the capital. The one inconvenience, I recognize, is the scent of their piss: it is pungent, and it permeated the dry Madrid air. Mixed with my own odors, it was disgusting. Fox urine stinks, and in those weeks you would see people in the street heaving and vomiting, put off by the foul scent that permeated everything. After a while the foxes left as mysteriously as they had arrived. And the damned rats slowly returned.

Osorio says the city loves those little beasts. Another milestone for contemporary culture, which is on the verge of bursting the limits of credulity. The other day he swore to me that in several cities there are foundations and institutions seeking to legalize marriage between human beings and animals. Maybe he was pulling my leg, because he didn't give me tangible proof of the existence of those institutions. But if they do not yet exist, they will soon. It would be amusing to attend the first wedding of a man and a dog or a woman and an ape. Even more if, instead of just going to the courthouse, they do it in a church to the bars of Mendelssohn's wedding march.

When I told him about my experience with the "imbalanced," Osorio joked that one of these days a commando of vegetarian fanatics would set fire to the clandestine restaurant where, once a month, he and I drop in to treat ourselves to a nice oxtail or a rare filet. Thanks to the prohibition, we carnivores seem to take much more joy than before in a meaty feast. This is one way in which human nature has not changed: risks, taboos, interdictions around anything make it infinitely more desirable and attractive. A friend of mine, a secret smoker, told me the same thing some time ago, that he and his friends enjoy themselves much more in clandestine smoking

dens, in the knowledge that a cigarette butt could land them in jail, than when they used to smoke wherever they wished with no risk at all.

Osorio defends the "imbalanced," and I think he does so from his heart rather than out of dedication to his favorite sport, which is to contradict me. According to him, the old ideals of social justice and egalitarian societies simply don't do it for the new generations, because they aspired to things that already form a part of contemporary life. And whatever falls outside that, whatever remains wedded to chimerical and impossible ideals, repels them rather than excites them, since they are schooled in "realism," the fundamental bias of present-day culture. They are pragmatists, and they refuse to waste time and energy on things that they will never achieve, especially as they remember the consequences of the search for perfect societies in the past: civil wars, bloody revolutions, and injustices worse than those being fought against. According to Osorio, it is sensible, even wise, of these young people of today to substitute for the longing for a perfect world something more human: a world in which young people have regular bowel movements and no longer suffer the torment of acne. I praised his joke, but a few seconds later I felt forlorn when I realized that he wasn't joking.

When I told Osorio that it struck me as a strange paradox that young people had begun to scorn sex — to act as the priests tried to convince us to act when we were young (even if many priests where doing it this, that, and the other way) — at the very time when religions were withering like the *peau de chagrin,* Osorio corrected me: "What's withering is the churches, not religion." I had to admit that he was right.

We had arrived at a question on which Osorio and I tended to agree: are we free, or mere automata? Orwell hadn't known

that problem, writing in the most rabid moment of Stalinism, which he combatted in such splendid books as *Animal Farm* and *1984* as a man of the left and a defender of a democratic left, if such a thing ever existed. He was a socialist and at the same time not one, for in the guise of his democratic socialism he defended capitalist democracy, knowing very well that without free private business it is impossible for liberty to survive, and that if the state controls employment and the production of goods, sooner or later communism will triumph in its tried and true forms, and with it totalitarianism and poverty. That is why the Soviet Union disappeared and the People's Republic of China turned into a dictatorship of crony capitalists. What exists in China is a private company of millionaires who swallow all the lies of the regime. Yet the regime is a caricature of capitalism and the lack of freedom will strangle it sooner or later.

What kind of regime are we living in now? It's impossible to say, but what is certain is that we are surrounded by systematic mendacity. The economy functions thanks to private enterprise and the free market economy. But are we free? Neither I nor Osorio thinks so, though at times he changes his mind. My own belief hasn't wavered since the newspapers disappeared. True, on almost every corner there is a screen that presents news all day, and apparently the businesses represented there favor a diversity of ideologies and systems. But do they, really? We both have the impression that they do not, and that beneath the apparent differences the screens project a single supposed truth — that is, a heavily guarded lie; that all of them in essence defend a system in which government and business perpetuate a lie in common, as in China so long ago, making a show of superficial discrepancies to conceal their basic commitment to this system that keeps the world

hoodwinked and more or less happy, since there are jobs, pensions, medicines, and education for all and even something called freedom, however much it is just a smokescreen invented by technology to keep the masses entertained. Men and women have turned vulgar and malleable as culture has died or turned into a mere diversion. We are slaves, more or less content with our fate. Orwell could never imagine that this would be the end product of the "free socialism" that he promoted, which was, in a word, impossible. Now we have lost our freedom without realizing it, and the worst thing is, we are happy and we think that we are free. What imbeciles we are!

Isn't it strange that in these conditions sex has lost all interest, when its great enemy, the Catholic Church, the entity that worked hardest to eradicate it from our lives, at least in theory, is losing worshippers, congregants, and priests, becoming in some countries the equivalent of an organization of stamp collectors? I have often argued with Osorio about why the great churches are going under in our day, and with them the terrorist fanatics who used to try to destroy them with bombs and assassinations. What holds for Catholicism holds likewise for Judaism, Protestantism, the Orthodox Church, and even Oriental religions such as Islam and Buddhism: the ranks of the faithful are thinning, attendance is collapsing, and many think that they are on the verge of extinction. After exercising such influence over history, leaving their mark on it in burning letters, the churches are gradually disappearing without anyone attacking them, in a climate devoid of hostility, and despite government subsidies. Nietzsche's observation from so long ago is coming true: God is dead and no one cares, because men and women have learned to live without God. God was a product of culture, and since

culture is now entertainment we don't even recognize that the old deities have been replaced by football tables, images on screens, circuses, cartoons, and advertisements, which increasingly seem like something other than what they are.

I suspect that the Catholic Church signed its own death warrant when it began to modernize, when the erstwhile bastion of machismo, conservatism, intolerance, and dogmatism relaxed, buckled, made concessions to progressive priests and the laity. The move backfired. It seemed impossible, but there it was: the Church began to ordain women as priests and nominate them as bishops, allowed priests to marry the way Protestant pastors do, and the Pope himself oversaw a gay wedding in Saint Peter's Basilica. My poor mother, may she rest in peace, let out a bloodcurdling cry and fainted when she heard the news and saw it on her tablet, then slipped from her wheelchair to the floor. Poor old thing. "Those were steps forward that the time required," Osorio says. "If they hadn't done it, the Church would have begun to wither like a rose left out too long in the sun." But didn't that happen anyway?

He and I disagree about this too, of course. People liked the Church because it wasn't like life, like society — it represented the very opposite of existence in that century. In the church you felt as if you were in another world, a territory far from everyday routine. It was a pretty illusion, made of rituals, chants, incense, Latin phrases that seemed wise to the faithful who didn't understand them, celestial allusions to perfect lives, heroic, marked by purity, by innocence, by inner peace. Now the church has ceased to be such a refuge: it is an extension of everyday life, where everything is more or less permitted, where there are no taboos or dogmas. The church has lost its mystery and ceased to be interesting, like those political parties no one believes in, or college fraternities or football clubs.

94

When the Vatican determined that Limbo doesn't exist, things started to take a bad turn. The abolition of Hell calmed many faithful sinners, but it disappointed others, those who had dreamed of their enemies, their oppressors, burning eternally in Beelzebub's flames. With no flames and no Beelzebub, the beyond lost its attraction for much of the flock. Now they say the Vatican is about to declare that Heaven exists only in the symbolic and metaphorical sense, not in tangible, material terms. Poor Christian martyrs! They were broken on the rack, devoured by wild beasts, and burned alive defending the principles and truths of the Christian faith, and now it turns that out neither Hell nor Limbo nor even Heaven exists. What's the Church good for, who is it good for, under such conditions?

Now I should clarify a point that Osorio makes often, and rightly to my mind. The decline of the great churches has not put an end to religiosity. It has just become vulgarized and bastardized to the point of embarrassment. Now that no one believes in priests, people place their faith in witches, sorcerers, shamans, divines, palm-readers, holy men, hypnotists, that whole rabble of liars and tricksters who for a few pennies will make their gullible clientele believe that another world exists and that they are privy to it, that the future is written and they can decipher it in coffee grounds, coca leaves, cards, or crystal balls. What serious religions did elegantly, beautifully, with intellectual complexity, is now the monopoly of rogues, two-bit scammers, and illiterates. Just when science and technology have reached their peak we have returned to paganism, to primitive bewitchment. This is where the culture of our time has left us. And this twit Osorio calls it progress.

Just then I woke up. It was the depth of night, and the sky was a sea of stars. I was sitting on the stone bench in the

95

The Winds

Plaza de Oriente, and in front of me to the right I could see the Teatro Real and the back of the palace, and beside them a little street of restaurants and the service door to the theater, where the crew entered and exited, along with the cast and the musicians when they were rehearsing. I knew perfectly that if I walked down that street I would find, on the corner to the right, the Plaza de Isabel II, and that the street I lived on branches off of it. Calle de la Flora, it was called. Of course! My building, with my room and bathroom located in the attic, was number 1.

I was neither excited nor sad. I remembered now that my dwelling lay on this short street called, naturally, I repeat it again, Calle de la Flora. You could walk right past it. My house was on the corner where it runs into Calle Hileras, just by the Plaza de San Martín, which opens in turn onto the broader Plaza de las Descalzas. There stands one of the oldest convents in Madrid, full of paintings, which opens to the public only on Sundays. There is always a long line of people waiting to enter.

My memory had come back to me. I remembered that, if I stood up and put those last few streets behind me, I could enter my home after an entire day spent looking for it. But that didn't excite me, or even especially please me. I knew it would be like that. I had been frightened, I had thought I might die on the street like a stray dog, but now I was relaxed. I kept sitting there. What time was it? There weren't many people around. In the Plaza de Isabel II, I would probably run into a couple of drunks. I still didn't stand up.

"Was today a waste?" I asked myself. No, it wasn't. I had felt death closer than ever as I walked around this square sensing that my home was somewhere nearby. Now my memory was back. After I slept and recovered, I would call Osorio and tell him the story. I had felt death close, but it had not been a waste

of time. I knew now that I would never again leave my house — or rather, my room — without taking along a piece of paper with my name and address and instructions to notify Osorio if I fell down dead, and I would write down his phone number and address there too.

I struggled to breath. I wasn't cold, hungry, or thirsty. I didn't feel happy and I didn't feel sad. It had been an adventure. A new adventure. A lesson, too. I could lose my memory and spend an entire day looking for home without finding it. From now on I would take precautions, I would always keep that document on me with my name and address and Osorio's number. I learned this. So I had gotten something out of it.

I stood up with difficulty. Now I felt a little cold. Nothing serious. I knew I could walk, but slowly, stretching out my legs, right, left, feeling a little cramping, right, left, confident that my memory was back and I knew perfectly well where I lived. I would get there, climb the five floors slowly, unagitated, would wash my pants with soap and bleach, and would go to bed calmly, in the awareness that I had survived a new experience that had brought me a little bit closer to death. I told myself this without sorrow or rage, but with a newfound tranquility: I had discovered that I could lose my memory and fail to find my way home and not know who I am and lose an entire day trying to remember. Now I did know who I am and where my room and bathroom are. I walked, but unhurriedly, like a man out to stretch his legs who has decided that it's time to return home. "My home," I said with affection. And I felt tears streaming down my face. (I repeat: with the years, I've become a crybaby.)

I know that alley by the back door to the Teatro Real very well. Most of the restaurants there had already closed, but one was still open, and there were two couples sitting at the outside

tables paying their check. When I passed by them, slowly, I said goodnight. They responded with a silent movement of the head.

I was afraid I would fall, which is why I walked slowly. When I reached the corner I turned right, and less than a minute later I was in the Plaza de Isabel II, which was still brightly lit. I breathed calmly. The usual spectacle was there: a row of taxis, the drivers standing in groups to smoke and converse; a very young couple making out on a bench; two shuttered newspaper stands; and at the intersection of the Calle Arenal, which led to the Puerta del Sol, a solitary dog trying to bite its own tail. To the left of it was the street that led to my home — to my little room with its bathroom. Again I told myself that I would take the stairs slowly, not tire myself, even if I had to sit down on each of the landings. Calle de la Flora, it was called. How could I have forgotten? I walked up it sluggishly, very sure of myself, musing over what an idiot I had been, looking around all day for my address. There it was, at the end of the street. My confidence was back. I had reflected on many things. I had been very afraid.

And I was afraid again, when I reached the corner of Calle de la Flora and Hileras, beside the tiny Plaza de San Martín, which opens onto the Plaza de las Descalzas, where I realized, feeling around in my pockets, that I didn't have the key to open the large front door to number 1, where I live. I felt again the lash of terror that had harrowed me all day. Would I spend the rest of the night sitting here on the ground, hoping that someone who lived in the building would show up? But I got lucky. After just ten or fifteen minutes of waiting, a gentleman with a cane appeared who looked more or less familiar. He stopped by the door, removed his key, and opened it.

I approached him and said, "At last you're here. I forgot

my key. Would you let me in?" The gentleman — somewhat older — looked at me with distrust. "I live here," I assured him. "In one of the apartments on the top floor. I've been walking all day. I'm very tired. I beg you, please let me in." The gentleman nodded, opened the door for me, and stepped back so I could enter first. When I was standing in the long vestibule with its flagstones, I thanked him again, effusively. The gentleman turned left, taking the door opposite the one that led to the office with the gas, electric, and water meters. He was very kind. He opened the door to the elevator with another key and asked me if I would take it up with him. I agreed. Those of us on the top floor don't have access to the elevator. That was a surprise. The man lived on the third floor, and from there I would only need to climb two flights of stairs to reach my room.

I took them very slowly, stopping for a moment on each step, inwardly cheerful, but trying to still my heart, which was pounding from the effort. I felt it racing in my chest, and I had the fleeting thought that I might die here from a heart attack before I could reach my room and my bathroom.

I took the last few stairs in slow motion. Whenever I placed a foot on the next one, I could hardly believe the effort required. Once I reached the attic, I breathed easier. If I had a heart attack here, I didn't care. The people, the neighbors here, know me, they could tell the police, even Osorio, who has visited me here a few times. I took a deep breath, and when I reached the door to my room I saw the key still dangling from the door. That is to say, the keychain with the key to the front door and to my apartment. I was in a hurry that morning and had forgotten them, and there they were, where I left them. For an instant I felt happiness as the key turned in the latch, and at last, at last, I was in my room.

The Winds

It is a tiny space full of books and papers. But very clean and orderly. I sweep and tidy up every morning before I go out for my coffee and chat with Osorio. I always make the bed and wash the sheets once a week; not the blanket, which gets washed every fifteen days. I clean the bathroom, the shower, the sink, and the toilet, every day after showering and carefully lathering myself up — especially my backside, which is always dirty because of my constant expulsions of gas. Tonight, after breaking so much wind during the day, it must be filthier than usual.

No sooner than I turned on the light than I looked around with satisfaction at my clean, ordered room. Then, rather agitated, I shuffled to the bathroom, where I took off my shoes and pants. It was a long operation, as I was exhausted and my heart was about to burst from my chest.

When I realized that I had soiled my underwear, I turned desolate. I had felt the farts, of course, but the shit surprised me. It had squeezed past my underwear and streaked my legs. I had become a man made of shit from the waist down. I was disgusted with myself. But instead of standing there like a dimwit, feeling sorry for myself on account of this minor catastrophe, I emptied all the shit into the toilet and flushed. It worked, and once the shit was gone and the toilet was pristine once again I opened the faucet and waited for the water in the shower to warm up before carefully scrubbing my legs and behind until I had made sure, ten times over, that both were impeccable. Then I washed my underwear with soap and bleach in the shower until it, too, was clean, and I hung it on the curtain rod with a couple of clothespins to dry. I toweled myself off gently, feeling ready to fall asleep and yawning constantly.

I went back into my room, but I didn't bother putting on the pajamas that I keep folded under my pillow in bed. I was exhausted, but at least I had showered and washed off all that

repulsive shit that had clung to my legs for hours and hours without my knowing it.

I dried my hair hastily, running the towel back and forth over and over, remembering how ages ago my grandfather used to tell me that you lose your mind if you go to sleep with wet hair. When he said this the old man would bring a finger to his temple and laugh, imitating Napoleon, who apparently lost his mind in Santa Elena. That's one of the few things I remember from my childhood, which is largely erased, apart from the memory of the happiness that I experienced until I discovered the horrible way women get pregnant and give birth to children. I was fine so long as I thought you ordered them from Paris and the stork delivered them. I don't think I was ever happy once I found out the truth.

At last, I got into bed, wrapped myself in my blanket, curled up, and turned out the light.

Almost immediately afterward, the tachycardia set in. But it wasn't my heart that frightened me, it was the sweat. It wasn't hot, it was cool or even cold — it was the end of autumn, the nicest time in Madrid — and yet I was soaked with sweat. I ran my hands over my face, then a handkerchief, then the sheet, but it was pointless, because more droplets emerged from my pores and my face and neck were soaked again, along with my chest, back, and thighs. What was this? I thought I should call Osorio, but it was late and my friend usually went to bed early. What would I say to him? That I was sweating and my heart was racing? He would laugh at me. "I forgot the address to my building and I spent the whole damned day looking for it, I just got home a second ago. I washed out my shitty underwear and showered and got in bed, and now I've got tachycardia and I'm soaked in sweat." Osorio would crack up and joke back: "You woke me up for this bullshit?"

The Winds

Instead of calling him I balled up, tried to forget the sweating, brought my knees all the way to my chin, and waited for sleep to overtake me. But the pounding in my chest got worse. I had to keep my mouth open to breathe. I thought, frightened, in the darkness of my room, "Am I going to die?" Many times I had imagined that it might happen, especially recently, whenever something felt off. But I always got through it, usually after falling asleep. Now my heart was thumping like a kettledrum and I was gasping, slack-jawed, as if I couldn't get enough air. My chest, my shoulder, and my right arm began to hurt. Should I call Osorio? Would I wake him up? I imagined hearing his mocking laugh: "Are you dying, brother?" And so I didn't.

Now my left arm and shoulder hurt too, and I was sweating from head to toe. Everything ached, even my neck and back, my muscles, veins, tendons, and bones. I was sinking into something that was not sleep but unconsciousness. Was I fainting? My body began to shiver all over. And I swooned as though sinking into a whirlpool. Perhaps it was for the best. Death surprising me while I slept was a good way to go. Osorio would call me in the morning, according to our agreement, and when I didn't pick up he would realize that I died in my sleep and would tell the ambulance to come. The paramedics would declare me dead and would take my body to my columbarium in Madrid. I would be immediately incinerated — or almost immediately, after the inevitable paperwork. The worms would already be pullulating in my body, but the fire would destroy them.

My chest ached. This was not a false alarm. This was the end. I wasn't scared, only aching. I felt myself sinking into something viscous and confused, not sleep but the dawn, the anteroom of death. I was not consoled to imagine that in a

few minutes — a few seconds? — I would know whether God existed, whether the soul would survive the disappearance of that bodily energy that kept my heart pounding and the blood flowing through my veins, or whether in the future there would be only silence and oblivion, a slow decomposition of the organism, until the tongues of fire extinguished the filthy, damp flesh that had already begun to rot when they burned it.

JAROSLAW ANDERS

Belarus Incognita

I

Long before the protests that shook Belarus in the summer and fall of 2020, I was sitting in a restaurant of a Minsk hotel. It was a late afternoon after a day of intense meetings, and I had nothing more planned for the evening. Suddenly a singer came on stage and started a rather touching rendition of John Lennon's "Imagine." I noticed that I was the only person in the room. She was singing just for me! (The poor thing probably had it in her contract that if only a single customer appears, she must begin her act.) I was suddenly overcome by a strange emotion that almost made me tear up. I felt momentarily dislocated both in space and time. Where was I and, more impor-

tantly, when was I? Vertiginously I felt that I had been here before. Was this Belarus in the second decade of the twenty-first century, or was it Poland in the 1970s? Or Poland in an alternative timeline, in which communism survived and transformed itself into a brutal non-ideological dictatorship with a paper-thin façade of democracy? I felt, again, the bipolar mood swings of my youth: irony, swagger, excitement ("All this is too ridiculous to last!") and bouts of depression ("Nothing will change here during our lifetimes!") It was strange and familiar, disturbing and deeply moving.

I had gone to Belarus with low hopes. I envisioned grayness, monotony, repression, and stasis. A Soviet Jurassic Park, with a handful of brave dissidents fighting the noble battle against the totalitarian monster. This is the image that has dominated press reports, and also quite a bit of the Western scholarship about the country. Alexander Lukashenko, it is commonly said, is the last Soviet ruler, and Belarus is "the last dictatorship in Europe." In attempting to understand Belarus, everybody has subsisted on a heavy diet of easy analogies. What about the history of Belarus itself? It presumably didn't have any. Literature? Name a single Belarusian author. National language? Barely surviving in the predominantly Russophone population. The people in Belarus were supposed to be lacking in national identity and thoroughly Sovietized. Are they Europeans like the Poles, or even the Ukrainians?

The country made news almost exclusively in the geostrategic context, as an aspect of the larger problem of Russian expansionism. Its well-known violations of human rights were also noted and regularly condemned, but they were accepted as a matter of fact. It was its near-total dependence on Russia — punctuated by occasional quarrels over Russian oil supplies and the speed of the political and economic integra-

tion of the two states (Lukashenko's initiative during Yeltsin's rule that came to haunt him under Putin) — that made Belarus of some interest to Western politicians. Even a modicum of Belarusian sovereignty had to be protected because it created a fragile buffer between Russia and NATO's eastern flank, and it introduced an element of unpredictability into Putin's designs. Everything else about the place was fuzzy at best, and not particularly relevant or interesting. Nobody in the West marched for Minsk.

But now I was here, and everything looked somewhat different and quite a bit disorienting. The Soviet symbols were everywhere. Statues of Lenin still adorned city squares, likely the only place in the world where they can still be found in their old honorific locations. So were the red stars on the top of government buildings and gargantuan monuments. The good old KGB was there, proudly keeping its old name. There was the dreary communist-style official television, mostly in Russian, and a tingling sensation of being constantly under surveillance. Visually, Minsk is probably the most Soviet city in the world. Destroyed during the war, it was rebuilt from the rubble according to the best and most glorious Stalinist concepts, with miles upon miles of absurdly wide avenues lined with neoclassical colonnades. (At one point UNESCO wanted to declare it a world heritage site but found it too "contaminated" with Khrushchev's drab apartment buildings and high-rise architecture of the later periods.) A gigantic upscale apartment building known as "the Chizh House," from the name of its now disgraced oligarch-developer, looked like something out of a "city of the future" in a sci-fi movie of the 1950s. For someone driving from the airport after a sleepless flight, it all felt like a dummy city, a life-size movie set.

At a closer look, however, the scenery acquired an

106

unexpected depth. It was a palimpsest, a compilation of half-erased outlines, shapes, and histories. Not everything here had been flattened by the Soviet steamroller, and the zeal with which the steamrolling was being done attested to the fact that so much in this land was totally non-Soviet. There is a memory living here, and one can sense energy and expectation. A growing elan was clear during my meetings and conversations with committed dissidents, and people hoping that their work (intellectual, artistic, technological) can speed up the changes, and people who just wanted to survive without selling out or doing something ugly. (Where was the line beyond which one should never step?) An independent literary life was flourishing, thanks to a handful of daring publishers ready to displease the regime (some of them have had to relocate abroad), surreptitious art galleries, music concerts, and theater shows. How did they survive in the minuscule market, against constant administrative and financial obstacles thrown at them by the government? There was also a lot of grassroots activity, or simply people huddling together in informal groups: a whole ecology of pulsing life trying to survive in the cracks of the seeming monolith — trying, failing, and trying again.

A partial explanation of the tendency among foreign observers to wrap Belarus in lazy clichés may lie in its tangled non-linear history. "Before 1991, Belarus was never a country," I recently heard on CNN from an expert on Eastern Europe who should know better. In fact, Belarus has as much, or more, backstory than any European country. It is certainly true that before 1991 there was no sovereign state known as Belarus, the name itself — White Rus, *Ruthenia Alba* — being of relatively recent

and unclear origin. There was, however, a whole sequence of states populated and ruled by the ancestors of today's Belarusians. Some start with the legendary Kriviches, a tribe that settled in those parts of Europe around the time when the first Anglo-Saxons were disembarking on the coasts of Britain. They were most likely Slavs, though possibly mixed with Balts and Finns who also lived in those areas. Recorded history starts around the twelfth and thirteenth centuries, when several local principalities, using East-Slavic dialects and Cyrillic script, and professing an Eastern Byzantine brand of Christianity, were overrun by mostly pagan Baltic Lithuanians. Thus, the Grand Duchy of Lithuania was born, stretching over the lands of today's Lithuania, Belarus, and western Ukraine. The gigantic state kept its Baltic name throughout its history, but its population was predominantly East Slavic, or Ruthenian in the Latin exonym, and even Lithuanian rulers soon adopted their language and culture. A proto-Belarusian dialect, known as Chancery Ruthenian, became the official language of ducal courts, as well as of medieval religious and secular literature.

Things got even more complicated in the late fourteenth century, when a shrewd and ambitious Grand Duke of Lithuania, Jogaila, faced a dilemma. Threatened by the Teutonic Knights waging their Northern Crusade against pagan Balts and Eastern Orthodox "heretics," he had to choose between a crown union with rising Muscovy or with Poland. Muscovy looked like a natural choice, since it shared a culture, a script, and a religion with much of the Duchy's population. But Jogaila chose Poland, and sealed the union by marrying Poland's fourteen-year-old queen Jadwiga. Together with his Lithuanian peers, he was baptized in the Roman rite and was crowned the king of Poland, Wladyslaw II Jagiello, while retaining the title of the Grand Duke of Lithuania. (You can

see him in Central Park in New York, menacing Turtle Pond with two raised swords.) From now on, both Poland and the Duchy were ruled by the same monarch of the Jagiellonian dynasty, from two capitals in Krakow and Vilnius. In 1569, Poland pressured the Duchy to form a more permanent entity, the Commonwealth.

The union between Poland and the Duchy of Lithuania had not only political and military effects but also a significant civilizational impact on both countries, though mainly on the Duchy. It was pulled out of its East Slavic, Byzantine domain and into the orbit of the West. The new union blurred the cultural demarcation line that had existed since the division of the Roman empire into the Western part and the Eastern part. The move was never complete, and it was accompanied by the eastward slide of Poland, but from then on the Duchy was straddling almost every European border. It drew influences from Constantinople and Rome, from Latin and Old Slavic literatures, from the Baltic and Scandinavian north, and from the Balkan south. Never ruled by Tatars, it nevertheless had a sizable Muslim Tatar population, lured by Grand Dukes with land grants and titles of nobility in exchange for their military service. It also became the largest European home of Ashkenazi Jews after their oppressions in, and expulsions from, western Europe. As the only East Slavic domain, it experienced the Renaissance, the Reformation, deliberative democracy (in the form of often unruly noble gatherings, or *sejms*), and city self-government under the Magdeburg law. Roman Catholicism, Greek Catholicism, Eastern Orthodoxy, Calvinist Protestantism, Judaism, and Islam were practiced openly, and the followers of these faiths lived in relative harmony. The country was huge, stretching from the Baltic Sea to the Black Sea coasts, and seemed to have enough room for everyone.

Yet the Polish-Lithuanian union was never an equal one. Although many aristocratic families from the Duchy attained key positions in the politics and the military of the Commonwealth, Poland always saw itself as the dominant unit. Gradually, the Duchy upper classes started to adopt the Polish language and to convert to Roman Catholicism, which in the pre-nationalist era made them indistinguishable from Poles. This, in turn, split the population into two distinct socio-ethnic groups. Soon the once clear concepts of Poland, Lithuania, and the Commonwealth began to blur and change their meaning. In 1696, the Ruthenian language was forbidden in official business, which halted the development of native literature and degraded proto-Belarusian to the level of peasant dialects. More and more often, the Commonwealth was called "the Polish Commonwealth," or simply "Poland." There was now Poland proper, or the Kingdom of Poland, and the larger Poland which included the Duchy. (Imagine the term "England" being casually applied to the whole of the United Kingdom.) Disappearing as a notion is often a prelude to disappearing as a nation.

By the end of the eighteenth century, the once mighty Commonwealth had weakened, owing to a combination of devastating wars, internal dysfunction, and the connivance of its neighbors, and was divided between Russia, Prussia, and Austria. The Duchy fell to Russia, and the Russians hailed it as the "reunification of Russian lands." The Russian nation, according to the official theory, has always consisted of three parts: Great Russians (Russians proper), Little Russians (Ukrainians), and White, or Western, Russians. Both parts of the Commonwealth disappeared from the map, but Lithuania disappeared much more completely than Poland. Its past was erased, its history was rewritten, and the names "Belarusian"

and "Lithuanian" were forbidden in official documents. The country was renamed the Russian Northwestern Territory, and its non-Polonized lower classes were told to consider themselves Russians.

Despite intense Russification by the tsarist administration and schools, and the Moscow-controlled Eastern Orthodox Church, the "Belarusian national idea" started to germinate at the end of the nineteenth century among the local poets and amateur ethnographers. At the end of the First World War, when the European empires started to crumble and Russia was in the throes of the Revolution, a group of Belarusian patriots declared the creation of the Belarusian People's Republic, a democratic polity that purported to represent Belarusians of all social levels and political inclinations. It was hailed as "the first Belarusian state since the Grand Duchy of Lithuania," but it existed mostly on paper. Its territory was still controlled by the Germans, and soon was to be contested between the Poles and the Soviets. No major power saw fit to recognize it or lend it support, and soon it faded away. But it left behind a powerful myth: the date of its proclamation, March 25, 1918, is now celebrated by the Belarusian democratic opposition as Freedom Day, and its now-forbidden emblems — the white-red-white flag and the "Pursuit" coat of arms (a knight on horseback with a raised sword) — have become the symbols of anti-Lukashenko protests.

At about the same time, Belarusian communists, with some help from their Soviet comrades, were busy constructing their own Belarusian polity, the Soviet Socialist Republic of Belarus. When, after the Polish-Soviet war of 1920, Belarusian lands were divided between the two countries, Soviet Belarus became the only de facto Belarusian polity. Now it could claim to be "the first Belarusian state since the Grand

Duchy of Lithuania." (Poles considered their part as "historical Polish territory," and suppressed Belarusian national activities, and treated Belarusians as a national minority in their own homeland.) Soviet Belarus remained a theoretically independent state until 1922, when it became a founding member of the Soviet Union.

In the paradox-rich history of Belarus, one of the strangest paradoxes is the fact that Belarusians owe much of their modern national self-awareness to none other than Joseph Stalin. As the Commissar for Nationalities, he made Soviet Belarus the main test of his *korenizatsia* (indigenization) policy. According to the doctrine, which the Soviets implemented from the early 1920s to the mid-1930s, the best way to the hearts of an often reluctant population was to dress Marxism-Leninism in the national costume. In contrast to tsarist Russia, all things Belarusian were not only allowed, they were actively promoted, and if necessary coerced. Soviet party leaders and government officials were supposed to harken from Belarusian stock, and were expected to switch from Russian to Belarusian almost overnight. Practically for the first time in their history, the Belarusian population had free access to education, publications, and mass media in the Belarusian language.

Many among the Belarusian elites — scholars, writers, journalists, artists, left-leaning activists — declared their support. Some decided to return from exile, or to sneak in from the seemingly less hospitable "Polish Belarus." Soon, however, the Soviet policy changed, and "indigenization" was replaced with "proletarian internationalism." Belarusian elites were practically wiped out in the Stalinist purges of the

1930s. At the end of the Second World War, when both parts of Belarus were "liberated" by the Red Army and merged into one Soviet Socialist Republic of Belarus, they included practically all the lands of the former Grand Duchy, minus Lithuania and parts of Ukraine, but emerged from the war devastated, decapitated, and fully under Moscow's control.

And yet Belarus in the years of communism was not the political and cultural wasteland it was taken for. Under Khrushchev's policy of "de-Stalinization," unofficial networks of Belarusian scholars and writers started to emerge. They set out to secure and to preserve the remnants of Belarusian past — historical artifacts found in abandoned manor houses, architectural items, old books and documents buried in private libraries. Moscow looked askance on these efforts. From time to time it intervened, forcing the local authorities to expel the "bourgeois nationalists" from their jobs or even to prosecute them.

Some have argued that Belarusian literature missed the modernist phase, since much of the literature written in Soviet Belarus after the war, both in Belarusian and in Russian, was horrible socialist-realist drivel. But in the 1960s several outstanding literary personalities began to make their presence known. One of the finest and most independent voices that emerged in the Soviet Union at that time was a Belarusian writing in the Belarusian tongue. Vasil Bykau (1924 – 2003), the author of harshly realistic war novels and short stories, became a phenomenon on the all-Soviet and soon international scene. He was nominated for the Nobel Prize in literature by Czeslaw Milosz and Joseph Brodsky, among others. His books were translated into scores of languages, including English.

Incongruously, Bykau was often presented in the West

113

simply as a "Soviet," or even a "Russian," writer. The story of the glorious and heroic Great Fatherland War was still a staple of Soviet literature and film, and here was a war writer of unquestionable talent, someone who could be proudly presented to international audiences. (Some of his translations were in fact financed by the Soviet Ministry of Culture). Never a member of the Communist Party, Bykau was showered with the highest Soviet honors — until it was discovered that in fact he was writing against the hallowed Soviet war genre. The war that he portrayed was neither glorious nor heroic. It was horrible and absurd. His commanders were callous and brutal, and there was the strong whiff of fear not only of the enemy, but also of the NKVD officers watching from behind the lines.

Bykau was also accused of, what else, Belarusian nationalism. His stories are universal, existential tragedies whose protagonists face impossible moral choices, and pay an absurdly high price for preserving even shreds of their human dignity. But his stories usually center around a Belarusian, or a group of Belarusians, who display a higher level of tolerance, compassion, and stoicism than their more hard-edged comrades-in-arms. And, as some critics noticed, they are often the last to die, or even to survive their ordeals. Bykau became a harsh critic of Lukashenko, who treated him with particular venom. He had to spend a few years in exile, but he returned to Belarus shortly before his death.

Another writer of the war generation, Ales Adamovich (1927-1994), while collecting oral materials for what he was planning as a novel about Belarusian villagers slaughtered and burned alive by the Nazis, decided not to fictionalize his story but instead transcribed and arranged the recorded testimonies of witnesses and survivors. He thus invented a new kind of a non-fiction novel, a tapestry of interweaving real narratives.

Svetlana Alexevich, the extraordinary Belarusian journalist who won the Nobel Prize in literature in 2015, adapted Adamovich's technique for her own purposes, acknowledging her debt to him in her Nobel lecture.

A younger and very different writer, Uladzimir Karatkevich (1930 – 1984), who came from the old gentry, revived in his popular novels the deeper and more romantic past of the Belarusian lands, including the anti-Russian uprising of 1863, in which his ancestors allegedly took part. He picked up Yiddish on the streets of his native Orsha and would sneak into a local Jewish theater to enjoy plays by Sholem Aleichem. Bohemian, cheeky, and charming, he vexed the Soviet authorities and sometimes had to survive on his friends' charity, but survive he did, which testifies to a measure of solidarity and mutual support among the Belarusian literary community. His slightly madcap Gothic novel, *King Stakh's Wild Hunt*, is available in English translation.

Belarusian poetry has always been rather conservative, even conventional, in its form and its structure. But Ales Razanau, who was born in 1947, is a poet of unusual inventiveness and originality. In his later career he has perfected two different poetic forms: short gnomic statements resembling Zen koans, paradoxical and logic-defying puzzles or proverbs (he calls them "ellipses"); and slightly longer "versets," equally paradoxical parables and philosophical meditations rendered in rhythmical and mesmerizing poetic prose. I cannot find much in contemporary European or American poetry to liken to his unique idiom.

In 1980s, during Gorbachev's "perestroika," an informal group of writers known as *Tuteisha*, or Locals, was formed around two powerful but antithetical personalities — the dark *poète maudit* Anatol Sys and the caustic, urbane ironist

Adam Hlobus. The writers of *Tuteisha* were equally involved in literary innovation and political activism. Their generation produced several popular *samizdat* publications (*samvydat* in Belarusian) and formed unofficial pro-reform groups that led to the creation in 1989 of the Belarusian Popular Front, the first democratic political party in Belarus. (Their elders, Bykau and Adamovich, were also among its founding members.) It was the Front that persuaded the Belarusian Supreme Soviet to declare the "state of sovereignty" in July 1990, a whole year before official independence.

In terms of historical and cultural experience, then, Belarusians have a lot to build on. The problem, at least a problem for some, is that what we call today Belarus existed in so many different forms, and changed the course of its history so often, and was known under so many names. It was inhabited by people who called themselves Ruthenians, Lithuanians, Poles, or Belarusians, depending on circumstances or social status, and often irrespective of their actual ethnic roots. It was hard to distill from this multiplicity a straightforward national storyline that could serve as the foundation of a unique and easily recognizable Belarusian ethnic identity. Under the influence of the rising nationalisms of neighbors — Poles, Russians, Baltic Lithuanians, and Ukrainians — such attempts were repeatedly undertaken since the end of the nineteenth century. Each of them eventually failed, because each left out something valuable and important for at least a part of Belarusian population.

Having a strong ethnic identity with a proper foundation myth, a throng of "national heroes," and a national literature allegedly testifying to a unique "national character" is still

supposed to be a condition of true nationhood. It is obviously an anachronism, a holdover from the early stages of "nation-state" nationalism (which neatly coincided with, and was much helped by, the Romantic literary movement). Despite that fact, and despite many recent and awful examples of the glorification of ethnicity, ethnic nationalism is still viewed by many as the only nationalism worthy of respect. (Even by some belonging to such a clearly non-ethnic nation as the United States.) For this reason, Belarusians regularly receive bad grades for their national identity. We often hear that Belarus is at best a nation in the early stages of its formation, and at worst an example of nation-building efforts that were tried and failed. If only the Belarusians could go backward in time and retrace the steps taken by other nations nearly two hundred years ago.

Luckily, more and more people in Belarus have begun to notice the absurdity of this proposition. While some leaders of the "perestroika" generation still tried to fashion Belarus into a traditional ethno-linguistic entity, the generation born in the 1970s and later generally reject the notion. Most writers who started their careers in the turbulent, promising, and soon disappointing 1990s write in the Belarusian tongue and hold it dear, but some of them write both in Belarusian and Russian, or exclusively in Russian. (Almost all have their works eventually translated into Russian.) Prose writers in this generation have mastered a mixture of picaresque tale, fantasy, and grotesque which is described as postmodern fiction, but which is in fact modern Menippean satire. It is a perfect style with which to disparage the regime without sounding portentous, while at the same time poking fun at the believers in an abstract and sacred "Belarussianness." What we see in the works of the best practitioners of the genre is the delightful

confusion of myths, symbols, Soviet, post-Soviet, and Western codes that constitutes today's Belarus.

The Belarusian philosopher and poet Ihar Babkou, who was born in 1962, writes in one of his essays about the strange resilience and potential of the Belarusian "transcultural tradition," its "heterogeneous elements," and various "cultural and civilizational formations." The Belarusian nation, says Babkou, "hesitating, making detours, moving from one identity to another, travelling through languages, dialects, empires, and historical epochs" not only survived, but managed to achieve a kind of coherence of those "mutually exclusive diverse elements."

Watching today's Belarusians, for the most part rather unexercised by with such theoretical questions, one does notice signs of this resilience and this tendency to reconcile seeming contradictions. They consider themselves Belarusian and are proud of having a state of their own (only a minuscule percentage would accept a full absorption into Russia or the Soviet Union-redux). They often wax sentimental about the beauty of their countryside, which is, indeed, quite magical and captivating. Hospitable and friendly, they also seem more cautious and restrained then their Slavic brethren: Poles, Ukrainians, and Russians. (No bear hugs or multiple kisses on cheeks.) They value order and stability and seem to steer clear of all extremes. They appear naturally egalitarian and communitarian. A Norwegian colleague, with whom I travelled outside Minsk, surprised me by saying she noticed something Scandinavian about them. Lots of blond hair and blue eyes, to be sure, and an occasional biker with Viking braids, but also something deeper. Perhaps a touch of *lagom* — not too much, not too little, just the right amount.

It is possible that Lukashenko, a folksy "people's guy" and

118

anti-corruption firebrand, appealed to exactly those populist preferences in the turbulent first years of independence. Some people who are now struggling against him admit that they were deceived by him; some of them voted for him, and some even worked for him. His populism and his disregard for constitutional niceties was well known, but Belarus was a democracy, after all. If he goes too far, people said, we can vote him out. Unfortunately, he has gone too far. He turns out to be a natural-born, and quite skillful, autocrat. And he has moved quickly and effectively to assure that no democratic process will ever interfere with his rule.

Practically every country in the former orbit of communism faced this kind of temptation during the first years of liberation and transformation. Most dodged the bullet, sometimes narrowly. Some, like Poland or Hungary, are still grappling with a sudden upsurge of anti-liberal sentiments. Lukashenko was not inevitable, and he did not come to power because the average Belarusian is an unreformed *homo sovieticus*. In fact, under different leadership the same characteristics of caution, moderation, and commonality would make a decent foundation for a democratic community.

Belarusians dwelled for over two hundred years in the political and cultural orbit of Russia, and the experience was not entirely negative. It was the Russian tsars who first started building railways and roads and increased the number of public schools. Even under the Soviets, despite horrific Stalinist repressions, the Belarusian lower classes for the first time had a chance to obtain an education and experience social mobility. Despite its rural public image, Belarus became one of the most industrialized and productive Soviet republics, hosting most of the advanced chemical and

electronic manufacturers. It must be admitted that whatever material progress the Belarusians saw, it came with a Russian stamp. Practically all Belarusians are bilingual, although only a minority can use standard Belarusian correctly and fluently. (A mixture of both languages is a more frequent means of communication in smaller towns and villages.) Russian media are ubiquitous and offer, along with Putin's propaganda, a great deal of attractive entertainment. Russia is a natural destination for ambitious Belarusians seeking better education and professional opportunities. (European alternatives have begun to emerge, but much more needs to be done.)

This "Russian dimension" is a problem because it exposes Russian speakers to Putin's disinformation. But that is the result of Moscow's policies and Lukashenko's pro-Russian bent, though even he gets nervous about the influence of Russian media, which dwarf his own. Lukashenko used the attempts at rapid cultural "decolonization" undertaken right after the independence, including making Belarusian the sole official language, to instill a fear of exclusion among Belarusian Russian speakers. With a better leader and a more nuanced policy, the understanding of Russian language and culture may prove to be an asset rather than encumbrance. Obviously, the Belarusian language must enjoy full support, and one can hope that it continues to gain ground in all walks of life. (It has become a sociolect of the opposition and young people, and has recently acquired its own street jargon, which bodes rather well for its future.) But Russian speakers should be made to feel fully Belarusian, and not only under the questionable protection of an autocrat.

The Belarusian philosopher Valiantsin Akudovich has remarked that "Russia is not east of us. It is our east." It is one of the poles of Belarusian identity, as important as all the others.

But it is the multipolarity that distinguishes Belarusians from Russians. In Akudovich's view, Belarusian activists and intellectuals, many of them his friends and colleagues, have overplayed their hand in their attempt to revive a monolingual ethnic entity. They were imagining a nation that simply did not exist. But it could exist as a civic nation, an inclusive, sovereign community united by common values of freedom, tolerance, equality, and individual rights. In fact, considering their diverse historical experiences and cultural points of reference, Belarusians are uniquely well-equipped to become such a nation.

II

Is that not what we saw in August 2020 — a new civil nation rising? How strong is it, and what is its staying power? And why now? Lukashenko has cheated before. Not a single election — presidential or parliamentary — since the one which brought him to power was considered "free and fair" by international observers. What was different this time?

Belarusians are no strangers to mass protests. Presidential elections in 2006 and 2010 led to street demonstrations, but the equally fraudulent election in 2015 passed rather quietly. In 2017, Belarusians, mostly blue-collar workers, took to the streets to decry the so-called Parasite Law that imposed special tax on persons without regular employment. In 2018, large groups of people gathered at events organized by non-government organizations, sometimes with the tacit permission of the authorities, to commemorate the centennial of the Belarusian People's Republic. Although not strictly political, these gatherings had a clear anti-authoritarian theme. But Belarusians seemed to be losing their appetite for street action. Only hundreds of people showed up for occasional "unautho-

rized" marches organized by more radical opposition leaders. Traditional political opposition — several pro-democracy parties that survived since early 1990s — was divided and melting away.

In attempting to explain the sudden and unprecedented mobilization of 2020, people have pointed to the looming economic downturn, the relative success of the anti-Parasite Law movement (the law was eventually shelved), the government's negligence in the face of the coronavirus pandemic, and the removal of crosses placed by citizens at the site of the Stalinist mass executions in Kurapaty near Minsk. All these factors have certainly played a role, but even taken together they can hardly explain the magnitude of the recent "Awakening," as the demonstrations came to be called.

What may explain it better is the so-called Tocquevillean paradox: revolutions happen not when things are getting worse but when they are getting better, and too slowly to meet rising expectations. In the last five years, things in Belarus were indeed getting better, although at a maddeningly slow pace. What prompted this change was probably the Russian invasion in Ukraine and the annexation of Crimea. Until then, Lukashenko believed that he could use Putin to his advantage while keeping him under control. Overnight, however, the eastern neighbor turned into someone with whom you would not like to be alone in a room.

In the past Lukashenko tried to "play" Russia off the West and vice versa, scheming to obtain concessions from both. This time, however, it was no longer just about the price of Russian oil or easing Western economic sanctions imposed after the fraudulent presidential elections of 2006. Minsk needed to create at least an appearance of being willing to "balance" its chief strategic partner with a stronger relation

with Europe and the United States. Lukashenko did not recognize the annexation of Crimea and offered his capital as the site of negotiations of the "Ukrainian issue." He released six remaining political prisoners and slightly relaxed the laws restricting free speech, assembly, and association. There was a bit more opportunity for independent civil activities. Those who pushed the envelope were still punished, but by hefty fines rather than long prison terms. In the otherwise state-dominated economy, small and medium-sized private enterprises, including in advanced technologies, were allowed to develop more freely, providing employment choices and funding sources for non-government organizations.

Right at the same time, a whole new generation of young, outward-looking Belorussians came to the fore. All these changes were visible to the naked eye. Chic cafes and restaurants started appearing under somber Stalinist colonnades. The Minsk Upper Town and the Trinity Suburb, two parts of the city with some preserved or reconstructed historical buildings, began to seem positively European. The Minsk art community transformed a decrepit, abandoned industrial area on Kastrychnitskaya Street into a neighborhood of galleries, art workshops, and music clubs, decorated with fantastic murals by local and international street-artists. Among the growing middle classes, foreign vacations became commonplace. This was the Belarus that I encountered on my first visit. A colleague returning to Minsk after twelve years of absence was positively surprised by the scope of the transformations. He immediately noticed the absence of the "Soviet posture": stooped back, head in the shoulders, eyes fixed on the ground, an angry or contemptuous look on the face. On nice days people, especially young people, walked around looking up, smiling, and even enjoying themselves!

The West started to lift or to suspend many of the economic sanctions that were imposed after the election of 2006. There were talks with the United States about exchanging the ambassadors who were withdrawn in 2008 during a spate over the sanctions. All the while Lukashenko remained inaccessible, inscrutable, unpredictable. It was obvious that he could in an instant retract the freedoms that he was cautiously permitting. Nobody was fooled, but the West played along hoping to gain some time and some breathing room for Belarusian society. And Belarusians started getting used to their new, slightly more colorful life, to the measure of "normality" that creates its own expectation of permanence. These were Tocqueville's "rising expectations."

Another thing that separated the presidential election of 2020 from all previous elections was the appearance of three unexpected contenders, none of whom emerged from the "old" opposition. Valery Tsepkalo was a former member of the Lukashenko administration, a former diplomat (from 1997 to 2002 he served as the ambassador to the United States), and an entrepreneur. Capitalizing on the quick growth of Belarusian tech industries, he founded the Belarusian High-Tech Park designed as the country's own Silicon Valley. Viktor Babaryko is a millionaire and philanthropist, a patron of the arts and the head of BelGazpromBank, which is a subsidiary of the Russian Gazprombank. His well-run campaign and meteoric rise in the polls made him an instant star among Lukashemko's challengers. The third "new" candidate was Siarhiej Tsikhanouski, the producer of a political YouTube show called "A Country Fit for Living," with over 330,000 followers. There were also candidates from the "old" opposition, but it was those three that electrified the political atmosphere. Something new and unexpected was in the air. Maybe this time...

The government must have sensed it too, because it quickly moved to put those people out of play. They were denied registration on technical grounds, and one by one they were hit with trumped-up criminal charges. Tsepkalo avoided arrest by leaving the country together with his children. Babaryko and Tsikhanouski were thrown in jail. The other contenders were allowed to run. Then something even more unexpected happened. Thikhanouski's wife Sviatlana, a school teacher, decided to run in his place. Tsepkalo's wife Veronika, who stayed behind in Belarus, and Maria Kalesnikava, Babaryko's feisty campaign manager (and an accomplished musician), appeared at Sviatlana's side. The three campaigns merged into one. Three young, strong, modern women with no political experience were challenging the old patriarch notorious for, among other abuses, his misogynist slurs. Thousands thronged their rallies, and their three smiling faces, as well as their three hand symbols (Tsikhanouskaya — the fist, Tsipkala — the V sign, Kalesnikava — the heart), became the mark of the "new" revolution.

It is anybody's guess why Lukashenko allowed Tsikhanouskaya to run. It was probably out of sheer contempt. But run she did, until the election day of August 9. What happened on that day was shockingly predictable. According to the official results, Lukashenko won with his favorite "around eighty percent." Tsikhanouskaya allegedly got just above ten percent. The other three contenders gathered less than two percent each. Protests erupted almost immediately — a surge of anger and disbelief that despite all the mobilization, the enthusiasm, the sense of strength, everything was to be exactly as it always was.

The day after the elections, Tsikhanouskaya went to the Central Election Commission to file a protest and request a

recount. She was admitted into the building alone, and then she disappeared. She reappeared a few hours later in Vilnius, in Lithuania, in an obviously coerced video looking traumatized and defeated. She said that she was "just a weak woman." For her, she said, children were the most important thing in life, and politics wasn't worth it. In another video, presumably shot still inside the Central Commission, she called on her followers to accept the results and stop protesting.

According to some sources, the head of the Central Commission, Lidia Yermoshina, one of Lukashenko's key enablers, "introduced" Tsikhanouskaya to two gentlemen from the KGB who had "a long conversation" with her. With her husband in jail and her children seemingly still within the government's reach (the deprivation of parental rights is one of the regime's most potent tools of intimidation), she was forced to emigrate and abandon politics. Game over? Not quite. Soon after the two videos, there was a third one, in which Tsikhanouskaya defiantly called on her supporters *not* to recognize the results, and on various opposition groups to form a Coordination Council to push for a new election under international supervision. Her office in Vilnius, which recently obtained diplomatic status, serves now as a legation of "democratic Belarus." Surrounded by a team of prominent Belarusian activists and experts, she incessantly travels Europe calling for robust economic sanctions, diplomatic pressure on Lukashenko, and material help for the Belarusian opposition and victims of the repressions. She has met with practically every European leader at least once, and in July 2021 visited the United States where she met with Secretary of State Anthony Blinken, National Security Advisor Jake Sullivan, and President Biden. Serious, composed, and well prepared, she is taking considerable risks with her

husband still hostage in a Belarusian prison and herself on the Belarusian most wanted list.

Of the remaining members of the trio, Tsipkala decided to join her family in exile, and Kalesnikava remained active and visible until she was kidnapped in Minsk on September 7, 2020 in broad daylight. She was being driven with others towards the Ukrainian border for a summary deportation. She apparently resisted, after which she was "properly" arrested by border guards. The dissident Coordination Council was formed, but its presidium members were either arrested or, like Svetlana Alexievich, had to leave the country. As protests grew in strength and started to spread across the country, including to smaller towns and villages, Lukashenko pulled out all the stops. Earlier festive demonstrations, many organized and run by women, became scenes of horror. Smashed faces, broken limbs, bodies blue from truncheon blows. Men and women brutalized during arrests, inside police vans, and in detention centers. Prisoners kept for hours in "stressful positions," horrid reports of rape and torture.

The demonstrations continued through the summer and the fall. "Keep beating us. You'll beat out all our fear," proclaimed one defiant song. But the marches were growing smaller and more localized, turning into neighborhood gatherings, sing-alongs, courtyard poetry readings. Those, too, were brutally dispersed. A young artist who went to argue with police over the removal of red and white ribbons from the courtyard of his apartment building was arrested and beaten to death. With the coming of cold weather and the intensifying repression, the protests eventually subsided, and did not return, as some expected, in the spring. The government continues with its brutal crackdown — arresting remaining leaders, charging them with "actions against state security,"

and slapping them with long prison terms. (Babaryko has been sentenced to fourteen years.)

Most notoriously, Roman Protasevich, the young founder of an internet platform used to coordinate the protests, has been snatched from an Athens-to-Vilnius flight that was forced to land in Minsk. In a spectacle reminiscent of Stalinist show trials, he later appeared on state television confessing to everything, performing self-criticism and naming names. At the same time the regime is eliminating the last remaining independent information outlets, ransacking and closing editorial offices and arresting journalists. Independent publishing has come to a virtual standstill. Even Belarusian publishers operating abroad have problems with importing their books into the country. There are over six hundred political prisoners recognized by international human rights organizations. Reports from detention centers and prisons continue to horrify. Ostracized by practically everybody except for his nemesis-friend Putin, Lukashenko seems ready to rule by fear alone.

What will happen next? History likes surprises, and Putin may still decide to replace Lukashenko with someone equally subservient but less infamous, and task his new puppet with putting a "human face" on the regime. Or he may be quite satisfied with the present state of affairs — a completely isolated and weakened satrap totally dependent on him. The movement has been pushed off the streets, but not necessarily defeated. In 1981, Polish Solidarity was crushed by the communist regime in Warsaw, but it survived because during its brief heyday it managed to create an institutional network. The Belarusian

movement, with its flash-mob quality, seems to be much less structured. This may be its weakness or it may be its strength. Despite government efforts, information and ideas still flow freely. Today's Belarussians are happy not to have to print their leaflets on homemade mimeographs and carry them around in easily spotted bulky bags. We are probably in for a "silence, exile, cunning" stage — the words belong to Stephen Dedalus, the non-conformist hero of Joyce's *Portrait of the Artist as a Young Man,* in which he called these strategies "the only arms I allow myself to use" — when the work of dissent is primarily conceptual, developing coherent programs and building up the broadest possible consensus among various social groups. (Acknowledging that such a consensus does not yet exist would be a good starting point.) We are talking about Belarusian liberty's second chance.

Then there is the inevitable geopolitical aspect. If the Polish and Central European example may be invoked again, the breakthrough of 1989 happened only because Gorbachev casually dismissed the "Brezhnev Doctrine," which stipulated that the Soviet Union will intervene in any Warsaw Pact country where the monopoly of power of a pro-Moscow communist party is threatened. As long as Putin, or someone like him, holds power in Moscow and relations between Russia and the West are as adversarial as they are now, Belarus is of too much strategic value to Moscow to be simply let go. Losing Belarus might be the final blow to Putin's already shaky internal position based on skillfully maintained great power illusions. The Belarusian opposition is extremely cautious when it comes to Russia. During the recent protests, there were scarcely any openly anti-Russian slogans. Neither were there openly pro-EU or pro-NATO declarations. A strategic reorientation of the country does not seem to be on the agenda. One

129

Belarus Incognita

can only speculate, but it is possible that Belarusians would accept an "in-between" status, a Moscow-friendly neutrality, if Russia finds a way of securing its interests without treating Belarus as a satrapy. Could Belarus attain at least the status of Finland during the Cold War? As for now, there is no indication Russia would be ready to accept such a solution. (And the Finns had the good luck of never being treated as part of the larger Russian nation.)

But it is almost certain that things will not go back to what they were. The sheer brutality with which Lukashenko is clinging to power is a portent of its end. Each wave of repressions creates new opponents — some vocal and visible, and some quiet, waiting for the right moment. To quote Akudovich again, "Lukashenko is our great pause. To seize the highest power and hold it for so many years, he had to stop time, to freeze it in the forms and patterns that lingered in Belarus since the Soviet era." But time, once unfrozen, cannot be refrozen. It is obvious that Belarusian civil nation will not accept a life of absurdity, of preposterous historical anachronism.

There is a long list of things that the West can do to hasten the end of Lukashenko's dictatorship. Most importantly, we must be clear about why we should be doing it. Belarus is an important piece on the global strategic chessboard, but it is infinitely more than that. It is a piece of our shared history and shared destiny, a part of our constantly emerging world. Without it we are incomplete. That is why we need to make it a subject of our conversations, to make it — however cynical it may sound — interesting for our thinking classes. That is what happened in 1980s with Central Europe in the throes of its own transformation. I observed it among the intellectuals of New York. Suddenly Poland, Czechoslovakia, Hungary,

Yugoslavia, and the rest became a part of their world. This happened largely thanks to writers from the region, such as Czeslaw Miłosz, Zbigniew Herbert, Leszek Kolakowski, Adam Zagajewski, Stanislaw Baranczak, Vaclav Havel, Milan Kundera, Georgy Konrad, Miklos Haraszti, Danilo Kis, and others, whose work became available in English translations. They presented their native realm not as an abstract political issue, but as a rich, often deeply conflicted human universe, less lucky than ours but not unlike it in many respects. It is fortunate, therefore, that the Belarusian Free Theatre, the creation of an indomitable couple, Natalia Kaliada and Nikolai Khalezin, has gained much deserved recognition for its innovative form and sharp political messages. It performs internationally, and until recently staged stealthy shows in private apartments in their native country. Many of its members in Belarus have been recently arrested. A fine Belarusian-American poet, Valzhyna Mort, has also made her mark with an excellent English-language (but very Belarusian) volume entitled *Music for the Dead and Resurrected*. But I find it quite incomprehensible that today's Belarusian writers — Uladzimir Niakliaeu, Valancin Akudovich, Pavel Seviaryniets (currently in prison), Uladzimir Arlou, Artur Klinau, Alhierd Bacharevic, Victor Martinovich, Ales Razanau, Barys Piatrovich, Tania Skarynkina, Yulia Tsimafeyeva, Ihar Babkou, Andrei Khadanovich — the list could go on — are virtually unknown in America.

"The most important thing has already happened — in 2020 we won the war against a discourse that took no notice of our existence," wrote the poet, translator, and essayist Maryja Martysevich. I hope she is right. Among the many battles that the new liberal Belarus is fighting today, perhaps the most crucial is the campaign against the invisibility

and the inattention that it suffered for so long in the eyes of the West. The worst kind of isolationism is the cognitive kind. We cannot do the right thing in circumstances that we refuse to see.

SEAN WILENTZ

The Tyranny of the Minority, from Calhoun to Trump

The deadly mob attack on the U.S. Capitol on January 6, 2021 —
exhorted and then cheered on by President Donald J. Trump,
with accountability later stonewalled by the Republican Party
— was unprecedented in our history, but then again it wasn't.
It is true that never before had a losing presidential candidate,
after pounding a Big Lie about a stolen election, helped to whip
up a crowd into a murderous frenzy and directed it to prevent
the official congressional certification of his defeat. The last
time a losing candidate's campaign tried to overturn the results,
in the incomparably closer election of 1960, Richard Nixon's
supporters, having lost by a whisker to John F. Kennedy, tried

to raise a stink about massive vote fraud in eleven states. But the Nixon forces gave way, after recounts, judicial decisions, and state board of elections findings — including those under Republican jurisdiction — went against them. Trump, the Roy Cohn protégé who has long regarded Nixon as insufficiently ruthless, pushed much further, to the point of sedition.

In another vaguely analogous historical example, Andrew Jackson in 1825 charged that a corrupt bargain had denied him the presidency after the uncertain electoral results of a four-way race threw the decision into the House of Representatives. Yet Jackson undeniably won strong popular and electoral pluralities, as Trump did not, his charges of behind-the-scenes chicanery were plausible if unknowable; and he raised no mob nor did anything else to interrupt the normal transfer of power. (Jackson participated in the inauguration ceremonies for the incoming administration.) Trump and his supporters have for years tried to fool the public into viewing him as the reincarnation of Old Hickory; but once again Trump's subversive words and actions only dramatized their differences.

More recent examples were authentic precedents to Trump's sedition. Nixon may never have matched Trump's standard for cynicism, but after 1960 he outdid himself and every previous president in undermining democracy. In 1968, during his second try for the presidency, Nixon illicitly tampered with preliminary peace talks over the war in Vietnam, halting their progress, which may well have secured his narrow victory over Vice President Hubert Humphrey. Five years later, investigations into the offenses known collectively as Watergate revealed that, above and beyond the famous break-in at the Democratic National Committee's headquarters, Nixon contemplated using the FBI, the CIA, the

134

IRS, and other government agencies to spy on, harass, and if necessary detain his political adversaries. Had it not been for an alert night watchman at the Watergate, whose discovery of the attempted DNC burglary began breaking everything open and eventually led to Nixon's resignation, Nixon might have succeeded in the most systematic internal overthrow of the Constitution in our history.

Then there was the notorious "Brooks Brothers" riot on November 22, 2000, during the presidential vote-return struggle in Florida between Al Gore and George W. Bush — a foreshadowing of Trump's outrages right down to some of the persons involved. Canvassers in Miami-Dade County, in order to make the recounting of votes more efficient and meet a court-ordered deadline, moved their work to a smaller room in the recount headquarters. Suddenly, on a direct order to "shut it down" from Republican congressman John Sweeney of New York, a mob of Republican staffers and other operatives — some of the hundreds of Republicans dispatched to South Florida to protest and disrupt the recount — rushed the doors and started pounding on them, while punching and trampling anyone in their way. The melee halted the Miami-Dade recount which, unlike the tallying of electoral votes on January 6, was permanently suspended.

Given that Bush eventually won Florida, and thus the presidency, by 537 votes out of more than six million cast, and given that the rest of the returns in populous Miami-Dade Country broke in favor of Gore, it is highly possible that the riot actually turned the election, which would make it one of the most consequential events in American political history. And that would not be its only legacy. Roger Stone, the self-described Republican "hit man" who worked for the Bush campaign during the recount struggle, reportedly had a

great deal to do with the Miami-Dade attack and even boasted about organizing it — the same Roger Stone who, having been pardoned by his patron Trump after multiple convictions, mingled with the neo-Nazi Proud Boys and addressed the crowd on January 6, declaring that "we will win this fight or America will step off into a thousand years of darkness." Today Matt Schlapp, as president of the American Conservative Union, has been one of the chief propagators of the lies about a stolen election that propelled the mob, and in 2000 he was one of the more conspicuous Brooks Brothers rioters.

From another angle, however, despite some obvious departures, there were unsettling similarities between the events surrounding January 6 and American democracy's worst moment of crisis since the nation's founding until now: the secession winter of 1860-1861 triggered by Abraham Lincoln's election as president. For months prior to Election Day, pro-slavery southerners had warned that they would not respect the outcome if Lincoln won. "Let the consequences be what they may – whether the Potomac is crimsoned in human gore, and Pennsylvania Avenue is paved ten fathoms deep with mangled bodies...," a relatively moderate Georgia newspaper declared, "the South will never submit to such humiliation and degradation as the inauguration of Abraham Lincoln." For the slaveholders, a Lincoln presidency would be thoroughly illegitimate because his party's program violated what they described as the Constitution's protection of states' rights as well individuals' property rights in slaves, as enunciated by the Supreme Court majority in the Dred Scott decision three years earlier.

Rather than contest the correctness of the popular and electoral vote count, the pro-slavery southerners withdrew from the Union, state by state, and set about forming a nation of their own — a course that had been bruited for decades, by

irreconcilable New England Federalists as well as pro-slavery militants. When the federal government at length attempted to assert its authority by refusing to surrender federal installations in the South — thereby affirming Lincoln's legitimacy — the insurrectionists fired upon and captured Fort Sumter in Charleston harbor, a target with real as well as symbolic importance.

Trump, like the seceding slaveholders, made it clear long before the election that he would not respect the outcome were his opponent declared the winner. His talk of potential violence during the 2020 campaign, building on his instructions to supporters four years earlier to "beat the crap" out of peaceful protesters, was less gruesome than the slaveholders' rebellion in 1860, but it was menacing enough, as when, during the first presidential debate, he instructed the Proud Boys to "stand back and stand by." (The truly grisly rhetoric came from Trump's supporters inside the irregular militias, plotting and then spreading the word on social media and in the nether reaches of the pro-Trump Web, during the build-up to the riot.)

Although based on fantastic lies about a rigged election instead of a fallacious Supreme Court decision, Trump's charges about monumental unconstitutional offenses rang true to his tens of millions of supporters, much as the secessionists' charges rang true to theirs. There was even some of the slaveholders' apocalyptic tone in Trump's doomful rants that culminated in his instructions to the crowd on January 6 to march up Pennsylvania Avenue — peacefully and patriotically, of course — and to "fight like hell," warning that if they failed, "you're not going to have a country anymore."

And so, in the name of their Great Leader, the mob, including some rioters carrying Confederate flags, violently

137

assaulted not a fort containing a U.S. Army garrison but the U.S. Capitol itself, containing the leadership and hundreds of members of both houses of Congress along with Vice President Mike Pence. Acting as self-proclaimed guardians of the true Constitution, ordered into battle by the Leader himself, the Trumpists, no less than the Confederates in 1861, believed that upholding American justice required insurrection, this time by violently overturning a presidential election and, quite possibly, assassinating some of the nation's highest-ranking elected officials, including Trump's own vice president, a supposed turncoat.

The scale of Trump's machinations, to be sure, were in some obvious ways far smaller than southern secession (although it might be worth noting that there were no fatalities during the bombardment of Fort Sumter compared to the five deaths that resulted from the attack on the Capitol). The events of January 6 did not instantly initiate a civil war. The idea of seceding and formally creating a Trump Confederacy, or some such entity, evidently exceeded even the most fevered imaginations inside the White House and the Republican Party. Disturbing as it was to watch well-armed pro-Trump paramilitaries storm the Capitol, they did not constitute the Confederate batteries arrayed against Fort Sumter, let alone an Army of Northern Virginia. Above all, in the crunch, key state and local officials, Republican as well as Democratic, resisted Trump's bullying to "find" him the votes that he needed or otherwise overthrow the results. State and federal judges, including some Trump appointees, rejected the baseless and desperate efforts (supported by a large majority of House Republicans and prominent senators such as Ted Cruz and Josh Hawley) to undo the election in the courts. Remarkably, under extreme duress, the system held, as it did not in 1860-1861.

And yet, as the seditious examples of Cruz and Hawley suggest, the events of January 6 and all that led up to them were also in some ways a far more profound assault on American democracy than the slaveholders' secession — a direct attack by the Trump Republican Party on the national democratic process that even the Confederates did not attempt. The secessionists regarded Lincoln as an illegitimate president on constitutional grounds, but they never claimed that his election was fraudulent. They did not attempt to de-certify Lincoln's victory on the grounds that that the democratic system itself was corrupt and that the election had been rigged. They did not identify their cause with the personality and political fortunes of a single autocratic leader or subdue an entire national political party to the autocrat's will. They did not try to browbeat state and local officials into falsifying voting results or bid state legislators to violate their public trust and simply negate the popular vote. They did not compel a large majority of the compliant political party's members in the House, along with some of the party's high-profile members in the Senate, to support overruling state officials and decertifying official results in a presidential election.

The secessionist slaveholders were not, it needs to be said, dedicated democrats, even when it came to their fellow white southerners, whom they intimidated by calling out state militias during the state-wide referenda over approving secession. Still, in national politics, the secessionists committed treason by repudiating the democratic Union; but the Trump Republicans committed something akin to treason by repudiating democracy itself.

The Trump Republican sedition has far from ended, and the worst may be yet to come. By helping to convince one in four Americans and more than half of all Republicans that

Trump and not Biden is the "true" President of the United States, Trump and the GOP have in fact attempted nothing less than a kind of virtual secession from the American political system. Instead of founding a new country, Trump's secession aims to stoke his followers' intense resentments, have them withdraw any remaining loyalties they might have to the existing system of government, and re-attach those loyalties to an imagined pro-Trump nation within the nation — projects already well advanced long before Election Day. Then, while they finally purge the party of remaining RINOs such as Liz Cheney — the high-ranking House arch-conservative who turned against Trump over January 6 — the Trump Republicans aim to exploit the demonized system's vulnerabilities, chiefly through gerrymandering and voter suppression, in order to regain control of the entire federal government, once and for all. That project, too, was underway before the election and has rapidly gained strength since then. And although seditious in intention, that project, unlike Trump's failed insurrection in January, will fall squarely within the law, some of it recently revised and upheld by the conservative Supreme Court majority.

If these efforts succeed, the Republicans, at a minimum, will regain control of both the House and the Senate in 2022. Once in command, House Republicans in particular will obstruct and harass the Biden administration and any other Democrats who stand in their way, just as Republicans have hounded Democrats going back to the phony scandals and investigations promoted by Speaker Newt Gingrich in the 1990s. Finally, if everything goes as they hope, the Republicans' harassment will help produce a resounding GOP victory in the 2024 elections with Trump, presumably, the party's presidential nominee.

Once restored, the Great Leader, unchecked by Congress or the courts, may be expected to pursue authoritarian, kleptocratic politics on a scale merely hinted at during his first four years in office, including a foreign policy friendlier than ever to repressive dictatorships abroad. But more than that, the Republican Party, if successful, will be poised to secure what has been its supreme political goal for a long time, long before Trump, something that the southern Slave Power had hoped to achieve before the rise of the Lincoln Republicans drove it to disunion — a more or less ironclad system of undemocratic minority rule. That new system would block national action over any issue that the red state minority finds objectionable, from civil rights, abortion rights, and gun-safety to economic regulation and progressive income taxes. And by sustaining and reinforcing every undemocratic instrument the system affords, the Republicans could make that minority rule more or less permanent. Without dissolving the Union or amending the Constitution, or assaulting the Capitol, the Republican Party will have replaced American democracy with minority despotism.

It may not happen, but it very well could, in part because the Trump Republican dystopia, on the horizon for decades inside the GOP, also has deeper roots in American history.

Trump Republicanism is more of a continuation than a break from the sordid GOP politics of the Reagan years and after, but it also echoes, albeit crudely, debates in our politics dating back well before the Civil War to the nation's founding in 1787. Those debates center on whether the United States is truly a single nation with a national majority, or merely a

patchwork of sovereign states that have the right to ignore the will of the nation at large. The Trump Republicans flourish by suppressing the Constitution's core idea of an energetic national government beholden to a surpassing national majority, obligated to pursue what the document repeatedly refers to as "the general welfare."

At the nation's founding, of course, so-called Anti-Federalists opposed the Constitution because they feared that the new and more powerful national government it created would become tyrannical. Remarkably, though, once the states completed its ratification in 1788, opposition to the Constitution disappeared, and for half a century thereafter Americans struggled not over whether the Constitution was legitimate but over how it ought to be interpreted. Still, in the 1790s, not just former Anti-Federalists but also supporters of the Constitution, including none other than James Madison, began objecting that the new government (under what they considered the malefic influence of Alexander Hamilton) was dangerously exceeding its authority.

Desperate when the government began actively suppressing political dissent, Madison, along with his even more imposing friend Thomas Jefferson, improvised what became known as the compact theory of the Constitution. The national government, the two Virginians claimed, was not a self-created entity of, by, and for the people at large, connected to but wholly independent of the states. It was merely a creature of the states, a congeries of them, which reserved considerable powers for themselves, including the authority to disregard federal legislation that any individual state believed violated the constitutional compact.

The compact theory cut little ice at the time, and soon enough Jefferson and Madison turned to majoritarian politics.

(What undid the Federalist excess, to their opponents' enormous relief, was Jefferson's election to the presidency in 1800-1801, not state challenges to the government's authority.) Thereafter, a sense of national purpose and of the general welfare thickened, in part thanks to rulings by the Supreme Court under Chief Justice John Marshall. But as the renaissance of plantation slavery brought about by the cotton revolution awakened northern antislavery sentiment, the matter of slavery's future became a national issue as never before. Fearing the power of a growing Yankee majority, pro-slavery southerners, led by the erstwhile nationalist South Carolinian John C. Calhoun, transformed Madison and Jefferson's emergency improvisation into one the chief instruments for defending minority states' rights and slavery's expansion.

Calhoun's first gambit was his theory of nullification, whereby a specially elected state convention could declare null and void inside its state's borders any federal law that it deemed unconstitutional. Although ostensibly aimed against the protective tariff —which Calhoun and his supporters charged, fancifully, hurt the South severely —nullification's underlying motivation was to halt any accretion of federal power that might hasten slavery's abolition. (The tariff, the leading South Carolina pro-nullification group contended, was only a pretext to advance "the abolition of slavery throughout the southern states.")

When South Carolina moved to nullify the tariff in 1832, an appalled President Andrew Jackson, himself a slaveholder, denounced it as a blatantly undemocratic effort by a small minority to repudiate the constitutional exercise of the national majority's will, and he duly suppressed the uprising by threatening to send federal troops, after which Congress enacted a compromise tariff. (The South Carolina legislature

143

initially responded to Jackson by mobilizing the state militia, but the compromise averted serious violence.) The Constitution, Jackson proclaimed, formed "a *government,* not a *league*"; accordingly, it was incumbent upon the states to respect the national majority on matters like the tariff over which the Constitution extended authority to the national government. The aging Madison sided with Jackson, deploring the South Carolinians' "strange doctrines and misconceptions."

Defeated over nullification, Calhoun spent nearly two decades, until his death in 1850, defending slavery as a positive good, while also devising, unavailingly, one outlandish argument after another that would provide ironclad protection to the slaveholder minority. On a more practical level, meanwhile, pro-slavery southerners seized upon every advantage they could find within the limits of the Constitution to inflate their power and insure minority rule. No institution was more effective than the United States Senate.

Recent historians have made a great deal out of how the three-fifths clause of the Constitution, by giving the slaveholding states representation based on their enslaved populations in both the House of Representatives and the Electoral College, helped to create the Slave Power that dominated national politics until the eve of the Civil War. In fact, though, as the Northern majority in the House grew beyond the slaveholders' reach, the undemocratic representation of the Senate gave the South its ultimate advantage in national politics. This became clear as early as the Missouri crisis in 1819-1821, when a southern-controlled Senate repeatedly rejected House-approved measures that would have admitted Missouri as a free state and thereby weakened southern domination of the upper house.

So, for the next thirty years, the Senate remained a

144

slaveholders' redoubt. At the very end of the 1850s antislavery northern Republicans held a healthy plurality in the House (where only slightly more than one-third of the members represented slaveholding states), and this plurality proved sufficient to elect a Republican as Speaker, albeit after a prolonged struggle. In the Senate, however, where nearly half of the members represented slaveholding states, Republicans were a decided minority. So long as the pro-slavery forces could also count on a pliable president to go along with control of the Senate (which meant, in turn, having control of appointments to the Supreme Court), they could at the very least check and contain antislavery efforts. At best, they could bend federal power to their will to promote slavery's expansion, as they largely succeeded in doing in the 1850s during the administrations of the doughface presidents Franklin Pierce and James Buchanan, and above all in the Dred Scott decision by the pro-slavery Supreme Court majority in 1857.

Finally, though, the Republican Lincoln's election to the presidency in 1860 on a platform dedicated to slavery's eventual eradication was enough to push Calhoun's successors to give up on the Union and secede. Drawing on Jackson's reasoning from the nullification crisis, Lincoln replied to the disunionists in his first inaugural address, denouncing secession as "the essence of anarchy," and describing the Calhounite politics that led to it as a direct assault on the will of the national majority, the cornerstone of American constitutional democracy. "The rule of a minority, as a permanent arrangement, is wholly inadmissible," he observed, "so that, rejecting the majority principle, anarchy or despotism in some form is all that is left."

More than a century and a half later, a transformed Republican Party, no longer the party of Lincoln, has turned

rejecting the majority principle into its core political imperative, seeking to make the rule of a minority a permanent arrangement. And, as Lincoln warned, the modern GOP, having revived the spirit of Calhounism, has flown to a form of despotism under Donald Trump.

The compact theory of the Constitution did not survive the Civil War; and in 1869, ruling in the case of *Texas v. White*, the Supreme Court struck down the alleged right of individual states to secede, holding instead, in Chief Justice Salmon P. Chase's majority opinion, that the Union was "indestructible." The ratification of the Thirteenth, Fourteenth, and Fifteenth Amendments revolutionized the status of blacks and the rights of all American citizens by augmenting the national government's authority over citizenship and voting. The violent overthrow of Reconstruction, however, halted that revolution and that augmentation, and achieved a specious national reconciliation at the direct and disastrous expense of black Southerners.

That violence left a larger legacy as well. Just as the Confederate secession involved taking up arms rather than acceding to the national majority, the resistance to Reconstruction was in its own way a series of insurrections, state by state, aimed at repudiating national law upheld by new Republican-controlled state governments. In 1870 and 1871, the administration of Ulysses S. Grant, with congressional support, managed to crush the initial resistance mounted by the newly formed Ku Klux Klan, but the violence returned in the mid-1870s, led by paramilitary forces with names like the White League and White Liners that constituted the armed wing of the Democratic Party in the Deep South.

Committed to using terrorist violence to reverse the course of Reconstruction, the paramilitaries focused on the lethal, systematic suppression of democracy, especially around election days, targeting Republican politicians for death while hounding and killing black men who showed even an inclination to support the Republicans. Unlike the earlier Klan, these paramilitaries operated openly, with the support of local newspapers and notables. Weary of what Grant called "these annual autumnal outbreaks in the South," persuaded that reforming the South was a fool's errand, and gripped by other issues closer to home, northerners finally lost faith in Reconstruction. The terrorist counterrevolution had won, initiating a new regime of white supremacy that would soon lead to the mass disenfranchisement of blacks and the imposition of Jim Crow segregation, enforced by lynching, mob attacks, and other forms of violent intimidation.

So long as the rest of the country permitted white supremacy in the South to go unchallenged — indeed, virtually uncriticized — there was no need for talk of southern nullification, let alone secession. Into the middle of the twentieth century, with some sporadic exceptions, the nation at large seemed indifferent to the realities of what amounted to a perpetual American domestic reign of terror. In the long run, though, the acquiescence in Jim Crow did not hold, and when that happened, all the instruments of minority rule came back into play.

The rise of the southern civil rights movement in the 1950s, and above all the Supreme Court's ruling in *Brown v. Board of Education* in 1954, blew the lid off southern politics and then American politics, with effects that reverberate to this day. The *Brown* decision was not simply a frontal assault on segregated schooling, a cornerstone of the Jim Crow regime; it was also an indication that, for the first time since Reconstruc-

tion, the federal government was determined to exercise its power to secure the general welfare against the system that sustained the southern white ruling class.

The furious segregationist backlash, in time dubbed "massive resistance" by the segregationist Senator Harry F. Byrd of Virginia, brought Calhounism back from the dead. James J. Kilpatrick, the influential pro-segregationist editor of the *Richmond News Leader,* hoped to rise "above the sometimes sordid level of race and segregation" by dressing up nullification as the milder sounding "interposition." Kirkpatrick borrowed the term from Madison, but his intentions were pure Calhoun. Indeed, he would have extended the states' nullification power well beyond the acts of Congress that Calhoun specified to include Supreme Court decisions such as *Brown,* and even — well ahead of his time — the outcome of presidential elections.

Several southern legislatures duly passed resolutions of interdiction in defiance of *Brown.* Alabama lawmakers even used blunt Calhounite language, claiming that they had the power to declare any offending law or decision "as a matter of right, null, void, and of no effect" in their state." Yet these tactics proved no more effective in the 1950s than they had in the 1830s. Most dramatically, in 1957, Governor Orval Faubus of Arkansas unilaterally nullified *Brown* by ordering the Arkansas National Guard to prevent black students from entering Little Rock Central High School. President Dwight D. Eisenhower — channeling Andrew Jackson, like Lincoln before him — placed the Arkansas Guard under federal control and dispatched the 101st Airborne Division to Little Rock to enforce national law, and thereby broke the resistance. Elsewhere, state as well as federal courts ruled legislative interdiction unconstitutional.

Liberties

When legal resistance to *Brown* and subsequent civil rights reforms failed, segregationists turned to terrorism, echoing the nullifying violence that helped to kill Reconstruction. Along with innumerable murders of civil rights workers and their leaders, violent racists came to specialize in bombings that destroyed black homes and churches, killed small children, and spread fear across the South. The deaths of four black girls in an explosion detonated by segregationists at the 16th Street Baptist Church in Birmingham, Alabama, in 1963, sparked outrage, but the incident was one of more than fifty dynamite attacks between 1947 and 1965 that earned the city the nickname "Bombingham." Thanks in part to modern communications, images of the bloodshed only stiffened public and government resolve to demolish Jim Crow.

In time, to be sure, segregationists found ways to deny American law and to circumvent *Brown*, most successfully by establishing all-white private Christian academies, much as their forbears had skirted the Fifteenth Amendment by disenfranchising blacks through subterfuges such as the "grandfather clause," which barred from the polls anyone whose grandfather had not voted. Still, the formal rule of national law as interpreted by the Supreme Court stood, superseding the latest version of the state sovereignty claptrap. Finally, in 1958, in its ruling in *Cooper v. Aaron*, the Court held that, under the Constitution's Supremacy Clause, federal law "can neither be nullified openly and directly by state legislators or state executive or judicial officers nor nullified indirectly by them through evasive schemes."

Pro-segregation obstructionists made much better use of the slaveholders' old bastion, the U.S. Senate. Prior to the emergence of the modern civil rights movement, the most forceful attacks on Jim Crow had originated in the

149

anti-lynching movement that arose during the first two decades of the twentieth century, spearheaded by Ida B. Wells-Barnett and James Weldon Johnson, and led, after its formation in 1909, by the National Association for the Advancement of Colored People. Repugnance at a crescendo of lynching and other forms of racist violence following World War I prompted northern Republican congressmen to propose legislation that turned lynching into a federal crime. In the Senate, however, southern Democrats, with the connivance of the Senate's Republican leadership, killed the measure by launching a filibuster — a rule rarely used before the 1880s, and recently watered down to make it easier to shut down debate. "Never has the Senate," the *New York Times* reported, "so openly advertised the impotence to which it is reduced by it antiquated rules of procedure." Over the ensuing four decades, Democratic southern segregationists, when they were not allying with Republicans to fight pro-labor legislation, could count on the Senate filibuster as an effective weapon in scuttling or at the very least dramatically diluting federal civil rights bills.

Just as important as the filibuster, meanwhile, was the southern minority's disproportionate control of key congressional committees in both houses of Congress. Indeed, resort to the filibuster was in some ways a sign of defeat, a last resort deployed when an offending bill actually made it out of committee to the House or Senate floor. With the Democrats a virtually permanent majority in both the House and the Senate for more than four decades after 1932, southerners, aided in part by rules that rewarded seniority, assumed the chairmanship of numerous crucial standing committees. Accorded enormous independent power, these "barons" exercised it mercilessly. One of the most notorious of them, Representa-

tive Howard W. "Judge" Smith of Virginia, chaired the House Rules Committee from 1955 through 1967 and thus controlled the flow of legislation in the House, enough to insure that, by his fiat alone, proposed civil rights laws never came to a vote.

It took a southern-born president and former master of the Senate, Lyndon Baines Johnson, to oversee the congressional breakthroughs that finally overcame minority rule and achieved the landmark legislation of the Great Society, including the Civil Rights Act of 1964 and the Voting Rights Act of 1965, and also Medicare and Medicaid. The conservative backlash that followed, which culminated in the presidency of Ronald Reagan, aimed to undo the reforms of the New Deal as well as the Great Society, not by withdrawing into obstructionism but by building a new conservative national majority under the aegis of the Republican Party to match the long-lasting New Deal coalition it had disrupted. Reagan's historic landslide re-election in 1984 was enough to convince Republican loyalists that at the very least they had a lock on the White House, upon which they then could build.

That conservative national majority, however, never quite cohered. Bill Clinton's victory in 1992 was not supposed to happen; and although Republicans reflexively blamed their loss on the third-party candidate Ross Perot, part kook and part fluke, Clinton's re-election in 1996 refuted the GOP's majoritarian White House lock theory, as would the succeeding quarter-century of presidential politics. In all, between 1992 and 2020, Democrats prevailed in the popular vote in seven out of eight presidential elections, a record comparable to — and even slightly better than — the Democratic domination during the New Deal-Great Society era from 1932 to 1964, when the Democrats won the popular vote in seven out of nine elections. Although the Republicans managed, by hook

and by crook, to win the Electoral College vote half the time in that span, the emerging Republican national majority, as hyped by GOP pollsters and prognosticators since the late 1960s, simply never emerged.

The one truly smashing national victory that the Republicans enjoyed after Reagan's re-election came in 1994, when the scabrous congressional right-winger Newt Gingrich of Georgia converted Clinton's unsteady first two years into an electoral tsunami that left in its wake the first Republican House majority in four decades, whose members duly elected Gingrich Speaker. Yet Gingrich's leadership, with its scorched-earth partisanship, proved anything but stable, and only five years later he resigned from the House in disgrace, pushed out by Republicans who stood well to his right, chiefly from the South and led by Tom DeLay and Dick Armey, who accused him of political apostasy. The Republican House majority outlasted Gingrich for only six years before the Democrats recaptured command. Since then, the majority has swung wildly back and forth.

The Gingrich years, which not coincidentally also brought the rise of right-wing talk radio and Fox News, saw the commencement of what numerous observers have described as the rightward radicalization of the Republican Party. By 2012, the G.O.P had degenerated into what the centrist commentators Thomas Mann and Norman Ornstein accurately described in 2012 as "an insurgent outlier — ideologically extreme; contemptuous of the inherited social and economic policy regime; scornful of compromise; unpersuaded by conventional understanding of facts, evidence and science; and dismissive of the legitimacy of its political opposition." The re-election of Barack Obama that same year — which as late as Election Night many Republi-

cans thought impossible — only hastened the decay by infuriating a core anti-government political base that, whipped up by conservative media demagogues, blamed the party's leadership for insufficient boldness and fortitude.

Four years later, mainstream Republican leaders, reading the significance of the African American Obama's re-election very differently than the base, counseled a return to something approximating normality by nominating Jeb Bush to succeed his father and brother. But Donald Trump and his henchmen recognized the party for the ganglia of resentments that it had become. They ferociously channeled those resentments, swept to the nomination, and, after a freakish election in which Trump lost the popular tally by nearly three million votes, began to remake the G.O.P. into a decidedly minoritarian right-wing personality cult.

Along the way from Gingrich to Trump, Republicans learned to exploit the familiar tools of minority rule, thumbing their noses at the very idea of balanced majoritarian national government, which was of course the central idea, the central accomplishment, of the Constitution. Trump stood out for his willingness to exploit the most brutal of these tools, open threats and displays of physical force.

The violence as well as the subversive intentions of the insurrection on January 6 shocked the world, yet that violence, with its long history dating back through the civil rights era to Reconstruction, had a more recent history inside the Republican Party, commencing in Gingrich's heyday. Gingrich's smashmouth demonizing style took on more sinister meanings amid a resurgence of anti-government

153

paramilitary violence that seemed to be spinning out of control in the mid-1990s, as pursued by an assortment of neo-Confederates, neo-Nazis, survivalists, and others at war with the federal government. The bombing of the Oklahoma City federal building in 1995, the deadliest domestic terror attack in American history, is the best-remembered event, but it occurred amid a rising mood of virulent anti-government militancy — a mood that some Republican officials winked at and others embraced.

In the wake of the Oklahoma City horror in 1995, the *Washington Post* reported that "in return for grass-roots support, some members of Congress, along with state officials and state legislators, have provided access and help to militia leaders." The most notorious militia-friendly member of Congress was the Republican Helen Chenoweth of Idaho, who introduced legislation that would hamper federal efforts to stymie the self-styled militia groups. Other prominent Republicans, including House members Robert Dornan of California, Larry Craig of Idaho, and Lauch Faircloth of North Carolina, served as conduits for militia complaints to the Justice Department. In Michigan, where then as now there was, as the *Post* reported, "a sizable militia organization," Republican governor John Engler refused to condemn them, offering the ludicrous observation that there was "no indication that they were created for the express purpose of bombing government buildings." Gary E. Johnson, the Republican governor of New Mexico, met with a group of militia leaders whom he praised as "responsible, reasonable, lawful" citizens.

Dispatching well-connected, well-off Republican staffers to shut down the democratic process in the frenzied presidential recount in 2000 came as an alarming confirmation of how

154

far supposedly upright Bush Republicans were now willing to go to seize power by physical force. After twenty more years of Republican radicalization, a Republican president who had been elected counseling violence thought nothing of emboldening right-wing paramilitaries, whom his own Department of Homeland Security had identified as the foremost terrorist threat facing the nation. In one shout-out in April 2020, Trump took to Twitter to egg on members of the Michigan Militia — the same terrorist group whom former Governor Engler had excused — as, armed to the teeth, they stormed their state's capitol over Covid restrictions, with some of them planning to kidnap and execute the state's Democratic governor. In retrospect, it turned out to be a dress rehearsal for the January 6 insurrection, which should have come as a warning that some terrible development was underway. But alliances between right-wing militias and the radicalizing Republican Party were nothing new.

In more benign but still portentous ways, Republicans revived other age-old minoritarian tactics and arguments. Around 2010, with Obama in the White House and the Democrats holding majorities in the House and Senate, a full-fledged Calhounite revival arose among Republican state legislators across the country. Numerous states passed laws as well as resolutions affirming state sovereignty and vowing to nullify everything from firearms control legislation to select provisions of the Affordable Care Act. That the Supreme Court long ago ruled nullification unconstitutional did not deter the neo-nullifiers, whose efforts may have been purely symbolic and opportunistic. In the years since, nothing has come of the outburst. Still, the campaign certainly advanced Calhounite ideas of state sovereignty last heard from the die-hard southern segregationists, fanning the anti-govern-

155

ment extremism that now propelled the party's base. Those minoritarian ideas, meanwhile, had been circulating in conservative legal circles for some time before 2010, as part of general revival of interest in federalist jurisprudence. In 1995, for example, Justice Clarence Thomas, in a dissenting opinion, appeared to endorse, if not nullification, then the compact theory on which nullification rests, writing with breath-taking candor that "the ultimate source of the Constitution's authority is the consent of the people of each individual State, not the consent of the undifferentiated people of the Nation as a whole."

Meanwhile, as ever, the key anti-majoritarian institution has proven to be the U.S. Senate, with its undemocratic representation, where Senator Mitch McConnell of Kentucky has raised the arts of obstruction to levels that even the most obdurate of the old Deep South segregationists would have admired. One of McConnell's chief priorities has been to advance and to solidify the long-term Republican project of transforming the federal judiciary into a bastion of hard-line judicial conservatism. Earlier efforts had produced, among other successes, a shift of the Supreme Court just far enough to the right to produce the two most consequential anti-democratic rulings in modern times. First, in 2010, came the 5-4 decision in *Citizens United v. FEC*, which overturned election spending restrictions dating back more than a century and shifted power heavily in the direction of a small number of anonymous wealthy donors. Three years later, in *Shelby County v. Holder*, another 5-4 decision, the court gutted the Voting Rights Act of 1965 by striking down crucial oversight provisions, which helped to pave the way for the wave of voter suppression proposals that are now wending their way through Republican-dominated state legislatures.

In his most notorious intervention to reinforce that conservative majority on the court, McConnell refused even to take up President Barack Obama's nomination of the moderate District Court Judge Merrick Garland in 2016, on the unprecedented, extra-constitutional, and transparently cynical grounds that no president should be able to make an appointment to the Court in a presidential election year. As soon as Trump was elected with a Senate majority, however, McConnell cleared the way by suspending the filibuster rule for Supreme Court nominees, which greatly eased Senate approval of Neil Gorsuch's and (with greater difficulty) Brett Kavanaugh's appointment to the court. Then in 2020, on the eve of another presidential election, McConnell brazenly rammed through the Senate Trump's nomination of the highly conservative Circuit Court Judge Amy Coney Barrett, shifting the court almost forbiddingly to the right, especially on voting rights.

Apart from these well-known episodes, though, McConnell's most effective obstruction has involved perfecting the filibuster as a weapon of legislative destruction, on judicial matters and virtually everything else. Not coincidentally, during his first session as Senate Minority Leader in 2007-2008, the number of Senate cloture motions filed — an indicator of the number of filibusters undertaken — more than doubled from 68 to 139, by far the highest jump on record at the time. But McConnell's systematic obstruction — call it the McConnell Filibuster — truly came into its own during Obama's presidency. The election of 2008, while it swept the Democrats into the White House, also proved a bloodbath for Senate Republicans, yielding the Democrats, briefly, a filibuster-proof majority to go along with a commanding Democratic majority in the House. With the nation in the throes of the worst financial disaster since the Great Depression, and with

public opinion clearly running against his party, which bore responsibility for the disaster, McConnell might have encouraged compromise. Instead, he announced that his top priority was to make Obama a one-term president; and when, following the death of Senator Edward M. Kennedy, the Democratic majority dropped below sixty, Senate Republicans filibustered as never before, with particular urgency over judicial appointments. By 2013-2014, the session prior to the 2014 midterms when the Republicans regained the Senate majority, the number of cloture motions had skyrocketed to 252.

McConnell knew that with the steady radicalization of the GOP, he could count on his caucus for disciplined loyalty, thereby preventing the White House or the Democratic majority from calling their proposals bipartisan, a sign of credibility. McConnell also understood that the public generally holds the party in power responsible for dysfunction and inaction, meaning that his opponents would pay the price for his calculated obstructionism. "For the Republicans," Jacob S. Hacker and Paul Pierson recently observed, "the filibuster was a win-win-win: It sharply reduced the range of issues that Democrats could advance; it ensured that even bills that got through were subject to withering attacks for months, dragging down public support; and it produced an atmosphere of gridlock and dysfunction for which Democrats would pay the price."

The gravity of the McConnell Filibuster's impact on American democracy has been evident for many years. One study of the Senate Republicans' filibuster in 2013 of a compromise bill that would have required background checks for firearms sales found that, while eighty-six percent of the American public supported the reform, senators representing thirty-eight percent of the population killed it. More glaringly,

the study also found that the votes of senators representing only ten percent of the population would have been sufficient to block the proposal — or, for that matter, to block any federal policy. That one of the disappointed two co-sponsors of the 2013 bill was Joe Manchin of West Virginia — one of two Senate Democrats now most forcefully opposed to reforming the filibuster — makes the episode, in retrospect, all the more frustrating. To be sure, crafting bipartisan compromise in the Senate on important measures is not utterly impossible, as revealed by the Biden administration's recent exertions over infrastructure funding, but the trend in recent history pushes heavily in the other direction.

Coupled with exempting the GOP's two major priorities — the budget process (meaning regressive tax cutting) as well as Supreme Court nominations — McConnell's obstruction puts the lie to claims that the filibuster is a venerable Senate institution that promotes bipartisanship. "Far from fostering compromise," Hacker and Pierson write, "the current filibuster has given a unified minority party every incentive to block legislation, no matter how many Americans support it." By wrecking the legislative process, the McConnell Filibuster in turn feeds the anti-government fervor skillfully exploited by the charlatan Trump, who claims that he alone can set things right. Above all, it solidifies the modern Republicans' strategy to succeed where the Slave Power and the Jim Crow segregationists ultimately failed: to bend the nation permanently to the will of a fiercely determined minority.

Looking to the presidential and congressional elections of 2024, numerous minoritarian strategies are open to the

159

Republicans — old maneuvers and new. Having captured control of both houses of a large majority of state legislatures, including those of such vital states as Pennsylvania, Florida, and Georgia, the Republicans will have a free hand, in accordance with the 2020 census, to gerrymander congressional election districts even worse than they enjoy at present, and to do so with minute precision. This will advance the minoritarian trend, going back many years, whereby Republicans consistently win a wildly disproportionate number of legislative and congressional seats relative to their share of the total vote. In a few states, including Kentucky, some Republicans have gone as far as to propose redrawing district lines in order to break up urban constituencies, with an eye to eliminating Democratic representation in Congress completely. Although party leaders have warned that such excessive tactics could backfire, inviting prolonged litigation that would not end well, the existing Republican advantage is such that, even with more conventional gerrymandering, the GOP could well retake the House by means of redistricting alone, before a single vote is cast. New districting lines would also insure permanent Republican control of the legislatures, which would in turn yield permanent minority rule in Congress.

160

Other forms of partisan interference center on new state voting laws recently passed or pending in states with Republican controlled legislatures. Between January 1 and May 21, 2021, at least seventeen states enacted twenty-eight new laws that restrict access to the vote. Under the phony pretext of preserving ballot integrity, these laws make it more difficult for citizens to vote, especially racial minorities and younger voters, by requiring official government identification, restricting absentee mail-in voting, and similar measures. By the early summer of 2021, a complementary nationwide effort

to expand the powers of poll watchers, thereby expanding opportunities for voter intimidation and harassment, had produced new legislation in three states, Georgia, Montana, and Iowa, with more almost certainly to follow.

Even more ominously, there were signs that the Big Lie about rampant voter fraud would camouflage Republican power plays to place state election oversight completely in Republican hands. Take, for example, the controversial new voting law in Georgia. Recall that during the turmoil in 2020, the state's Republican secretary of state, an independent elected official, refused to buckle to Trump's harassment over vote totals and certification, earning Trump's vilification which culminated in the January 6 insurrection. Several of the new Georgia law's less noticed provisions strip oversight power from the secretary's office and hand it to a newly created chair of the State Election Board, supposedly a "non-partisan" official but chosen directly by the state legislature. That same board, meanwhile, newly influenced by the legislature, will have the authority to suspend vital county election officials and temporarily replace them with their own selections. The incumbent secretary who stood up to Trump, Brad Raffensperger, while supporting most provisions in the new state law, has raised red flags about the oversight changes, charging that with an unelected election board controlled by the legislature, "you'll never be able to hold someone accountable."

Georgia is hardly alone. The revised Arizona voting laws recently upheld by the Supreme Court took the power to litigate election laws away from the Secretary of State, a Democrat, and gave it to the Attorney General, a Republican. In at least six other states with legislatures controlled by the GOP, legislators are maneuvering to wrest power to oversee elections away from governors, secretaries of state, and

non-partisan election boards. The strategy is as brazen as it is cynical: just in case gerrymandering and voter suppression are insufficient to produce Republican victories, decisions over post-election recounts and certification will now belong to hyper-partisan Republican state lawmakers.

At one level, these changes have justly drawn criticism as a kind of Jim Crow 2.0, by which minoritarian Republicans are seizing upon every means possible under existing federal law (in addition to the Fifteenth Amendment) to suppress voting by, and representation of, the majority. At another level, they invite truly nightmarish scenarios in which the electoral outrages over contested tallies and de-certified results that were turned aside in 2020 would not only return in 2024 but would succeed, with the help of pliable Republican state legislatures. Yet even short of such a constitutional crisis, the combination of gerrymandering and voter suppression could be enough to insure a Republican sweep in 2024 and the return of Donald Trump to the White House. With the Supreme Court majority firmly on its side, the minoritarian Republican Party that long ago became a hard right-wing outlier in our politics will have established a firmer a grip on American government — across the board, from top to bottom — than any other party in our history has enjoyed.

Compounding this dire prognosis, there will be nothing that the majority can do about it — or even much of a sense that there is anything to be done. After nullification failed, an increasingly desperate Calhoun had to come up with innovations that, if adopted, would have radically altered the constitutional order, such as establishing a dual presidency divided between the North and the South. In order to overcome the antislavery majority, the Confederates had to commit the treason of secession and war. Today's Republican minoritar-

ians, by contrast, more like the twentieth-century segrega-
tionists but on a vastly larger scale, have been playing entirely
by the established and accepted rules, if not always respecting
traditional norms, including on matters of judicial appoint-
ments and voter suppression. This itself blunts criticism, even
from Americans who object to the outcome: Democrats will be
in no position to say that the Republicans cheated, and if they
tried, Republicans could simply turn around and call them sore
losers. Should anyone try to challenge the rules themselves as
unconstitutional, the Supreme Court would almost certainly
decide otherwise, as it has done about restricting the vote. The
Republicans will have triumphed not by repeating Trump's
sedition but instead by manipulating and perverting the
system in order to overthrow it. Right-wing Bolsheviks, they
will have strangled democracy with its own rope.

Should this happen, it will not be because American
politics has broken from its past or succumbed to some alien
ideology. It will instead mark the triumph of a form of our
politics that stretches back to John C. Calhoun: the tyranny
of the minority. The framers of the Constitution feared
that tyranny as surely as they did an unchecked majority.
Liberals have been raised on warnings about the tyranny
of the majority, and have prided themselves, quite rightly,
on their commitment to the protection of minorities. But
we have reached a point of crisis at which we must remind
ourselves that the tyranny of the majority is odious because
it is a debasement of the founding principle of democracy,
which is majority rule. Democratic majoritarianism was one
of the breakthroughs of civilization, and the truest source of
political legitimacy. The framers built on that breakthrough
by creating a national government that was supposed to
reflect a balanced national majority, vastly expanded today

beyond what it was in 1787. Now we must worry about protecting the national majority from the minority. We must recognize a minoritarian danger. In a democracy, what is minority rule if not a subversion, and a seizure of power? In its severest test until now, Abraham Lincoln successfully defended the primacy of the majority principle as the nation's last best protection from anarchy and despotism. Should we fail the same test today, historians will be left to examine the irony of how the Republican Party that Lincoln helped to found became the vehicle for democracy's destruction.

ANGE MLINKO

The Mesocosm

———

Two sounds in the house lately:
clanking barbells and electric guitar
behind garage and bedroom doors.
J.'s mesocosm failed; he flagrantly
excused himself on the basis of gender,
as the gathering of mud and spores,

weeds and worms for "nurturing"
is not the métier, apparently, of boys.
Dear A., I myself was quite taken
with the idea that we can bring
a world to life like animated toys,
a sealed jar sustaining frog and fen.

So much for that. It's the fall equinox:
the radio broadcast Vivaldi twice.
I know the change by the slant of light—
slant of light + concerto. The clocks
quietly gallop. Maybe it's the promise
of achieving equilibrium, under tight

conditions, of carbon and oxygen
in give and take. I'm in dire need of
—what to call it?—magic. I worry
that Zoom is ruled by djinn
that filter out the wavelength of love
and so I wear my evil eye jewelry,

as you advised, against being too
much in view: that tiny frog on display
(like the specimen I saw once
on a man's gold ring in Italy. Who
could wear that showpiece of the atelier?
Only, perhaps, a witty prince.)

166 Personal adornment is out anyway.
Yet the citrus trees have kept up
appearances (no shortage of lemons).
I watch the progress day after day
of those novitiate spathes that erupt
from the peace lily.... a summons

from the offices of mediation. (Laws
are stipulated by plants too. See *stipule*).
Occasionally a rare aircraft
lights up the tropopause.
Where is the workshop of the soul?
His bed, I averred. You laughed.

Those late spring nights the street
was overrun with frogs, I walked with care:
a purse, a pulse ... a pulse-in-a-purse
mimicking the heart that skipped a beat
or made a choice in error
it couldn't, then or now, reverse.
Cold-blooded hearts everywhere I stepped!
Lentil-colored, stippled, with the froideur
of the ex-lover. What's one more plague?
Outside, it's too hot. Summer's overslept,
a season out of touch with the calendar.
The strip malls, dear A., exude nutmeg.

Chiminea

1
A girl puked on the tour bus
on the switchback up Vesuvius.
Her mother looked the other way
—out the window. Where else?
Wildflowers, hardy and tender,
seemed unaware of the perils
of flourishing in cinder.

We trudged, as through beach sand,
and when we got back on, sand
had been shoveled onto the mess.
I got my contraband: pumice
out of the core's juices—color puce—
alarmingly warm from the crater,
that supreme indifferent mater.

2
Chimeneas were all the rage.
Hemispheric, the copper bowl
hung fire, like the globe:
a cross-sectioned model.

In the dark behind us, what?
Panthers, birds of prey.
Night inverts the hierarchy.
The flames of February purify

the pique, the umbrage, the stuffy
dreams, the nasal cathedral
close with incense. Hence
our embers spray and cleanse,

our ash an alkaline scrub.
Never mind the Pompeiian brain
that turned to black glass—
a dark crystal ball wherein came to pass

the future: us, reflected in its sheen.
Having excavated his dream
(for we found the skeleton in bed),
we speculate now on papyrus scrolls

compressed into coded coals
that rose into the skies as smoke,
the burnt sacrifice of lyric,
ode, supplication, obloquy.

3

The log wouldn't take right away,
and we had no accelerant.
My son fetched dryer lint,
which did its voodoo. It burned
for the duration of a movie.
(Firecrackers, leftover, passé,
reminded us the year had turned

but wetly they popped, distant,
anticlimactic.) The full moon
was lost in cloudcover, mist,
winter's high dew point.
For as long as the hero kissed
the heroine, or a great fortune
was tied up in red tape,

we would hold out for the plot
which, abstracted to this,
was passion's caveat—
its propensity to ashes
swelling on a pillow of gases
then subsiding under the stars
and scouring meteors.

The Mysterious Barricades

These bareback races are medieval
in the modern sense: a bribe, a ruse,
the occasional fall, fracture, and a bullet

—but also in the sense of a retrieval
of standards and emblems, the use
of symbol, allegory, amulet,

the team colors you cannot refuse.
Tomorrow the terracotta dust
will plume for about two minutes

taking the imprint of horseshoes.
The beasts will reslot themselves addorsed
in bays like a train line terminus ...

Stone palazzos keep their iron rings,
which served as hitching posts,
antiquated and ornamental,

rusted and simple, the kind of things
the eye probes for the ghosts
of the enduring and the gentle.

Ahead of me walks an elderly pair,
divorced in the modern sense:
she employs him to manage her condo,

keep the villa in good repair,
til from tax exile (an expense
of spirit in the wastes of Monte Carlo)

she returns, scattering guests
with her dogs and her armory
of caustic appraisals and lightly flung

(as he scoops up her favorite) jests:
"Ah, you're just his type, Amore—
long brown hair, and much too young."

Treatise on Love

1. The Empire of Flora

A tossing garden in a rising wind,
an air of expectation. And Claire
tutoring me on the landscaping:
pagoda plants, crotons, a kind
of blue ginger; over there,
African lilies, bellwethers of spring.

When she points me to liriopes,
I expect the terrace to be inhabited
by a feminine miniature, nymph
or naiad out of ancient Greece
who makes a cushy, scented bed
for fauns, or Jupiter Himself.

I've forgotten that "cerulean Liriope"
is the mother of Narcissus.
The Empire of Flora, Claire says,
is a disquieting kaleidoscope:
limbs, and hair, and faces
of those that love discountenances.

For—as if I needed reminding—
immoderate love comes to no good.
Claire is wearing a crisp white shirt.

To garden? ... Ah, she's rewinding
her lecture on Poussin, who could
take the measure of our hurt

and scale it to the distance between
roiling heavens and rock terrain.
Now instead of pointing out plants,
she's mapping the labyrinthine
myths of that famous picture plane:
Smilax sprawls on Crocus; Clytie pants

after Phoebus, but what she wants
to show me is the distancing
of Narcissus from close-seated Echo.
"Look at how desire taunts:
gazing is at right angles to listening:
that tells you all you need to know."

174

The ear at right angles to the eye.
I never thought ... and now the rain.
White-haired Claire in her shirt
(spotless; linen; almost a shroud) my
new garden cedes. Palmettoes fan.
We put a frame around the dirt.

2. Voluptuous Provision

Ice storms shatter and varnish the South.
Up North, where my mother's housebound,
snow's furious refusal to fall wears out the wind
until it lies slack on swathes of earth.
Here, on a peninsula that looks, on the map,
like a toe shoe pivoting on the Caribbean,
orchards shiver their aromatic snow, driven
by green rain and purple thunderclap

(and the subtle palpations of the bees)
until the ground approximates Paradise's
parody of winter. How good it smells, this
orange blossom. If anything could freeze
time into a crux of possibility and fruition
both at once, it's this cluster of citrus
amid florets. I've been exiled to Paradise,
it seems: all seasons are now one.

Resurrection fern will grow in the groins,
lichen will pattern the trunk;
and where a harmless rat snake slunk,
silver moss will mint itself like coins
out of a magician's thin air. Production
is relentless, like the rain. Countrywide
ice and snow cause pileups that slide
into the next life, but this goes on and on

like my mother's television, 24/7,
she dozing in its glare, the Jack Russell
curled like a fox on the daybed. Oh well,
when the pandemic is over, I imagine
nothing will have changed very much.
Her cake and cookie clippings will all
have remained aspirational,
gesturing toward kitchen research.

And we will both have grown old.
How strange that the infant that lay
in her young mother's arms can play
at being contemporaries, as the cold
creeps south. Voluptuous provision,
keep me in your antic sight,
the ground of being underfoot,
fruit that mirrors back the sun.

3. Easter Mass Vaccination

In the event we forget the effect
of spiraling up the on-ramp
to expressways above the trees
where our eyes are wrecked
by sunlight bearing the stamp
of angelic principalities

and a hallelujah chorus
of so much chrome and mirror,
en route to the feculent parking lot
of a downmarket, dubious
strip mall—where we'll bare
a shoulder (pick one) in a squat

Federal Emergency Management
Agency tent set up with tables,
folding chairs and electric fans
whose roar is likewise giving vent
while we stick our printed labels
over our hearts. The bar code scans,

the flesh is swabbed and jabbed
by Navy personnel in camo,
surprise consideration in the gaze
above their masks. We're tabbed
and filed in seats row by row
for observation: is what this says

is that strangers are still good;
that when the stainless bandage falls
we are the beneficiaries, less of
new antibodies in the blood
than the ancient protocols
of principled and impersonal love?

BENJAMIN MOSER

Against Translation

A couple of years ago we rented a beautiful apartment in London, a large flat where we must have stayed four or five times. It was perfectly comfortable and perfectly private, and the location, directly behind the British Museum, was ideal for visits to theaters and museums. It was decorated in the taste of a refined gay man of my parents' generation. It had good Chinese porcelain, carefully chosen oriental rugs, witty French prints. It also contained the kind of photographs which, in that mysterious way, have grown dated without becoming quite old — gently pushed, by an accumulation of tiny changes, into the past. Some minute evolution in eyewear, some invisible

reformulation of lipstick, some arcane improvement in cameras, betrayed their age. They did not look ancient. But though I couldn't say exactly why, I knew that the pretty young bride was now middle-aged, and that a lot of the jolly middle-aged folks at Angkor Wat were now dead.

I also knew, as soon as I walked inside, that the house belonged to an American. I saw this by the shapes and colors of the books on the hallway shelves. It had never occurred to me that American books from the middle part of the twentieth century had such a specific appearance. Few had dust jackets. Their bindings came in serious colors: rusted reds, navy blues, vomity greens. Some were bound in something that looked like floral wallpaper, and that must have looked lovely when fresh; but few made the strenuous effort to be attractive that later books would. Their type was generously spaced. Their paper was sturdy, made of crushed rags.

I was unprepared for them to strike such a chord. Even before I saw the titles or the authors, I knew exactly what this library was. These were the books that my grandparents had on their shelves. In our world of painless communication and cheap travel, it was rare to see something that made my fatherland feel so distant. Here were the tastes and interests of Americans two generations removed from me, people I had known as a child: the people who came into the world around the turn of the twentieth century, and left it at its close. These were the books they had read at school, when they were young, and kept all their lives, even when moving across the ocean. They were too precious to give away — but not valuable enough to sell, not valuable enough for the kids, if there were kids, to keep. Most could be found for a few dollars in online bookstores. It was a miracle that such a collection had survived.

179

During my first week in the flat, I foreswore friends in order to pick through it. There was something about it that I wanted to understand. As I went along shelf after shelf, I felt an upswelling of emotion, suddenly close to people I thought I had finished mourning years before. Perhaps for the last time, I was a boy spending the night in my grandmother's house. I wanted to chronicle it, catalog it, before it disappeared forever.

I noted its specifically national focus: overwhelmingly American. The only foreign country that was well represented was England, which was not, in literary terms, a foreign country. The American classics began with the great founders of our nationality: *Travels and Works of Captain John Smith*, Bradford's *History of Plymouth Plantation*. There were some nineteenth-century books, including a *Life and Character of Stephen Decatur*, published in Middletown, Connecticut in 1821; and M. Sears' *The American Politician*, published in Boston in 1842, containing portraits of all the presidents "from Washington to Tyler." Most of the books were fairly common, or had been: two volumes of Bancroft's *History of the United States*, and parts of a series called "American Statesmen," which included Lincoln but also Lewis Cass and Thomas Hart Benton, this latter written by no one less than Theodore Roosevelt, who also wrote another volume about Oliver Cromwell. There were books about Charles Francis Adams and Seward and Sumner; *Mark Twain at Your Fingertips*; Mencken's *The American Language*. There was a selection of books about California: *Cable Car Days in San Francisco*; Oscar Lewis' *The Big Four*, about the railroad barons; and a book from the dawn of the twentieth century called *The Wild Flowers of California* by Mary Elizabeth Parsons. There were

works by Stephen Crane and Walt Whitman, Melville's *White Jacket* and Bret Harte's *Luck of Roaring Camp*; *Our Old Home* by Hawthorne and *Mont-Saint-Michel and Chartres* by Henry Adams; *The Titan* by Theodore Dreiser and *Lorenzo in Taos* by Mabel Dodge Luhan; Frank Norris' *The Pit* and Edna Ferber's *Giant* and Thomas Wolfe's *You Can't Go Home Again* and Willa Cather's *A Lost Lady*. There were seven volumes of the writings of John Greenleaf Whittier, and six of the *Works of Edgar A. Poe.*

Of the British and the Irish, the usual authors were represented. George Eliot, Sterne, Defoe; several volumes of Evelyn Waugh, *The Real Bernard Shaw*, books by Virginia Woolf, *The Gothic Revival* by Kenneth Clark, *Revolt in the Desert* by T.E. Lawrence. There was Tinker's *Boswell* beside an illustrated *Life of Samuel Johnson* in a couple of dusty boxes. There was a large multivolume set of Dickens, Morley's *Life of Gladstone*, *Travels with a Donkey* by Robert Louis Stevenson, *Letters of James Joyce*, *Byron's Poetical Works*, Alec Waugh's *Hot Countries*, Thackeray's *Vanity Fair*, De Quincey's *Works*, *Lady Chatterley's Lover*, *The Secret Agent* by Joseph Conrad, Sir Walter Scott's *Life of Napoleon Bonaparte*. And there was a smattering of foreign books, mostly French, alongside some Russian classics and some books from and about antiquity, in translation. There was Napoleon's *Correspondence with King Joseph*, Eve Curie's *Madame Curie*, Balzac, Marmontel, Molière, Dumas, Hugo, Rabelais, and ten volumes of *The Complete Writings of Alfred de Musset*.

I include this list as a record of something once so common that it would not have been noticed, much less documented: the library of the literate middle-class American, born around the turn of the twentieth century. The books themselves, individually, were not strange; it was the collection, representing the idea of a library shared by every educated

person, that had disappeared as utterly as the readers of Bret Harte or Morley's *Life of Gladstone*. The culture that connected people of my generation was popular television and music, and the consumeristic emphasis on newness meant that nothing lasted long. I noticed when I traveled that bookstores were as crammed with seasonal novelties as shoe stores; and used bookstores — this has been one of the saddest developments of my lifetime — had mostly disappeared.

As I perused these books, the feeling of going back into a past — my own, my culture's — filled me with a sense of reverence for an ancestral world. Even the kinds of books, like the multivolume sets, spoke of some other age. Were they expensive — like a Christmas present, something you might have to save up for — or cheap, cheaper than the individual books? I remembered them displayed, like encyclopedias, in the homes of my childhood. Now I only ever saw them at the very top of the shelves of second-hand bookstores, dirty — because rarely touched — and dirt cheap. They were too handsome to toss. But did any bookseller expect to find a taker for those seven volumes of Whittier? It was easy to imagine that an author might once have dreamed of having his career crowned in such a way. Now these sets were dust traps. Where would one begin to read such a thing? Who, now, would bother?

"It'll last another ten years," a friend, a rare books dealer in New York, once said to me. He had made a career selling the archives of authors to American research libraries. These libraries thrilled me. I worked in one as an undergraduate, and was dazzled by the range of its collections, the sum of the efforts of centuries of American bibliophiles. These libraries were a great collective work, our cathedrals, our monasteries. But the era of archives was over, he thought. Part of this was

due to the passage of paper. Researchers of the future would not have the pleasure of rustling letters, or the ability to see the scary way a once-neat handwriting starts to unravel during a painful breakup, or as a writer grows old. There would be no more envelopes with postage stamps from exotic lands — no more finding, caught between the pages, the stray hairs of a great poet. Activity that had once been the province of paper had moved onscreen.

Books, he said, were disappearing.

Books had always disappeared, in a different way, as they passed from literature into the history of literature. Their life cycle, if they last long enough to have one, begins with a first reader. It is exciting to read writing that is not yet a book, a possible book from the future. If this writing is published, there will be a moment of publication, when a book's destiny is unknown. We know most books will be ignored; only the lucky ones will be embraced and attacked, interpreted and misinterpreted and translated, reprinted and revised and reviled. During this process, the book is contemporary, part of what people are talking about — the current life of the culture. This life eventually winds down, and as a book has a first reader, it has a last one, too: the last person who picks it up and reads it as an artifact from his own time. When this last person puts it down, it belongs to the past.

But that is not the end. Now comes the first person who reads a book from the past, the first who looks through it in order to see another age. In this guise — as a reference, a school requirement, an object of study — its life can be far longer than its flash of contemporary relevance. It joins a culture that connects people to something bigger than themselves, that gives them a sense of where they came from. And they keep that culture alive because it defines their sensibility and

helps them to understand it. This is why time burnishes the greatest works. Yet their beauty will change. It will come to require a key — as a poem by Virgil, immediately comprehensible to any Roman, requires years of careful study by those for whom Latin is not a natural language, and for whom the religion of Rome is a quaint mythology. As centuries pass, that knowledge becomes available only to those willing to dedicate years to acquiring it. I did not know anyone who naturally understood the world that produced a Greek statue or a painting by Jan van Eyck. But I had known plenty of people who had read Theodore Dreiser or Thomas Wolfe when "everyone" was reading them — before they had been handed over to antiquarians and graduate students. There is no one alive who remembers them that way now.

I noted the information I was finding about the men to whom this library had belonged. The older was Ney Lannes MacMinn. There was a book, *Riley Child-Rhymes with Hoosier Pictures*, which seemed to have been kept to remember an Indiana childhood. There was a date, August 7, 1922, and a place, Hammond, Indiana. I thought he must have been about to leave home then, perhaps for college, since another date follows: January 14, 1923, Champaign, Illinois. He was, however, a bit older, as I learn from the single internet page with any information about him, from Northwestern University.

He was born in Brockway, a dot on the map of western Pennsylvania, in 1894. He studied at Westminster College, further to the west, near the Ohio border. He served with the United States Army for two years in World War I, and remained in France to study at the University of Toulouse.

Upon his return to the United States, he completed a master's degree at the University of Illinois, and then went to Northwestern, where he completed his Ph.D. in 1928. His archive, at Northwestern, ranges from 1924 to 1994, "with the bulk of the material from 1941-1967," the year he died. This entire archive fits in a single box.

Online, I find one photo of MacMinn. It is a news photo, for sale for nine dollars. He is in a study. He is not wearing a tie, and the jacket of his suit hangs, rumpled, on the back of his chair. On the shelves and table, books and papers are piled in a way that suggests frenzied thought. The room and the attire suggest that the photographer has snapped him in the heat of some great scholarly endeavor; he had not had the time to fix his clothes, put on his jacket, make his office more presentable. His face is timid, almost haunted. He is hunched in his chair — as if aware of the self-consciousness of this pose — as if crushed by the library and what it seemed to expect of him — by the photo and the role it asked him to play. There is a handwritten caption on the back:

> This American professor of Philosophy has chosen a
> houseboat on the seine to live and pursue his work: A
> learned 70 year old American, professor Ney Lannes
> Macminn became aquinted with France as a combat-
> tant in 1914-1918, and then as a student at the Faculte
> de Toulouse. He always retained a certain nostalgia
> for it so after receiving a doctorate in philosophy in
> England, he bought a house boat in Holland and went
> to sttle in Paris on the Seine where his boat is moored
> near the Concorde. A specialist in social questions and
> especially of the great English Phlosopher of the 16th
> century Thomas Morus, he is preparing a large work on

185

Against Translation

the relations between the Utopias of the 16th century. Professor Ney Lannes Macminn in the library installed inside his houseboat and which contains 6,000 volumes and precios manuscripts.

From photo and caption, a dream emerges, and a life story. A war sweeps a bookish small-town kid to Europe. We do not know what he saw in that war. But we know that he retained a "certain nostalgia" for France. For forty years, semester after semester, Midwestern winter after Midwestern winter, as his first students were themselves starting to grow old, he cherished a dream of taking up the life that he had glimpsed. The brief Northwestern biography said that he had been married and divorced twice. I had the strong feeling that he was gay. There was a note from the archive description: "The correspondence, spanning the years 1939-1967, is primarily between MacMinn and Macklin B. DeNictolis, a former student and close friend of MacMinn's." Perhaps there had been a boy in Toulouse; perhaps you could live in France as you couldn't in Illinois. He dreamed of going back, bringing those six thousand volumes, writing his large work, mooring his boat "near the Concorde." And then, on that boat, he would discover that it was too late. Such a dream was bound to be disappointed; I imagine I see that awareness in the photograph. He died three years later, the work unwritten.

I do not know how the library I saw, which had nothing like six thousand volumes, reached its next proprietor. On the internet, which contains almost no information about him, I find that Carson Kohle was born in 1932 in Ventura County, California, and died in London in 2011. I cannot find any pictures of him, and wonder at how someone who lived in central London in 2011 could be so absent from the

internet. He seems to have been a businessman, and though I assume the slightly aged family pictures show relatives, there are no names besides his. His taste was outstanding. He had a penchant for exotic travel, and in his time — he was born fourteen years before my parents — travel was far easier than in MacMinn's. His books reflect that easy time. The old canon expanded to include works from all over the world: *A Survey of Zairian Art, Woolf in Ceylon, Chronicle of the Chinese Emperors, L'art du Mexique ancien, Art & Architecture of Cambodia.*

When I left MacMinn's books in the purgatory between the rare and the out-of-date, the antique and the merely old, I turned, with relief, to these bright illustrated volumes. MacMinn's books witnessed a single tradition; Kohle's, the moment when that tradition burst into a wider world, preparing for the Great Expansion of which I was a part. It was like seeing an old museum add a wing for Asian or Pre-Columbian art. Such an addition would complete a view of the world. It would assert a cosmopolitan ideal that felt natural to me. It was a globalized culture, but when viewed alongside MacMinn's library, it seemed firmly anchored within a specific national culture. And you needed a national culture before you could generate, or create, an interest in the cultures of other nations.

I have spent decades translating books and advocating for international culture. I am proud of this work, especially my part in bringing Clarice Lispector from Portuguese into English. This project, sustained over decades, corrected an injustice: she now stands in her rightful place among the great writers of the twentieth century. Yet even while I was doing this work,

I was growing more skeptical of my assumption that an international culture can exist, at least more than superficially; of the idea of the museum with expanding wings.

I did much of this work in the Netherlands. During my many years living there, I marveled at two things. The first was how well, how easily, how nearly accentlessly the Dutch spoke English. For English speakers, used to thinking of speaking a foreign language as something like a superpower, the assumption that everyone could and should speak at least a couple of languages seemed dazzlingly superior. At the same time, I marveled that, though fluent in our language, the Dutch always sounded, when talking about the United States, like people offering insights into the affairs of a celebrity known only from glossy magazines. ("I can't believe Jennifer Aniston is dating a guy who clearly doesn't deserve her.") They explained our country to us with an overfamiliarity, a shallowness, that annoyed Americans in the Netherlands. We were frequently forced to endure denunciations of racism, the Second Amendment, or the Electoral College, as if, until the Dutch had come along to explain them, these were things Americans had never noticed. I doubt that Omanis or Sri Lankans were schooled about their own societies as often, or as thoroughly, as we were. And this illusion of intimacy was made possible by a knowledge of our language.

Those conversations, and their relentless superficiality, revealed that knowing how to speak and understand a language — which children master before kindergarten — was only the tiniest part of *knowing* a language, which even native speakers rarely achieve. I shudder to think what percentage of Americans can consistently write and speak without errors of grammar or spelling. (I shudder even more to think that this number is higher in the United States than in most other

countries.) Yet grammar and spelling are only the surface. Imagine a newspaper, written in perfectly correct English, that covers the culture, sports, economics, and current events of Oman, written for an Omani audience. You could read it. But you would miss a lot.

My Dutch neighbors would always be missing something about us. And I would always be missing something about them. Indeed, the deeper I went into languages, the more I bumped up against an immovable barrier: that intuitive feel for the resonances in a word — a question of music, of something you felt physically, in your ear. Even without complicated vocabulary or poetic turns of phrase, words sound different in different languages. The most straightforward English sentence sounded entirely different when turned into Dutch, to which English is closely related. This mystery suggested something besides the complaint that translation is difficult — and something besides the cliché, which made me impatient, that something is "lost in translation." After all, something, namely a new book, is also gained in translation. Even the limited access that translation provides is preferable to no access at all.

The push for translation has been a central part of the literary culture of our time. Like the new wing for Asian or African art, this was something I cheered. But it rests on presuppositions, as I slowly started to understand, that have not been adequately examined.

It is not easy to learn your own language. French kids had French class; Dutch kids took Dutch. I, like every American child, was taught English every day until I graduated from high school. I

learned spelling, punctuation, vocabulary, grammar. I learned something else, too, though I didn't realize it at the time. Learning how to read and write meant being brought into a community, inducted into a tradition. By learning what people around me mean by the words they used, I was being prepared for citizenship within the culture into which I was born. I would not be like those people reading an Omani newspaper, seeing effects without being able connect them to causes.

This preparation demanded years. It was an immersive training for immersion. It had a ritual aspect, and it taught a sense of community, the value of a collective experience, of "we." We were being instructed in filial piety. To see oneself as a son or daughter is to understand that one has emerged, inevitably and inalterably, from a specific time and place; and by connecting the speakers of a language with those who lived before, my teachers were preparing us to play a modest part in the great collective work of our particular tradition.

This tradition existed in sharp opposition to another aspect of our culture, whose values were derived from the fashion and music industries, from popular television and our never-ending election "cycles." The basis of the consumerist society was the illusion of uninfluenced individual liberty and choice. The study of grammar, however, revealed that we did not have choices in some basic matters. It revealed structures so deeply embedded that we were unaware that they were structures. Unless a teacher points it out, it would never occur to an English-speaker that our sentences use a subject-verb-object order — and that such a structure, so inevitable to us, would be unnatural to the speakers of many other languages. And as we study Shakespeare, for example, we learn that so many of the words we use to structure our interior lives are the product of a single long-dead writer. Thoughts we assume

are our own move in grooves set down centuries before us and make our minds different from those of people who speak another language.

I came to think of a language as an old city. When I first came to Holland, I was struck by the Amsterdam canals, perfectly preserved relics of the days of Rembrandt, miraculously handed down to us from a distant Golden Age. But as I grew more familiar with the city, I realized that I had been tricked into thinking that the city was a perfectly intact Baroque relic. When I examined it house by house, I found buildings in dozens of completely unrelated styles: neoclassicism, Jugendstil, postmodernism, rococo, brutalism. Yet none of these novelties — and some were wildly extravagant — disrupted the general impression of unchanging, venerable age. I became fascinated by the question of how this coherence was maintained.

I concluded that the style did not matter as much as the restrictions imposed on any building here. Every builder was bound by a series of rules, some of which seemed obvious and some of which did not. Climate, for instance: Amsterdam's location in a northern marshland. Geology, which placed a layer of sandstone beneath a shallow skin of water. History, which laid down the streets, dug the canals, divvied up the lots. Economics, which made land too expensive to permit large projects. Politics, which forbade certain constructions. Any building had to adapt to these limits, no matter what façade you put on it. The result was a near-perfect visual harmony.

I came to think of a book as a house, and of a literature as an old city. The products of millions of anonymous hands, both a city and a literature contained an enormous range of constructions, and had room for an astonishing diversity; but they also emerged in a specific place, under specific conditions, and

191

imposed — invisibly, invariably — a series of views on their inhabitants. Like a city, a literature took its character from the continuous encounter of young people with a tradition. Their responses added to it, like new houses in an old city. It was this chain that distinguished a city from a collection of houses, a literature from a collection of books. It seemed urgent to understand the foundations upon which our city — our language — was built. Literature told us what our words meant, who and what we were.

"Whoever writes in Brazil today is raising a house, brick by brick, and this is a humble and stirring human destiny," wrote Clarice Lispector in 1971, using another architectural metaphor. "We are hungry to know about ourselves, with great urgency, because we need ourselves more than we need others." In Brazil, there were many reasons for this urgency. One was historical. Unlike the English, Spanish, or French colonizers, the Portuguese forbade printing from 1500, when they first arrived, until 1808 — three hundred and eight years of forced cultural dependency. The nation had been starved of its own literature, and this explained part of the hunger, the great urgency, that Lispector described: the need "to use a Brazilian language inside a Brazilian reality."

This was an older story. In one form or another, many countries shared a history of colonization or censorship. In recent years, however, a new threat had emerged that was different from the old attacks on languages and their literatures. This was the threat of English, the threat from English, the imperial language, all the more insidious because it looked so attractive. For billions of non-writers, English was

the language of education and economic advancement. For writers, English held out the promise of a truly international readership. To be published in English meant joining the broader conversation to which artists aspire. It also meant the prospect of a financial independence unavailable to writers who could only sell their books in a single small country.

English was so useful, it offered so many possibilities, and it was precisely this usefulness that threatened even languages protected by rich and populous states: this was the argument of the Japanese novelist Minae Mizumura in *The Fall of Language in the Age of English*. The book reflects on her unusual life story. Owing to her father's work, she moved to New York at twelve, then stayed in the United States for twenty years, all the way through graduate school. This meant that when she embarked on a writing career, she had the luxury, which almost no other Japanese writer shared, of being able to choose English. But she didn't. She rejected a language spoken "everywhere" in favor of a language spoken in a single nation. Japanese had millions of readers, but nowhere near as many as English.

Mizumura had made a brave choice, a choice with integrity, one that required a certain stubbornness. The promise of English was the allure of "universality," but it also had the unintended effect of downgrading every other language to "local" status. Why be local when you can be universal? My partner, a Dutch novelist, had his early books translated into English, and this, for any Dutch writer, was the opportunity of a lifetime. It meant escaping the country-and-a-half where Dutch is spoken in order to be read all around the world — in the English-speaking countries and in lots of others, too, since an editor at a publishing house in Paris or São Paulo or Tokyo who cannot read your work in Dutch can read it in English.

For a while, he was published all over the world. But despite excellent reviews the books sold indifferently, and eventually they stopped being translated.

This was more demoralizing than if the possibility had never existed in the first place. In earlier times, it hadn't. With only the rarest exceptions, Dutch, Brazilians, and Japanese built houses in their own cities, never expecting to be read beyond their own countries. Now the possibility of projection was dangled in front of writers, from novelists to poets to the authors of self-help books. In recent years we have seen writers outside English become global phenomena: Elena Ferrante, Karl Ove Knausgaard, Haruki Murakami. But such a literary life, the popularity owed to translation, began to seem a little fake to me. And when I read Mizumura I found myself agreeing that, strictly speaking, literary universality does not exist. The books I loved were, after all, about something, not everything. But even in practical and commercial terms, the prominence of English created more losers than winners, favoring, like so many other forms of globalization, a handful of instantly recognizable and inoffensive brands.

I was never "against translation." I spent more time studying languages than almost anyone I knew — aware that even the most dogged student could never master more than a handful, and dependent on translators to read the classics of those languages that I would never be able to learn more than superficially. I will probably never learn enough Russian or Greek, say, to be able to read the books in those languages without which no person could really consider himself educated. But I didn't read foreign books in order to consider myself educated. I read them because I liked them. And because I could: either I had studied the language or publishers and translators had made them available to me. For years, I read

more in foreign languages or in translation than in English. I probably still do.

But my reading reflected scholarly interests — in Brazilian literature, for example — that were not easily generalized to a broader English-speaking public. It was hard enough to find readers for even authors of unquestionable canonical status. It took twenty years of work to bring Clarice Lispector into English. This meant translation in the sense of "Englishing," as well as in the Latin sense of bringing something across. This is the work of proselytization. It meant, in this case, spending five years writing a critical biography. It means everything that goes into publishing a translated book once the text is ready, from making sure that it is attractively designed to making sure that it gets sent out to influential people to making sure it gets reviewed to making sure it gets into bookstores to getting blurbs, writing introductions, giving interviews, speaking at universities, assisting theatrical productions, sending and answering thousands of emails. Not everyone has the time or the ability or the interest to do this. As a profession, after all, translating is even less lucrative than writing. But I never thought of it as a profession; I thought of it as a labor of love.

Yet in the twenty years since I began working on Clarice Lispector, the rhetoric around translation changed. From something that belonged to the field of scholarship or to art or to love, it started to become a kind of obligation. The increasing dominance of English made people like me feel that we ought to do something to counteract an unjust situation of which we were the apparent beneficiaries. English had come to appear as an unearned and inherited "privilege," like certain skin colors or class origins or sexual orientations, and it was an important part of the sensibility of my generation to

195

foreswear such privileges, to work to reverse them. I myself imagined that my work with Lispector was a way of resisting the dominance of English. For those who did not want literature to become another corporate monoculture, the privilege of English was a source of guilt — a moral affront, even, that accounted for the stridency which surrounded discussions of translation in the English-speaking world.

In those discussions, no one questioned the basic goodness of translation. It was good for the authors translated, who gained access to a readership they would otherwise have lacked. It was good for us — mostly meaning educated, middle-class American and British readers. Without translated literature, we would be doomed to provincialism. Even worse: the provincial refusal to publish, to buy, or to read foreign books was in fact a kind of chauvinism, a high but still very low variety of xenophobia. (I was never sure who was actually refusing.) For these reasons, the bookshelves of my generation were far more international than those of our grandparents, the kinds of bookshelves that I found in London. At least in our tastes, we were principled cosmopolitans.

Many of these books were, of course, marvelous — books we would have hated to be without. And those of us who advocated for translation saw ourselves as the heirs to a movement of broadening the canon, expanding it, as our parents' generation had fought to include works by certain artists, particularly women and African-Americans, who had been excluded by old prejudices. That movement had been accused of undermining the idea of a common heritage. It was true that, in some quarters, the "canon" was spoken of with a sneer. But that was never the intention of the people I knew who had dedicated themselves to reform and expansion in this area. We simply wanted to make more books available to more

people. And over the years this movement brought to light all sorts of fine overlooked works.

Yet reading books like Mizumura's made me wonder if we had looked at this work — at translation generally — too uncritically. The emphasis on success in English that Mizumura lamented meant a transfer of critical power to people outside a writer's own language. I knew what she meant, because, through my work on Clarice, I had inadvertently become one of those people. My efforts had earned her global prominence and had earned me the love of many Brazilians. I had not "discovered" her — she had been venerated in her own country for years by the time I came along — but it was true that my biography, and then the series of translations I published, brought her a new level of international recognition. She was, for example, the first Brazilian on the cover of *The New York Times Book Review*. For me, it was exciting to see a labor of love — carried out in obscurity, and at great expense, over many years — rewarded with such affection. For Brazilians, it was exciting to see one of their own so warmly applauded abroad, and this success brought her a new level of recognition within her own country. At the same time, I was well aware that I had brought her into the imperial language, and that I would not have received a fraction of this gratitude if I had brought her into Dutch, French, or Japanese.

Was that right? I knew from conversations with writers around the world that the prospect of success in English was distorting the way people received their own language. As more and more books were translated, the judgment of a few faraway "gatekeepers" was elevated above the judgment of the readers of one's own language. It was nice to enjoy critical success in São Paulo or Tokyo or Amsterdam, but if the possibility existed for success in New York, then "local" success, success in one's

own language, was no longer enough. One's book was placed in the hands of foreigners, for whose interest one was grateful; but they could never replace the healthy critical culture, the thoroughly knowledgeable culture, the deeply racinated culture, that intellectual and artistic life requires.

On our end, the English-speaking end, it was important to remember the distinction between cosmopolitanism and dilettantism. We were people for whom it was common to eat a different cuisine every night of the week — Thai on Monday, Italian on Tuesday. A wide-ranging taste in food was a central aspect of our sensibility, and a penchant for travel — we were better traveled than any other generation in history — had committed us to tourism, which is a meager way of acquiring knowledge. Tourism is not only an itinerary, it is also a cognitive state. And visiting foreign countries is not the same as dipping into foreign literature, in which so much understanding depends on years of difficult and sustained scholarship. The deeper you sustain that scholarship, the more you appreciate how many works really could not be translated. You cannot have the building without the whole city.

Even within a language, cultural differences can be difficult to bridge. Any American who has lived in Britain, any Briton who has lived in America, knows that a shared language is no guarantee of understanding. We comprehend each other's words, but we know how little this can mean in practice: without having lived in Britain, Americans rarely understand the jokes on British television, for example. Was translation creating a simulacrum of a common language? I became skeptical that even closely related cultures — say, Britain and America — could ever really understand one another. I became skeptical even that they need to. What they need is to respect one another.

"We need ourselves more than we need others," Clarice Lispector wrote. Could an English-speaker say the same?

Much of my life has taken place within a certain English dialect. It was my mind, my home. And it seemed inclusive. You did not need to belong to a particular race or tribe in order to speak it. It was the vehicle for the diversity seen in the great English-speaking cities, where people of different backgrounds lived together more in harmony in than conflict. Yet it was also the vehicle for gentrification, for homogenization — for condos and branding and duty-free stores and management consulting. Like the internet, it was "universal," prized precisely because it seemed free of any connection with any one place or people. That was fine for those whose interest in the language was chiefly transactional. But for us to view our own language as a neutral medium, denuded of its particularity and uncoupled from its history and culture, was to risk turning our own city into an airport mall, stripped of vitality or personality, a space without past or future, where business is conducted in the most inert and boiled-down form of English. This is a place where everyone is only passing through, and a language that exists only in the present tense.

This denatured language, this nondescript space, was appropriate for an age of globalized capitalism — for a time of generalized forgetting, an era when the past had lost its authority. When I saw that library in London, I thought of a change that my professor friends were always warning about: their students knew so much less, had read so much less, than students did five or ten years ago. It was easy to dismiss this as the whingeing of the middle-aged, but I had heard it from

enough different people in enough different places that it came to seem plausible. It always reminded me of a sentence from an interview I once read, I don't remember with whom, but I did remember the phrase, and especially the italics. His students, someone said, had never heard of Carol Burnett — *"and they never will."*

As a Brazilian or a Japanese would have felt a pang at sacrificing their cultural heritage, so, too, did I. To see that library was to see something that was impossible to reduce to a neutral, indistinct, universal language. It was so specific: this culture, not that culture; a particular culture; my culture. Ours was one of the oldest continually written literatures in the world, an uninterrupted stream that goes back beyond even *Beowulf*. But if our books are no longer read, if that tradition is not kept alive, then the great river of our language — the White Nile of Britain and the Blue Nile of America and all their smaller tributaries — will be reduced to a drool of tweets and ads. A city cannot paint itself, collect its own trash, restore its own cathedrals, and neither can a cultural tradition maintain itself: *people* need to maintain it. Yet that cultural maintenance, that literary education, has passed out of fashion, even out of legitimacy, and it is not likely to return. The books that made up my tradition are no longer read — *and they never will be again.*

When speaking of the substance of that education, it was easy to quibble about texts — *Beowulf*? — and lose sight of the goal. This was to teach people how to read, and how to understand what they read. Easy to describe, this goal was difficult, expensive, and time-consuming to reach. The reading that was taught by the old education demanded a protracted and intense focus, a wariness of sheer novelty, that is at odds with nearly everything in contemporary culture;

200

and so, without the authority of the past, we have been delivered to the tyranny of opinion, and all of us now live in the disinformation age.

The evidence is everywhere that native speakers of English no longer understand their own language, and no longer bother to try. They no longer require of it anything more than practical communication; as in the rest of their lives, they demand of their language mainly efficiency and informality and velocity. And if this is the case with our own language, how much could we understand of anyone else's? And how, absent years of dedicated scholarship, could books from other contexts be read or understood? Much advocacy of translation relied on the idea that it was enough to bring a foreign text into our language, and serious readers would do the hard work of diving deeply. But one risk of emphasizing works in translation was never spoken: that a smattering of Polish or Yoruba or Chinese books would be playing into the same vogue for novelty, for passing sensations and transient enthusiasms — for multicultural sanctimony — that was undermining every other area of our cultural and social life.

There is nothing wrong with reading a book from a culture that one does not know well, but I do not understand the insistence that in itself this is a positive good. It depends on the book; it depends on the reader. And it strikes me that, after years of following these debates, I rarely heard a justification beyond "diversity": an unanswerable concept that dispensed with other justifications — artistic, scientific, scholarly, spiritual — for translation. It was harmless to enjoy Swedish crime novels or Elena Ferrante, but such enjoyment no more implied a familiarity with Scandinavian or Italian literature than enjoying Mexican food denotes a familiarity with Mexican culture.

201

Translation without context can be a form of consumerism, of tokenism, of — dare I say it? — "cultural appropriation." The real problem with "cultural appropriation" is that it does not appropriate deeply enough. Clarice Lispector called Brazilians "fake cosmopolitans," and the term seems uncomfortably appropriate to us: people forever dipping in and out of cultures they hardly understand. By expanding into too many other worlds, we have sacrificed depth in our own, and cut ourselves off from what was particular, and profound, about us.

Translation — not the thing but the unquestioned emphasis on its virtue — started to feel to me like another philistinism masquerading as worldliness: another part of the infrastructure. The way we read, the way we engage with the world, resembles the ways we travel: journeys that, though distant in terms of mileage, were almost always inside our own class. As Chesterton observed, travel narrows the mind.

During my years in Europe and Latin America, I realized that most contemporary books that ended up being translated were written by the people whom "we" felt comfortable with. These were the people who lived in the neighborhood we would choose to live in if we lived in Bogotá or Budapest, the class of people, shaped by the infrastructure, who shared our tastes, politics, and cultural interests. I started to become sure that a book from or about Paris, Texas, would have been far more instructive to people like us than a book from or about Paris, France. Frequent-flying is no proof against provincialism, as anyone who has ever observed frequent flyers knows.

It took me a long time to realize this. It took me a long time to grasp that reading international literature might make one less cultured, less educated. When I found the library in London, I saw why it would be pointless for people with such a shaky sense of their own culture to try to engage with others. Instead of deepening our understanding of our tradition, we had opted for engagement with people who, though from other places, were in so many ways just like us — not least in their detachment from their own culture. This was why Mizumura seemed so radical to me. She had made a choice that nobody I knew had made.

For her, English was a threat. Most advocates for translation in the English-speaking world agree. But as I looked at those volumes, I began to wonder if the culture that threatened other languages was hollowing out English, too. That culture goes by many disparaging names. It was called "corporate," "capitalist," "neoliberal"; it was taught as "Business English." It was the vehicle of the infrastructure, for the most basic communication: for checking into a hotel, sending an email, participating in a sales conference. It makes no claim to tell you who or what you are. It is a language that calls for an app, not a library.

I felt it as a loss the way I regretted the loss of other sensibilities: the way I regretted that other once-distinct groups to which I belonged, gay people, for example, or Texas people, had been absorbed by the globalized monoculture. This was the feeling that Mizumura described in seeing Japan reduced to just another satrapy of the empire, its culture — because it is not conducted in English — second-rate almost by definition. Since English is our natural language, it is a bit harder for us to see that this universal language, so convenient for us, is becoming thin and bland and insecure, or how "Business

203

English," the lifeless argot of transactionalism, is seeping into real English.

Another reason for the erosion of our literary tradition, for the passage of those books into obscurity, was that we started to regard our own culture with increasing wariness. Behind the movement in favor of translation was a feeling of failure that had been creeping up on us. When I was younger, it seemed harmless enough to indulge in performative guilt about the dominance of English. Constant atonement for sins we had not ourselves committed was, after all, a salient characteristic of our culture, and often enough yet another expression of our comfort and security. It was an expression, too, of the belief in philanthropy that colored so many of our interactions with people from different backgrounds. Translation was a form of atonement for being exempted from the increasingly universal requirement to learn English.

As I grew older, the movement for translation started to express something else. Many of us who grew up in triumphant America experienced, as we entered middle age, a loss of confidence in the culture that raised us. We felt despairing about political reform. We were embarrassed by the condescension of our philanthropy, and appalled by the empire that we stood to inherit. We started to see our language as a force that, like our armies and corporations, swept everything before it. Like other great languages, English was the product of a great empire; and some embraced translation as a form of resistance to that empire, to a culture we felt was ill — a culture that, in some fundamental way, had failed.

Maybe it had. There was no doubt that there was a lot in our collective past that was shameful — though how this made us different from every other nation was never clear to me. What was clear was that feeling ourselves to be the worst was

— like feeling ourselves to be the best — characteristic of our particular form of national narcissism. And I thought that, if we were going to turn our backs on our patrimony, we ought to do it consciously. We ought, at the very least, to know what that culture was, what it had been.

JONATHAN ZIMMERMAN

The Quiet Scandal of College Teaching

In 1925, student delegates from twenty colleges met at Wesleyan University to discuss a growing concern on America's campuses: the poor quality of teaching. They decried dry-as-dust professors who filled up blackboards with irrelevant facts while students doodled, read novels, or dozed off. At larger schools, "section men" — soon to be known as teaching assistants — led aimless discussions or simply lectured, in a dull imitation of their elders. What was the point of going to college, the students assembled at Wesleyan asked, if you didn't learn anything in class? "It is not that college boys have ceased to have a good time on the campus," wrote a correspondent from the *Boston Globe*, one of

several national newspapers that covered the conference. "It is rather that an increasing proportion of them are wondering what college is all about and why they are there." The keynote address was delivered by James Harvey Robinson, a historian and one of the founders of the New School for Social Research, who dismissed most college teachers as "insufferable bores." He urged the students to "stand up and kick" against poor instruction, because "college belongs to them."

Belongs, indeed. In a higher education system financed mostly by tuition dollars, the customer is king. Colleges and universities have become full-service lifestyle stations, competing for students and catering to their every material need. Become your best self, the brochures proclaim; find the real you. But if you look at the pictures, you will see that everyone is somehow finding their best selves in really nice gyms, dormitories, and dining halls. Of course, there is enormous variation across our 4,700 degree-granting institutions; almost half of the student population attend community colleges, for example, which are almost never residential. But every school must fill the coffers and balance the books. And the best way to do that is to advertise "the experience" — that is, the fun you will have in those beautifully appointed spaces — or the opportunities they will provide to you down the road.

I, too, had a lot of fun in college, which opened doors to the Peace Corps, high school teaching, graduate school, and the professoriate. Yet it also opened my mind to strenuously different ways of seeing the world. Surely, college should be about something more than a four-year party that sets you up for a decent-paying job; it should improve the way you think, by exposing you to rigorous and imaginative instruction in the classroom. That is what the students who gathered at Wesleyan a century ago agitated for, and I think they were right.

It is hard to find that dissident spirit on our campuses right now. To be sure, students "stand up and kick" — to quote Robinson — about a wide range of issues, especially those related to race. Over the past five years, they have demanded compulsory diversity training for faculty, multicultural centers for minority students, limits on campus police, and much else. But they have not demanded better teaching. During the recent pandemic, students at dozens of schools petitioned for tuition discounts on the altogether reasonable grounds that Zoom classes were not as good as the regular kind. But there was no organized protest to improve virtual instruction or to replace it with in-person classes once that became possible. My own university invited students back to campus last spring but continued to teach them virtually. And most of the students seemed fine — or more than fine — with that. They got the college experience, albeit a socially distanced one. And they could take classes in their pajamas, interrupted only when their Wi-Fi went down or when their tech-challenged professors hit the wrong button.

I did the best I could, teaching all those faces in all those boxes, but it was not good enough. As a wide swath of surveys confirmed, students thought they were learning less in online classes than in face-to-face ones. That was especially true for low-income and first-generation students, who more often lacked reliable internet connectivity or a quiet place to work. To their credit, some institutions provided grants and other kinds of emergency assistance to these students. But the worries over "equity" were not matched by a broader concern about the overall quality of education that our institutions were delivering to everybody. Our campuses get riled up whenever someone alleges that a certain group does not have equal access to the educational goods of the university.

But whether the university itself is good at educating does not seem to exercise us at all. "Nothing can straighten out the college question except good teaching," declared a student leader in 1924 at Dartmouth, one of dozens of schools to witness protests over poor instruction. "Everything else is besides the point." Today, college teaching is mostly besides the point. Almost nobody stands up and kicks about it; instead we sit on our hands.

This complacency has one over-riding cause: the research revolution, which began in the late 1890s and was kicking into full gear by the time of the Wesleyan conference. First at larger universities and eventually at smaller schools, institutions organized themselves around the production of knowledge. Replacing the avuncular ministers and doctors who taught at the nineteenth-century colleges, a new generation of specialists came to dominate the professoriate. They were "doctors," too, but of a different type: they had earned a Ph.D. by performing original research in the laboratory or the archive. Whether they could teach was besides the point, as William James noted glumly in 1903. "Will anyone pretend for a moment that the doctor's degree is a guarantee that its possessor will be a successful teacher?" asked James, who taught psychology and philosophy at Harvard but did not possess a Ph.D. in either field.

The question answered itself. Faculty were hired and promoted based on their research potential and achievements, not whether they could successfully educate the students in their charge. Indeed, a reputation for skilled teaching could be the kiss of death to an academic career. "Many college professors are suspicious of a colleague who appears to be a partic-

ularly good teacher," a dean at Ohio State admitted in 1910. "There is a rather widespread notion in American Universities that a man who is an attractive teacher must in some way or other be superficial or unscientific." If callow undergraduates could understand what you had to say, the argument went, how significant could it be?

In the 1920s, the undergraduates struck back. University enrollments skyrocketed, fueled by overall economic prosperity and — especially — by the revolution in gender norms: consigned mainly to women's colleges before that time, female students flooded into the larger universities. That meant ever more crowded lecture halls where students strained to hear the professor so they could copy down what he said before spitting it back on a test. You didn't have to be John Dewey to know that this was not a good way to learn. Echoing a quip attributed to Mark Twain (although there is no record of him saying it), students routinely described college as the place where the professor's lecture notes passed to the student's notebook without passing through the brains of either.

Others denounced the instructional system as "Fordized," a ruthless human factory that mass-produced students just as Henry Ford built cars. In campus editorials and demonstrations, they demanded smaller seminar-style classes, independent tutorials with professors, and a range of other reforms to "personalize" their education. They also developed and distributed evaluation forms about their professors, a bottom-up student movement that was later appropriated by college administrators. Professors almost uniformly resisted such ratings, which brought a sharp rejoinder from the Cal-Berkeley student newspaper. "The Academic Senate is naturally concerned with the privileges of the faculty, but we are just as naturally concerned with the rights of the students,"

it declared in 1940, after the Senate refused to endorse student evaluations. "Who is to protect them against poor teaching?"

The next great wave of growth in higher education arrived after World War Two, when the G.I. bill brought millions of new faces into American college classrooms. Half of American students in 1947 were military veterans, who did not suffer poor teachers gladly. "If pedagogic desks were reversed and the veteran in college now were given the opportunity to grade his professor, he would give him a big red 'F' and rate him as insipid, antiquated, and ineffectual," one journalist wrote, taking note of veterans' complaints about boring lectures, useless discussion sections, and so on. Nor did faculty members shy away from criticizing their own. In 1951, an English professor at the University of Detroit published a list of the "Seven Deadly Sins of Teaching": failure to prepare, sarcasm, dullness, garrulity, tardiness, digression, and belligerence. A University of Missouri professor reduced the list to four bad-teacher types: Ghost, Wanderer, Echo, and Autocrat. The Ghost discouraged discussion and exited class right after the bell; the Wanderer rambled from one topic to another; the Echo simply repeated what was in the textbook; the Autocrat treated students as if they were inmates in a prison.

As in the interwar years, students demanded smaller seminars and discussion sections to leaven the anonymity and tedium of large lecture classes. But when the University of Chicago psychologist Benjamin Bloom played back recordings of seminars to student participants, asking them to reconstruct their experience, fewer than half recalled any "active thinking" at the time. In the era of McCarthyism and the Red Scare, moreover, professors and students were often reluctant to share political opinions in class. Universities responded by offering courses and training sessions to

improve classroom dialogue and instruction. But most faculty members eschewed such activities, which they associated with early-childhood teaching and especially with the low-status, much-maligned schools of education that prepared America's K-12 instructors.

So the universities moved in the opposite direction, creating gigantic televised classes that could — at least in theory — expose the "best" professors to thousands of students at the same time. By 1959, over a hundred colleges and universities provided nearly five hundred televised courses to half a million students around the country; at one institution, Penn State, more than one-quarter of the students were registered for at least one TV class. But the televised revolution fizzled over the next decade. Students found TV courses dull and impersonal, "giving the feeling that I was looking thru a window at the class," as an Ohio University student explained. Likewise, faculty who taught TV courses said they missed face-to-face interaction with their students. They also feared that television would introduce a new spy in the form of "Cyclops, the one-eyed mechanical man," as a worried professor wrote. Television was easy to record, capturing words that could be used against a teacher later. It also brought in wider audiences, who were in turn more likely to raise political objections to something that was said in class.

All these patterns repeated in the 1960s and early 1970s, the third and greatest era of growth in American higher education. Between 1960 and 1964 alone, student enrollment rose from three million to five million; by 1973, it topped ten million. Before World War Two, no American university had more than 15,000 students; in 1970, fifty institutions did. That meant huge lecture classes as well as more courses taught solely by teaching assistants, who received little or no prepara-

tion for the job. It also triggered protests by students, who denounced "mass classes" (as the giant courses were called) alongside racial discrimination, nuclear proliferation, and America's war in Vietnam. During the Free Speech Movement at Berkeley in 1964, the student leader Mario Savio blasted not just the university's repression of political expression but also the poor quality of its classroom instruction. Echoing student demonstrators in the 1920s, Savio said Berkeley was a "knowledge factory" that regarded students as "raw materials"; he also said the university treated them like IBM computer cards, a more contemporary technological metaphor. (Do not fold, bend, or mutilate.)

In 1970, a presidential commission on campus unrest connected the nationwide spate of violent protests that year — including eight thousand actual or attempted bombings and seven thousand arrests — to weak undergraduate teaching. College professors "have become so involved in outside research that their commitment to teaching seems compromised," the commission found. Unrest was most common at the largest universities, which had "failed [students] in a larger moral sense" by herding them into enormous classes taught by disengaged faculty members or inexperienced graduate students.

Have we failed our students, in a larger moral sense? I believe that we have, in four ways.

First, we have not evaluated or incentivized teaching in a meaningful or intellectually defensible fashion. I taught for twenty years at New York University, where I was observed in the classroom by a supervisor exactly once — in my very first semester. I am now entering my sixth year at the Univer-

213

sity of Pennsylvania and have not been observed at all. What does that tell faculty — and students — about how much we value teaching?

Defenders of the universities will point to student evaluations, which have become ubiquitous across higher education. Colleges and universities fought them for years but eventually capitulated, reasoning that the institutions could provide a more comprehensive and statistically valid analysis than the student organizations that had rated professors since the 1920s. Not incidentally, the evaluations also provided a ready answer when a regulator, a donor, or a parent complained that colleges were not taking teaching seriously enough. Student evaluations can indeed tell us important things about a college teacher: whether she returns work on time, whether she makes herself available out of class, and more. What they cannot tell us is whether her course is academically sound. That is a professional judgment, rendered properly only by fellow experts in the field. When I wrote a book on college teaching, I did not submit it to students for their evaluation; it was instead vetted by specialists in the history of higher education, who decided if I had something important to say. But my own college teaching is evaluated by people who are typically taking their very first class about the topic. If we truly believed in the importance of teaching, we would subject it to peer review in the same manner as our research. We instead allow ourselves to be judged almost entirely by novices, which again speaks volumes about what we really value.

Predictably, their judgments reflect all the cultural biases in our society: students rank men more highly than women, whites more highly than non-whites, attractive professors more highly than less attractive ones. Worst of all, student evaluations have contributed to declining student workloads

and runaway grade inflation. About forty-three percent of college letter grades in 2011 were A's, up from thirty-one percent in 1988 and fifteen percent in 1960. Over roughly the same years, the average amount of studying by people in college declined almost by half, from twenty-four to thirteen hours per week. In a recent survey of undergraduates at twenty-four different institutions, half of the respondents reported that they were not taking a single course requiring a total of twenty pages of writing. You cannot blame all of that on student evaluations, of course. But the faculty's best route to a high rating is to scale back assignments and hand out lots of good grades, and this cannot be good for the academic or moral development of our students. In a study in 2010 at the Air Force Academy, where a mandatory curriculum allows for convenient natural experiments, professors who gave higher grades received higher student evaluations — but their students did worse in subsequent classes. Professors who graded more strictly got lower evaluations, but their students performed better later on. In short, student evaluations do not protect against poor teaching, as the Berkeley newspaper imagined. If anything, they make it even worse.

What about teaching awards? Don't they make all of us teach better, or at least work harder at it? That has been another refrain of the universities, which instituted a wide range of teaching prizes following the student protests of the 1960s. While I was at NYU, I was fortunate to receive its university-wide Distinguished Teaching Award. There was a lovely dinner, at which my dean called me to the podium to receive a medal and then, in her kind remarks, she proceeded to tell the audience about the books I had written! That spoke volumes, too. The reason I got that job was my research, not my teaching. And everyone knows that they can earn more

215

The Quiet Scandal of College Teaching

by publishing another book or article — and receiving the higher base pay that comes with promotion — than they can by winning a one-off teaching award.

Recent history is littered with instances of professors who won teaching prizes and were denied tenure; the more you exert yourself in the classroom, the less time you have to produce the research that actually makes or breaks you. All of this was already apparent a half-century ago, when the classicist William Arrowsmith noted that teaching prizes, devised to enhance the low institutional importance of undergraduate instruction, actually confirmed it. "At present the universities are as uncongenial to teaching as the Mojave Desert to a clutch of Druid priests," Arrowsmith told the convention of the American Council on Education in 1966. "If you want to restore a Druid priesthood, you cannot do it by offering prizes for Druid-of-the-year. If you want Druids, you must grow forests. There is no other way of setting about it."

One way to do it would be to institute real professional preparation for college teachers. But here, too, we have failed our students.

This is not a new problem. In 1947, Harry Truman's President's Commission on Higher Education issued a ringing demand to make higher education available to any capable citizen who wished to obtain it. But none of that would work, the commission cautioned, unless America also taught a new generation of professors how to teach. "The most conspicuous weakness of the current graduate programs is the failure to provide faculty members with the basic skills and the art necessary to impart knowledge to others," it declared.

"College teaching is the only learned profession for which there does not exist a well-defined program of preparation toward developing the skills which it is essential for the practitioner to possess." As a Rice University professor quipped, a new college teacher was like someone who was briefed about an airplane's engine and then told to fly the plane. "Tragedy for the pilot is almost inevitable; in the case of the young instructor, the tragedy befalls his students," he wrote.

Actually, it was hell for everyone. In his brilliant and heartbreaking memoir, *Becoming a Man*, the gay author and activist Paul Monette recalled the tedium and anguish of TA-ing a Yale freshman literature class in the 1960s for "overgrown high-school jocks who thought literature was sissy stuff." He struggled in vain to convince them otherwise. "To them it was just depressing and weird, and what did they have to know for the final?" Monette remembered. "Only four years older than they and painfully out of my depth, I felt skewered by their boredom as they rolled their eyes at one another, all of us counting the minutes till the bell rang."

By then, some of the colleges had been shamed into providing graduate students with a few non-credit seminars or training sessions about classroom instruction. Like teaching prizes, however, these efforts tended to confirm the same problems that they targeted. The Harvard biologist Kenneth Thimann·began one such session by reminding participants that "the young teacher must always keep in mind the importance of doing individual research which is essential to his career," which was surely one lesson that Harvard doctoral students did not need to learn. But he also urged them to get as much teaching experience as they could during graduate school, when the stakes were lower. Thimann told the story of an American medical officer stationed in Japan,

where he diagnosed a soldier in his unit with appendicitis. Having never performed the requisite operation, the officer captured a stray dog and removed its appendix; after that, he felt confident operating on the soldier. Likewise, Thimann said, doctoral students should experiment on undergraduates to prepare themselves for teaching jobs later on. The message was clear: teaching isn't brain surgery or rocket science, but it does require practice. Just do it for a while, and you will get the hang of it. As a professor friend of mind likes to joke, he learned to teach the same way he learned to have sex: on the job.

Today, most universities have established a bit more formal training for rookie teachers. At Penn, for example, TA's take a three-day workshop before we throw them to the wolves. That is an improvement on what came before, but it is hardly a ringing affirmation of the importance of teaching. To get a Ph.D., you need to spend many years immersing yourself in a discipline so you can — ideally — contribute an original idea to it. And to teach a group of undergraduates? A class or two will suffice. Most of these sessions are sponsored by centers for teaching and learning, the tragic heroes in this bleak winter's tale. Nearly all our colleges and universities have established such offices, which provide programming and consultation for faculty members as well as training for graduate students. I have deep respect for what the centers do, but they are fighting an uphill battle. Indeed, the very need to create a separate unit devoted to teaching demonstrates its diminished status, even at small liberal arts colleges. "A Center for Teaching?" an emeritus professor at Colby asked incredulously in 1992, after the college established one. "I thought that's what the whole college was." It isn't, and it hasn't been for a very long time.

Also consider this: a majority of college teachers are now adjunct or contract faculty. This is the third way we fail our students. If we really cared about their education, we would not slough it off on itinerant laborers. When I was in graduate school in the early 1990s, we were told that the old guard would retire and that we would get their jobs. That was right on the first count and wrong on the second one. Many professors did retire, but institutions replaced them by hiring adjuncts — at several thousand dollars per course — instead of new full-time faculty members. A fortunate few of us actually got hired onto the tenure track, which now feels like winning the lottery. Everyone else had to drive from campus to campus, picking up courses here and there and waiting for the real job (with a living wage, health insurance, and even a desk) that would never come. A quarter of part-time faculty rely on public assistance; some of them live in cars, and others have turned to sex work to make ends meet. In 2013, Pittsburgh newspapers reported the death of an adjunct professor who taught French for twenty years at Duquesne University. She never earned more than $20,000 in a year, so when her classes were cut she was rendered almost homeless. She died at 83, with no health insurance or retirement benefits.

You would think that an institution so exquisitely attuned to "social justice" would bridle at this radically unjust situation. But a professor quoting the n-word out loud from a James Baldwin book generates vastly more indignation than the systematic exploitation of adjuncts, which barely registers on the campus outrage meter. We have made our undergraduates into accessories to this crime, and it is not clear how many of them know or care about it. But they should care, because it harms their own education as well as the lives of their struggling instructors. Surveys have shown that adjuncts

spend less time interacting with students than full-time professors do; they are also more likely to give multiple-choice tests, less likely to assign papers, and less likely to require multiple drafts of them. This is not because the adjunct faculty are lazy; it is because of the conditions of their labor. Many of them do not have offices, so it is hard for them to find space to meet with students. Most of all, they simply do not have enough hours in the day to perform the tasks that good teaching requires — planning lessons, grading essays, responding to emails, and so on — while commuting between several campuses and trying to publish research that might qualify them for one of the handful of tenure-track jobs that come up each year.

Nor do they have any job security, which might be the biggest injustice of all. If you are an adjunct, you can be let go at any time and for any reason. Maybe the enrollment in your course dipped, or a full-time faculty member decided she wanted to teach it. Or, perhaps, your school simply didn't like what you had to say. In Virginia, an adjunct instructor who told his class that the massacre at Virginia State University in 2007 had been overhyped by the national media — because so many victims were white women — was fired the next day. An Iowa adjunct was dismissed for calling the Biblical story of Adam and Eve a myth; another part-timer in the state was not renewed after students complained that he had assigned them "offensive" course readings, including a book by Mark Twain. More recently, a New Jersey community college fired an African-American adjunct instructor after she went on television to defend a Black Lives Matter event that asked non-Blacks not to attend. That is a complicated position, and surely there are many reasonable objections to it. But now her students will not get to hear them, or her. She's gone.

Which brings us to the greatest moral failure at our universities now: the narrowing of expression in our classrooms.

In a student survey released last year by Heterodox Academy, over half of the respondents said they were afraid to voice their opinions in class. White students were more reluctant to share their views on race; men were more reluctant to discuss gender; Republicans were less likely to speak about politics. Other research by the same organization shows that faculty — especially those who are centrist or conservative — are also biting their tongues, in class and outside of it. In a poll of 445 professors, over half said they believed that expressing a dissenting view at work could hurt their careers. People are especially afraid of getting slammed on social media and by university "bias response teams," which allow anyone who believes they have been harmed by a comment to register an anonymous objection to it; this triggers an investigation by the institution, which is also charged with devising punishments for offenders. When asked why they did not share opinions in class, over one-third of respondents in the Heterodox student survey cited fears that they would be reported for violating a campus harassment or speech policy.

We have been here before, too. In the 1950s, a pall of fear and censorship fell over American colleges and universities. Back then, of course, people on the Left had more reason to worry: hundreds of professors were fired for alleged communist affiliations or for refusing to disclose them. But that understates the day-to-day toll of the Red Scare in college classrooms. "Now I no longer say what I think, but what I'm told to say," one professor told a researcher. Topics related to communism and Soviet Russia were the most dangerous, even

at smaller schools that proudly touted their liberal bona fides. "We don't discuss Red China; instead, we discuss whether the student should wear shoes or not!" quipped a professor at the famously bohemian Antioch College. But many faculty members also avoided mention of the New Deal and other government social programs, which conservatives had tainted as "Red" in spirit. "Quite often I'm a little afraid to say anything about Social Security, etc. that may be interpreted as leftist," a historian in Louisiana admitted. Students reported supposedly subversive comments by their professors to college administrators; indeed, a faculty member grimly observed that students were "the best Gestapo" on campus. "In American democracy it is our boast that we exalt the individual, provide for freedom of thought, cultivate the open mind, inculcate respect for differences of opinion, provide for freedom of the opposition, recognize the rights of the non-conformist," one university official remarked in 1954. "But, as a general rule all of these procedures and noble ideals are violated or ignored in the college classroom."

That is the case today, too, except fewer people decry or even admit it. When last year's polls came out about student and faculty self-censorship, I did not hear a single major university leader bemoan the results. And now that Republican politicians are making hay over the matter, we are even less likely to acknowledge it. After Governor Ron DeSantis of Florida signed a law requiring state higher education institutions to conduct surveys to see whether students and faculty "feel free to express beliefs and viewpoints," an official with the American Association of University Professors deemed the measure "a solution in search of a problem." In fact, it is a terrible solution to an all-too-real problem. DeSantis has suggested that colleges might have their budgets cut if they

inhibit student speech, which could allow him to penalize any speech of which he disapproves; the measure also lets students record their professors during class and sue if they think that their "expressive rights" are being violated, a truly appalling specter to anyone who has actually taught in a college classroom. (Don't like a professor's politics, or even the grade she gave you? Sue her!)

But the answer is not to circle the wagons and pretend that everything is fine, when we know it is not. The noble ideal of free exchange is being violated or ignored in the college classroom, just as it was in earlier eras. Only now we are afraid to say that we are afraid. And if the professors do not speak up, the students will lose out. They are scared, too, and they are looking to us to set a different tone and example. I don't begrudge the adjunct faculty for keeping their mouths shut: they have to eat, after all. But the rest of us have no excuse. Whenever I write a column denouncing fear and self-censorship on our campuses, I receive at least one appreciative email from a colleague. Sometimes they ask if I have received blowback; others will remark that I have guts, or another more intimate body part. My reply is always the same. I don't have guts, or the other body part. I have tenure. What's it for, really, except to say and write what is on our minds?

And what is college for, except to challenge the minds of our students? That was the question raised by the Wesleyan conference, a hundred years ago, and it is every bit as pressing today. We simply cannot fulfill our duty to our students unless we devote ourselves more rigorously to their instruction. Zoom will not save us, any more than television did in the 1950s; the internet has its uses, to be sure, but it cannot substitute for the real revolution that we need. That will require actual professional preparation for teaching and peer review

of the same, plus a livable wage for everyone who engages in it. But it will also require us to raise our voices on behalf of freedom of thought, open minds, differences of opinion, and all the other small-l liberal values that have undergirded good teaching in all times and places. I know there are some students who believe we should restrict classroom inquiry and dialogue in the name of larger social goals, especially the struggle against racism. But those students are wrong, and we condescend to them when we refrain from saying so.

And maybe, just maybe, we can help inspire them to demand what is truly and rightfully theirs: an institution that puts undergraduate instruction first, above everything else. On a Zoom call during the pandemic, a student told me that she was despondent that Penn had brought students back to campus but was not teaching them in person. I told her that I felt the same way, but that my views didn't much matter; the only ones that would count were, yes, those of the paying customers. If enough of them refused to send in their spring tuition until they got face-to-face classes, I suggested, they would get face-to-face classes right away. "Professor, this isn't the '60s," the student replied, smiling sadly. No, I thought, in some ways it is the '60s: the campus is again rife with agitations and causes. Why not this one? Students protested poor teaching in the past, I told her, and the future is up for grabs. She and her peers should seize it.

LEONARD COHEN

Images

MARIANNE 1960

GOOD GREEK COFFEE

Liberties

GRECIAN WOMAN STUDY

Images

2

MONTREAL WOMAN NO. 1
———————

Liberties

just to
have been
one of them

even
on the
lowest
rung

לאל ברוך נעימות יתנו

229

JUST TO HAVE BEEN
———

MY FIRST WIFE
———

231

MONTREAL WOMAN NO. 2

Images

232

MONTREAL VISITOR NO. 1

Liberties

*vibrant,
but
dead*

VIBRANT BUT DEAD

Images

CASS R. SUNSTEIN

Liberalism, Inebriated

Does liberalism have poems? Are there liberal poets? John Stuart Mill, who loved Shelley and who celebrated "human feeling," thought so: "Although a philosopher cannot make himself, in the peculiar sense in which we now use the term, a poet, unless at least he have that peculiarity of nature which would probably have made poetry his earliest pursuit; a poet may always, by culture, make himself a philosopher." But a philosopher of liberalism?

Charles Baudelaire, a contemporary of Mill, died in 1867. In 1869, a collection of his prose-poems — a form that he helped to invent — was published under the title *Le Spleen de Paris*, a

phrase that Baudelaire had himself used for a selection of these texts. The title has been translated as *Paris Blues*. (The original title was much better.) Baudelaire believed that life is a struggle between *spleen* and *ideal*, and in his work he studied the former and championed the latter. Among the prose-poems in the posthumous book was one called *"Enivrez-vous,"* which first appeared, in February 1864, in the newspaper *Figaro*. It has been translated into English by Michael Hamburger as "Be Drunk."

Here it is, in full:

One should always be drunk. That's all that matters;
that's our one imperative need. So as not to feel Time's
horrible burden that breaks your shoulders and bows
you down, you must get drunk without ceasing.

But what with? With wine, with poetry, or with virtue,
as you choose. But get drunk.

And if, at some time, on the steps of a palace, in the green
grass of a ditch, in the bleak solitude of your room, you
are waking up when drunkenness has already abated, ask
the wind, the wave, a star, the clock, all that which flees,
all that which groans, all that which rolls, all that which
sings, all that which speaks, ask them what time it is;
and the wind, the wave, the star, the bird, the clock will
reply: 'It is time to get drunk! So that you may not be the
martyred slaves of Time, get drunk; get drunk, and never
pause for rest! With wine, with poetry, or with virtue, as
you choose!'

Now that's a liberal poem! *"Enivrez-vous"* is liberal in its celebration of freedom; profoundly anti-authoritarian, it

Liberalism, Inebriated

offers a license to its readers. Getting drunk and so refusing to surrender to drudgery, suffering, or the inevitability of aging and death — to be a martyred slave of Time — is not a sin, an offense, a transgression, or a violation of anything. It is a right. But it is no mere right; it is an "imperative need," something that counteracts "Time's horrible burden."

You might object that the poem is not so liberal after all, because what I am calling a license takes the form of an imperative, a kind of mandate: "One must always be drunk." But this is a poem, not a treatise, and a license would be far too grudging or qualified, and a lot less fun. "One may drink" or "one has the right to drink" would not have the right valence or spirit. (Note well: This is not a poem about, or an essay on, tolerance. It asks you to act, not to tolerate. Its subject is your attitude toward yourself, not your attitude toward others. Anyhow, tolerance is begrudging.)

The poem is also liberal in its recognition, at once mischievous and celebratory, of the diversity of preferences and tastes — of what one gets drunk on. In his *Autobiography*, Mill said that *On Liberty* was meant as "a kind of philosophic text-book of a single truth," which is "the importance, to man and society, of a large variety of types of character, and of giving full freedom to human nature to expand itself in innumerable and conflicting directions." For some, wine is best; for others, poetry; for others, virtue. (For some, it is all three.) The power of the poem comes, of course, from the oddity of the juxtaposition. It is not all that shocking or even interesting for a poet to celebrate getting drunk. It is far more interesting (and far more liberal) for a poet to link wine, poetry, and virtue, and to see them all as sources of inebriation. A part of the merriment, and the clarity, of *"Enivrez-vous"* is its insistence that poetry and virtue can get you drunk, too.

It is not easy, of course, to explain how virtue in particular can make one drunk, without becoming high-minded or sanctimonious, or patting oneself on the back. Sure, many people do get "drunk on power," and those who act on behalf of causes, including horrific ones, seem to have some kind of erotic attachment to what they do. (Consider O'Brien in Orwell's *1984*. Was he drunk? Maybe.) But that is not what Baudelaire had in mind. Many of those who help other people, and whose life is defined in part by good works, feel thrilled, or excited, or something like that, by what they feel privileged to do. The neuroscience is worth investigating here. Doing good works is associated with the release of oxytocin and the production of dopamine — and that can make you feel intoxicated (and drunk).

It is true that, for Mill and many other liberals, some pleasures are higher than others, and those of poetry and virtue are higher than those of wine. In my view, they are right. But let's not say that too loudly, or with too much earnestness, or with a condemnation of the lower pleasures. Liberals insist on accepting divergent conceptions of the good, and equally important, on acknowledging and celebrating diverse kinds of good.

"Enivrez-vous" is quintessentially liberal as well in its insistence on human agency, and on activity rather than passivity. ("As you choose!") The reader is instructed to get drunk as well as to make the choice about exactly how. Different people can exercise their agency in different ways. If you choose to get drunk on poetry — as Baudelaire evidently did, along with wine — that is fine; so too if you get drunk on good works. And of course, the listed options for intoxication are merely illustrative. The reader is invited to think: What, exactly, gets me drunk? (That is, in fact, an excellent question to ask.)

Liberalism, Inebriated

Mill was similarly insistent on the importance of human agency. In speaking of happiness, he urged that we mean "not a life of rapture; but moments of such, in an existence made up of few and transitory pains and various pleasures, with a decided predominance of the active over the passive." Baudelaire was speaking not of mere moments but of "a life of rapture," but then he was that sort of poet.

"Enivrez-vous" is liberal in its exuberance — its pleasure in its own brazenness, its radical openness to experience, its defiance, its rebelliousness, its implicit laughter, its love of life and what it has to offer. It is the very opposite of dutiful. Its middle finger is raised. It is far more exuberant than Mill's *On Liberty*, but it is exuberant in the same way. It, too, celebrates activity and joy. Baudelaire found a way to combine those two celebrations without the slightest sentimentality. His poem opposes everything desiccated and lifeless. It exemplifies what it celebrates. Baudelaire's poem might even be seen as a companion to Mill's book. Consider Mill's embrace of "experiments in living": Mill had his own ways of getting drunk. (*"Enivrez-vous"* was probably written in the same decade as *On Liberty*.)

Here is Mill on Shelley, whom he preferred to Wordsworth: "He is a poet, not because he has ideas of any particular kind, but because the succession of his ideas is subordinate to the course of his emotions." (Recall Mill's emotional recovery, with the help of poetry, in his account of his nervous breakdown in his memoir.) And here is Blake on Milton: "The reason Milton wrote in fetters when he wrote of Angels & God, and at liberty when of Devils & Hell, is because he was a true Poet and of the Devil's party without knowing it." Baudelaire was not of the Devil's party, but he was a true Poet, and he knew something about Hell.

Baudelaire had a lot to say about poetry and its place in life. In 1846, in a short essay called "To the Bourgeois," he insisted that people must "be capable of feeling beauty, for just as not one of you today has the right to forego power, equally not one of you has the right to forgo poetry." He added that it is possible to "live three days without bread; without poetry, never; and those of you that maintain the contrary are mistaken; they do not know themselves." The most important words are here the last five: those who think that they can live without poetry lack self-knowledge. Poetry, then, does not fall below virtue (or wine). And indeed, Baudelaire's elevation of poetry can be associated with what philosophers call "liberal perfectionism," elaborated by Mill and Joseph Raz, which is respectful of freedom of choice and the diversity of preferences and values, but which insists on a distinctly liberal conception of the good life, one that involves cultivation of the higher pleasures and one's own capacity for agency.

Nothing about Baudelaire is simple, of course, and the same is true of liberalism. In politics, Baudelaire was emphatically not a liberal. He was dedicated to art, not democracy. He was anti-republican and pro-aristocracy, and he admired de Maistre — a true and complete horror, and a virulent enemy of all things liberal. Though he participated in the revolution of 1848 in Paris and was to be found on the barricades, Baudelaire lost interest in politics after Louis-Napoleon Bonaparte's coup in 1851, and his political attitudes became an extension of his cultural philosophy and his high aestheticism. And yet *"Enivrez-vous,"* read on its own, is unmistakably the product of a liberal imagination.

We live in a period in which liberalism is under considerable pressure. On the left, "liberalism," or more specifically "neoliberalism," is said to be old and dead and boring and dull,

to be over and exhausted, to have failed dismally. Some people on the left hold it responsible for an assortment of social evils, including poverty, climate change, inequality, racism, sexism, the demise of labor unions, the rise of monopolies, technocracy, and a general sense of alienation and disempowerment. On the right, and particularly the religious right, "liberalism" is said to have ruined everything. It is allegedly responsible for much that is bad — a growth in out-of-wedlock childbirth, a repudiation of traditions (religious and otherwise), a rise in populism, an increased reliance on technocracy (the bane of both left and right), inequality, environmental degradation, sexual promiscuity, a deterioration of civic associations, a diminution of civic virtue, political correctness on university campuses, and a general sense of anomie.

I have put liberalism in quotation marks, because the set of ideas that is under attack is not always specified, and because its connection to liberal political thought is not clear. Any list of liberal thinkers would have to include John Milton, John Locke, Jeremy Bentham, Mill, Benjamin Constant, Mary Wollstonecraft, Immanuel Kant, Friedrich Hayek, Isaiah Berlin, Jurgen Habermas, John Rawls, Raz, Amartya Sen, Ronald Dworkin, Martha Nussbaum, and Jeremy Waldron, among others. (Walt Whitman and Bob Dylan could be counted as liberals as well. Whitman, sounding a lot like Baudelaire, only more saccharine: "Do anything, but let it produce joy." Dylan, sounding a lot like Baudelaire, only more edgy: "Everybody must get stoned.") A lengthy book could easily be written about the differences between Bentham and Mill, and in important respects Hayek and Dworkin are not on the same team. But all of these thinkers share a commitment to human agency, and to the idea of human dignity.

It would be a mistake to treat the author of *Fleurs du Mal* as a liberal, but Baudelaire's poem does capture something essential about the most appealing forms of liberalism: the insistence on freedom, on the diversity of tastes and preferences, on human agency, on a kind of exuberance without apology. Liberalism must not be treated as an instruction manual. It is not an edict; it has to be made, not followed. But because of what it understands about the human spirit, and because of its hopes for that spirit, it is the right thing to make. *"Enivrez-vous"* helps to explain why.

241

Lambs and Wolves

For paradise to be possible either the lion must lose his nails,
or the lamb must grow his own.

HANS BLUMENBERG

Before setting out to Moriah, where he intends to obey God's command to sacrifice his son, Abraham loads the wood into Isaac's arms and carries the burning torch and a sharp knife himself. On the way his son asks, *but where is the lamb for a burnt offering?* The question is devastating, as is Abraham's answer: *My son, God will provide himself a lamb.* It is a scene of unspeakable cruelty. (The murder of Abel is a crime statistic by comparison.) For Isaac is doubly innocent. Unaware of God's command, and presumably too inexperienced to beware fathers bearing torches, he is psychologically innocent. And since he has presumably done no wrong, he is morally innocent as well. All

this weighs on Abraham, and it is meant to. He has agreed to be the hand by which innocence is extinguished.

There are other mythical traditions in which a father might kill a son without qualms, whether to gain divine favor or to assure a military victory. But the Hebrew Bible is a different sort of book. Its God is a test giver who keeps an eye on the moral spectator. Isaac turns out to be just a prop in a drama revolving entirely around his father. Once Abraham has proven his infinite resignation before God — without, in the end, committing the unspeakable — nothing more is required of the human lamb and the incident is not mentioned again. The real test for Isaac will come later, when he becomes an adult and is saddled with two difficult sons. One wonders if he ever thought back to that strange afternoon. He certainly would not have been encouraged to dwell on it. In Judaism there is no cult of the innocent white lamb.

In Christianity there is. The Gospels rewrite the Abraham drama and present a divine Father who for mankind's sake willingly sacrifices his divine-human Son, who just as willingly offers himself up. In this version, the Father is the prop and the innocent Son is the story. This focus on sacrificed innocence explains why lamb imagery suffuses the Christian imagination and shows up so often in scripture, theology, and the arts. But it is an ambiguous symbol. In the Gospel of John, Jesus announces, *I am the good shepherd: the good shepherd giveth his life for the sheep.* Early Christian iconography relied heavily on this metaphor, beginning with catacomb paintings showing the Redeemer with one lamb draped over his shoulders while two others accompany him. The image implies that to be a good Christian is to be a good lamb, harmless and willing to be led by someone who knows the way.

John the Baptist had something different in mind when

243

he declared, on first seeing Jesus, *Behold the Lamb of God, which taketh away the sin of the world*. Now we are asked to think of Jesus not as a wise caretaker but as an innocent victim allowing himself to be beaten, lashed, spat upon, and crucified. A self-immolating Isaac. This image of a passive redeemer would leave a far deeper impression on the Christian imagination than that of the Good Shepherd. But as a symbol it leaves something to be desired. The God of the Hebrew Bible is a fearsome God, leading His people out of the wilderness in a pillar of cloud to the lands they will conquer. A suffering Christian can surely identity with the suffering Lamb of God. But where is the solace, where is the guidance, where is the hope of gaining protection?

The other John, author of the Book of Revelation, provided one answer. As his revelation begins, we are introduced to a repulsive exterminating beast with seven horns and seven eyes who has been sent to settle every divine score. Like Oedipus solving the riddle of the sphinx, or King Arthur extracting Excalibur from the stone, the lamb confronts a challenge that others cannot meet: opening the Book of the Seven Seals, which will bring about the end times. As the lamb breaks the first four seals, the four horsemen of the apocalypse emerge, the first on a pure white steed, the last on a black one. With the fifth, those slain for the Word of God emerge from darkness, demanding vengeance against their killers, which they will soon have. The bloody work begins when the sixth seal is broken, revealing the rulers and the rich, who try to hide themselves from judgment and cry out, *Hide us from the face of him that sitteth on the throne, and from the wrath of the Lamb!* No one answers and they are doomed to eternal suffering. When the dust settles, John looks out and the destruction has been swept away. He sees a new heaven and

244

a new earth. The lamb is still there, though he has been cleaned up and is about to be given in celestial marriage to the New Jerusalem. *And the city had no need of the sun, neither of the moon, to shine in it: for the glory of God did lighten it, and the Lamb is the light thereof.* That, and its defense force.

The scene in the Christmas creche is so familiar that it takes some effort to realize how strange it is. The exhausted parents we recognize. But who are these silk-robed and turbaned men who bow and kneel before an infant? And what about the animals, who seem just as mesmerized as the visitors? Even the little lamb approaches and leans its head over the manger to get a closer look.

We are all Magi when it comes to children. Like other animals we are hardwired to protect our young. But the subjective feelings that accompany this instinct point to something beyond mere preservation of the species. How we imagine children to be really reflects how we imagine the world ought to be. This has not always been true for all peoples and societies, but of ours it is. The death of a child affects us very differently from the death of an adult. Even the death of other species' young disturbs some people. They will eat beef and mutton but wouldn't think of touching veal or lamb. In what sense grown animals are less innocent and worthy of protection than young ones is difficult to discern, especially given that the latter will face the same fate as the former if they reach maturity. One might even make a clever case that eating lamb or veal saves the animal from months or years of suffering in captivity. But that is really not what our feelings are about. They are about holding onto a world

Lambs and Wolves

picture. The child in the cradle has no idea what a burden it already carries for us.

We oscillate between two ways of thinking about the newborn before our eyes. One is to see it as a blank slate, knowing nothing, intuiting nothing, having neither moral nor immoral instincts (or weak ones). This can fill us with a sense of promise as we project its life into the future. Seeing an infant, Rousseau wrote, is like seeing nature in early spring:

> I see him bubbling, lively, animated, without gnawing
> cares, without long and painful foresight, whole in
> his present being, and enjoying a fullness of life which
> seems to want to extend itself beyond him. I foresee
> him at another age exercising the senses, the mind, and
> the strength which is developing in him day by day,
> new signs of which he gives every moment. I contem-
> plate the child, and he pleases me. I imagine him as a
> man, and he pleases me more. His ardent blood seems to
> reheat mine. I believe I am living his life, and his vivacity
> rejuvenates me.

246

Rousseau was a pessimist who saw life as a trial, not only in his particular case but for everyone who is forced to share the world with others. Why then doesn't he foresee the grown child suffering in such a world? Because he, like most of us, is inclined to saddle children with expectations that their new lives might somehow redeem our own, or redeem life itself. We are always on the lookout for occasions to rejuvenate our hopes in rejuvenation, from wedding days to Inauguration Days. They are all opportunities to convince ourselves that this time it really will be different.

If the child's innocence is a blankness, an absence of pre-de-

termined qualities, we can be hopeful about its prospects. But if we think of its innocence instead as the presence of something valuable, a kind of purity or moral perfection, then more melancholy thoughts might occupy us. Not because we see something dark in the infant's eyes, but because we imagine that its perfection can only be diminished or lost over time. On this assumption, infants are not starting a journey into a world they will make their own through experience. Rather, they stand as an alternative to our fallen world, a symbol of what we might have been had we not succumbed to it. Experience, which leaves permanent stains on the sheets of the soul, is their greatest enemy. And so it must be postponed, blunted, diluted. *Save the children!* This might mean that we must protect them from harm until they can protect themselves. Or it might mean that we should preserve the child-like within them, or within ourselves, or within our society. Or even that we should hold up innocence as a civilizational ideal and stave off knowledge about our intractable world, distrust it, and listen instead to the bleating of the lambs.

Ancient documents tell us that in the Mediterranean world of the first century BCE adults were using children as spiritual mediums in the theurgic ceremonies of mystical cults. A child would be selected for the job and blindfolded, and then the cult's adepts would begin secret incantations to entice the divine to make its presence manifest. This was one of them:

> Come to me, you who fly through the air, called in
> secret codes and unutterable names, at this lamp
> divination that I perform, and enter into the child's soul,
> so that it may receive the immortal form in mighty
> and incorruptible light.

Lambs and Wolves

This done, the blindfold would then be removed, and the child would be asked to look into a flame or a bowl of oily liquid and report to the adults whatever he or she saw in it. The assumption was that children, lacking experience and perhaps imagination, were less likely to be blocked by their own thoughts and feelings and illusions, and thus were purer conduits for unadulterated truth. We make the same assumption whenever we say *out of the mouths of babes*, unconsciously quoting the Psalms. It is a very old thought.

Americans are particularly taken with it, as we see in the movies they produce and flock to. Steven Spielberg is the great mythogogue of the wise innocent child, and in this domain his masterpiece is *Close Encounters of the Third Kind*. Aliens are coming, but before they arrive children begin to have premonitions of them, which they receive in complete serenity. When the time comes and spaceships begin to hover and emit a blinding light, the children giggle. When the mothership lands, they toddle up to it and are met by hairless, sexless aliens who look like stretched out infants with very large heads. The children grab their hands and enter the ship as if that were the most natural thing in the world. Grown-ups in the movie are portrayed as oblivious or resistant, their age and experience having closed their minds. Except, of course, for the one exceptional adult who has never really grown up. He has revelatory dreams and spreads the Good News despite being treated as a madman. In some films of this genre the news about the aliens delivered by the children can be bad, very bad. But no one listens to these little prophets until it's too late — and now *they're here.*

In the history of myth, children have been portrayed not only as prophets or mediums of a higher power, but as partaking of those powers by virtue of their youth. Tibetan Buddhists are

248

only one people to have searched for a child to lead them. The very fact that Jesus came as an infant and did not descend from heaven in adult form was long taken in the Christian tradition as a sign of the spiritual potency of innocence. In the Middle Ages there developed a myth, long taken to be historically accurate, about a supposed Children's Crusade that took place in the early thirteenth century. It recounted the exploits of a group of children who were said to have spontaneously marched across Europe and organized their own brigade to seize the Holy Land from the heathen Turk and to shame adults unwilling to make the ultimate sacrifice.

To take a modern example, consider *Heidi*, the nineteenth-century Swiss children's book that remains a perennial favorite. Its basic theme has been adopted and adapted in countless books and movies. In all these stories an innocent, preferably dimpled little girl is put into the care of a gruff old man or woman. This adult treats her abysmally at first, but little by little is transformed by the child's relentless, not to say tiresome, good cheer and good deeds. The cherub turns her cheek again and again until the adults begin to see how cruel they have been, but even more how they have darkened their own lives. How? By refusing to look on the sunny side. The story ends with a tearful embrace between innocent child and the now healed adult. And why not? If the Messiah came as a child, why shouldn't the psychotherapist?

At the age of seven, any child would throw the first stone.
MICHEL HOUELLEBECQ

Children are naturally good. They are honest, pacific, sympathetic, and wise. No parent of a two-year-old or a thirteen-

year-old will be taken in by this myth. The market for it is expectant couples, forgetful grandparents, and the childless. But innocence is not all we project onto children. We also express our fears about evil in the world, spooking ourselves with tales of demon-possessed infants and child killers. As if on cue, when Spielberg began making his movies in the 1970s Hollywood also gave us films such as *The Exorcist* and *The Omen*, reflecting the other half of our disassociated fantasies about the young. Both spawned popular movie franchises, and *The Exorcist*, which won the Academy Award for Best Picture in 1974, is one of the highest grossing films in history.

The first of the genre was *The Bad Seed*, released in 1956, an eerie film about a cute little blonde girl who kills friends and neighbors without the least trace of guilt. Soon she is revealed to be the granddaughter of a serial killer, therefore his "seed." On learning this her mother tries to kill the child, but fails. In the novel on which the movie was based, the mother then commits suicide, leaving the child free to continue murdering and haunting our imaginations. A brilliant ending. At the time, though, it ran up against the Hays Code, which dictated that onscreen crime could never be shown to pay. And so a more uplifting ending was written, in which the little girl is struck dead by lightning in the final shot. (Thus fulfilling a fleeting fantasy that all parents have had at one time or another.)

The ancient world seems to have had less trouble recognizing children's capacity for wickedness. Even the Hebrew Bible contains a story about it. In the Second Book of Kings we read of Elisha, who has just taken on the mantle of prophet after Elijah was taken up to heaven in a chariot of fire. One day, while making his way to the city of Bethel, Elisha runs into a large group of boys who tease him and mock his baldness. He does not turn the other cheek, nor does he use

250

the episode as a teaching moment. Instead he curses the boys *in the name of the Lord,* the Scripture says. Immediately two bears appear out of the forest and maul them to death.

The infant-besotted New Testament, on the other hand, keeps children's capacity for cruelty at bay. Jesus suffers the children to come to him and exhorts his disciples to be like them. But in a classic example of the return of the repressed, a second century Christian author aiming to celebrate the supernatural powers of the Messiah left an apocryphal text, known as *The Infancy Gospel of Thomas,* that portrayed children in a much darker light. Its hero/anti-hero is the pre-adolescent Jesus, who is portrayed with an almost cinematic vividness. Straight away we are introduced to a young Messiah who curses a child found messing with something he built on the sand; the boy shrivels up like a tree. When another boy inadvertently bumps into Jesus while running, he drops dead on the spot. Seeing what a menace the young savior was turning out to be, parents of the other children in the village complain to Joseph and Mary, only to be struck blind. Finally Joseph stirs up his courage and confronts his son. *Why do you do such things?,* he asks. The child only stares at him stonily and replies, *Do not vex me.* A horror movie moment.

Perhaps in the early centuries of Christianity, when pagan realism was still a force, it was easier to confront the gap between the idealized image of Jesus in the manger and the actual children with whom adults have to cope. The most profound analyst of this gap was Augustine. He is rarely mentioned in books and anthologies on child psychology, no doubt because he rejected the Pelagianism that still undergirds our secular culture. We generally assume that human evil can be traced back to human action (early childhood traumas, social conditions) and that the damage can be undone by

251

human means: social reform, pedagogy, therapy. In other words: human beings are not born with evil propensities, we make them bad.

Augustine saw the logical flaw in this assumption. Of course, bad influences harm us. But we cannot explain the evil that children commit by pointing to the world created by evil adults, since those adults were once children. We face an infinite regress. The real difficulty is accounting for the fact that anyone is capable of evil at all. Augustine appealed to the Fall and original sin to solve the conundrum, a move that few are still willing to make. But we have been unable to come up with another concept to explain the conditions of the possibility of evil in children. We try to block out the thought that a young boy can pull on a ski mask, load his gun, walk into a school cafeteria and kill classmates he was joking with the day before. That among the children sitting at Jesus' feet were a few who preferred Barabbas.

Augustine saw such propensities within himself as a youth. As he recounts in the *Confessions*, one day he was playing with a group of friends and they decided to steal some pears from a nearby orchard. They weren't hungry and threw the pears away immediately. Why did they do it? This question plagued Augustine for many years, not as a matter of guilt but as a barrier to self-understanding. Only just before his conversion could he see why he had done it: *my pleasure was not in the pears; it was in the crime itself.* I loved my fall, he admits, I loved the shame. Tyrants and even murderers can have motives for their crimes; I did not. I am worse than they. Though the crime was petty, it was radically evil because it was gratuitous. Radical evil cannot be reduced to pleasure seeking or fear, nor can it be explained away as a reaction to previous harms. Radical evil we commit *just because*. And our capacity to commit it is innate.

Augustine's examples of ordinary child behavior, rather than adult crimes, gives his argument force. But of childhood crimes we also have plenty of examples. In a famous case dating back to the 1990s, two ten-year-old boys in Kirkby, England, abducted, tortured, and murdered a two-year-old by the name of James Bulgar. They had planned everything. They kicked and stomped on him, threw bricks and stones at him, crushing his skull, and mutilated the rest of him. Batteries were shoved into his mouth and he was placed on train tracks where his body was cut in two by a train. The internet will oblige you with countless similar stories if you are inclined to look for them. They serve to remind us that, on the map of the human psyche, Columbine is not far from Neverland.

Lovers slip home from trysts beneath the palm trees.

MARGARET MEAD

———————

So how do we reconcile the Gospels' image of innocent children at the feet of Jesus with Augustine's image of sinful ones stealing a neighbor's pears? Without resorting to casuistry, it is not easy. Which is why even in our post-Christian culture we see educated opinion about innocence swing from one extreme to the other without finding a settled resting place. Nowhere is this more evident than in our thinking about the sexuality of children.

The revolution in Western attitudes toward sexuality that began in the early twentieth century is still misunderstood. It remains conventional to portray the intellectual and cultural transformation that followed as a glorious and uncomplicated release from the suffocating grip of Puritanism and an escape into an equally uncomplicated sexual freedom. Freud,

who did more than anyone to trigger the change, did not at all see things that way. His insight was that in not accepting children's sexual nature, their desires and their aggression, Christian societies were preventing them from integrating passions and experiences into a productive, autonomous adult life. Maturity, not liberation, was Freud's goal. The same is true of Margaret Mead, whose hugely influential anthropological study, *Coming of Age in Samoa,* which appeared in 1928, idealized Samoans' guilt-free attitude toward sex. She did not, however, prescribe these practices for Western societies, which she considered impossible; the point was to make her readers reckon the psychological costs of living with pointless, pervasive sexual guilt. Like Freud, she wanted to help us cope better with the adult world that we have built for ourselves, not escape it.

What neither Mead nor Freud anticipated was that their work would inspire educated adults in the West — and soon just about everyone else — to demand that the new stigma-free approach to childhood sexuality also be applied to themselves. With astonishing speed in the decades following the Second World War, free sexual exploration went from being considered an early stage in childhood development to being a life ideal for adults intent on offloading their hang-ups. In the 1960s Mead complained publicly that this was not at all what they meant, to no avail. It is hard not to see the sexual revolution that began a half-century ago as inspired in part by a kind of innocence-envy. What's good for the gosling should be good for the gander, no? If taboos are inherently bad (something Freud and Mead never asserted) and impulses are inherently good (ditto), wouldn't escaping the first and unleashing the second restore a lost innocence? Of course not. Instead we discovered that the pursuit of a

second sexual innocence for adults could rob many children of their first.

Extravagant examples of this inversion began popping up in the 1970s. A well known one was a commune formed in Friedrichshof, Austria, by the artist Otto Mühl, a former Wehrmacht soldier who after the war fell under the influence of Wilhelm Reich. Mühl created a group called the Action-Analytical Organization, whose program was to liberate society from its psychological dependence on repressive bourgeois norms and consumerism through free love, group therapy (which mainly involved screaming), and a return to nature. He built an enormous complex in the countryside that housed dozens of children who slept communally in one area, and many more dozens of adults who slept communally in another. In the group's home movies we see footage of smiling long-haired men working the fields and women with closely-cropped hair running around topless, a baby hanging from each breast. We see naked children playing in the mud or smearing themselves with paint, to the delight of the grown-ups. And we see a room full of naked adults imitating the children by rolling around on the floor in a therapeutic group grope, sometimes jumping up to deliver primal screams before diving back into the scrum. It's hard to imagine such scenes delighting the unfortunate children who witnessed them. Inevitably, rumors of child sexual abuse began circulating, and, just as inevitably, they proved true. Adolescent girls, it turned out, were regularly taken to Mühl for sexual initiation, while boys would be taken to the woman he called his wife for the same reason. And parents let this happen, out of ideological conviction or studied ignorance. By the 1980s the law caught up with Mühl and he was finally convicted of pedophilia and spent seven years in prison.

Lambs and Wolves

But it was the subtler intrusion of images of sexualized children into Western popular culture that has had the most lasting effects. One cannot help thinking that the Gospel's image of children as innocent of sexual desire, pure little *putti*, had the boomerang effect of exciting a perverse adult desire to see that innocence violated, or at least toyed with. In 1976, a year before *Close Encounters* was released, Jodie Foster appeared as a fourteen-year-old prostitute in Martin Scorsese's *Taxi Driver,* and won an Academy Award for her efforts. Upping the ante, Louis Malle cast Brooke Shields as a twelve-year-old prostitute in *Pretty Baby* in 1978. Even more insidious, given its omnipresence, was the new blatant sexualization of young girls in advertising. In the 1980s pre-pubescent girls began to appear in billboard and magazine ads in absurdly tight jeans, topless with hands covering their half-developed breasts, blow-dried hair and makeup, looking knowingly into the camera. *Nothing comes between me and my Calvins.* At the same time beauty pageants were being organized where girls under ten years of age were transformed into wink-wink miniature seductresses, singing slightly risqué songs and making suggestive dance moves at competitions. (Today parents take home videos of their own children doing this and post them online for delighted friends and family.) Indecency was continuously and radically defined down. A former Miss Vermont Junior Queen, when challenged by a writer for putting her child in competitions, replied: *Do I put makeup on her? Yes. But I don't think I overdo it for a 5-year-old.*

And then, beginning in the 1980s, the mood swung wildly in the other direction and Americans found themselves gripped by a collective panic about their little lambs. It began in 1983 when a mentally unstable mother in Southern California went to the local police and began making bizarre claims that

the childcare center her son attended routinely raped and abused children. After interviewing many of the children, overeager police and unscrupulous therapists using dubious "recovered memory" techniques began arresting members of the center's staff. The trials that followed, the longest and most expensive in American history to that point, were reported on breathlessly by the local and national press, and copy-cat accusations kept being made around the country for years, long after the original stories had been debunked and the accused were exonerated. One staff member spent five years in prison without ever being convicted of a crime. Not long afterward, of course, we learned about a genuine scandal, the massive global cover-up of systematic child abuse committed by Catholic priests, which only reinforced the fears.

Strangely, though, Americans remain strangely indifferent to the most obvious violations of children's sexual innocence all around them. Advertising firms still portray flirty, pouting pre-teen girls to hawk their products, and young Pretty-Baby actresses are still cast in movies which other children see. Young boys with internet connections can watch the sexual torture of women online without fear of the overweening state stepping in. And countless teen and pre-teen girls routinely post self-made videos of themselves stripping or masturbating for the pleasure of their boyfriends; or they upload the clips for free to highly profitable porn sites where pedophilicly inclined adults can enjoy themselves for free. Meanwhile, after having been driven to school by their frightened parents, adolescents are given lectures about obtaining explicit consent from the opposite sex before trying to hold hands or plant a first kiss. The result being that pleasure is the only thing American young people are still innocent of.

Innocence is like a dumb leper who has lost his bell, wandering
the world, meaning no harm.

<div align="right">GRAHAM GREENE</div>

———————

Millions of adults around the world call themselves Christians. But can a Christian be an adult? It's a fair question.

The Hebrew Bible, overflowing with family sagas, *Bildungsromane*, and political intrigue, reveals the world and its ways even while bringing divine judgment down upon them. Adults marry, have children, educate them, cultivate land, seek and give counsel, get angry and are appeased, suffer and smite their enemies, get ill and die. There are good characters, evil characters, and many ambiguous ones such as King David, who swings from sin to repentance and back again, like a metronome. God, too, has his bad days, and the Hebrews never know quite what to expect of him. So they are forced to learn from experience and live with uncertainty. The characters of the Hebrew Bible mature before our eyes, and we mature as we read their stories.

Children and lambs get more than their due in the Gospels, but we learn next to nothing about adult life. Jesus is precociously wise and has nothing to learn, no capacities in need of development. Mary says hardly a word, and Joseph doesn't speak at all. The disciples are little more than stick figures. James and John have trouble staying up at night; Peter is something of a coward; and Thomas needs the evidence of his fingers to accept Christ's resurrection. Beyond that, we learn nothing about them, not even about the extraordinary Judas, who seems to have strayed in from the Old Testament. Jesus does not prepare his disciples for carrying the burdens of adulthood in their families and communities. Instead he admonishes them, *If any man come to me, and hate not his father,*

and mother, and wife, and children, and brethren, and sisters, yea, and his own life also, he cannot be my disciple. A good disciple drops his nets and follows without asking questions. What his wife and children eat that night we are not told.

The early Christians were an apocalyptic sect that expected Jesus to return in their lifetimes, so it makes some sense that they were little inclined to plan for their own futures or their children's, or create anything durable in the world. But the longer Christ's return was delayed, the more Christians had to accustom themselves to living in a world they found alien. Discipleship turned out to be more complicated than being reborn as a child, or imitating a lamb, or washing the feet of the poor. It required a knowledge of life, of human psychology, of political necessity. This their new scriptures did not confer on them. And so, as time went on and the Church became a vast bureaucracy and a force in world affairs, it conformed more and more to the ways of that world and lost its soul.

That, in any case, was the view of the Protestant Reformers, whose alternative was to return to the unmediated words of the Savior, which now any believer could read in a vernacular tongue, and hold fast to them in the face of whatever challenges the world posed. One does not have to be a Counter-Reformation polemicist to recognize that however much this return to the sources enriched the inner spiritual lives of the Protestant faithful, it also induced a constriction in their conception of terrestrial life and its inevitable demands. Simple believers looked to the Gospels, then to the world, and the world looked pretty simple right back at them. *Be harmless as doves...consider the lilies of the field... love your enemies...whosoever shall smite thee on thy right cheek, turn to him the other also...forgive men their trespasses...take therefore no thought for the morrow: for the morrow shall take*

259

thought for the things of itself. That doesn't sound so hard. And the Old Testament, reread in light of the Gospels, seemed pretty straightforward, too. Under the klieg light of *sola fide*, Abraham, Jacob and Esau, Moses, even Job resembled ordinary Christians just like you and me. A rich tradition of Protestant systematic theology developed in the Reformation, beginning with Calvin's monumental *Institutes of the Christian Religion*. But on the ground every time a Protestant church's doctrine has been formalized, hierarchies of authority established, and centers of learning founded, there has arisen within its ranks little Luthers who denounced this betrayal, calling the faithful back to a more "primitive" Christianity (their term, not mine). Which is why the history of the Protestant churches resembles nothing so much as a child's game of leapfrog, where the point is to keep one step ahead of maturity.

Pure? What does it mean?

<div align="right">SYLVIA PLATH</div>

Everyone needs experience with experience. Certain pious protectors of the innocent labor under the illusion that piety can only be preserved by waging a war against it. Life, they think, is a siege that can only be survived by retreating to the cloister, the yeshiva, the madrasa, the gated community, or the home school. The illusion behind their illusion is an old and crude psychology of mimesis, which holds that acquainting people only with good things will make them good and banishing all bad ones will keep them from turning bad. Even Plato may have believed this. But it is false: to guard ourselves against evil we must learn to recognize it, and to recognize the ruses people use to hide evil intentions from us. The more good one

wants to do in the world, the more knowledge one needs of it, not less.

Historically the greatest victims of these prophylactic illusions have been women, who have been secluded and kept ignorant of life in many cultures and on many and shifting grounds. Young girls have been caged during menstruation to maintain their purity, then kept under surveillance to guarantee their virginity until marriage. The need to assure paternity has been invoked to justify this obsession with virginity; so has the symbolic need to maintain the sacredness of public rituals, as, for example, with the Greek Pythia and the Roman vestals. But the Christian convent is a unique institution.

In theory, convents were established to encourage spiritual contemplation and to relieve innocent Christian women of worldly cares so they could serve others. In practice, convents were often dumping grounds for poor families unable to afford dowries or even food, or for rich families wanting to park their daughters somewhere safe before marriage. The acts of charity accomplished by the sisters over the centuries are legendary in their modesty. But until recently young nuns received little formal education unless they managed to learn Latin (something few priests were willing to teach them), and no informal education on how to deal with men, property, politics, or much else in the outside world. And they certainly learned nothing about their own sexual desires, which could only be satisfied in illicit ways. By the eighteenth century, a large European literature had developed chronicling the misadventures of young girls sent to convents at an early age, where they either had a sexual awakening (proving the futility of seclusion), or were sexually abused (proving its perversity), or remained innocent, only to be preyed upon by unscrupulous men

Lambs and Wolves

when they left. The most influential of such tales was Diderot's *La Religieuse* (*The Nun*). Drawn from a contemporary true story, the book takes the form of a series of letters written by a young woman forced by her parents to take vows and enter a convent, where she is treated brutally. When her petition to leave the order is denied, she is transferred to a second convent, where the Mother Superior tries and fails to seduce her, and ends up killing herself. Under the shock, the young woman becomes anorexic and practices self-mutilation before finally managing to escape.

Much has changed for women in Western societies and many other parts of the world. But in the vast United States there are still pockets of radical religious believers who in the name of purity do their best to keep the minds and bodies of their children, especially girls, from developing. With predictable results. Consider the case of Elissa Wall, author of *Stolen Innocence: My Story of Growing up in a Polygamous Sect, Becoming a Teenage Bride, and Breaking Free of Warren Jeffs*, published in 2008. Elissa, or Lesie as she was commonly known, had the misfortune to be born in 1986 to a family that belonged to a break-away Mormon sect in the American Southwest. The tragedy begins with her mother, Sharon, who was also brought up in the Church's cloistered community. Sharon received no sex education, no preparation for marriage apart from learning that women belonged to men *body, boots, and britches* (as she put it), and that at every moment, without fail, they must *keep sweet*, an injunction that recurs with creepy regularity in this memoir. At an early age she was compelled to marry, then was "reassigned" to another man when that marriage broke down. Eventually six of her children would rebel against the strictures of the Church, and when she was ordered to permanently cut off

relations with them she complied, telling one of them, *I'd rather see you die than fight the priesthood.* Her greatest fear was not the priesthood, though. It was the outside world, about which she knew nothing.

Lesie's fate seemed sealed. She was molested at the age of two and her parents knew it. At the age of seven she was rebuked by the prophet's deranged, sex-obsessed son Warren for inadvertently holding the hand of a cousin during school recess, and at the age of fourteen she was made to marry a different cousin whom she loathed. Totally unaware of sexual relations or how children are conceived, she resisted her husband, who was equally ignorant about it all. Eventually he just raped her, after which she swallowed a bottle of aspirin and a bottle of ibuprofen, hoping to kill herself. Lesie became pregnant several times over the next few years, but mercifully miscarried every time. She celebrated her second anniversary joylessly at a local Denny's restaurant, in a rare trip outside the sect's camp.

The rest of Lesie's memoir is devoted to her escape, her discovery of "true love," and her brave and successful efforts to bring to justice Warren Jeffs, who is currently serving a life sentence for sexual assault of a child, among other crimes. But the memoir is much more than a conventional prison break story. The unforgettable scenes are not of cruelty and horror, though there are plenty of those. They are the scenes that evoke a suffocating, and in the end tyrannical, innocence that holds even the adults in its grip, creating an environment ideal for predators who are no more worldly than their victims. Lesie grew up in a Christian dystopia where the directive *keep sweet* was as effective a means of control as any police force.

263

Their singleness, their ruthlessness, their one continuous wish
makes the innocent bound to be cruel, and to suffer cruelty.
The innocent are so few that two of them seldom meet —
when they do meet, their victims lie strewn all round.

ELIZABETH BOWEN

———————

In every life the license to innocence should expire. Societies with public rites of passage into adulthood mark this moment with ceremonies that put everyone on notice that it is time to put away childish things. Only in the United States, it seems, is the license valid for life. Appeals to history and expertise fall on deaf ears here because Americans are convinced that life belongs to the living, that anything is possible with enough effort, and that in a democratic society everyone's opinion ought to count and be weighed on the same scale — the scale of sincerity, not truth. Like members of the ancient Roman mystical cults that used children as spiritual mediums, Americans are more inclined to listen to their inner child than to scientists with their charts and graphs, who they believe probably have some secret agenda.

This prejudice is not happenstance. It flows naturally from the national myth of America as a new creation, brought into being in a self-conscious act of will after the Old World botched history up. Yet this birth was also, in a deeper mythical sense, a rebirth, the return of Adam to Eden after centuries of exile. The human race was granted its second innocence at Plymouth Rock. Consequently, the great fear is that Adamic America will bite the apple again and be cast out into the twilight world of skepticism, uncertainty, guilt, and compromise, where every other nation lives. Any backsliding into contaminating experience must be resisted or immediately forgotten. What is every American presidential election but a ritual for restoring

the collective virginity? The country lives in what William James called a state of congenital amnesia, which is what makes American politics, domestic and foreign, so frustratingly predictable. Mr. Smith is always going to Washington and Mr. Deeds is always going to town, but they never learn anything and leave as proud of their redeeming ignorance as when they arrived. America saunters through history as the Neonatal Nation, the Playpen Upon a Hill.

Reinhold Niebuhr explicitly blamed this arrested development on the Christianity that he himself professed. Or rather, on the optimistic, dewy-eyed, whistle-while-you-work version of Christianity that Americans of every faith and non-faith practice when confronted with difficult political realities, particularly abroad. Niebuhr called for a return to the fundamental insights of Augustine, whose doctrine of original sin provides, he thought, a more realistic psychological foundation for understanding human political behavior. During the Great Depression Niebuhr was a minister in Detroit, and the experience of strikes and strike breakers turned him into a committed socialist engaged in improving conditions for workers and the poor. It also taught him that fallen people do bad things if they have the power to do them, and so a counter-power must be developed and exercised to turn the world right side up. Protestants, as he saw it, have rarely been good at that. They are torn between withdrawing from politics to keep their aprons clean, or self-righteously using it to establish God's moral kingdom on Earth without recognizing their own fallen nature. The harmless Lamb of the Gospels or the vengeful Lamb of Revelation: American Protestantism doesn't offer a third model.

During the Cold War, Niebuhr became an important voice in public debates about American foreign policy, which he saw

swinging perpetually between naïve isolationism, principled internationalism, and thoughtless brute force. He cannot be pegged into any conventional ideological category. He argued for the necessity of actively resisting Soviet expansionism, but also of discerning when and where to pick a fight, and for observing limits when engaged in it. He supported the building of a nuclear deterrent, but opposed the Vietnam War. He also understood why the United States came to be hated in many parts of the world, and why his fellow Americans could not comprehend this. *Nations, as individuals, who are completely innocent in their own esteem, are insufferable in their human contacts.* Niebuhr was, in other words, that rare thing, an American political adult. He knew from experience that innocence is the mother of political cruelty and that its wages are often death, usually for other people.

In the minds of many Americans we are the Billy Budd of nations, with only the loveable fault of believing that people are basically good and that all problems have solutions. In truth, we too often resemble Travis Bickle, the raging innocent who becomes an exterminating lamb in *Taxi Driver*. A Vietnam veteran with scars on his back to prove it, Travis returns home in the 1970s and finds himself driving a cab in New York, where every street corner is a cross between *Vanity Fair* and the *Inferno*, strewn with garbage and men in superfly outfits and women in hot pants looking for tricks. Travis loathes it and vows to clean it up. He is looking for a cross to nail himself to. And so he writes himself into a chivalry tale, choosing a random teen prostitute as his reluctant damsel in distress, and her two-bit pimp as his nemesis. Travis is no spontaneous naïf; he is a master of strategic planning worthy of a general's star. He chooses his weapons carefully; he eats right and works out; and every night he prowls the ill-lit

streets waiting for his chance to set the world back in simple order. In a silent homage to the noble savage, he shaves his hair into a Mohawk and struts like a cowboy. One night he heads out on his divine mission, muttering *keep sweet and pass the ammunition.* And blood splatters the camera lens.

HELEN VENDLER

Art and Anger

Poetry can sometimes offer to the young a piercingly accurate formulation of their inchoate suffering. I remember reading, at twenty-three, two lines in a new book:

> For to be young
> Was always to live in other people's houses.

Perhaps some poet had said it before, but if so, I hadn't come across it. I learned from those lines what I was — a provincial girl in a house constituted by persons so alien to me that they were in effect "other people." It had not occurred to me that

one could think of one's parents as "other people." It was not "our house" — it was "their house." And where, then, was my house, and how could I find it? And who were my people, if not those in the house with me?

The poem containing those lines was "The Middle-Aged," written in her twenties by Adrienne Rich. It is spoken in the plural "we" by newly adult siblings, as they consider the house in which they grew up — its values, its conditions of "belonging," its rules, its "people." That house of their childhood was established by what the title estrangingly refers to as "the middle-aged," the parents now being judged by the altered eyes of their altered young.

When I read those revelatory lines in Rich's second book, *The Diamond Cutters*, I knew almost nothing of her life. I hadn't the slightest notion, before reading her lines, of how to frame the defects — always felt — of my life as a child, but I learned from the lightning-bolt of her page that my life was being lived in some other people's house, and they did not understand me, nor I them. Later, reading about Rich's early life (she was born in 1929 and died in 2012), I saw that really we had little in common except that as adolescents we had found ourselves living with people different from us: they were "other people" and we had to live in their house. That formulation — so insistently phrased in the poem — was what Rich so assuagingly offered me. She had "solved," by naming it, the inexplicable misery in which we both had existed as adolescents. We could not speak aloud our disturbingly deep disquiet with the life imposed on us. The problem of a coerced silence was already troubling Rich earlier; her first book, published when she was an undergraduate, had included a poem called "An Unsaid Word," recommending self-suppression in love. She had to train herself not to

269

interrupt the thoughts of "her man," knowing that "this [was] the hardest thing to learn."

The tyranny of the socially unsayable is a pervasive theme in the work of some fiery writers, and the anger provoking their fury often creates, in their verse, problems of tone. In "Easter, 1916," Yeats encounters on the street former friends planning armed revolt against English rule and finds himself betraying a poet's most exigent obligation: to speak intellectual and emotional truth in accurate words. After briefly greeting the conspirators, whose willingness to kill he cannot condone, he bitterly utters first a self-reproach for his cowardice in avoiding truthful conversation, then, using identical words, reproaches himself for actually lingering and prolonging his "meaningless words," an offense worse, because hypocritical, than the first:

> I have passed with a nod of the head,
> Or polite meaningless words,
> Or lingered awhile and said
> Polite meaningless words.

Such early self-restriction in fear of social ostracism is likely to result in a later explosion of language. Yeats, for instance, finding "polite meaningless words" intolerable, quite rapidly turned the hitherto unsayable into the complexly said, willing to bear the opprobrium that meets defiance of social norms. Other poets, such as Rich, have a more uncertain evolution within contrary states of feeling.

Rich, conventionally reared, found a relief from self-censorship in discreet poems such as "The Middle-Aged." Like the endangered Hamlet discovering that he must keep silence concerning his father's murder — "But break my heart, for

I must hold my tongue" — Rich could not at first become entirely candid about her prolonged suffering (fully revealed to her readers in the recent biography by Hilary Holladay). Her unhappiness — partly situational (an uncongenial family, a failed marriage, social expectations of women), partly physical (as her early rheumatoid arthritis became crippling), and partly uncontrollable (resentment against her father's estrangement from her after she married a Jew) — generated a growing tumult in her work, fortified by a commitment to a newly enthusiastic feminism especially directed against "the patriarchy." After her marriage, Rich found it impossible to hold her tongue as she had done in "The Middle-Aged," and made the search for a responsible tongue a life-long endeavor.

But like most young protestors, she had on the whole no tolerance for ambiguity, no empathy for opponents, no metaphors for a middle way. If we look back to her chief predecessor in social protest, Milton, we can see him as our most eloquent denouncer of silence in his moving elegy for his fellow-student Edward King (bearing the Greek pastoral name "Lycidas") who, like Milton, was being trained for the priesthood and already composing poetry. Milton's anonymous surrogate, who sings the elegy for his companion Lycidas, witnesses with horror a flock of local sheep abandoned to hunger and disease by their criminal shepherd-guardians. In a second dereliction of their duty, the guardians have left the sheepfold open to nightly invasion by the "privy paw" of the "grim wolf." Starvation, disease, and massacre meet the innocent eye of the young singer, and his shocked voice reveals the hideous results of the guardians' vices:

> The hungry sheep look up and are not fed,
> But swollen with wind and the rank mist they draw,

Art and Anger

Rot inwardly, and foul contagion spread;
Besides what the grim wolf with privy paw
Daily devours apace[.]

Reacting to that appalling scene of starving sheep and bloody corpses, the singer excoriates the total silence of the bystanders with three bitter words: "and nothing said." The grim wolf every single day, day after day, preys on the hapless sheep, and though everyone witnesses the ghastly daily sight, no one utters a word: the wolf "daily devours apace, and nothing said." Milton is allegorically rebuking the corrupt English bishops, as the bystanders' fear of episcopal vengeance creates a moral abyss between religious duty and social intimidation. After the young singer's lurid words of denunciation — *swollen, rank, rot, foul, grim, devour,* and not least the subhuman *paw* — the accusation arrives, surprisingly, with maximum understatement: "and nothing said." There is no immediate divine vindication of the singer's judgment; the evil shepherds are not punished, not in this poem and not in this life. Only in eternity will they be condemned.

Milton is the principal model for English civic fury, but Rich had other poets in mind as well. The punishment for poetic subversion in Dickinson is banishment, with one's name blackened by rumor. "Don't tell!" she warns any fellow-dissenter. In the Johnson edition, where Rich would have found the poem, it reads:

I'm Nobody! Who are you?
Are you - Nobody - too?
Then there's a pair of us! Don't tell!
They'd banish us - you know!

Dickinson's contempt for female social timidity ("Such dimity convictions"), however youthfully and lightly voiced in "I'm Nobody," prohibits her from choosing a name from the restrictive role-identities bestowed on women — "Daughter," "Wife," "Mother." She prefers to hide out as "Nobody," defying the parental and institutional assumption that women will take their husband's name after marriage and will fit themselves into some group-identity. (I was struck, on a visit to Dickinson's churchyard in Amherst, by two tombstones, side by side: on the first, two lines identify a man by name and dates, but the neighboring stone says only "His Wife.")

In the even-toned blank verse of "The Middle-Aged," Rich, just out of college, ventures her first explicit sally against the dutiful silence expected of her by her parents, equally silent themselves. The reader is made to feel the otherness of parents to their adult children by Rich's strange use of definite articles, beginning in her title. (Normally, we have to acquire the abstract sociological category of "the middle-aged" before we can refer to our parents as merely one set of "the" middle-aged; the title firmly places the parents as permanently sociologically distanced.) As the young adults reflect on their apparently irreproachable parents, their opening vignettes display innocuous adjectives paired with equally innocuous nouns (the parents' "safe" faces, "placid" afternoons, "measured" voices), and continue with comparably "innocent" verbs as the parents "lay the tea" or "trim the borders." Nothing could be less alarming. Yet the verbs immediately following the resuscitated memories are angry and pained: the parents' qualities and behavior — so unoffending, so inoffensive — are to the siblings the very

Art and Anger

features that they now recoil from, disclosing how "afflicted," how "haunted" they became, as they grew into adolescence, by the stiflingly conventional "custom of the house."

The irreconcilable cohabiting of parental peace and adolescent affliction generates the unforeseen but undeniable aphorism that so disturbed me when I was twenty-three: "For to be young / Was always to live in other peoples' houses." The "peace" in the house, a tacit agreement by the parents to conceal unlovely marital truths, became unreal to the adult children evaluating it later because it was theirs "at second hand," an ill-fitting temporary hand-me-down.

The poet insistently disavows the comforts of the parental house even as she names them: the peace, "not ours," the customary life of the house, "not ours." Even the domestic status symbols — the expensive Venetian "silver-blue Fortuny curtains" — have become repellent. The parents' nostalgic reminiscence of a Christmas party betrays their wish to keep the children children: the parents have to reach back fourteen years to remember the last Christmas party enjoyed by all. Now a second abstract "grown-up" formulation arrives: not only was the house alien in its otherness, but everything about it testified to the ubiquitous parental motive: "Signs of possession" (the upper-class decor) and, more sinisterly for the children, signs "of being possessed." The children are as yet uncritical, essentially owned by the parents who mold their taste: wanting what their parents have amassed, they view their domestic environment "tense with envy." In adulthood, the childhood envy has mutated into hostility.

The rest of the poem undoes the concealments of the house. There is a brief attempt to mitigate the parents' avoidance of candor as Rich recalls the forms of kindness directed at the children: "they" would have given "us"

274

anything, she says — the bowl of fruit was filled "for us"; there was a room upstairs we must call "ours" (we recall the earlier decisive "not ours. . . not ours"). Yet the twenty-year gap separating the generations now produces the "children's" harsh verdict. Against all the apparent parental devotion Rich instances the persistent scars testifying to secrets never mentioned. The estranging article "the" reappears to present the inscrutability of those mute domestic presences, their unhappy origin never divulged: "the coarse stain," "the crack in the study window," "the letters locked in a drawer and the key destroyed." Finally, as the poem closes, the siblings come to understand the artificial "peace" of the house and what was crucially integral to it: "how much [was] left unsaid." "Unsaid," — like Milton's more vehement "And nothing said" — goes on reverberating,

The unsaid continued to preoccupy Rich; her protest against parental authority, suggested rather than nakedly expressed in "The Middle Aged," turns aggressive in "Tear Gas," a poem she published when she was forty, establishing the parents as cruel enemies:

Locked in the closet at 4 years old I beat the wall
with my body
. that act is with me still.

Dickinson had made a comparable complaint:

They shut me up in Prose –
As when a little Girl
They put me in the Closet –
Because they liked me "still" –

Rich's anger against authority mounted to stereotype in some poems of her forties, as it does in the aesthetically untenable "Rape," in which she forgets that a demonic rendering of a fellow human being is rarely persuasive. Here the demon is the neighborhood "cop," who began as a boy you knew: "he comes from your block, grew up with your brothers, / had certain ideals." (The hazy second-person address — "you" — frequent in Rich, exempts the poet from directness: is she addressing herself, the woman in the poem, the reader, or all three?) The "cop" has been brutalized by his own barbaric training, and as the woman reports her rape to him, she notes (or thinks she does) his sexual arousal by her tale; at that point he becomes indistinguishable to her from her rapist. "There is a cop who is both prowler and father," says Rich, improbably opening the poem by intimating that the father of the reader, too, could become a prowler, since the two identities are apparently compatible. The woman's perception that the "cop" is taking pornographic pleasure in her tale makes her feel raped a second time; she has to "swallow" his sadistic relishing of the details, as she confesses them, of the assault. The cop's indecent "glistening eyes" fuse him with her rapist. As the poem closes, the woman leaves the precinct, intimidated and shamed:

> He has access to machinery that could get you put away:
> and if, in the sickening light of the precinct,
> and if, in the sickening light of the precinct,
> your details sound like a portrait of your confessor,
> will you swallow, will you deny them, will you lie your
> way home?

As the cop becomes her "confessor," he becomes a Father in the ecclesiastical sense. And who is to say that the woman's

brothers — once, like the cop, guiltless children — have not evolved in the same direction as their boyhood playfellow? Rich widens the stain of rape until it envelops not only three adult male social roles — father, sibling, and priest — but also two male criminal roles — the morally compromised cop, the criminal prowler.

If "Rape" is Rich's moral sermon, her aesthetic sermon from that violent period of verbal coarseness is the poem preceding "Rape" in *Diving into the Wreck*: "The Ninth Symphony of Beethoven Understood at Last as a Sexual Message." To convey her perception of the music, she summons up theatrical words: *terror, howling, yelling at Joy from the tunnel of the ego, gagged and bound and flogged with chords of Joy, and the/ beating of a bloody fist upon/ a splintered table.* Not everyone will recognize the symphony in this physically ferocious version. And "Rape" disappoints because in its indignation it sacrifices believability by demonizing generic males in both private and public functions. Although denunciation can be a distinct pleasure, the pleasure it gives is not an aesthetic one. Melodrama, caricature, and stereotyping weaken protest. In any credible poem, whether protest-poem or not, intellectual reflection, social perception, and aesthetic intuition fuse into an imagined entity that does not defy believability.

It takes even great poets some time to come to these virtues of reflective practice. Consider Eliot's early poem called "The Love Song of St. Sebastian," with its unintentional hilarity of rhyme:

You would love me because I should have strangled you.
And because of my infamy;
And I should love you the more because I mangled you.

All indignant poets eventually learn the impotence of a purely oppositional ideology. Milton's Adam comes to understand that the response to evildoing must indeed be acts, but not the Satanic ventures of literal or conceptual war. Rather, as the Archangel Michael tells him, he must add to what he knows,

> Deeds to thy knowledge answerable, add faith,
> Add virtue, patience, temperance, add love,
> By name to come called charity, the soul
> Of all the rest.

(Later, under the pretext of a pre-Christian plot, Milton allows physical violence sanctioned by divine "motions" as the blinded Samson kills the Philistines — and himself — by pulling down their temple. Intemperance can recur as temperament reasserts itself.)

If the expressive caution of "The Middle Aged" had to explode into such belligerent poems as "Rape" and "The Ninth Symphony" (both omitted in Rich's *Selected Poems*), Rich eventually found her way to a more finely filtered language of social protest by turning from polemic absolutes into an aspiring recognition of "The Cartographies of Silence." She calls on herself and her agitated sympathizers to arrive at "a deeper listening, cleansed / of oratory, formulas, choruses, laments, static / crowding the wires." In the "Transcendental Etude," dedicated to Michelle Cliff (who became her life-partner), Rich hopes to exhibit "a whole new poetry beginning here," "as if a woman quietly walked away / from the argument and jargon in

a room." She begins to assemble for her poetry a nest of varied items from both nature and art, better coinciding with her acknowledgment of her multiple selves: she will write "with no mere will to mastery,/only care for the many-lived, unending/ forms in which she finds herself." As she attempted to broaden her lyric repertoire into a globally epic one, her fame grew, and her readings were crowded by hundreds of listeners. Many women found in her work (as I had done as a girl) feelings and situations largely unrepresented in past poetry, but salient in their own domestic and social lives.

Still preoccupied by the pervasiveness of the familial unsaid, however, Rich returned to the topic at fifty-two, writing a new sequence repeating the familial scrutiny undertaken in "The Middle-Aged." "Grandmothers," an affecting three-part medita-tion, names Rich's grandmothers in the initial two subtitles of the sequence: first, her widowed maternal grandmother, Mary Gravely Jones, an Alabama Episcopalian who visited the Rich family rarely and formally, all the while "smoldering to the end with frustrate life," harboring "streams of pent-up words," a literary forebear quoting poetry to her grandchildren. She left behind an unpublished play, but after her marriage gave up writing. Next comes Rich's widowed paternal grandmother from a New York immigrant Jewish family who had relocated and prospered in Vicksburg, Mississippi: Hattie Rice Rich is remembered for her "sweetness of soul," but lacks a home of her own, and is shuttled every half-year from her son's house to her daughter's house, on one occasion (recalled by her granddaughter) sobbing at the imposed transfer. The poet remarks on the paradoxical life of her grandmother, incapable of living independently outside an immediate family context: "You had money of your own but you were homeless." Finally, in the third poem of the sequence, "Granddaughter," Rich

reproaches herself for her past egotism, for not speculating upon the inner lives of her grandmothers (fellow females inhabiting the same house), for not having written "words in which you might have found / yourselves." The grandmothers — both widowed, unanchored, untethered, pitiable — had, at least to their young granddaughter's eye, no life of their own once their years of wifehood and childrearing had ended. It is a forlorn poem, its vignettes credible, its sympathies deep, its self-reproach a surprise after Rich's earlier presumption of personal righteousness in her most polemic period.

The quieting of rage is everywhere in the late verse. (One can even long at times for the excitement and fervor of Rich's youthful poems.) The self-judgment threaded through the poet's later work does not entirely erase Rich's warm memories of the wild exhilaration of her youth in the city: friends, old neighborhoods, talk, poetry, imagined projects, sex, loud music. But beneath the nostalgic illusory elation lie the graves of that lively company, and the poet's memorial request must be posed to her own hovering death:

> Cut me a skeleton key
> to that other time, that city
> talk starting up, deals and poetry
>
> Tense with elation, exiles
> walking old neighborhoods
> calm journeys of streetcars
>
> revived boldness of cats
> locked eyes of couples
> music playing full blast again
> Exhuming the dead. Their questions

Liberties

Holladay's biography (unfortunately lacking a chronology) tracks the volatile quarrels of Rich's life and verse. The poet's first fierce declaration of independence expended itself on the lifelong quarrel with her autocratic Jewish father Arnold Rich, a brilliant physician and professor, the first Jewish doctor at the Johns Hopkins Medical School. He had extirpated from his family every trace of Jewishness, marrying a gently reared Protestant woman trained as a classical pianist and bringing up his daughters as Episcopalians. In "Sources," a long and absorbing autobiographical poem reflecting on her father's life, Rich addresses their permanent estrangement after her marriage in 1953 to Alfred ("Alf") Conrad (originally Cohen) from an Orthodox Jewish family, a Harvard graduate student in economics (soon promoted to faculty status). No member of either family attended the wedding.

There followed in Rich's life a more open quarrel with political power, pursued together with her husband (who had not been awarded tenure at Harvard) as they moved to New York in 1967, where she taught in Columbia's MFA program as she and Alf both joined the SEEK scheme of alternative education at the City College of New York, where Alf had been appointed Chair of the Economics Department. In this more public form of protest, Rich condemned the inadequacy of government support — for the schools, for the improvement of race relations, for equal justice, for women — and in the SEEK program she taught mostly minority students.

Her increasingly demanding feminism led to a quarrel with marriage itself, as in 1970 she forsook cohabitation with her husband and three sons to live alone in a small New York apartment (while returning each night to cook for the family). Her husband, treated too late for a profound depression, shot himself a few weeks after their separation. The boys

returned to Rich's care, and, according to Holladay, remained close to their mother, all visiting her in California as her death approached. Rebelling against her father's wish to erase from his life and his family all remnants of his Jewish origin (which included changing his surname from Reich to Rich and keeping a secular household), Rich began to place more emphasis on her own half-Jewish status, and to recognize the extent of American anti-Semitism.

In her final quarrel with social norms, she wrote about lesbian sexual experience, and lived with her lesbian partner. Her inner ideological and aesthetic conflicts — visible, although pent-up, in "The Middle-Aged" — continued to seek fully formed expression. As she chose to widen her gaze from those personal conflicts, she undertook panoramic Whitmanian catalogues of anonymous lives, aiming — by ranging through space and time — at an epic "objectivity" rather than subjective self-disclosure. Her decision is formulated in "And Now":

> I tried to listen to
> the public voice of our time
> tried to survey our public space
> as best I could

Her apologetic tone — "I tried," "as best I could" — marks her adult sense of her own fallibility and her own limitations as a poet. She also became newly willing (in "The Spirit of Place") to admit the conflicts struggling to articulate themselves within the human personality. In New England, "the spirit of the masters/flickered in the abolitionist's heart.../while the spirit of the masters / calls the freedwoman to forget the slave." She concedes that she and her companions must decline utopian aims and take on the imperfect world

as it is. not as we wish it
as it is. not as we work for it
to be

Her sermons, increasingly addressed to herself, repent her earlier wish to control others, and criticize her susceptibility to ideological "counterfeit light":

... hold back till the time is right

force nothing, be unforced
accept no giant miracles of growth
by counterfeit light

It is fair to say that the anger exhibited by Rich against all forms of male domination was gradually accompanied by a deep-seated querying of herself. In a poem called "The Phenomenology of Anger," she represents herself as besieged by "Self-hatred, a monotone in the mind," especially as she finds her own rage inextricable from any adult awareness of selfhood, time, and history:

Every act of becoming conscious
(it says here in this book)
is an unnatural act

In "Cartographies of Silence," warning against the black-and-white judgments of hasty or unscrutinized anger, she reminds both herself and others who had found themselves seduced by ideological passion that "We must disenthrall ourselves":

Art and Anger

cleansed
of oratory, formulas, choruses, laments, static
crowding the wires.

Like the Polish poet Zbigniew Herbert, who found himself
incapable of replicating the clichés of Communist dogma
("Really, it was a matter of taste"), Rich came to feel revulsion
against the very sound of pre-scripted and prescribed words.
In truth it is only a matter of time before a writer who respects
the resources of language can no longer echo programmed
group-speak, however politically virtuous.

Yet nothing is harder to sacrifice for a social reformer than
the audience-aimed style and psychological reassurance of the
doctrinal "we." Even when Rich thinks to abandon the "choral"
resonance accompanying the miraculous multiplication of
the lonely "I" into the powerful "we," she cannot forsake it,
although she alters its extension: her closing "we" in "Transcen-
dental Etude" turns out to be not a sisterly chorus but the fused
pronoun of the erotic couple. That idyll, however, cannot
wholly compensate for the predicament of "the pitch of utter
loneliness" in which each unique poem is "a cry to which no
echo comes or can ever come." Although Rich has claimed the
rise of "a whole new poetry" when a woman has "quietly walked
away / from the arguments and jargon," she discovers that
although feeling can be communal and choruses legitimate in
pressing for political reform, the only authentic resources for
a responsible poet must be her own penetrating imagination
and her hard-won idiosyncratic style.
From her early decision in "The Middle-Aged" to expose

284

the unsaid to her later dedication to accurate social reportage and the mitigation of declamatory hyperbole, Rich's poetry records the faithful psychological trajectory of one complicated mind, whose central topic became the sufferings of the subordinated, especially those of women. It must be noted that certain groups of the American subordinated — the blind, the sterile, the impoverished males — did not much interest her. Her political base was always her own smarting social afflictions encountered as a woman, a daughter, a wife, a mother, an exile from her family, a non-observant Jew, a lesbian, a disappointed lover. Her insight into the emotions of others never attained Whitman's spectacular capacity to "effuse" himself into other personalities whose lives were altogether different from his own — a preschool child, an alcoholic, a slave, a soldier. His profound imagination of another's existence justified his unforgettable line, "I am the man, I suffered, I was there."

Rich's heated arguments in prose as well as poetry against the coercive customs of her own society brought her fame, chiefly among women, but also led her at times into a regrettable coarseness of expression that she had the courage to abandon in later life, gaining intellectual credibility by a worthy sacrifice of her raised voice. Even as a young poet, Yeats arrived at the realization that "Out of the quarrel with others we make rhetoric; out of the quarrel with ourselves we make poetry." Rich made a half-peace with that truth but continued until her death her Whitmanian outward-looking and sometimes vague inventory of suffering, poverty, and needless death in the United States and abroad. Rich's catalogues are in theory unending, and like Whitman's they can sometimes go on too long; they gain plausibility insofar as the items in the inventory embody her specific perceptions of

the ubiquity of social failure and the unforeseeable distribution of vice and virtue.

It is not yet clear how Rich will fare in literary history. From her earliest lyric exposures of the unsaid to her later extended investigations of self and society, and from her bracing essays and other prose, she won an audience that was perhaps less attracted by poetic energy than by social critique. (The same could be said of Ginsberg's audience.) But when the temporary topical relevance of any century's poetry fades, its imaginative and stylistic powers survive. As Stevens says in "Men Made out of Words," "The whole race is a poet that writes down / The eccentric propositions of its fate."

HOLLY BREWER

Race and Enlightenment: The Story of a Slander

In 1945, Columbia University published an obscure treatise by Jean Bodin, which originally appeared in 1566, as part of its "Records of Civilization: Sources and Studies" series. Bodin was a theorist of absolutism, but one who had a profound influence on later natural rights thinkers, and this was his first work, translated from Latin by Beatrice Reynolds. Scholars across Europe and the United States were busy for over more than two centuries, but especially after World War II, collecting and publishing works that they deemed crucial to "civilization." They sought works that would aid students in understanding and furthering modernity, defined as democracy

and human rights, enlightenment, and the scientific method, as well as capitalism. As they sought significant works that would contribute to furthering "civilization" in the present by understanding its past — a kind of scholarly uplift for society — they omitted from their assembled record works that did not fit present desires. Ancient, medieval, and modern works that were not a useful past for liberal modernity were ignored — not revived, not translated, not reprinted, not quoted, not read, not taught. It was thus that they created a modern canon that revolved around and vindicated the issues that they themselves cared about.

In the years after World War II, it was increasingly the Enlightenment that garnered such attention, the one that featured John Locke and other theorists of democracy and republics, modern science, and modern economics. As American universities flourished and expanded in the 1950s and 1960s, and efforts to promote human rights and democracy around the world expanded under the auspices of the United Nations, Locke's *Second Treatise of Government*, for example, was translated into many different languages. Scholarship on Rousseau and Adam Smith, among many others, flourished. But there was a problem. The Enlightenment occurred in a period of the expansion not merely of rights, but also of European empires, of slavery and subjugation. How should we explain such inequalities? How can all these historical realities be reconciled?

Many scholars and critics, starting in the late 1960s with David Brion Davis in *The Problem of Slavery in Western Thought* and Winthrop Jordan in *White over Black,* and later blossoming in works such as Edmund Morgan's *American Slavery, American Freedom,* sought answers to this paradox. And in seeking those answers, they consulted the same sources already so

carefully selected to create the modern canons. They looked to the sources that had been chosen and compiled to represent civilization and modernity, so as to understand the origins of the subjugation, racism, and slavery as well as their supposed opposites.

It makes sense, after all. As they went through college and graduate school, those were the texts they read, and were now reading more critically. Of course, they added other sources: as greater access to more documents became available, they read more widely. Edmund Morgan once told me that his research method was to read all books published in the mainland colonies, in chronological order, as they were reproduced in the microfiche database Early American Imprints. And in the decades that followed, as post-colonial theorists built on that critical foundation, their attention has remained on that same canon, on the classics already singled out. It is a bit like the problem that police detectives describe, of the man who loses his wallet at night. Some part of the street is lit up by a street-light, and it is easiest, even instinctual, to look there. But that might not be the best place to look.

In that spirit I choose to focus here on the distasteful and the repulsive, on ideas and texts that we should not be teaching or reading, except in context. These are to be found in books and pamphlets that have been excised, on moral grounds, from our uplifting collections about civilization and enlightenment. They propound racist ideas that appear in works that we usually ignore. I have in mind a very particular and repugnant debate, mainly in the seventeenth century, over whether African women had sex (and children) with monkeys, and whether Africans were therefore of a different species and should be seen as bestial or monstrous. It is an ugly chapter in our intellectual history, but we have a lot to learn from it. I was

289

led down this path because the streetlight did not illuminate all the answers.

My adventure began with the broad claims made by Ibram X. Kendi in his widely read book, *Stamped from the Beginning*, which, building on earlier post-colonial scholars of "whiteness," attributed the origins of the repulsive racist idea that I have just described to the Enlightenment, and particularly to Locke's foundational treatise *An Essay Concerning Human Understanding*, which appeared in in 1690. The term "essay" does it no justice: it is a long and dense philosophical work, published in four books, that, for all intents and purposes, was one of the most widely read treatises of not only Britain's enlightenment, but also all of Europe's. Its insistence on ways of knowing, its exploration of how humans come to understand truth and to repudiate falsehood, it provided the definition for individual as well as group "enlightenment." Paired with Locke's theories of government, it helped to explain how human beings can and should make their own judgments about government (instead of accepting divinely chosen monarchs). I had read *An Essay Concerning Human Understanding* comprehensively, and Kendi's discussion of it clashed with my remembered reading. I had pondered every page for questions of race and racism. How had I missed what Kendi had found? Thus began my journey down a nasty rabbit hole, one that has led me to think more deeply about canons and sources of civilization, and to explore more deeply today's fierce debates about the connections between racism, slavery, and democracy in America's (and Britain's) history.

In Kendi's reading, as in much recent scholarship, the

Enlightenment was anything but enlightened. It embodied whiteness and privilege. Its scientific theories created racism. It legitimated slavery. Slavery, in the contemporary "anti-racist" account, emerged in each of England's thirteen colonies in the Americas as a result of relatively unified (and relatively democratic) support among whites. My point here is not to belabor the realities of racism in early America: on that I think we are all agreed. But I do want to challenge an assumption about its pervasiveness, and where it came from, and especially the idea that it was "stamped" from the beginning. From my study of these sources (and many others) I would argue instead that it was contested from the beginning, and that it changed over time and varied by place.

I suggest that maintaining our focus on the works and the authors whom historians in the past identified as progressive helps to conceal a more complex, and more interesting, debate over principles of privilege and power, over racism and inclusion, a debate fiercely fought on many levels in early modern England and its colonies, even as they went through three revolutions over those centuries. Racism and slavery were not isolated from those struggles, but part of larger contests over power. Many scholars and thinkers whom we now identify with the Enlightenment were in fact pushing back against slavery and racism as well as the larger structure of power that had mainly promoted them.

Kendi's analysis of four hundred years of American history in *Stamped from the Beginning* sorted thinkers into racist, neutral, and anti-racist. He consigned Locke to the racist camp.

Locke also touched on the Origin of Species in *An Essay Concerning Human Understanding*. Apes, whether "these be all *Men*, or no, all of human *Species*,' depended

291

on one's "definition of the word *Man*," because, he
said, "if History lie not," then West African Women
had conceived babies with apes. Locke thus reinforced
African female hypersexuality in a passage sent round
the English-speaking world. "And what real *Species*, by
that measure, such a Production will be in Nature, will
be a new Question." Locke's new "Question" reflected
another new racist debate that most debaters feared to
engage in publicly. Assimilationists argued monogenesis:
that all humans were one species descended from a single
human creation... Segregationists argued polygenesis.

Kendi placed Locke squarely in the ranks of the most
racist thinkers, acknowledging that while an obscure Italian
thinker named Lucilio Vanini might have broached the
repulsive idea in 1616, Locke was the first to popularize it in
English. This is a grave charge, and it is somewhat difficult to
challenge since Kendi provided no footnotes to the passage
that he cited from Locke.

Who was Locke responding to? Kendi says Locke was
repeating Vanini, an arcane Italian philosopher of the late
sixteenth and early seventeenth centuries who seems to
have been both a theologian and a freethinker, and an early
proponent of biological evolution. It is true that there were
some Italian claims about this issue beginning in 1618, and a
few even earlier, but in fact the idea was "popularized" by
another Englishman, Thomas Herbert, in 1664. And Herbert
did much more than popularize this racist canard about black
bestiality. He claimed to have observed it! Locke, as we shall
see, was actually trying to *refute* such claims.

Making sense of them requires beginning with Jean
Bodin's *Method for the Easy Comprehension of History,* the work

292

that was translated and included in the history of civilization series at Columbia in 1945. First published in 1566, Bodin's book appeared in the midst of debates all over Europe about the justice of colonization and over the best forms and practices of government, and amid speculations about all the different peoples that European explorers and colonizers were encountering and describing. Bodin sought laws of human behavior, and he claimed that the Roman historian Tacitus had argued, in an instance of such a law, that people who live in hot climates were more lustful, a conclusion that he validates by basing it on the medical theory of the humors. Bodin then wrote, claiming to be following Tacitus, that "because self-control" for "southerners" in hot climates "was difficult, particularly when plunging into lust, they gave themselves over to horrible excesses. Promiscuous coition of men and animals took place, wherefore the regions of Africa produce for us so many monsters." Bodin thus maintained, in a single sentence, following an ancient authority, that in Africa human bestiality led to non-human progeny. But his sensational claim was buried deep in a Latin text that was available only to a few scholars. And it appeared on a page full of outlandish claims made by ancient authorities: Caesar's assertion, for example, that "Britons have twelve wives in common and that brothers cohabit with sisters."

In the early seventeenth century, there were a handful of brief references in European sources to the possibility of interspecies sexuality between people and monkeys, but it is always described that way (as between humans and animals), and it was always treated as a rumor, and in no more than a passing remark. So, for example, the Portuguese explorer André Donelha referred to rumors that he heard about sex between monkeys and women in his book describing his

293

travel to western Africa in 1625. "They say" he wrote, that if a male monkey "meets a woman alone, it makes a match with her." Donelha said nothing more about it, and he included that brief sentence at the end of a long discussion about monkeys, not people. There was no mention of any progeny of such unions. It does not appear that Donelha's book (or Vanini's or Bodin's) was widely read, except perhaps by a few scholars, though the rumors were being repeated.

It was only after the restoration of Charles II to the throne of England that the claims became anything more than rumors, and the effort to proliferate this dehumanizing allegation seems to have been deliberate, emerging in tandem with the English crown's efforts to become formally involved in the slave trade. Such efforts began mere months after the restoration, and centered on the efforts of the King's brother James, the Duke of York, who would later brag that the Royal African Company was his idea. England had an earlier company with monopoly rights to trade in Africa, known as the Guinea Company, but no real territorial claims and no fortifications in Africa before 1660. Initially called the Royal Adventurers into Africa, the Royal African Company was its nickname almost from the start. On October 3, 1660, Samuel Pepys recorded in his journal "I heard the Duke [of York] speak of a great design that he and my Lord of Pembroke [Philip Herbert, fifth Earl of Pembroke] have, and a great many others, of sending a venture to some parts of Africa." James convened the first meeting to plan for a Royal African Company that would organize and provide military support for English trade with Africa later that month. One of his biographers noted that while many

at the time reported that James supported trade generally, in practice he was actively involved only in the Americas and Africa. While the public talk was of gold, which was indeed a part of the plan, the private discussion included, from the first, slavery.

A part of what Charles and James were promoting in their policies was explicitly racist. Given that all publications had to gain the royal imprimatur to be published, it is subtly revealing to consider what the censors approved. One of the books which earned their approbation was an important work by Thomas Herbert, cousin to Philip Herbert, the Earl of Pembroke, which went through three editions between 1664 and 1677. Significantly, Herbert was cousin to the Earl of Pembroke, who, as Pepys reported, was one of the primary planners of the Royal African Company, and Pembroke was Herbert's sponsor in court. Herbert was also popular in court circles because he claimed to have protected Charles I at the end of his life, such that Charles II knighted him in 1660.

In the 1620s Herbert had traveled along the coast of Africa in the delegation of the English Ambassador to Persia. In 1634 and 1637, he published two identical accounts of his travels, which had a substantial section on Africa. The account was racist in its portrayals, but at first he used relatively generic words about savagery and, as the historian Jennifer Morgan has pointed out, added a claim that African women nursed their children by swinging one of their breasts over their shoulder, a claim that makes them seem less than human.

But what Herbert added in 1664 was far worse. He claimed to have witnessed, with his own eyes, African women having sex with apes, and that they were bestial and belonged to a separate non-human species. His discussion went on for many pages. Of Africans, he wrote that

Their language is rather apishly than articulately
sounded, with whom 'tis thought they have unnatural
mixture... having a voice 'twixt humane and beast, makes
that supposition to be of more credit, that they have a
beastly copulation or conjuncture. So as considering
the resemblance they bear with Baboons, *which I could
observe kept frequent company with the Women*, ... their
savage life, diet, exercise, and the like considerations,
these may be said to be the descoent [descent] of Satyrs,
if any such ever were... Now what Philosophers alledge
concerning the function of the Soul may be made
applicable to *these Animals*, that the Soul of Man is
gradually rather than specifically differenced from the
Souls of Beasts...

Herbert's claims are staggering and foul, but what is most
disturbing is the claim of witness: he is pretending to have
actually observed these things, so as to create an argument
about a different species of human, even implying that Africans
do not belong in the category of human at all. In this early stage
of the scientific revolution, Herbert was claiming the mantle
of empirical authenticity. His edition of 1677 would under-
score and elaborate these assertions.

Herbert was building not on earlier claims about Africans,
but on similarly bizarre claims that Spanish priests had made
about Peruvians.

Upon which account, the Spaniard of late years made
it the Subject of their dispute, whether the West-Indi-
ans were of descent of Adam, or no? or whether they
were not rather a middle species of Men and Apes? Had
it been a *quare* concerning these Salvages, might have

carried with it greater probability. *Bocerus* also treating of monstrous births in Peru says that it proceeds from a Copulation of Women with Monkeys; which as repugnant to the due course of nature is not to be maintained; though these are a subject for that dispute as much as any.

Perhaps the creepiest part is how Herbert describes such activities as repugnant, and argues that if this happened in Peru, why not in Africa, and connects such sexual activities between Peruvians and "apes" with "monstrous births," with a non-human "middle species." Herbert then returned to the subject of Africans, to quote Aristotle, in Latin, that "all human beings throughout the world worship god, true or false" and concludes: "I saw no signs of any knowledge of God, the law of Nature scarce being observed: No spark of Devotion. He thus insinuated that Africans were far worse than mere "savages." They were, quite simply, not human.

Herbert's grotesque addition of such material in 1664, just as the Royal African Company launched the slave trade to its colonies in the Americas and as England began to supply enslaved Africans to the Spanish in Jamaica (their first formal involvement in the Asiento), suggests that pseudo-scientific stories and lies helped to justify the differential treatment of Africans. Herbert added these new claims without traveling to Africa again. He also added new sections in 1664, wherein he made observations about other parts of the world that he had never visited, as other scholars have noted. There is no doubt that Herbert's imaginative additions — his lies — about African and ape sexuality emerged not from his observations, but out of deliberate propaganda efforts. His claims went far beyond those of Bodin, Vanini or Donelha. They had referred

to rumors. He was writing ethnographically and describing what he claimed to have observed. By linking such sex acts to monstrous births, he provided a basis for considering Africans as a different species of non-humans.

Herbert's claims were far from universally accepted. Over the two decades that followed, many would argue with Herbert's claims that Africans were a separate species. Those who did included Chief Justice Sir Mathew Hale in *The Primitive Origination of Mankind* in 1676, the only work of his that he allowed to be printed during his lifetime. In the book, over four hundred pages long, Hale asserted the common humanity of all peoples, and argued that heathens, too, have souls.

These arguments echoed across the Atlantic. In Barbados, a minister named Morgan Godwyn referred to both the original claims and to Hale's response. A former student of John Locke's at Christ Church College, Oxford, he spent fifteen years as a minister in Virginia and Barbados. He mixed up the source of such claims, confusing Herbert with a travel writer named Tavernier, but he took pains to explicitly refute them when he published his *Negroes and Indians Advocate* in London in 1680. Godwyn reported that even in Barbados many were talking about the allegations of bestiality and bestial progeny, so presumably they were in London as well. He then carefully challenged the accuracy of Tavernier's account, arguing that mandrills or apes (whom he calls "drills") who have some of the semblance of men are actually very different from humans.

Godwyn alleged that the only people who disagree with his observations — who express "wild opinions" that follow Herbert's claims about interspecies sexuality — were planters, who were driven to these falsehoods by their hunger for profit. He refers to such allegations of sexual encounters between Africans and apes as a "wild speculation." He asserts that the

298

claim is made only by those who want it to be true, in order to deny rights to Africans, including their right to baptism.

Insisting that such claims of interbreeding between Africans and monkeys were patently ridiculous, he observed that the Africans whom he met in Barbados were smarter than many of the Englishmen around them. He argues, again contrary to Herbert, that Africans have religious sensibilities. All of the Africans he met were people with souls who possessed reason. "The shape and figure of our Negro's Bodies, and their Limbs and Members; their Voice and Countenance, in all things according with other Mens; together with their Risability and Discourse (Man's peculiar Faculties). . . These being the most clear emanations and results of Reason, and therefore the most genuine and perfect characters of Homoniety [humanity]."

Godwyn asserted that all the Africans he knew were capable of learning to read and to write. "How should they otherwise be capable of *Trades*, and other no less Manly impoyments; as also of *Reading and Writing*; or shew so much Discretion in management of Business; eminent in divers of them; but wherein (we know) that many of our own People [Europeans] are *deficient*, were they not truly Men?" Some have become overseers of plantations, and have been placed in charge of complex financial and management responsibilities. "Or why should their Owners, Men of Reason no doubt, conceive them fit to exercise the place of Governours and *Overseers* to their *fellow Slaves*, which is frequently done, if they were but meer Brutes?" He then poked some fun at racist idiocy: "It would certainly be a pretty kind of *Comical* Frenzie, to imploy Cattel about Business, and to constitute them Lieutenants, Overseers, and Governours, like as [the Roman Emperor] Domitian is said to have made his Horse a Consul."

299

Godwyn, as noted above, was one of Locke's few students from his time at Oxford, and almost certainly met with Locke in the 1680s upon his return from Barbados. Locke had a copy of Godwyn's *Negroes and Indians Advocate* in his library, and appears to have used the same words, in his brief discussion of the issue, as Morgan; like Godwyn, he referred not to apes or monkeys but to "drills," short for mandrills, one kind of monkey. Although he read widely in travel narratives, and referred to them frequently in his writings, Locke did not own a copy of Thomas Herbert's travels. He did own Tavernier's six volumes, but if he tried to find Godwyn's reference, which was clearly to Herbert and not to Tavernier, he would have been frustrated, as I was, because it is not there. Locke's references to the source of the claims that Godwyn was countering were therefore left vague.

Locke discussed these claims in a short section in the middle of his *Essay Concerning Human Understanding,* and only abstractly. Uncannily, he dedicated his treatise to Thomas Herbert, the eighth Earl of Pembroke, who was the son of Philip Herbert, the patron of Thomas Herbert the traveler (now dead), the current Earl's cousin. It is almost as though there was a strange trans-generational conversation about these questions — of what defines a human or an animal species — and the current earl was trying to distance himself from his father's and his cousin's views.

In the third book of his work (§22-23, first edition), Locke speculated about the inadequacies of our words to understand the essence of ideas, including our ideas about the essence of human beings as a distinct species. How do we form an abstract idea about a species, whether human, animal or plant?

It cannot be based merely on appearance, as there are animals that look like humans: "there are Creatures in the World, that have shapes like ours, but are hairy, and want Language and Reason." It cannot be merely by the ability to speak, as there are humans who are born with birth defects, who lack reason, or are born without the ability to speak: "There are Naturals amongst us, that have perfectly our shape, but want Reason, and some of them Language too." He continued that there is a third category of "Creatures . . that have Language, and Reason, and a shape in other Things agreeing with ours, have hairy tails." So how do we know who is a human? "If it be asked, whether these be all Men, or no, all of humane Species; 'tis plain, the Question refers only to the nominal essence." Unfortunately, he argues, most would draw conclusions based on a judgment of whether the "internal Constitution" reflects the "outward frame." Locke's larger effort in this section was to identify the "real essence" of different species and how humans use "abstract ideas" to understand that essence, and to see beyond the outward appearance. Even children with major malformations, whom he here calls "naturals" or "change- lings," still have an "internal constitution" that makes them human, even if these are different from "reasonable men." They are different from apes ("drills"), even if they share an outward appearance.

301

He then introduces a reference to the allegations that had been floating around: whether "women have conceived by drills" a kind of monkey. He argues that it is difficult to tell a species merely from generation, since different species can generate mixed issue. as when "the mixture of a Horse, and an Ass" makes a mule; it confutes our ability to think about species. Then he wrote the crucial sentence: "For if History lie not, Women have conceived by Drills; and what real Species,

by that measure, such a Production will be in Nature, will be a new Question; and we have reason to think this not impossible." We are left wondering about his source. (Tacitus, via Bodin? Herbert? Godwyn's unnamed source?)

Yet the phrase "if history lie not" already expresses skepticism. Likewise, Locke states that if in fact a woman and an ape could have children, such an offspring "will be a new question" as to what species it is, since it would be, if so, in-between the two. The words "will be" indicates Locke does not in fact believe that anyone respectable has seen it. It might be true — as in the case of an "ass and a mare" — that such a union would produce a mule (which is sterile). But he draws a distinction between a woman (of human species) and a drill (of animal species).

Moreover, Locke does not, as Kendi implies, use a racial signifier in this discussion: not "west African women" or "negroes" or "Africans." He simply uses the word "women," without any qualifiers. If one did not already know about this debate, one would have no idea what Locke was talking about. Indeed, inasmuch as a reader of Herbert might think he was talking about women in Africa, he states that these are women like all women. It is a dramatic leap from this theorizing about the essence of humanity as a species, and our conceptual understanding of "man" as opposed to animals, to Kendi's claim that Locke argued that "Ethiopians and apes must have the same ancestry, distinct from Europeans." Nor is there anything here to suggest that any particular group of women is hypersexual. This discussion is a minor part of Locke's larger project, which is to understand how humans come to have reason.

In his *Essay Concerning Human Understanding*, then, Locke held that any claims that women had sex with apes, "if true," would not create a separate species. His argument

302

is not as strong as Godwyn's, but he was also not answering the question directly, as was Godwyn. He was addressing the question of how humans categorize ideas. Kendi's claim is false and highly misleading. And since Kendi uses the claim that Locke originated this particularly heinous racism to impugn the integrity of Western liberalism, the slander is rather a large one. There is nothing pedantic about getting this intellectual history right. The stakes are considerable.

Does referring to such an issue as procreation between women and apes, even in such an oblique way as Locke did here, constitute in and of itself racism, especially if the emphasis is on the claim that women and apes are of two entirely different species? Is it racist to mention the claim explicitly and then to challenge it point by point, as Godwyn did? By such a standard Kendi himself would be racist, as would I, merely for considering this evidence. Kendi claimed that Locke was arguing for a racist position that "most feared to engage in publicly." But Locke, and especially Morgan Godwyn, whom Kendi also discusses, were arguing *against* such claims, and especially against such implications. Godwyn in particular is acting as an "antiracist" here, to borrow Kendi's own categories, and Locke should either be considered an anti-racist or a neutral figure.

Why does it matter for Kendi's larger argument whether or not his analysis of Locke and Godwyn — and of other contemporary thinkers such as Richard Baxter — is accurate? The answer is simple: Kendi makes it appear as though virtually all whites agreed with racist positions that were "stamped from the beginning," including those whom we might expect to do the opposite, such as "enlightened" thinkers who advocated for human rights, such as Locke. Such references from Locke and Godwyn are Kendi's "proof." They permit him to argue that ideas about consent or rights were

303

meant to apply only to whites, and therefore are themselves morally and racially flawed.

In this first section of his book, Kendi conflates the arguments of many authors — not only Locke but also Richard Baxter and Morgan Godwyn — with those they are arguing against. The crucial figure with whom they were contending was Herbert, whom Kendi ignores. Kendi instead identifies another French traveler as the father of racial classification and a "friend of Locke's": Francois Bernier. Locke did correspond with Bernier, and Bernier did distinguish between four different races of human beings (African, European, Asian, and Laplander), but he did not state that these different races were of different species. For purposes of this consideration, Locke's work does not reflect any theories of racial difference. The divergence between the actual text of *An Essay Concerning Human Understanding, the Negroes and Indians Advocate*, Baxter's *Christian Directory,* and Kendi's interpretation of them makes it appear that Kendi did not read the originals of these texts, but only other scholars who quoted from them.

Kendi also claimed that Locke's family was long involved in the slave trade. "In 1554," he writes, "an expedition captained by John Lok, ancestor of philosopher John Locke, arrived in England after traveling to 'Guinea.'" Yet the *Dictionary of National Biography* — not exactly an arcane or out-of-the-way source — confirms that "John Lok," the person who traveled to Guinea, died without issue. The philosopher John Locke's father was John Locke; his grandfather, born in 1674, was Nicholas Locke and he was a clothier by profession. His great-grandfather, born in 1540, was Edward Locke, and his great-great grandfather was Nicholas Locke, born in 1517. They were artisans, not slave traders. Repeatedly, Kendi labels people who criticized slavery and racist ideas — and were

persecuted for such criticism — as supporters of both. I would put Richard Baxter in particular in this category: in 1775, the ideas of this alleged racist villain were cited by none other than Thomas Paine to argue against slavery.

As for Locke himself, he does not emerge from careful examination with clean hands. Between 1660 and 1675 he and his mentor, Anthony Ashley Cooper, the third Earl of Shaftesbury, cooperated with Charles II and his brother James: both owned stock in the Royal African Company (sold in 1675), and both participated on some level in the crafting of the Fundamental Constitutions of Carolina in 1669, which included language about the powers of masters over slaves (even if, as I have shown elsewhere, most of the provisions corresponded to the earlier charter and to the wishes of the eight proprietors). But Locke's later work, for which he is best known, arose in critical response to such policies and attitudes by the Stuarts, including the *Two Treatises of Government* and *An Essay Concerning Human Understanding*. After the Glorious Revolution, he was appointed to positions of substantial responsibility on the Board of Trade, with colonial oversight, and in that capacity he helped to reverse earlier policies that had given planters fifty acres of land for buying a slave. He also argued that "people of all nations are of one blood" (from Acts 1:17) and that the children of "negroes" and Indians who lived in the colony should be "baptized, catechized and bred christians—" a right that arguably, given then current legal norms that to gain the rights of subjects one had to be Christian, should have enabled them to claim other rights, including potentially manumission. Did Locke do enough to reverse slavery? No. But did he make arguments that indicated that he thought Africans were fully human with rights, and part of the same species? Absolutely.

Race and Enlightenment: The Story of a Slander

Of course Locke is merely one figure of the Enlightenment, and there were many more over two centuries. It is certainly not my purpose here to exonerate all these figures, some of whom expressed racist sentiments. I wish, rather, to place those comments into broader struggles over power, over empire, over legitimacy; and to insist that outside of such contexts they cannot be properly understood; and to suggest that the Enlightenment had its origins in the struggle against slavery, a struggle which is much older than recent historical discussions would have us believe. Likewise, early modern science as it emerged in this period should be put into the context of the religious debates and the travelers accounts and the political structure that surrounded it. Interestingly enough, Charles II's Royal Society, which promoted science, never gave Thomas Herbert a platform (from what I can discover); he certainly never published in their *Philosophical Transactions.*

And still earlier, it is possible to trace an entire range of speculations about apes and their similarities (or not) to humans made not by scientists or philosophers but by religious figures and the writers of a wide range of pamphlets, many of them not respectable, though their authors are little known. In 1670, for example, in his treatise *The Divine History of the Genesis of the World*, the cleric Samuel Gott clearly distinguished between "Apes, Baboons, Marmosets, Drills, and I known not what Bestia Fauuns and satyrs, as one degree removed form ourselves . . . yet we [humans] Classicaly differ, and vastly excell them, in our Intellective Spirit." In 1653, in its second edition, which was enlarged with many woodcuts, John Bulwer's *Anthropometamorphosis* reflected on these questions, through both his reading of a *Book of Monsters*

written by the Dutch physician Nicolaes Tulp in 1641, and his own observation of a Guinea Drill that he had viewed that Christmastime near Charing Cross in London.

> The haire of whose head (which was black) grew very like the haire of a child; it was a compleat Female too, not above eleven months old, and yet it seemed to me to answer the Dimensions which Tulpius gives of his Angola Satyr. The Keeper of it affirmes, it will grow up to the stature of five foot, which is the ordinary size of little men: He would go upright and drinke after the same manner. Her Keeper intended never to cut her haire, but to let it grow in full length, like a womans; in case she should dye, her carkasse was bespoke for Dissection by some Anatomists, who perchance have a Curiosity to search out what capacity of Organs this Rational Bruit had for the reception of a reasonable soule, or at least of such a delitescent reason; which Drill is since dead, and I beleeve dissected, but of the Dissectors and their observations I have not received any intelligence.

In 1699 an English scientist would publish a comprehensive account of such a dissection of a Drill, this time with the patronage of the Royal Society. He concluded that it and humans were quite distinct. Moreover, Bulwer proceeded to tell a story that made the woman who had sex with the ape not an African but a European, a Portuguese, woman:

> Of which monster I may say what Jordanus saies of the aforesaid Orang Outang, or Tulpius his wild man, that it proceeded from the wicked copulation of man and beast, the Devill Cooperating, and Divine revenge (without all

doubt) ensuing thereupon: of the same Tribe and Origi-
nall were those two children which the Portugall woman
bore to the Great Ape, when she was exposed into a
desert Island inhabited only by such Apes; a story well
known in Portugall, and is worth the reading in Delrio.

By the late eighteenth century such debates had become
more widespread, and they continued, as in the seventeenth
century, to interweave the political with the scientific. A
Jamaican named Edward Long, in his history of that island,
repeated comments that came from Thomas Herbert, alleging
that blacks were a separate species. Thomas Jefferson, in a
shocking passage in his *Notes on the State of Virginia* in 1781,
referred casually to "the preference of the Oranootan for the
black women over those of his own species." Jefferson's *Notes*
originated in his correspondence with the French naturalist
Buffon, and his awful remark appears in a section wherein
he described supposed differences between white and black
peoples. Jefferson was not the founder of modern racism; that
dubious accomplishment, as should now be clear, belonged
to Thomas Herbert. But once again the only appropriate
frame for understanding such racism is the full historical
picture. These were questions about which Jefferson was torn.
Elsewhere he spoke powerfully about including Africans
in the ranks of "all men are created equal," most notably in
his original draft of the Declaration, where he referred to
Africans as "*MEN*," in capital letters and italics, and in another
section of his notes on Virginia, where he wrote that in the
event of a slave uprising God would side with the enslaved,
as theirs was the cause of justice. It began: "I *tremble* for my
country when I *reflect* that *God* is *just*: that *his justice cannot sleep
for ever.*"

My point is that some Enlightenment figures, even as they made arguments that we might today want to celebrate, also reacted to racism, sometimes building upon it, sometimes rejecting it. The figures singled out by earlier scholars as "enlightened" hardly originated racism. The real garbage was usually generated by figures that earlier scholars in the twentieth century did not choose to celebrate, or honor, or reproduce. They are not generally included in our accounts of what we admire as our "civilization." Such seventeenth-century figures as Herbert and others, who legitimated both the slave trade and slavery for all non-Christians and specifically for Africans and Indians, are a perfect example. If we want to understand the origins of racism, then, we need to look beyond the streetlight, beyond the old canons.

We must understand that crucial texts of liberalism and the Enlightenment that to this day anchor our educational and political systems emerged within a context that included the distasteful and the unusual. We must look to the freaks and the monsters, those whose ideas still do not bear reprinting except as excerpts and in context. We need to discover the QAnon of the seventeenth and eighteenth centuries. Such reconstructions should always be in a political context, for the creation of racist ideas was always a political act — propounded, as Godwyn noted in 1680, by those whose interests were at stake, whose "wild opinions" were promulgated "by the inducement and instigation of our Planters chief deity, Profit." Godwyn acknowledged that "they'll infer their Negro's Brutality" to "justifie their reduction of them under Bondage; disable them from all Right and Claims."

Racists were emphatically not "stamped from the beginning." Racist ideas were contested, and debated, often sharply, by many Enlightenment thinkers who created

309

comprehensive arguments that challenged all hierarchies, including racism and slavery. The evils of racism and slavery provoked in their own time a tradition of antiracism. Even within the limitations of their time and their discourse, these disputations helped to create the foundation for many of the principles of human rights and democracy.

SHAUL TCHERNIKHOVSKY

To the Sun

Among the great longer poems of the twentieth century,
the circumstances under which Shaul Tchernikhovsky's
To the Sun was composed were perhaps the most unlikely. This
sonnet cycle was written in Hebrew in war-torn Odessa in 1919,
with Red and White forces struggling for control of the city.
Tchernikhovsky, then forty-five, had served on the front lines
as a doctor in the Russian army, an experience directly reflected
in the seventh sonnet of the cycle. He grew up in a modest-
sized town on the Ukrainian steppes, and Russian, not Yiddish,
was his first language. The experience of being nurtured there
through an intimate bond with nature is explicitly recalled

in the first three sonnets of the cycle, as is his feeling of being torn away from that cherished bucolic realm when he came to Odessa while still in his teens. After his army service, working part time as a doctor in Odessa, he was earning barely enough to support himself, his Russian wife, and their young daughter, and food in any case was in scarce supply.

In the midst of all this turmoil, Tchernikhovsky chose to compose a hugely ambitious synoptic poem that would tell the story of his calling as a poet, express his passionate credo as a vitalist and a pantheist, articulate a vision of the role of art and also science in human culture, and confront the challenge to that vision posed by violence in history. He did all this, moreover, in Hebrew, a language that was just beginning to be revived as a spoken tongue. The poetic form that he embraced was the sonnet corona, an especially intricate one originating in the Italian Renaissance. It consists of a sequence of fifteen Petrarchan sonnets, with the requisite rhyming octaves and sestets, in which the last line of each sonnet is repeated as the first line of the next sonnet, with the concluding sonnet composed of all fourteen of the first lines in the order in which they first appeared. Tchernikhovsky's choice of this difficult form is in itself an expression of his deep commitment, even under great stress, to the tradition of humanism, the formal perfection of the corona being a kind of homage to his Italian precursors and a bulwark against the chaos swirling around him in the Russia of 1919.

To the Sun is a work of stunning technical virtuosity. Unlike many of the Hebrew poets of his time, Tchernikhovsky had no traditional religious education, and the neo-pagan worldview that *To the Sun* articulates, conjuring up a fusion of fire and blood in all things, feels authentic to the poet. This translation makes no attempt to emulate the rhyme scheme, for it is

hard to see how that could be done without transmogrifying and distorting the meanings of the Hebrew. A compensatory effort has been made to give a certain rhythmic integrity to as many of the lines as possible. Tchernikhovsky's Hebrew is difficult, often deliberately swerving from the ways in which the language was used by other Hebrew poets of his era. At some points in the cycle, the exigencies of rhyme and meter produce lines that are crabbed and somewhat obscure in the original, and these have not been smoothed out in the translation. But whatever the limitations of this English version, it is offered in the hope that it will make visible to English readers a grand poetic edifice that combines humanistic values with a vivid sense of the world's pulsating, eternally sustaining life.

ROBERT ALTER

To the Sun

Our ancestors who were in this place, their backs to God's temple
and their faces to the east, would bow eastward to the sun.

BABYLONIAN TALMUD, TRACTATE SUKKAH

1.

I was to my god like a hyacinth or mallow
 That has naught in its world but its pure beaming sun,
 And an angel came knocking: "Rise, grow, blossom's scion,
 burst forth
In your song, festive song, in sharp thorns."

I sucked the juice of the furrow. Like wine the scent
 whelmed me
 Of the crop-yielding soil with its clods, its soft clods.
 Lacked he prelate and priest in the great city's temple
That he led me on here, set me out as his prophet?

Is the sap on cypress-silver any less in my eyes
Than your good olive oil glowing gold on the head,
And the fragrance of pear-tree in the field that I tended

Than Sabean merchants' powders, than my nard and my
 incense?
And I bowed to you secretly, bent low in reverence.
Like one stalk of gold grain in stalks heavy with yield.

2.

Like one stalk of gold grain in fields heavy with yield
 That sprang up in great beauty and flourished in vigor,
 Like this stalk of grain hiding within it its secret,
Life's pledge everlasting and relic of old.

Liberties

Like stalk of grain furrow-stolen that suckles the earth
 And moist with live nectar it dreams of its glory,
 I, too, did burgeon! But my soul ever thirsted.
Ah, day chases day! Shall I call in the writ?

My dream yet unrealized, my path still hidden.
When on all sides I am fearful: what for me, who for me...
Have I come to the border? Have I already crossed it?

Did my father deceive me and not keep his word?
A wildflower am I, and my sun is my father.
He sent me warm rains and decreed mountain mists.

 3.
He sent me warm rains and decreed mountain mists,
 And the twilight of sea-depths, abode of great silence,
 A dense cloud of fire burning hot in its casement,
And until it bursts upward, earth's breadth but confines it;

The sundial too confining to take in the limit,
 The sun with the clamor of ocean fire on it,
 And words from old times passed by father to father,
Raptures of great city's sick, lore of guileless peasants,

For me to be the axis of the world that he fashioned,
Its essence, true center, he stored up in abundance
For the present and future, for the past that sped by,

And in abundance of charm and colors never shamed me
And endowed me with much—through his power so strong—
Light-and-shade's symphonies, kohl, rouge, and crimson.

To the Sun

Light-and-shade symphonies, kohl, rouge, and crimson,
 Cold-crystal mummies and iridescent sea-sleepers,
 The brief moment of life of a spark struck off hot,
In heavy-hued alabaster and sepulchered shipwrecks;

And the networks of tree-veins in mahogany's crosscut,
 Trees that are bloodlogged and shoot up in fury,
 Hues before daybreak, of evening bathed in blood
That sloughs off gold treasures and will never be poor--

One melody all, one wondrous high song.
Can the master of numbers, can he solve the riddle,
Or life kingdom's scholars, can you tell it to me?

Guileless hearts have long solved it, and from innocent hearts
I, too, absorbed it, for my heart did not cheat me!
Age-old sorrow I fathomed, each nation's song charmed me.

5.

Age-old sorrow I fathomed, each nation's song charmed me.
 The dream of On's soothsayers etched on a wall,
 And the writing of druids incised in chalkstone,
Amulet on parchment, wizard's song, poor man's stammer.

In writ giving law to age and nation before me,
 Incantations of shepherds that are whispered by sheepfolds,
 In the rapture of magus who is seized by convulsion,
In the talismans of China does my curious gaze

Liberties

Descry but this prayer, flesh-and-blood's pleading:
"You who dwell in the secret of being,
 O keep for me the blood.
Quench not the fire you lit in me through your mercy,

Liquid fire guarding fire, just one spark from your flames!"
That is the grand sum in the bitter heart lodging,
Voice of soul wrapped in light, voice in foreign dark straying.

 6.
Voice of soul wrapped in light, voice in foreign dark straying,
 Clash within me—for my consecration fell short.
 A realm of stark doubting, of doubting what is certain,
Pressed round me like a dream in tight-woven raptures.

And in the living man's upheavals who clings to each ruling
 Of law piercing law undermining Shaddai,
 A guileless faith's armor I donned over my khaki
And in each day's profaneness its small remnant
 stayed with me.

Were it not for the scents of the rich crumbly soil,
Stifling heat drifting up from the granary's chaff,
The shovel's ring splitting furrow and scythe singing in grain,

I soaked these up in the village, in that freedom, still a child—
Who stood by me in the battle, when my heart
 clenched within me,
When I stood between the living and one breathing his last?

7.

When I stood between the living and one breathing his last
 (What a terrible craft), a sharp scalpel in my hand,
 Some would weep out of joy, some would curse me to my face,
I soaked up the last light in a dying stranger's eyes.

By the thunder of potent cannons that rolled
 through the meadow,
 By the fire flashing to me only in the dark of my trench,
 I traced the last line, wiped the living from my page,
From a jewel-studded chalice is a precious stone torn.

And yet in that spark in the guttering eye,
In the light soaking up light before it blanks for all time;
And yet in that fire-flash burning and shrieking,

In the fire calling to fire that bids disaster and ruin,
It was you who were in them, this your glory
 that stunned me—
Too soon did I come or too late did he make me?

8.

Too soon did I come, or too late did he make me?
 "Gods" are around me, they fill all existence.
 The stars are my gods, I pray to them enchanted
By their faces, light of day and pale moon.

For besides you there is nothing, O sun that has warmed me!
 Sun's offspring to me are you, the cocoons hanging high,
 Sun's offspring, looming tree and the mere garlic husk,
Light and heat's avatars, the combustible coal.

Liberties

And all existence is a voice of prayer, a prayer of all things:
To you jackal-mothers cry as they litter their whelps,
The battle trumpet sounds to you as day breaks in the camps,

Suns in the sphere above, as the sound sweeps them up.
In the chorus without end I shall sing, not be still:
In my heart yet rests the dew that descends on Edom's steppes.

 9.

In my heart yet rests the dew that descends on Edom's steppes
 And moistens the sand in the desert of god.
 In my ears the song lives that arrives with the shade
And a gentle star glitters to primeval lays,

And primeval night shades the world with its wings,
 And the desert and night become one single secret,
 From their tents gathered peoples bend low on each mound,
And bow to him, trembling, in their fete, in their blight.

When the nation's heavens change over it, those heavens
 of blue,
As the face of stars dims for it, and if in the yoke
Of a sky yet unknown it moves east and west—

Once a month it comes out in mysterious night
To hallow the moon as it hallowed it then
On the peak of Mount Hor, the ancient god's home.

To the Sun

On the peak of Mount Hor, the ancient god's home,
 It shines in light-clouds gigantic, possessing law-fire!
From the radiance before it Chaldee Bel bowed by
 the Euphrates,
Sphinx's visage went pale in Nile's red channel.

With his scepter El smashes—and stilled is
 The pride of marble-quickening Zeus, and Perun heard
 His word and fled to the forest, and the moth met the worm
On Lubian priest's breastplate, Wotan's cult-trees their prey.

When age succeeds age and the East once more brightens—
Nubia's icons shall quail, Hormuz, Kerub shall be shamed,
And Arabia's idols, by the crescent moon's light.

And yet still a vision...an age fashions like a smelter
Its god that is coming—and we worship him gladly—
For my heart utters song to the sun and Orion.

11.

320

For my heart utters song to the sun and Orion—
 Will you judge me by law, to the dust will you thrust me,
 For to a vulgar folk's god I will pour no libation,
In a dance before crowds I will not crown his head.

In his temple on high, bare of image or scroll,
 In all-in-all's beauty he sends me no cherub,
 With his noblemen's patent he comes not to blind me,
It bears a signed name like the rule for a fool.

Liberties

Yet if a wave of great holy bliss sweeps you
And a tremor of joy in prophetic creation,
In the wealth of heart's life that each mystery shares;

In the surge of your loving with a lusty man's bounty,
You found favor with him as gift-garden finds favor
When the beanpod shall swell and the tree's fruit shall ripen.

 12.
When the beanpod shall swell and the tree's fruit shall ripen,
 Wild weeds, all trespassers of borders and limits,
 When they ripen their seed in the heart of the fruit-skin
And light-beams are hidden and stored away sifted;

From them to time's end, with this earth's climate
 Changed and its forests' scent faded,
 With the remnant of structures on poles, rot's survivors,
In the graves of great princes, in amphoras and jars.

After thousands of ages, from a cramped mine it will come,
Will shine forth from the heights of the towers in courts
Of all fire-worshippers who burn daughters on pyres,

Will burn in the brain of the transcendent genius,
 in the flesh of
Mosquitoes that sing, and in an empty age lacking
An extinct world's idols—they have seized me, with no escape.

321

13.

An extinct world's idols, they have seized me, with no escape!
 Idols of this nation, all who touch it know beauty,
 Beauty became wisdom, its wisdom was beauty ,
And it scattered its splendor on Hades and Ocean.

North winds have bewitched me from among all the trees,
 Recounting frost's story in patterns of agate;
 Midst the sun-shrines of On, in the temple I sought,
I imagined this spark that says in me: Repeat—

But the spark from the East, and from Canaan I kept it;
Danite idols compelled me, cultic groves filled with trembling,
Asherah statues, blocks from Tyre, in Ur did I worship.

Where the way I must choose, where the path?
Anoint my oil for Yah or shall I choose Zeus,
Or the very last age's icons in the kingdom of idols?

14.

Or the very last age's icons in the kingdom of idols,
 Or the song of strength's dream we shall raise up forever.
 And a man's eye shall probe and reveal matter's secrets,
Permutations of atoms in gold and in tin.

From the minerals he lays down a line and a path
 To the kingdom of trees and unseen growing things,
 And his one single chain: among molds, the mushroom,
Green slime on a lake, almond, elephant's get.

Heat's secret is grasped, electricity, and light,
Magnetism's mysteries, the barley bloom's riddle,
The roused nerve's tremulations that is stretched without gap,

And it shall be just one secret, one high secret—the living.
Then the song shall be sung: this my sun that has warmed me,
I was to my god like a hyacinth or mallow.

15.

I was to my god like hyacinth or mallow,
 Like one ear of gold grain in stalks heavy with yield;
 And he sent me warm rains and decreed mountain mists,
Light-and-shade's symphonies, kohl, rouge, and scarlet.

Age-old sorrows I fathomed, each nation's song charmed me,
 Voice of soul wrapped in light, voice in foreign dark strayed,
 When I stood between the living and one breathing his last,
Too soon did I come or too late did he make me?

In my heart still the dew that descends on Edom's steppes,
On the peak of Mount Hor, the ancient god's home,
For my heart utters song to the sun and Orion.

When the beanpod shall swell and the tree's fruit shall ripen,
An extinct world's idols have seized me, with no escape!
Or the very last age's icon in the kingdom of idols.

To the Sun

DAVID THOMSON

What Shall We Watch Now?

Over the past year, there was so much to be afraid of that fear itself grew fatigued. Was the solitude of lockdown passing into a new systemic withdrawal? Or were we practicing turning our blind eye to kids on the streets with guns?

Nothing felt as eerie then as the bourgeois comfort that now at last, double vaccinated, we might be getting back to normal. As if there was a proven "we," let alone any structure of normality available. As if we had not learned yet that the phantom known as our norm had been a deluding pipe-dream for so long. As if the panoramas of fear had not taught us that hope and our future were Ponzi schemes. As if we didn't know

in our bones that the precious "it" — our culture — might be ending, so should we (quietly and discreetly) get whatever we could while there was still time?

So even among the pursuers of our liberties, there could be a secret plan of acquiring tactful guns, living on high ground, putting together a goodies satchel of Proust, Musil, Parker, and Mahler, and stockpiling toilet paper.

I hoped to make that short paragraph mischievous, as if that was the surest way of getting at you. But black comedy is a showoff relief now, our trick for sidestepping gravity. Blackness went noir in the last century, as horror was glossed as genre. So I want to find an example that can be unsettling.

On May 14, 2021, Amazon Prime streamed all ten episodes of Barry Jenkins' adaptation of Colson Whitehead's novel *The Underground Railroad*. Wasn't that splendid, and a sign of our improvement? Many said that this event was eagerly awaited, not just because Jenkins had achieved a high reputation with *Moonlight*, but because between the publication of Whitehead's novel in 2016 and the delivery of the work on film, America had been convulsed by, among other things, the murder of George Floyd and the Black Lives Matter response. Even in the crowded world of streaming shows, intensified by Covid stay-at-home life, *The Underground Railroad* was anticipated. (But note how this way of describing what happened makes it sound as if white America had been waiting patiently for George Floyd to provide a prompt for our indignation. We are so appealing when we're angry.)

Nothing but opinion can come next, and ordinary opinion has mattered more during Covid because the external view of critics has been minimized by our intense domestic living with television series. So the reviews for, say, *The Queen's Gambit* were very positive, but they felt irrelevant next to the

way word-of-mouth was making our secretive romance with that show as infectious as the trance attractiveness of Anya Taylor-Joy. Chess became a new home craze, but then the binge was gone as if it had never existed. We have to learn to swim with the streaming. But is *The Underground Railroad* a test of swimming or drowning? The reviews were very favorable, though I felt a curious wariness that did not properly convey the peril and the exhilaration in yielding to its current.

I found the show more expansive because it was so beautiful, while facing several looming facts of shame. In his novel, Whitehead had alluded to the "railway" as not just a network of abolitionists trying to get black people out of the South and the reach of slavery, but as an actual railway system. What amazed me in the film was the realization of tunnels, tracks, and locomotion in a surreal design for rescue. It was so unnerving that it made the mythology within the show suggestive of how the word "underground" signifies a depth of thought and action striving against surface tyranny. To speak of an underground reminds us of how the United States had a mild war; it knew neither bombing nor Gestapo on the stairs. It was mainly a movie war for us.

Audaciously — in defiance of every realistic objection that there had not been a real railroad — Jenkins had believed enough in the mystery to get at a true underground of America. That adjective denoted more than "railroad," for the underground force was an idea — just like dread at a world being occupied by unkind forces. If it helps this proposition, I would say that in *Psycho* — such a warning about journeying — there is a deliberate shift from the bleak modernism of Phoenix, through semi-desert and nocturnal highway, to a past where a Victorian Gothic house sits above a flimsy cardboard motel. In other words, *Psycho* in 1960 was feeling

out the conflict of change in America, and making it part of the film's shocking violence in which someone we cherished would be cut to pieces on a journey seeking salvation.

Suppose *Psycho* is a nightmare about the impact of sexual reality on a repressed American society: thus the initial bedroom scene between Janet Leigh and John Gavin sets up the voyeuristic tension that breaks open in the shower-scene slaughter, and the revelation of a buried sexual horror in Norman and his Mother. This is not a story that believes only in photographic reality; it is a legend pulled out of a grave. And that is the way to approach *The Underground Railroad*. Yes, it's about slavery in the nineteenth century. But it also feels the struggle between emotional expression and suppression that is the whole history of our United States.

Another aspect of that is the absence of the Civil War. It is not easy to be sure "when" the film is set — you would have to be an expert on clothes and décor; but as the film passed by I became more aware of how the famous war did not seem to exist. As I thought about that I was drawn to see that "our" Civil War was in part a white projection on a terrible history and a way of telling ourselves bad things had been cleaned up. But they were not, and because the war is absent from the film a feeling dawned that it still waits to be fought. In 2021 this was something to be afraid of, including that movie, *January 6th*, which occurred long after Jenkins had finished filming but in which the force of a rogue locomotive reared up out of the ground and aimed at us.

There is more to be said about what Jenkins had done. Naturally, there are slaving scenes that are ghastly (as well as natural) — a big one occurs in the very first episode. But as I tried to enter the film's world, I realized I had never seen a South so palpably and dangerously lovely. You feel the

warmth and the fragrance, the swamp and the snakes; the camera dwells on flora and fauna; the light is rare and thick and almost graspable (the photography is by James Laxton); and the natural sounds merge with the remarkable score (by Nicholas Britell) that seems to be feeding on the air. This becomes a transfixing experience, a naturalist's treasury, but it is a place where appalling things are happening. I had never felt America's Edenic ambiguity so thoroughly.

I haven't mentioned the acting, black and white, or the serene confidence to take the action off in unexpected directions. To be brief: I loved the film; I watched it as in bingeing, in just three nights, the shifts of light like a storm in our darkened living room. I felt it was a marvel, a great film, a savage rapture, if that is the kind of language you expect from "commentary," or one more demonstration of the ways streaming — with vivid imagery burning on the walls of our home — is changing our idea of watching. Forget the chance of seeing this in a public place, because that communal aspiration is gone now, eclipsed by our technology. We deserve it in our cave, the last place, where we hope to shelter.

As someone often asked to recommend films, I was urging *The Underground Railroad* on friends. But I thought I detected some reserve. Yes, people had heard it was good, and yes, they understood that it was "important." But I began to hear that several people had not gone far into the show. Some said the lengthy lashing and burning scene in the first episode had been an obstacle. Yes, they knew they needed to see that violence (they had honored it recently in *12 Years a Slave*), but they seemed to feel a little nagged about seeing the pain once more. I wondered if liberals were growing weary of their good cause.

A close friend told me, "I only saw the first episode but was put off by its odd mix of the pretentious and the unemotional,

even though many things were happening that should make me feel emotional. It felt academic to me — or something too studied." I disagreed; my friend was reacting to the magic and its allegorical point of view, which I have just tried to explain. Then, in another conversation with someone else, but taking it in that not enough people seemed to be watching the show all the way through, I heard myself say, "I think there's something else, which is that some white people do not really want to see black people."

There was a hush when I said that, as if it might be something one should not say — or as if it signaled a degree of racism. I am white; I was English for forty years, and then American for another forty. But I am trying to admit to a failing of the sort that I suspect many black people hear in conversations with whites, no matter how well-intended or liberal the whites think they are, and no matter how tolerant or amused the blacks can bring themselves to be. It's like the way rich people are not comfortable looking at poverty. (An old joke: a tattered beggar sneaks into the courtyard of a wealthy man's house. The plutocrat turns to his manservant and says: "Get him out of here. He's breaking my heart.") It's how some men and women cannot be together without fear and desire.

We like to see ourselves. We would rather hear our language than one we don't know. We prefer to be with people we feel share our experience. We are wary of strangers. There is systemic racism, if that means sheer racial difference, and willing it away will not dispel it. Candor can tame its worst defects. And watching can begin to offset prejudice, and tenderize differences. That is the chance for an intelligent society, or one that can warrant hope. Doesn't Proust tell us about that world?

So what can we watch now? What's on your screen?

What Shall We Watch Now?

Watching has changed so much in the spell of Covid, and I don't see many of the shifts being reversed. One reason is that the changes were well underway before our new way of sickening and dying made us suddenly more inbound. Just as *Mare of Easttown* is a more involving interaction than the self-satisfied isolationism of *Nomadland,* so for twenty years now the quality of things seen on the smaller screen — *The Wire, The Sopranos, Breaking Bad, Babylon Berlin, Ozark* — far exceeded the best that Hollywood put in theaters. I'll go further: the nature of a criminal society in those long-form series is more intricate, more human, and more political than the armored gloom that envelops the Corleone family in the *Godfather* films. *The Godfather* is an enclosed pattern of loyalty followed by betrayal. Its underground is mistrust. Of course it still works on screen, but the meticulous craft of the first two films is an expression of Michael's pitiless authority. He is making the film, and Coppola cannot challenge him. The films are cultured prisons, or a rite that we honor now with worship from our cells. We want to be in that terrible family. The fantasy of shared power and allegiance smothers any moral issues or a consideration of how crime became truly American when it got organized. And in an age of mounting fears, we yearn for organization and the promise of strong people in charge.

I know, this is horrid to hear; it should not be so. But notice the exultation you feel — the assist you are giving — in those finales where the Corleones' enemies are eliminated. And realize that generations of our kids have seen the two parts of *The Godfather* only on their home screen, clinging to the watchful dark in the way that Michael Corleone looks out on his wasteland. "Could we rewind, and run that execution again?"

By contrast, *Babylon Berlin* is a study in how insecurity can prompt fascist solutions, just as *Ozark* is an autopsy on a family breaking apart because of money. When was there a feature film that had a similar wish so fully to analyze poverty? Generally the movie system is fearful of showing that condition, and in terror of asking how it functions. What Hollywood movie comes close to Walter White's exhausted moral compass and the onset of fanatical self-interest? That is close to what I was saying about the underground pressure in so many of us to carry our cash in hand, with properties and delicacies that will make our life rewarding at the end. Don't jump to the liberal conclusion that the tremors of slavery are all gone now, not as long as poverty is as widespread an anxiety. Do not minimize how our culture has been telling us to expect the worst, and to be as deft as Butch and Sundance at handling it. Though that script required a merciful freeze frame.

There are people in the film industry telling themselves that the theatrical audience is going to come back with a rush. I'm not so sure, because we cannot be expected to ignore how the stuff "on television" is so much more adult and powerful than whatever mainstream movies can think of now. So we have relearned a condition that was there since the start of television: that it feels safer, warmer, and more personal on our own couches. We have liked the renewed intimacy of watching with our people (or alone — that last resort state is sinking in), and following the skilled, extended narratives into the night (the locus of solitude).

There is also another development that needs to be admitted. For many of us, with sophisticated television screens, the quality of the home image and the sound are more vivid. (Add headphones for the extra kick of secrecy.) We can get more detailed, brighter, more audible, and more

enthralling on the "small" screen than the standards of theater projection, which are often casual or uninterested. This may sound like heresy, but you'd have to be an idiot not to notice it.

And in our watching now we are in terror of idiocy. If lockdown has been a kind of imprisonment, then we are inmates desperate to improve ourselves. So we are watching at home with a concentration that has not existed since the golden age of theatrical movies. But our commonality then required a shared space; and what we have now is solitude or the décor of selfishness. In that state it becomes fanciful to maintain the cause of responsibility. We are all slipping into a version of the bitter negation of Congress and its complacency that government cannot, and should not, work.

Our "cinema" is in tatters: we welcome the fatuous *Mank* and begin to forget *Kane*. Or think of it this way: *A Quiet Place Part II* (one of the few legitimate successes among recent theatrical openings) does well enough with its preposterous but cute plot situation, though not enough to overcome the fear of a franchising fix in that drab "Part II." But put that beside the exploration — physical and social — of Albuquerque, Baltimore, New Jersey, Missouri and Berlin in the series that I am recommending. In all cases, the series show how thoroughly money and power are undermining society and our legal confidence. Does that remind you of anywhere you know? It makes me think of San Francisco, where I live, which in its unseemly marriage of money, smugness and squalor acts out the principle that America is not working. It's not that there could be a realistic thought of making it great again, but can we find a decent way of existing without the melodrama of greatness?

The question in watching is whether we can still possess systems that help us see the truth. Or do the systems run us?

This is in a context in which the infernal nature of our politics has been intensified because home-viewing has made us gather round the fire. George Floyd has become an archetype by being on our screens: we know that 9 minute 29 second shot by heart. The same can be said for the rolling coverage of the outrage of January 6, a disaster movie that goes on and on, not least in enrolling some observers in the contract that no, it wasn't really a disaster, while leaving others bemused that it has not justified charges of sedition. Time and again, watching action on the street, our headlong movie keeps asking what we are seeing.

I realize that may seem like a naïve homily. But it leads me to this. It is still widely believed that the crises we faced during the Depression and the War (a lesser ordeal than it was for most other countries) were alleviated or made orderly by the spirit and dreaming of Hollywood pictures. That case is worth making, and like most movie sentimentalists I have often made it. But suppose we consider another interpretation: that in those dire years we were fed quite different messages that misguided our trust in white male prowess and authority, female obedience and adorability, and the customary belittling of people of color, of poverty, and of the visible affliction known as ordinariness. It is possible therefore that the vaunted American century, not without the material evidence of power and accomplishment, was built on treacherous ground in which all manner of deviant or ugly systemics were weaving a national fabric that betrayed the American project and covered up the murderous insecurities of the child nation and all its Norman Bates.

Inescapably, with so much likely to be happening in the area of "breaking news," our lust for that breakage has led us into the rivalrous clamor of shows that like to think of themselves as ongoing news platforms, but which are really extended commercials for fixed points of view. Let's call them Fox and MSNBC. I watch the latter and I assume that most of you are on the same side. But preaching to choirs stops critical thinking. Why does it have to be a matter of sides? Or is that structure as essential as the ads that humiliate any attempt at fact? And if you are intent on reform, begin by forbidding all advertising in our media. Yes, that is how unforgiving and demanding survival is going to be. And how unlikely. That is why you have your satchels ready.

How does a cool scientific temperament assess the constant hysteria of the same talking heads agreeing with the fevered questions that Rachel, Lawrence, Sean, Tucker and the others recite? There is no more room for internal argument among the "saved" at MSNBC than among the scoundrels at Fox. The biggest conspiracy among them all is that "we" are watching or caring. Isn't it plain after all these years that if a liar as complete as Trump is still "on," then there is no longer a body of "us" paying attention that you would want to belong to? Audiences bear responsibility, too; but we are trained to expect to be pleased.

To all of which any partisans would likely ask, "What's the point then?" Or what's the chance of leading our screens into an accurate and fruitful discussion of what is happening in our world? Is the reasoned and accurate deliberation for which our political and social system was piloted any longer viable — can it go to series, or an enduring franchise? It is as if we have given up our hopes for reportage in news programming, let alone the informed and reasoned argument over issues. We

may deplore the retreat of Congress from governance, but that surrender is daily evident in what we still try to call television news.

So it is worth noting the bold chronicle testaments that television has offered in this time. *The Underground Railroad* is in that category. No matter its fictional atmosphere, or the use of actors reading lines, its intent is to uncover truly underground elements in American history, as the last viable way of making us angry. It asks what are we watching, and what are we seeing? Still, another dear friend, very smart and hard-working, and probably less systemically racist than me, told me that he could not face watching *The Underground Railroad* because he was so tired, he "needed to veg out." We all know that retreat.

But there are other angry shows that might seem exhausting in prospect. *Exterminate All the Brutes*, by Raoul Peck, is no less than a diatribe against the Western white man's true burden, his flagrantly incorrect account of his history in the underprivileged world. It is an HBO venture (with aid from Sky in Britain and Arte in France), and it is the Joe Frazier of such programs, loaded with hostility and an energy that keeps coming at you, no matter the ripostes of reason and the educated leftist leads you might throw at him.

Peck is Haitian, a politician and a filmmaker (he did films about Patrice Lumumba, the Rwandan genocide, and Karl Marx before *I Am Not Your Negro*), and he narrates his own picture in a snarly, incantatory way, like a worm burrowing into our skull. He fights tough (we might complain), but he is intent on clearing out the attic of jumble in which we won't let go of Columbus, the Alamo, the bracing fun of fascism, or those myths inherited from Westerns. This is a work that throws acid in the face of the John Fordian cult that said — in

335

Fort Apache (1948) and *The Man Who Shot Liberty Valance* (1962) — that "when the legend becomes fact, print the legend." There are few more damaging mottos in our bag of poisoned fortune cookies.

There is one more show to be mentioned, and I think it is the most compelling of them all, a masterpiece (if that boosting helps). What makes its introduction more timely is that you will not have seen it in America, and likely will not. Why is that? Well, the elusiveness begins in its narrative difficulty and its lyrically paranoid voice. It will not easily satisfy those commercial gravities, like Amazon's decision that they should do *The Underground Railroad*, for prestige and awards. Yet Adam Curtis's *Can't Get You Out of My Head* will be a harder sell, not least because of its uncanny, seething assembling of items from the immense BBC archive (a Borgesian library of Babel) has probably not cleared the rights for international transmission. So *Can't Get You Out of My Head* may pass into its most appropriate medium — that of underground communication, with smuggled links or incomplete Vimeo fragments. Or inexplicable samplers breaking into shampoo ads where Garbo's head comes off and her teeth fall out in CGI horror at not being suave. The proper delivery of this extraordinary fermenting show is as rumor or legend.

I'll say no more (to foster mystery), except that if you know and treasure Curtis from *The Century of the Self* (2002) and *HyperNormalisation* (2016), you may appreciate my opinion that no one was more prescient about the way towards the end of the dear old twentieth century an endless tsunami of internetting was erasing any confidence in fact or news or reporting and letting anxiety turn to havoc (we'll be right back). You have to see it to feel the crystallization of waking in the dark and not knowing where you are. Real dark is coming

336

back to us. The grid will start to falter and the lucid but manic voice of Curtis (he narrates the show himself) is what you are going to keep hearing.

The title that Curtis had chosen is significant, for while his shows are montages of what could be random selections from a Heisenberg archive where you can't tell the particles from the waves (until you begin to see the beast of pattern emerging, like Grendel in the dark), still Curtis was formed, like many Englishmen of his age, as much by radio as television. The voice is a sacrament still, whether it is some message on the ether describing *The War of the Worlds* in 1938, or the yelp of Rachel Maddow from another room tonight as you re-reheat the pizza, or the implacable drone of Peter Coyote's voiceover on the latest iteration of Ken Burns's America as an idea that seems to have occurred once upon a time.

There were two missionary epistles from Burns in the epoch of our plague: in April 2021, with his longtime working collaborator Lynn Novick, he delivered a six-hour *Hemingway*; and then, working with his daughter Sarah and her husband David McMahon, there are eight hours on *Muhammad Ali* for September. Why not "honey still for tea" and twelve hours on Johnny Carson by Christmas ...?

I'm kidding, in a Carsonian way. I have known Burns since *The Civil War* in 1990, and he is not just a likeable man, but an inspiring figure, so eloquent and persuasive that he might have succeeded in politics if he had not insisted on seeming so young and idealistic. Instead, to all our benefit, he created a kind of religion that uses old imagery and talking heads to make pioneering documentary (it owed something to traditions from Canada and the BBC), and he allied this skill and taste to the cause of PBS. The church became an industry, with album books to accompany major shows, and Burns is

337

What Shall We Watch Now?

loyal still to PBS, even if that outlet feels increasingly archaic in America. Television is wilder and more surreal than the PBS model and Burnsian uplift can contain.

The two shows for 2021 were majestic in their scale and assurance, yet oddly empty or missing. The vitality of the two subjects was becalmed under the coverlet of their being American masters (one of the PBS series that owes so much to the Burnsian organization of palatable history). So we had pages of manuscript and rounds of boxing to make us happy tourists at the show, implicitly subscribing (a key word at PBS) to the Rushmore of American greatness. And there was next to nothing, within the testament of Edna O'Brien and Walter Mosley or the inside stuff from boxing journalists, to suggest that Papa and Ali might also have been tortured tricksters, driven mad by America, eternal compromisers and opportunists — like us. The nastiness of Hemingway was bypassed with the gentle but miscast voice of Jeff Daniels, except for one hushed moment from Tobias Woolf at how shocking the master could be. The sexual recklessness and shuffling identity of Ali could not compete with the apotheosis of that palsied torchbearer at the Atlanta Olympiad of 1996.

It could be said that both men were so smart it was hard to realize they were chumps too, not so much masters as victims of fame, a suicide and a punch-drunk case. In eight hours of Ali we never got to hear whether he wrote those verses himself, how many women he exploited, and where and how all the money went — or what he felt about it all. There was no inner person. As for Hemingway, it was hinted that he flirted with being deviant, but nothing in the show bothered to assess how his whole thing about male grace under pressure, the right stuff, and sentences like trout in fresh stream water was humbug from a very mannered prose stylist who did not want

to write about his own nation and ended up getting the big prize for his worst book, *The Old Man and the Sea.*

The legend sailed on that America could deliver such heroes, and so it was sadder that the actual America had not lived up to Burns' valiant hopes. Baseball has turned shabby. As for jazz, it is too clerical now and respectable. When I put "Parker" in my satchel, I meant ...? It was Bird's centenary during Covid, but I'm not sure his lyrical outrage is heard anymore. The national parks have not tamed or excused the wasteland.

That said, Burns and Novick made a masterpiece in *The Vietnam War* in 2017, in part because that eighteen-hour film relied on the witness of ordinary victims, including those from Vietnam, and because it could not get the notion out of its head that in those 1960s and 1970s, from *The Quiet American* to the helicopters tipped into the ocean, the United States gave up its ghost. That is our proper starting place.

But the country now seeks vengeance against betrayers and a safe courtyard for its precious isolation. As if that norm is there to be had. As if our enlightenment can be seen before the grid starts to falter.

What Shall We Watch Now?

CELESTE MARCUS

The Legend of Alice Neel

The language of art is embodied in paint and line on canvas or paper, in stone or clay or plastic or metal — it is neither a sob-story nor a confidential whisper.

LINDA NOCHLIN

What makes an artist great? For the duration of the cultural drought that engulfed the plague year, as the rates of illness and death rose, there was hardly an opportunity to consider so decadent a question. Museumgoers were starved, subsisting largely on virtual exhibition tours and Instagram profiles dedicated to Old Master paintings. The ersatz screen-gallery is uniquely numbing. Zooming into and then scrolling through post after post of factureless paintings is like kissing through a sheet of glass. There is a semi-spiritual sensation which can grip a viewer who comes face to face with the actual product of a master's hands. Standing in front of a genuine work of art,

it is possible to enter the charged liminal space between one's own mind and the artist's. If one knows how to *look*, to silence all distractions and concentrate attention entirely on the work alone, the space between the two minds becomes asymptotic, and the capacity to see the world through the eyes of another human being, a brilliant human being, is within reach. This experience is possible only in proximity to the original.

When word of the vaccines' efficacy was reported like the olive branch in the dove's beak, the art-craving population was in no position to be picky. Museums were opening again and we would eat whatever was put on our plates. This is generally true of the public, pandemic or no pandemic: it will admire what it is told to admire by the appointed experts, but it is especially true regarding visual art. Most people have no idea what makes it good or bad. It is rattling to be confronted by images for which one is unprepared by prior certifying opinions, for which one has no received framework. Many people assume that if a painting hangs on the wall of a museum and they don't like it, they simply don't *get it*. It's just not their thing, which is not to say that it is in some way objectively deficient. On the contrary, many readily assume that their lack of interest or understanding is a measure of their own shortcomings. It is hard to trust your own judgement when you feel that you are being tested for your cultural literacy. The line of least resistance — to join the consensus and celebrate what is being celebrated — has its rewards.

And so, last spring, ravenous and trusting hordes flocked to the Metropolitan Museum of Art for *Alice Neel: People Come First*. It was Neel's first retrospective in New York in over two decades. The show had been conceived in 2018, but the delayed opening was serendipitous: in 2021, after a year of perpetual political agitation, in which it seemed as if the same inequi-

ties that Neel spent her lifetime protesting were laid bare, "a champion of social justice" (so characterized by the museum website introducing the exhibition) who created "images of activists demonstrating against fascism and racism" as well as "impoverished victims of the Great Depression... portraits of [her] neighbors in Spanish Harlem, leaders of a wide range of political organizations, [and] queer artists and performers" was positioned to model the progressive mood. Neel's work, said the Met site, is a testament to New York's "diversity, resilience, and [the] passion of its residents." A harmonic convergence of politics and culture was occurring. How felicitous it was that Neel's social consciousness was so aligned with that of her curators, and so pertinent to the political and social upheavals that overran our quarantines. Is it odd that the museum's webpage mentioned nothing about Neel's paintings qua paintings, or her skills as an artist qua artist? Maybe not anymore.

Who was Alice Neel? What could one expect to learn about her relationship with color and form from a visit to this show? Poring over books and catalogs of her work, the particular energy with which her portraits vibrate is obvious even in reproduction. (She was primarily a portraitist, though she did produce cityscapes and still lifes). Neel painted emphatically. Her late works, which are her most famous, were painted between 1960 and 1984, when she finally was awarded the recognition that she had been awaiting for decades. The books show that the later pictures are brighter than the earlier ones, airy, with stretches of canvas often left blank. She painted people of all shapes and colors. She painted herself, with a strange mixture of candor and complacency, when she was 80. Vitality shrieks across every page. No matter the subject, every pictured canvas gyrates with her idiosyncratic energy, with

which one feels a burgeoning familiarity before ever having seen the paintings in person. And so the encounter with the real thing promised to be exciting.

"You paint like Alice Neel," a friend of mine observed when, a year or so ago, he found my Instagram profile and scrolled through samples of my paintings. He made his remark just after the pandemic cast a curtain over the planet, greatly diminishing my chances of seeing one of her works up close. Since that initial instance a handful of others have made similar observations, and so it was with mounting interest that I scheduled my first post-pandemic trip to New York, and my pilgrimage back to the Met. On the appointed day, sketchbook and pencil in hand, I stood in a long queue of masked museumgoers snaking towards the exhibition, sketching the Rodin sculptures which lined the corridor as quickly as I could, with mixed results, before moving onward.

At long last the guards granted entry. Seeing the paintings themselves felt a bit like stumbling into a room full of Insta-influencers without the beautifying photo filters or other prettifying maneuvers. I tried very hard to like what I saw, not least because I had spent all that time turning those pages and speculating about the artist with whom I was supposed to have an affinity, but it was no use. I had anticipated thick planes of paint layered deliciously against each other, the way they are in, say, a Leland Bell self-portrait; or delectable Theibaud-like spreads, cakes of radiant palette-knifed colors, satisfyingly overlapping and cutting off one another. Instead, Neel's portraits felt flat, unexpectedly wan, almost deflated. Hungrily I moved from painting to painting, sketchbook opened to an

343

expectant blank page, searching for something nourishing to copy, some morsel to fold up in paper and take home. But she defeated me. I could find nothing worth lingering over, nothing from which to learn. I shuffled dutifully from one simplistic composition to another, growing irritated by the consistently clumsy perspective, the ghoulish body proportions, the increasingly predictable color choices, the amateurish lines, the unpersuasive fingers, arms, and legs: the startling lack of technical skill.

Neel's mythologized energy was there alright, everywhere, in every face, and even in her buildings and trees. In Aliceland every creature looks like Alice, which is to say, each one was a caricature, and sometimes almost a grotesque, thinned and twisted in a denatured space, their bodies and faces siphoned through her pumping, righteous spirit. Here was *Adrienne Rich*, from 1973, which looks more like a cartoon than the work of a gifted portraitist. Here was *Dominican Boys on 108th Street*, from 1955, in which the two bodies are simultaneously swollen and compressed. The best that can be said of this painting is that it looks like outsider art. Did Neel not know how to draw a body? Was this screaming inadequacy a statement of some sort — was it irony, or authenticity, or primitivism? And did no one else notice? Had everyone —museumgoers, curators, critics — conspired to pretend that they could not see what was in front of them? There was nothing brilliant or stimulating or moving about Neel's interpretative freedoms or her way with a brush. Work after work was shallow, underwhelming, visually vulgar, fully captured in a glance. To paraphrase C.K. Dexter Haven, to hardly know a Neel painting is to know it well.

Perhaps I was missing something. After all, there is a consensus. I moved from one room to the next, chewing on

nutritionless paintings like popcorn, searching for evidence that would justify the received view. Then I arrived at a place in the show in which the curators had done a very cruel thing to Alice Neel. There was a wall of works done by artists whom they claimed had influenced her. Like visitations from another world, there hung a van Gogh and a Cassatt, and most explosively there was a Soutine — a still life of a rayfish with its belly sliced open, bloody entrails spilling out onto a white tablecloth. Here was something to linger over, and long. Poor Neel didn't stand a chance.

This was a globby and disturbing feast of brushed, carved, and splattered paint. Soutine also has his own eccentric energy, his own refusal to be inhibited by perceptual or painterly decorum, his own contempt for the canons, but there is nothing simplistic about him. I stopped and stared, and continued to stare. I marveled at the glimmers of blue inside the fish's guts and on the tablecloth. I was smitten by the exquisitely subtle green line on the inside of the pitcher's handle. How had he known to put that there? Had he used a knife to carve those grooves inside the fish's fleshy underbelly, as if he were cleaning the fish itself? Imagine the motion he must have made with his hand to create those lines. And that enflaming flash of red running from the bottle towards the blood! How had I not noticed that at once?

The answer is that this is not a picture that reveals itself at once. There is so much happening in this painting, so many whirlpools and eruptions, so many unexpected details in which representation and abstraction pool into each other — and yet the composition is somehow stable and balanced. How had he designed this chaos so that it hummed? Did he plot it all first, or was he gripped by some kind of exalted frenzy — did it spill out of him like the guts onto the cloth in paroxysms

345

of paint and power, in the end creating a unity that he could not have explained? I recalled an apocryphal story of a film crew recording Matisse while he painted his mural on the wall of a chapel in the south of France. After he watched the film, he angrily accused the crew of perpetrating a deception: "You made it look like I knew what I was doing!" I smiled gratefully at the Soutine. Hardly any of the other viewers were drawn to this corner of the show, so I could stay as long as I liked. When I was satiated, and also drained, I left the exhibit, just glancing at the rest of Neel's works on my way out. Soutine's roiling, indigestible table had exposed her thin digestibility.

On my way out I paid my respects to the Courbets and the Corots that live in the tiny galleries off the main artery of that wing. This, I thought, is what the Met is for. (And their modern equals, too.) It is now the largest art museum in the United States, with a permanent collection of over two million works, and it is among the most powerful art centers on the planet. The might and the money that it has accrued since its founding in the nineteenth century are reflective of the importance that American culture and society once imputed to art — *art,* not politics, or fashion, or even social justice. What was an Alice Neel retrospective doing under this roof?

"If I ever write a biography," Alice Neel used to say (she meant autobiography), "I'm going to call it *I Am the Century.* I'm four weeks younger than the century." She was born on January 28, 1900. Neel's faith in her own strengths seems to have been first fed by her contempt for Colwyn, Pennsylvania, where she was raised. Life in a dull town can have that effect on a restless soul. Her marrow-deep commitment to her own artistic drive

began in Colwyn, which she left in 1921 to attend the Philadel-
phia School of Design for Women (now Moore College of Art).
Neel's lifelong commitment to communism — she was the
only living American artist to have a show in the Soviet Union,
which she financed herself in 1981 — was inchoate in college,
where she was acutely aware of what her political heirs would
call her privilege. She said of that time,

> I worked so hard because I had a conscience about going
> to art school. Not for my own family, but for all the poor
> in the world. Because when I'd go into the school, the
> scrubwomen would be coming back from scrubbing the
> floors all night. It killed me that these old gray-headed
> women had to scrub floors, and I was going in there to
> draw Greek statues.

Some have maintained that her political orientation was devel-
oped in Havana, where she lived briefly with her husband,
Carlos Enriquez de Gomez, whom she married in 1926, but
really the stirrings started while still in Philadelphia. (She and
her husband soon separated, though they never divorced, and
she had many other lovers, and children with other men in
addition to the two she had with him.)

34'7

Neel joined the Communist Party in 1935. Her commit-
ment to the CP was total and unreconstructed: decades later
she admired Fidel Castro, and did sketches and etchings of Che
Guevera. Her poster of Lenin still hangs in the kitchen of her
Upper West Side apartment now maintained by her family.
Throughout her life she contributed writings and illustra-
tions to Communist publications such as the *Daily Worker*
and *Masses & Mainstream*. It must be remembered that in
those years the CPUSA was the strongest force advocating

for African Americans and women in the country. (The year Neel became a member was the same year that the CP founded the National Negro Congress, headed by the socialist and civil rights activist A. Philip Randolph.) In his book *Artists on the Left,* Andrew Hemingway claims that Neel was "representative of that type of woman artist and intellectual who gravitated to the CP because — whatever its limitations — it offered the most sustained critique available of class, racial and sexual inequality." At that time, and certainly in her milieu, the Party was the popular social movement, so it is not surprising that she joined. It was her continued, unmodified commitment to Communism that was out of the ordinary: "She remained absolutely a kind of stalwart in her public support of Communism in the USSR," Hemingway writes.

Neel was a profoundly political painter. Her work's reputation has been buoyed by three cycles of leftist politics: Marxism (1935-1960); second-wave feminism (1970-1984); and contemporary progressivism (2010-2021). For the first three decades of her career, Neel was part of the Social Realist movement, which emerged after the Great Depression and was funded largely by the WPA. At its height the WPA employed over five thousand artists — "everyone was on it," Neel used to say, "Pollock, Rothko, everybody." In her book *Art and Politics in the 1930s: Americanism, Marxism & Modernism,* the historian and critic Susan Noyes Platt argues that artistic movements that emerged in the 1930s can only be understood through a political lens: "Characterizing the thirties in terms of individual artists and styles, the traditional methodology of art history, eliminates the ideological forces and political arguments that shaped the art. This fact is most obvious in the case of Social Realism. Speaking of a Social Realist 'style' separates the production of the artwork from its complicated

position within the Popular Front, the Communist Party and the New Deal."

Social Realist artists such as Neel, Charles White, Ben Shahn, the brothers Raphael and Moses Soyer (with whom Neel was friendly and whom she painted in 1973), Isabel Bishop, and Reginald Marsh painted works that championed the working class. In this early period especially, Neel was particularly emblematic of this style. The historian Gerald Meyer observed that she "represented an exemplar par excellence of the Party's hopes for a socially conscious contemporary artist. Her paintings were accessible art, which depicted ordinary people of all races and ethnic backgrounds in ways that captured and dignified their actual state of being." While living in Spanish Harlem, Neel was moved to capture life as a member of the working class in New York in the aftermath of the Great Depression.

Communism was the political movement that influenced Neel's artistic choices, but feminism is the one with which others have most consistently associated her since the 1970s. When Neel was given a retrospective at the Whitney in 1973, one critic aptly noted that "it is no accident that Alice Neel is finally coming into her own at this point in time, when it is fashionable to 'discover' neglected women artists." Though the upward shift in Neel's career began in 1960, when Frank O'Hara agreed to sit for her, it was not until the 1970s, a decade into second-wave feminism, that she achieved celebrity. Then as now, feminists kindled to her supreme confidence, to her unabashed faith in her own merit. Neel was a woman who believed that she deserved to be lionized. She regularly called herself a genius and referred to her work as revolutionary. Of *Nazis Murder Jews,* which she painted in 1936, her biographer Phoebe Hoban quotes her as saying that "if more people had

349

paid attention to that painting earlier, fewer Jews would have been killed." (The painting depicts a demonstration against Nazism, in which a man in the foreground holds a sign that reads "Nazis Murder Jews," and in the background a mass of protestors hold signs emblazoned with the hammer and sickle. This was clearly a Communist event, and apparently neither Neel nor the radicals whom she depicted cared that Soviets also murdered Jews.) Such megalomania is never attractive, but in a woman in Neel's lifetime it seems to have been mesmerizing.

In an interview about Alice Neel in 2008, Linda Nochlin (whom Neel painted in *Linda Nochlin and Daisy* in 1973) argued that Neel's ego is a constant topic of discussion only because she was a woman: "When a male artist does that you think oh Picasso, why shouldn't he have that, he's a genius but of course when a woman artist does that they become a prima donna or an egomaniac, but she was acting like, you know, artists have often acted." There is no gainsaying, of course, the egotism of male artists. But Nochlin's defense of Neel misses the point. It is certainly true, as she herself established in 1971 in her epochal essay "Why Have There Been No Great Women Artists?," that centuries of social norms and structural conditions made it much harder for women to aspire towards greatness in the arts, and it was not until very recently that women were allowed to study in art schools at all, and in the manner that men did — and so it was impossible for any woman to establish herself in that world without a "good strong streak of rebellion" and "total inner confidence." Neel had both, and her causes — racial justice and gender justice — were good causes. What she did not have was the talent to warrant her wild confidence in her own historical importance. (Picasso did.)

I do not mean to argue against the self-confidence of women, obviously. A rebellious woman is usually an admirable

woman. I mean only to suggest that there is no correlation between rebellion and talent; and also that being on the right side of a social struggle has no bearing upon the aesthetic status of a work of art. Alice Neel's idea of her own significance is devastatingly refuted by what hangs on the museum's walls.

Neel's belief in her own powers is relevant to a consideration of her art because it fueled her work. Understanding this element of Neel's legend is central to understanding her stardom now. Despite several decades with little professional success, in which practically her only supporters were fellow radicals, Neel stayed at it; and when she finally made it, she did not sell only her work, but also her legend. In truth she had to rely upon her story, because she was a woman, and because her work could not stand on its own. By the end of her career, she regularly gave interviews and slideshow presentations of her paintings that were spiced liberally with risqué stories of her past and acidic smackdowns of fellow artists. ("Am I being vicious? Well, maybe just a little vicious.") Her myth was charming; she was a hit.

But then there is the underwhelming work itself. Gallery-goers and critics alike persist in describing her artistic prowess almost as if they are describing some other artist's work. Her paintings are regularly characterized as mercilessly and richly realistic, as if the viewer is staring at a Neel but seeing a Freud. Throughout her biography Hoban quotes uncomplimentary reviews of Neel's work as if they are glowing. Of her Whitney retrospective, the reviewer in *ARTnews* reported that

> Neel's style... fall[s] somewhere between van Gogh and
> *Mad* magazine. Her colors, gangrenous greens and blues,
> have the lurid off-key quality of early color television.
> Offensive to the sensibilities as Neel's painting can be,
> they have an ungainly, engaging counter-charm. They

can be understood as a major contribution to the high caricature tradition of Daumier that relatively few fine artists have explored.

In a characteristically baffling evasion, Hoban writes that this review "with a few humorous disclaimers, highly praised the work," as if the wicked impiety of Daumier was the ideal to which Neel's pious paintings aspired. Of other reviews of the same show, Hoban remarks that one critic compared Neel "to Miss Jean Brodie in her prime," as if such a comparison were a compliment. She continues: "The reviews of the show were more or less glowing. Neel snagged a brief write up in *The New York Times*, which said, 'Alice Neels portraits... strike somewhere between benevolent caricature and expressionism as a vehicle for personal release.'" Again, as if this were a good thing.

Some other details of Neel's reception are harder to spin. The retrospective at the Whitney was curated by Elke Solomon, then curator of Prints and Drawings, rather than Marcia Tucker, then curator of Paintings and Sculpture. This seemed to suggest that Tucker did not consider Neel worth featuring. Solomon herself later said that she did not think Neel was an important painter, but that she was given a retrospective because "she was a woman painter who represented a kind of paradigm of someone who persisted in making paintings that represented a certain ideological position." Bingo! We are getting to the heart of the matter.

The survival of the legend of Alice Neel, and its contemporary flourishing, is not owed to her art. It is owed to her politics, and to the politics of our reputation makers. Neel is a progressive

saint, and her portraits are icons of the progressive faith. The curators at the Met intuited correctly that Neel's paintings of black and brown bodies are of a piece with today's social justice movement. The Neel show, their veneration of her paintings, may be seen as their contribution to the movement.

If the curators at the Met disagree with such a conclusion, if in fact they do consider Neel a great artist, they are not notably interested in saying so, or in discussing this dimension of her legacy. In the entirety of the catalog for *Alice Neel: People Come First*, which includes six essays, only the last essay has more than two paragraphs of description about her artistic choices. All the others consider Neel primarily in a social and political context. Even that final installment, which is about Neel's relationship with abstraction, is laden with politically charged descriptors like "masculinist formalism" and "feminist innovations," as if an exploration of something so high-minded as figurative versus abstract art must be justified by the political implications of the analysis.

Pardon my naiveté, but I thought that the essay called "Painting Fruit" in the catalog would be about Neel's still life paintings. Silly me. It is a portrait of Neel as ally of the LBTQ community. Fruit is euphemistic, you see: "a veritable orgy of phallic bananas overfills a bowl in the foreground [of one painting]." (I was under the impression that the association of homosexuals with fruit has long been regarded as a slur. Maybe only progressives are allowed to use it.) The catalog of the Neel show is quite startling for the paucity of its discussion of her artistic impact, her artistic technique, and her artistic development. Like the show, it is really just an admiring study of her politics.

On June 5, 2020, Kelly Baum, who curated the Alice Neel retrospective at the Met, was doing what many thoughtful

American were doing in the summer that George Floyd was murdered: looking to history for guidance through the paroxysms of horror and hope that were buffeting us all. On her private Instagram account Baum posted several photographs of Neel portraits, accompanied by the following text:

> The anti-racist movement needs feminists as allies and god knows white feminists have not always been good allies often the opposite, in fact. I'm.... recalling the activists/socialists/feminists that Alice Neel painted (Mercedes Arroyo, Alice Childress, Irene Pelikis, Faith Ringold) who took an expansive view of liberation, one that triangulated class, race and gender. I wish Neel had painted bell hooks and Angela Davis too — the timing would have been right but the place wasn't.

Baum was not speaking here as a curator. She was merely offering some thoughts to her few hundred followers, who might have been struggling with the same questions as she was. If she wishes to swoon over Angela Davis, it is her right. In the exhibition catalog for the show, however, Baum was not writing as private citizen, but with the authority of the Cynthia Hazen Polsky and Leon Polsky Curator of Contemporary Art at The Metropolitan Museum of Art. In "Anarchic Humanism," the first essay in the catalog, she and her fellow curator Randall Griffey offer a description of their project: "Besides foregrounding her often under-recognized artistic accomplishments [which they do not go on to describe], this publication positions [Neel] as an artist who engaged with progressive politics throughout her lifetime and attends to her place in the larger cultural history of the twentieth century." Is this what curators are now trained to do?

Evaluating art based on its politics supports both bad art and bad history. The few lame attempts made in the catalog to establish Neel's importance in the history of art are flecked with dubious and occasionally outright false claims. For example, consider the bizarre statement made by Baum and Griffey on page 22: "In West Harlem Neel also launched one of her most groundbreaking bodies of work: pregnant nudes. This subject is rare in the history of Western Art but Neel's blunt, forthright manner of representing the distended bellies of expectant mothers is simply without precedent." This claim is preposterous, as anyone who has flipped to the few pages of colored photographs in Hoban's biography (which is the least the curators of the retrospective should have done) would know. There, on page 267, Neel's painting *Margaret Evans Pregnant* (1978) is reproduced alongside Egon Schiele's *Red Nude, Pregnant* (1910). (In the description beneath Neel's painting, Hoban has helpfully written that "it closely resembles Egon Schiele's painting *Red Nude, Pregnant*.") There are indeed paintings of nude women with distended pregnant bellies that predate Neel's picture; a cursory search yields examples from Hendrick Goltzius (1599) to Otto Dix (1932).

Of Andy Warhol's work, Neel once remarked that "it may not be an important contribution to art, but it shows great powers of adjustment." If what Neel meant by "great powers of adjustment" is that Warhol's success was evidence of a cultural shift, and that he magisterially worked the shift, and possessed a canny sense of his time and his place, the same could have been said of Neel towards the end of her life. It is certainly true that her curators show great powers of adjustment. Their resuscitation of Neel now is evidence of the persistence of the political temperament that she pioneered. It may not be an

important contribution to art, but it confirms the triumph of politics in American cultural institutions.

A curator ought to be able to answer the question "What makes an artist great?" We should not expect the staffs of our museums to know what makes a political activist a great political activist, or what makes a feminist a great feminist. Nor should we come to them for such judgments, which are nothing more than their opinions. If they admire Neel's feminism, good for them — as it happens, so do I; but they are not experts in what is right or wrong. The fact that Neel was willing to advocate proudly for herself and to defy the constraints imposed upon her gender tells us nothing about the quality of her art. (Neel herself said that there is no such thing as a feminist way of painting, and that there is no difference between the way a woman paints and the way a man does.) And what would these *engagé* curators do about artists whose politics they do not share? What about the monarchist masters, and the fascist masters? The walls of our museums are full of fine pictures made by people with politics that liberals and progressives consider reprehensible.

"Bad" politics can generate good art. "Good" politics can generate bad art. Will we ever know this again?

LEON WIESELTIER

The Exclamation Point

For Tom at seventy in Zion

Sergio Sierra was born in Rome in the winter of 1923. When he was twenty-six years old he received rabbinical ordination, after which he assumed a rabbinical post in Bologna, where he assisted in the reconstruction of the shattered Jewish community. The embers of history's wildfires had not yet cooled. The great synagogue in Bologna, built by a well-known local architect in a sensitively adapted Art Nouveau style, had been destroyed in a bombing raid in 1943, and it was not until a decade later, and under Sierra's supervision, that its restoration would be complete. Sierra served in Bologna until 1959, when he left to take up a prominent pulpit in Turin, and to

direct its rabbinical college. His talents were not only clerical. The community rabbi also published erudite papers in scholarly journals on modern and medieval themes in Jewish literature. He produced a translation into Italian of Rashi's commentary on Exodus, and a translation of Bahya ibn Paquda's eleventh-century masterpiece *Hovot Ha'Levavot*, or *The Duties of the Heart*, a monument of Jewish reason and piety, and a translation of *Keter Malkhut*, or *The Kingly Crown*, an epic philosophical prayer in rhymed verse by the eleventh-century poet Solomon ibn Gabirol, who has been beloved by readers of Hebrew for a millennium. He also produced a critical edition of one of the most curious works of medieval Jewish literature, the Hebrew translation of Boethius' *Consolation of Philosophy* by an early fifteenth-century Jew in Perpignan named Azariah ben Yosef ibn Abba Mari, also known as Bonafus Bonfil Astruc, who fled to Italy from persecution in southern France and was one of the very last figures of the golden age of Provencal Judaism. Sierra was yet another of the many rabbinical figures in the annals of Judaism who managed to combine a pastoral calling with an intellectual one, leadership with learning. He served in Turin until 1985, and in 1992 he moved to Jerusalem, where he died in 2009.

In Rome, immediately after the war, when he was twenty-two, Sergio Sierra bought a book, a small book, about a hundred pages long, and small in format too. It was a translation into Hebrew of Theodor Herzl's *The Jewish State*. It had been published a year earlier in Tel Aviv under the auspices of the Department of Youth Affairs of the Zionist Federation, and the fine translation was by Asher Barash, a distinguished Hebrew writer and editor who came to Palestine from Galicia in 1914 and became a founding father of Israeli literature. (He was also the author of perhaps the first Hebrew

work on literary theory, which is a terrible responsibility to bear.) When the young man acquired the volume, he proudly stamped his name and address all over it, including on the dust jacket, right above the canonical image of Herzl with his weirdly Assyrian beard. I know all this because I discovered the book in the basement of an antiquarian bookshop in Jerusalem. No doubt Sierra's heirs had rid themselves of his library. We latecomers fill our shelves from the philistinism of the sons and the daughters.

But I did not acquire this book — I did not seize on it — for bibliophilic reasons. Herzl in Hebrew is not hard to find. And at the time I had no idea who Sergio Sierra was. What happened was that I opened the book and was shaken to my core. On the front endpaper Sierra had inscribed his name in Italian and in Hebrew, *Sierra Yosef Sergio*, in a fine hand, and next to his signatures he recorded the date of his purchase. "1945," he wrote — but not just that; he also underlined "1945" — but not just that; next to "1945" he also added an exclamation point. "1945!"

The exclamation point undid me. The entirety of a man's spirit and the entirety of a people's spirit was in it. It denoted astonishment: we are still here. It denoted ferocity: we really do intend to exist. It denoted resolution: we are still in our fight for the mastery of our fate. It denoted vitality: even now we are strong. It denoted politics: a state will be ours. And it denoted incredulity: could it really be that on the morrow of the greatest catastrophe in the history of these intimates of catastrophe there appeared *this* book in *this* language from *that* city and *that* land, and it made its winding way to the trembling hands of this ashen Jew? The young man was a believer, and the exclamation point was, for him, a punctuation of providence. I see no metaphysics in it myself, but I do not have the effron-

tery to deny the intimation of the miraculous that it granted in the rubble.

In all the years that I have been its custodian, I regularly turn to the little volume to behold the exclamation point. The sight of it fortifies me and refreshes my purposes. Emphasis is one of the central activities of identity. We are known by our emphases. The emphatic gesture of Sergio Sierra in Rome in 1945 has an elevating effect. And also an emboldening one, because we have reached a troubling point in time, less than a hundred years after he penned his inscription, in which the exclamation point must be defended. Was its truth obvious in 1945? It is obvious no more. The despisers of the principles for which it stands are growing in number, not least among Jews. Where there once was an exclamation point, there is now a question mark.

The story that I have just told would be dismissed by Omri Boehm as "Zionist Holocaust messianism." Boehm is the most recent in a long line of critics of Zionism who have attributed its success to the Holocaust, when in fact the structures of the Israeli state were built before the Shoah, and the only "upside" of the catastrophe for Israel was to buy it a few guilty decades of sympathy in the world. Boehm's formulation is incoherent: there are indeed messianists among those who call themselves Zionists, but Zionism represented a repudiation of Jewish messianism, which it disavowed in favor of a new conception of Jewish agency in history. And there is no such thing as "Holocaust messianism," which is a vaguely obscene phrase. In Boehm's view, the utility of the Holocaust for the Jews — we are again skirting obscenity: imagine a serious

360

discussion of the utility of slavery for black people — is that "the Holocaust remains opaque to reason and stands outside of normal politics." He explains: "Emerging from this ahistorical transcendent mystery, Israel remains beyond universalist politics and moral critique."

To establish this claim, he devotes many pages in his book *Haifa Republic: A Democratic Future for Israel*, a rich document of the new thinking about the Israeli-Palestinian conflict, to Elie Wiesel's theological response to the Holocaust, which he associates with the writer's lifelong disinclination to criticize Israeli policies. This is nonsense. No, not the bit about Wiesel's apologetic attitude toward the Jewish state, whose existence he (and survivors like him, and the children of those survivors) could never quite treat as a natural fact of world history. It is true that the large-souled Wiesel disliked controversy and might have played a more helpful role in those moments in Israel's history when its conduct was worthy of "moral critique." There were times when I beseeched him, futilely, to do so, to teach, to castigate, to clarify, because many Jews were confused and angered by certain Israeli actions; and once I came to him with a bundle of Biblical and rabbinical texts — he knew them all, of course — that taught the obligation to criticize one's own. About these matters we agreed to disagree, because we detected in each other the same over-arching love.

But Boehm is hiding behind Wiesel so as to propagate a caricature of Zionism and its ethos. The response to the Holocaust in the Jewish world was not primary theological, even if the catastrophe did crush many frameworks of explanation. (For whom is suffering of such magnitude not a mystery?) There was certainly nothing "ahistorical" or "transcendent" about the nationalism that roused the Jewish people and established a state. Zionism and the state that it

created were among the greatest triumphs of secularization in the modern era, a resounding historical and philosophical rupture, a genuine discontinuity, even if the social authority of the Chief Rabbinate of Israel is a hideous anachronism that should be abolished right after tomorrow morning's prayers. Zionism, and Israel, is assuredly not "opaque to reason," though a sickening amount of unreason now flourishes within it. Jewish nationalism proceeded not only through settlement or force; it grew in reasoning, in argumentation, in persuasion, addressed to both Jews and non-Jews, since its very inception. Nor does it stand "outside of normal politics." It is a cauldron of normal politics, whatever one's view of the current brew. Its founding documents are an application of "universalist" values to a particular people — a tense enterprise, but an admirable one. The Jewish state is not an occult entity and it is not immune from criticism. No state and no movement and no person is exempt from the duty of self-justification, especially about the treatment of others. Like generations of Israel's critics before him, Boehm complains that criticism is forbidden. Meanwhile whole careers are made out of it.

I have never met a Zionist who would not have preferred to persevere in the nationalist cause for another hundred years and Auschwitz not happen. Indeed, the tragic element in the relationship between the Holocaust and Israel is that the chronological order of extermination and statehood was not the reverse of what it was. If Zionism had accomplished statehood — which was not its common goal until 1942, owing to the excruciating events in Europe — a decade earlier, millions of Jews — *millions of human beings* — might have been saved. Can we all agree to react unambivalently to this fantasy, to share this regret? I wonder. We are witnessing instead an outpouring of lofty regret that Israel was created at all. This nasty rueful-

ness is owed to certain views of the Palestinian problem, not all of which are entirely incorrect. Fifty-three years of occupation, with no end in sight, is a miserable reality, violations of rights and laws are commonplace, heartlessness abounds, and the frustration is overwhelming. A feeling of despair about the plausibility of a two-state solution, an Israeli state and a Palestinian state, is everywhere, and it suits the cynical and irresponsibly short-term interests of both the Israeli government and the Palestinian Authority. There are no heroes in the leaderships of this conflict.

Now the feeling has been turned into an idea, known as the "one-state solution." In such a state, as Boehm describes it, Jews and Arabs in the territory between the Jordan River and the Mediterranean Sea would each enjoy "a sub-sovereign political autonomy with a constitutional federative structure." He has written his book to call for the end of Jewish sovereignty and the invention of a Switzerland in the Levant. The dissolution of a state — an actually existing state, not an ideological or political hypothesis — is a high price to pay for a release from exasperation. If this were medicine, we would call it quackery and demand an investigation. "At some point", Boehm declares, "one must admit that the two-state dream has faded into a two-state illusion." Nowhere does he prove that this is really so. He shows only that the two-state solution will be difficult to enact, and that the political will to enact it is now lacking. Is this not true also of the one-state solution, which upon inspection may be no solution at all? But I am getting ahead of myself.

The pertinence of the Holocaust to an understanding of Israel is not as a demagogic shield against disagreement, or as a sanctuary for yet another cult of victimization. Nothing large or lasting was ever built on self-pity. In this context the

Holocaust stands for a particular lesson about Jewish history, and Zionism is nothing if not a conclusion drawn from Jewish history, or more precisely from the experience of the Jews in the exile. I do not mean to say that the exile was one long death camp. The exile was not completely (in the famous word of a great historian who hated the notion) lachrymose, not at all. But it was lachrymose enough. The frequency of Jewish wretchedness in the exile, of discrimination and oppression and violence, urgently broaches the question of Jewish security and insecurity. Jews in the exile were sometimes happy and sometimes unhappy, and they attained to extraordinary heights of thought and literature and spirituality, but they were generally unsafe. There were no havens. They lived in perennial vulnerability and permanent subordination.

For some writers and scholars, from George Steiner to Daniel Boyarin, the powerlessness of the Jews was morally glamorous, and their "subaltern status" was the condition of their cultural refinement; and it is certainly true that if the Jews over many centuries did not commit certain crimes, it was partly because they lacked the power to do so. But powerlessness does not confer purity. It confers pain and death. There is no virtue in vulnerability. The Holocaust was the worst that happened to the Jews in exile, but — contrary to Jewish theologians and historians who numinously insist upon its "uniqueness" — it differed from earlier persecutions in degree but not in kind. The Nazis innovated new methods for old evils. The helplessness of the Jews in Europe in the 1930s and 1940s is unbearable to contemplate, but so is their helplessness in Ukraine in 1648, and in the Iberian peninsula between 1391 and 1497, and in Germany in 1298, and in the Rhineland in 1096, and in many other times and places that are too numerous to list here. They are plentifully documented in the annals of

Jewish tears. There are many differences between these specific events, which it is the duty of historians to mark, but they should not obscure a certain bleak political commonality.

Sooner or later Jews were going to see that for their own good they needed to acquire politics and power. But nowhere in Boehm's book, or in any other espousal of the "one-state solution" that I have seen, is there a shred of interest in the question of Jewish security. In one passage Boehm writes sneeringly that "Israel is designed to protect Jewish ethnicity, Jewish blood," as if the Zionist insistence upon self-defense is racist. (This slander reminds me of the awful charge that is sometimes made against the motto that "black lives matter.") No, brother; not Jewish blood, Jewish bodies. They need to be protected, not only on the grounds of their human rights, which even people with armies possess, but also if they are to reconcile with their neighbors. Anyway, the power of the State of Israel was not developed for purposes of conquest and expansion, even if that power, like all military power, has sometimes been abused.

The military strength of the Jewish state is an ethically and empirically warranted dispensation. Self-defense is a corollary of self-emancipation, or "auto-emancipation," which was the founding axiom of Jewish nationalism. Is it really necessary to be reminded that Israel has vicious and lethal enemies, and that a large portion of the enmity that it has encountered has been provoked not by its actions but by its existence? There are many ways in which the Holocaust has figured too prominently in contemporary Jewish identity, but it is cheap of Boehm to describe Zionism as "a sort of *Angst*-based mythical Holocaust messianism." There is nothing mythical about the suffering and the *Angst* is real. Jewish anguish is not the only anguish that counts, of course, but it must not be

coldly discounted, especially by people who pride themselves on the exquisiteness of their empathy.

The internecine Jewish debate about the Israeli-Palestinian conflict is sometimes portrayed as a quarrel between those who care about Israeli security, the hawks, and those who care about Israeli morality, the doves; but in truth security is itself a moral duty. I wish the rulers of Gaza would grasp this. Safety, too, is a right. Ensuring it is one of the primary duties of government. (As long as thousands of rockets are launched into Israel, the Iron Dome system, and the consequently low casualty statistics in Israel, is not an unfair advantage; it is the evidence of a state's seriousness about protecting its population.) For this reason, there is also nothing ethically scandalous about the insistence that there must be a Jewish majority in Israel. This is not an undemocratic majoritarianism, unless one holds that all major- itarianism is undemocratic. After all, there will be a majority in a one-state entity, too — a Palestinian majority, which does not seem to trouble the proponents of the exciting new idea. For some reason they are confident that a Palestinian majority will fulfill the ideal of equality more scrupulously than a Jewish majority has done. They have not yet disclosed the historical basis for their optimism.

Until the political borders and the ethnic borders of a polity — state, province, canton, district, whatever — coincide and perfect social homogeneity is achieved within a single political framework, which will never happen, and for the sake of the moral and cultural development of the citizenry should never happen, there will be majorities and minorities, and the supreme responsibility of a diverse polity will always

366

be to regard minorities democratically, equally, in full and active recognition of their rights. A multiethnic state, which is what all states are, whether they know it or not, cannot escape this duty, which will require it, in the name of social peace and common decency, to control the maximalist and authenticist and exclusivist incitements of each of the groups within its borders. This is the case with the State of Israel, and it will be the case, *inshallah*, with the State of Palestine, and it would be the case even with the State of Isratine, which was the name that Muammar Qaddaffi gave to his proposal for a binational federated one-state solution for Israelis and Palestinians. (#StrangeBedfellows.) What will determine the justice of any of these compound political entities will be their determination to deploy the principles and the practices of democracy to resist the temptation of ethnic tyranny. There is nothing anti-democratic about the nation-state. It all depends on the character of its governance.

The concern about Jewish numbers is nothing more sinister than a concern about Jewish security. The nightmare is simple: it is that one day Jews will need to flee to safety and a majority non-Jewish government will deny them entry. There is nothing paranoid, or even fanciful, about such a scenario. It is not "ethno-nationalism," it is prudence. One of the more outrageous aspects of the new proposal to abolish the Jewish state is that it is being advanced at precisely the moment when anti-Semitism is dramatically on the rise. The old crisis that Zionism was conceived to address, the primal emergency, is back. The higher rates of Jewish emigration to Israel in recent years have been a classical flight for safety, and the highest numbers of Jewish emigrants over the last decade have come from countries whose Jewish communities have been shaken by anti-Jewish violence. Jews and Jewish institutions are being

attacked on the streets of many cities, often in the name of Palestine. When Prime Minister Netanyahu — how nice it is to type those words retrospectively! — told the Jews of France to "come home," he was speaking uncontroversially from the standpoint of Jewish history. (Uncontroversially, that is, for those who have given up on the pluralistic prospects of France. The other French Jews, the majority of them, the ones who have chosen to remain in the fight for the Enlightenment traditions of the country, are certainly in a good fight.)

Why aren't Ilan Halimi and Sarah Halimi household names? Jews are still in need of refuge and Israel is still a refuge for Jews. But anti-Semitism does not particularly interest progressives, because it interferes with too many of their dogmas. Never mind that what happened at the Tree of Life synagogue in Pittsburgh was exactly what happened at Mother Emmanuel church in Charleston. The parallel is ideologically inconvenient. Jews, you see, are white (even when they are brown or black), strong, and privileged oppressors, and they are most perfectly exemplified by Israeli soldiers who shoot at Palestinian children. And so the Jews have been stricken from the canonical roster of threatened groups and scorned identities. It is now considered inclusive to commemorate the painful past of every group except ours. We have the unique honor of being disqualified from intersectionality. Who needs Israel, anyway?

For Boehm, who is an Israeli philosopher in New York, Jewish majoritarianism is another example of the "bad faith" of liberals, their way of concealing their own acquiescence in ethnic hegemony. In his account, there are only two parties to the debate now: those who are for his "federal binational republic" and those who, whether we know it or not, are objectively for ethnic tyranny and ethnic cleansing because

we support the existence of a Jewish state. He detests us, the hawkish doves, the democratic statists, the liberals. His hatred of Israeli liberals is tiresome in the old radical way, according to which liberals are progressives who dare not speak their name or reactionaries who dare not speak their name, but they must in either case be destroyed. Of course liberalism is no more a sign of cowardice than progressivism is a sign of courage. (These days the percentage is in progressivism.) And modern history provides abundant evidence of the calamitous consequences of the radical contempt for liberalism: it has regularly assisted in bringing the worst to power.

In support of his exercise in simplification, Boehm reverently cites that most dubious authority on Jewish and Zionist subjects, Hannah Arendt, who in 1944, after the Zionist Organization of America adopted a resolution calling for a "democratic Jewish commonwealth" in "the whole of Palestine, undivided and undiminished," grimly proclaimed that Revisionist Zionism was now "victorious." In her view, Zionism turned into fascism when it desired a state. "Seventy-five years later," Boehm writes, "we can see that Arendt was dead right about the collapse of Zionism into its hard-right Revisionist interpretation." Yet a student of history can see no such thing. Only three years later those same rapacious Zionists joyfully agreed to accept only a part of Palestine, very divided and very diminished, for their commonwealth, when they accepted the United Nations resolution of partition. (The Palestinians were the Revisionists.)

For the haughty Arendt, as for Boehm, all distinctions are erased: everything to the right of the left is the same. I am reminded of a heated argument I once had with Amos Elon when he loudly announced over dinner that he would not vote in the Israeli election of 1992 because there was no differ-

ence between Yitzhak Rabin and Yitzhak Shamir. A year after Rabin beat Shamir, the Oslo accords were signed. Boehm, like the Israeli right, gloats over the failure of that breakthrough. We liberals mourn it, its flaws notwithstanding, because we know how difficult it is to accomplish even a little good and to push evil even a small way back, and because the status quo, which Boehm deplores, really is deplorable. But David Grossman and Moshe Halbertal are not standing in the way of its amelioration.

The argument for the one-state solution comes with a politics of memory. Or more precisely, with a politics of anti-memory. Its proponents contend that the stasis between the Israelis and the Palestinians — no, there is no stasis, the situation constantly worsens — is the result of Jews remembering too much or remembering too little. Naturally Boehm trots out Nietzsche on the abuse of historical consciousness and the inhibiting effects of memory, though he, like everyone else, has events that he chooses to remember and events that he chooses to forget. He twice quotes, and twice misreads, Yosef Hayim Yerushalmi's haunting question, "Is it possible that the antonym of 'forgetting' is not 'remembering,' but justice?" Yerushalmi was not, to put it mildly, hostile to memory; he wrote an entire book lamenting the failure of more critical modes of historical awareness to do for a living culture what memory once did. The point of his remark is, quite obviously, to suggest that remembering is a condition of justice, which cannot be advanced by forgetting.

Boehm, by contrast, calls for forgetting. "It is time to restore a binational Zionism — with a strong notion of equal

citizenship in a one-state solution," he writes. "One way we can do this is by developing an *art of forgetting*, a politics of *remembering to forget* the Holocaust and the Nakba in order to undo rather than perpetuate them as the pillars of future politics." There are two chapters in Boehm's short book about this summons to forgetfulness, one about the Holocaust and one about the Nakba. Both of them, a little comically, are about the Jews. We remember our disaster too much and their disaster too little. But there are no injunctions to the Palestinians about the selectivity of their own memories, about their interpretations of their own historical narrative and its political uses. Why would there be? They have the past right, because they are the victims, without historical capability, with no good or bad choices that are relevant to the discussion, just the brutalized objects of Jewish representations and troops. The memories of victims are simple and sacred.

For many decades I used to wander like an itinerant fire-and-brimstone preacher among the Jewish communities of America, chastising my brethren for certain failures that in my view imperiled the future of our people and our culture, and one of those failures is their inability, or their refusal, to understand what the events of 1948-1949, and more generally the raising of a modern society in the sands, meant for the Palestinians. In school, a fine Zionist school, I was taught that the Palestinian refugee problem was created by the flight of Palestinians at the behest of their leaders. Even before Benny Morris settled the question once and for all, I suspected that the explanation was too tidy and too self-exculpatory. I am the son of refugees, and I have always associated refugee status with prior cruelty.

Moreover, I do not believe in the innocence of states, of any states; even in a just cause, innocent blood is spilled.

(About this the pacifists are right.) The war of 1948-1949 was a just war for the creation of a state that had a right to exist and a need to exist, and also a war of self-defense, but massacres and expulsions were perpetrated. We must not lie, especially to ourselves. The mythmaking powers of national feeling are well known, and they must be corrected by historical and ethical accountings. None of this, of course, absolves the Palestinians of their own mythmaking, and certainly not of the many repulsive falsehoods that their leaders have promulgated over the years about the Holocaust and the Jews. Still, as Amnon Raz-Krakotzkin has incontrovertibly observed, "Israel, a state of refugees, was built on the creation of a state of refugeehood." One has an obligation to become acquainted with the people with whom one will always live. It is past time for Jews to know, and to honor, the Nakba.

"The art of forgetting" is no more a guarantee of mutual respect than the art of remembering. Atrocities have been the work of people who believe that they are nullifying the past and beginning again, just as they have been the work of people with ancient grievances to avenge. (Sometimes they are the same people.) Collective memory needs to be carefully and morally managed. I want Palestinians to remember the Holocaust and Israelis to remember the Nakba, because otherwise they will not comprehend each other. I want Jews to remember the Holocaust and Palestinians to remember the Nakba, because otherwise they will not comprehend themselves.

Moreover, the culture of Zionism was already quite practiced in the "art of forgetting." I do not refer only to its tendentious interpretations of Jewish life in the exile. Revolution requires a sensation of newness, and so it always erases and exaggerates. Thus, to choose a prominent example, in 1942

the Hebrew writer Haim Hazaz wrote a short story — an essay in fictional form, really — called "The Sermon." It describes a fiery statement given to the central committee of a kibbutz by an otherwise meek member of the community named Yudka, which can almost be translated as "Jew." "I wish to announce," he tells his comrades, "that I am opposed to Jewish history." And more: "I do not respect Jewish history...No, 'respect' is not the word. It's what I said: I'm against it." And more: "I don't accept it...Not a single detail. Not a single line, not a single point. Nothing, nothing...None of it!" *Also sprach Yudka!*

This program of revolutionary amnesia, this ferocious rejection of inherited ways, this contemptuous avant-gardism, did not work out so well. It was eventually responsible for bitter fissures in Israeli society and culture, and for the slow collapse of Labor Zionism. No arrangements between the peoples in the land will succeed that are based on the denial of the wounds that they seek with those arrangements to heal. The most that we may permit ourselves to dream of is a coexistence of traumas, of haunted communities.

The meaning of national identity is not only morbid. One of the blandishments of security is the protection of immanent flourishing cultures. It is well known that alongside "political Zionism" there was "cultural Zionism", though the former also had cultural preferences and the latter also had political preferences. The political preferences of cultural Zionism have played an important part in the argument for a one-state solution. A distinction is drawn between cultural self-determination and political self-determination, between cultural self-determination and statehood. Statehood, it is said, is not required for

cultural fulfillment, for Zionist fulfillment, for Jewish fulfill-
ment. There is some truth to this claim, as the early history of
Judaism illustrates: it was Rabbi Yohanan ben Zakkai, when he
petitioned the Roman commander of the siege of Jerusalem to
grant him a small coastal town for the creation of an academy
of Torah and never mind the fate of the commonwealth, who
made Judaism as mobile as the soul and thereby freed Jewish
culture from what might be called the Ozymandian anxiety.
We have learned about many cultures from their ruins, but
Jewish culture is not one of them.

So isn't cultural self-determination Zionism enough?
The question has been posed heroically by Peter Beinart, in
his timely journey leftwards. If the world were flat, Beinart
would have fallen off it a long time ago. He has a reputation
for courageous dissent against the Sith Lords of the American
Jewish community, which is why he is the darling of Jewish
millenials everywhere. "You know," he once scolded me,
"criticism can be an expression of love!" Actually, I did know
this. "Yes, it can," I replied, "but it cannot be the only expres-
sion of love." Beinart is deeply worried that his rejection
of a Jewish state — "I No Longer Believe in a Jewish State,"
he grandiosely proclaimed in the *New York Times* — will be
mistaken for a rejection of Zionism. He aims for heresy, not
apostasy. That is why, for example, he has a strange habit of
ornamenting the expression of his views with assurances
about his religious observance. One afternoon I found him
on CNN screaming at a conservative pro-Likud interloc-
utor that he worships in an Orthodox synagogue and even
leads the prayers there. So what? I presume that many of the
worshippers in his synagogue disagree with him, since it is an
Orthodox congregation. When they lead the prayers, are they
right? Beinart is just shul-washing.

In order to prove that he is not anti-Zionist or post-Zionist, Beinart must locate a definition of Zionism that will give him cover, and identify a current of Zionism that would be satisfied with a political objective short of Jewish sovereignty. As it happens, the history of Zionism is rife with non-statist conceptions of Jewish self-determination. Neither Herzl (the title of his momentous book notwithstanding), nor Pinsker, nor Ahad Ha'am, nor Jabotinsky (some of the time), nor Berl Katznelson, nor David Ben Gurion (some of the time), nor any of the other titans of Jewish nationalism were animated in their work by the goal of sovereignty — until the Biltmore program of 1942, as I noted earlier. It is worth noting that the Biltmore program made no mention of a "Jewish state," but called for called for "ending the problem of Jewish homelessness" by "establish[ing] a Jewish Commonwealth" which "welcomes the economic, agricultural, and national development of the Arab peoples and states." A terrible hardening!

Beinart relies heavily for his new thinking — if his thinking seems so fresh, it is because his knowledge is so recent — upon a splendid book called *Beyond the Nation-State: The Zionist Political Imagination from Pinsker to Ben-Gurion* by the Israeli intellectual historian Dmitry Shumsky, whose previous study of Zionism in early twentieth-century Prague skillfully shed light on the origins of bi-nationalism. With exquisite scholarship, particularly about Pinsker and Jabotinsky, Shumsky shows that statism was a late development in Zionism, which pictured the Jewish homeland to which it aspired in sub-statist or bi-nationalist terms, and mainly as autonomy within a larger political framework. Shumsky's analysis seems unimpeachable to me, and also to Boehm, who quotes him at enormous length. But Shumsky's narrative

does not quite provide the Zionist alibi that one-staters and "cultural Zionists" such as Boehm and Beinart seek.

For a start, the broad outlines of Zionist political thought, its evolution from autonomy to sovereignty, have long been familiar. I learned about the bi-nationalist tradition in Arthur Hertzberg's seminar on Zionism fifty years ago. Shumsky has discovered new trees in an old forest. More importantly, there is a plain historical explanation for the trajectory of the Zionist political imagination. It is that all these figures, all these builders, lived and worked in imperial circumstances. The Ottoman empire and the Hapsburg empire were the contexts in which the idea of a Jewish homeland was first developed. It was conceived in the terms of its time, on the model of those tolerant multi-ethnic entities, in which the civil and cultural autonomy of ethnicities flourished in the absence of political power, which was held exclusively by the imperial authorities. The *Nationalitätenstaat*, or "states of nationalities," that inspired Zionist intellectuals and activists was a notion of Austrian Marxists who were promoting the benign imperial conditions in which they lived into their ideal. The question of sovereignty, in other words, was moot. Shumsky is perfectly clear about this.

But the empires are gone now. Is it progressive to be nostalgic for them? When the empires collapsed, sovereignty became possible for the nations that they contained and states were formed, as would happen again later with the end of the British empire. Subordinated peoples began to associate self-determination with political power. The Palestinians — who were subordinated to Arabs before they were subordinated to Israelis — would eventually express a similar desire. The vocabulary of self-determination had changed. And in the case of Zionism, there was another reason for the escala-

tion of its political ambition. Its name was Hitler. Is it really any wonder that in 1942 the Zionists chose statehood? Was a rescue from extermination to be found in autonomy? Would a *millet* have saved the Jews?

In the judicious conclusion to his book, Shumsky presents his own assessment of the relevance of pre-statist Zionism to the contemporary predicament. He notes "the ever-increasing pervasiveness of a bi-national existence between the Jordan River and the Mediterranean Sea resulting from the repeated failures of negotiations between Israel and the Palestinians and the constant expansion of the Israeli settlement enterprise beyond the Green Line." In the light of these discouraging developments, he continues, "one is sorely tempted to pluck the *Nationalitätenstaat* formula from the Zionist past, to rescue from oblivion the repressed and deliberately forgotten attachment to mainstream Zionism, and to place them squarely on the Israeli and international agenda as the old-new federative alternatives to the apparently no longer viable two-state solution." This is precisely what Boehm and Beinart and the other high-minded nullifiers of Israel are proposing. But Shumsky is not one of their company. We "would be well-advised to beware of such temptations," he cautions.

377

> After all, following many generations of a bloody
> national conflict and given that Israel's ongoing control
> over the occupied territories both Israelis and Palestin-
> ians continue to live alongside one another in separate
> institutional constellations, it is by no means certain
> that an attempt to reapply the binational models that
> occupied a central position in the political imagination
> during the Ottoman and British Mandate periods would
> meet the current "living concerns" of the two peoples....

The Exclamation Point

> Zionism's conceptions of national self-determination were never subject to a single static political model but were rather reformulated at each given point in time in line with changing historical circumstances.

(I wish the same historical flexibility could be imputed to the leaders of Palestinian nationalism.) Finally Shumsky elects to disobey the title of his own book and arrives at the sober conclusion that "Israel's political consciousness would do well to embrace the notion of the division of the Land of Israel/Palestine into two nation-states."

Boehm's advocacy of the autonomist option leads him in an unexpected direction — to the admiration of Menachem Begin. In 1977, after Anwar Sadat's magical visit to Israel, Begin prepared a plan about the Palestinians for the imminent peace negotiations. It was called "Home Rule, for Palestinian Arabs, Residents of Judea, Samaria, and the Gaza District." It was a surprising proposal. Most surprisingly, perhaps, it insisted that the question of sovereignty be left open. Though "security and public order" in the territories would remain in the hands of Israel, the plan terminated the Israeli military government in the occupied territories and established a Palestinian civil authority, headquartered in Bethlehem, whose officials would be democratically elected and provide "administrative autonomy." It extended a choice of citizenship, full citizenship, for Palestinians in Israel. Palestinian refugees would be permitted to return "in reasonable numbers," as determined by a joint Israeli-Palestinian-Jordanian committee. Palestinians in the occupied territories would enjoy "free movement and free economic activity," including the purchase of land, as would Israelis dwelling there. Boehm affectionately, and ludicrously, declares that

Begin's "autonomy plan" should more properly be called "the one-state program."

Boehm blames the scuttling of Begin's plan on — who else? — Israeli liberals, who, "deferring to the two-state orthodoxy," denounced it because they suspected that it was the prime minister's attempt to fob off the problem of the West Bank on an Austro-Hungarian fantasy. Given Begin's ideological and oratorical record, there were grounds for such a suspicion. I shared it myself, though I hoped ardently that I was wrong. For there was another element in Begin's plan that encouraged me: "these principles will lend themselves to re-examination after a period of five years," he stipulated in his famous speech to the Knesset in 1977. I remember thinking, a Palestinian flag could fly over a Palestine in 1982! Of course it did not come to pass, but not because of anything uttered by Amos Oz. The opportunity was squandered because Yasser Arafat refused to consider Menachem Begin's proposal.

The Palestinians turned autonomy, "the one-state program," down. The *rais* chose instead to give hysterical speeches and interviews about *sumud*, or steadfastness, in the PLO's war against the fascist and colonialist enemy. "The Palestinians," Boehm writes, "seeking sovereignty, rejected it." But they did not dismiss the plan because they were seeking sovereignty. They dismissed it for a deeper and less reputable reason: they were not prepared to recognize and to respect the being in the world of Israel. And Boehm's six words about the Palestinian rejection of Begin's plan are just about all there is to be found in his book about the role of the Palestinians in the story of the infernal stalemate, which is typical of the progressive prejudice in the discourse about the conflict. This manifesto for a state of two nations is about only one of them.

Why are Boehm and Beinart so confident that in a single state the lions will lie down with the lambs? What do they know about them that the rest of us do not? Boehm calls his utopia the "Haifa republic" in homage to the decades of Arab and Jewish coexistence in the northern coastal city. There "you get a glimpse of what Palestinian-Jewish cohabitation could one day look like." He is somewhat prettifying the place. Arabs constitute only twenty-five percent of Haifa's population: the harmony of the city is owed in part to the small size of its minority, which does not threaten its majority. One of the reasons that we reactionary proponents of the two-state solution long for the establishment of a state of Palestine alongside the state of Israel is so that the minority numbers in both states will make neither of the majorities jittery. The jitteriness of majorities promises trouble. Also, Haifa is not quite the idyll that Boehm depicts. It experienced its own share of the awful Arab-Israeli violence of last year. The assumption that a union of Israelis and Palestinians in a single country is an easy prescription for peace is delusional.

Beinart, who could use a little *sumud* of his own, peddles different reassurances. In an essay in *Jewish Currents*, he moistly reports that "a new generation of Palestinian activists has begun advocating one equal state between the Jordan River and the Mediterranean Sea." He has seen the future and it works. Of course it is no wonder that Palestinians, young or old, would endorse the idea of a single state, because that state, owing to demographic realities, will be Greater Palestine. This is the dishonesty in the argument: to be for one state is to be for a Palestinian state with a Jewish minority. Time, as two-staters have grown hoarse from warning, is not on Israel's side. Still,

I have met a few such young Palestinians and they do indeed represent a break with the immobilism and the illiberalism of the Palestinian establishment. I do not doubt their commitment to the principle of equality, even if I cannot suffice with it. It is certainly a thin reed with which to dismantle a state.

I used to pin my hopes on new people, on new generations. I have since discovered that all the generations contain all the varieties of human types, and that people change. In 1993, a few days after the handshake at the White House, I met with Nabil Shaath, one of Arafat's key advisors and an architect of the Israeli-Palestinian rapprochement. He was a worldly man, a rational man, a successful businessman, a longtime member of Fatah who became a minister in the Palestinian Authority. We had become friends, I liked him, and I brought him to lunch at the infamously Zionist magazine where I worked. He arranged for a few Israeli and American Jewish advocates for peace, including myself, to meet with Arafat at his hotel in the evening after the handshake. The chairman, he said, wanted to thank us. (Every negative impression I had of Arafat was confirmed by those few hours on the sofa.) At our meeting after the signing ceremony, Nabil spoke in noble and eloquent terms about Israeli-Palestinian reconciliation, and about building democracy in Palestinian society. He also talked with uncanny moral and historical sensitivity about the Holocaust. I was exhilarated. Then he moved to Ramallah and became one of the worst kleptocrats in the region and issued despicable pronouncements about Israel.

Equality may be honored, or dishonored, in one state as in two states. What will tell is the prestige of the principle in the respective political cultures. The enumeration of rights "without distinction of religion, race, and sex" in the Israeli Declaration of Independence has not always been realized

381

in the state that it launched, but it furnished the intellectual, legal, and social foundation for the quarrelsome and reformist politics, the persistent critique of inequality, that has characterized the public discourse of that state, rather in the way that the American Declaration of Independence provided the grounds for criticism of certain repugnant passages in the American Constitution; and Israel's founding document stands as a lasting rebuke to the contemptible "Nation-State Law" that Netanyahu and his xenophobic supporters manufactured a few years ago. There is a struggle taking place in Israel for the values that will define it, and the struggle is by no means lost. And there are resources for it, for the humane side in it, in the Zionist tradition itself. ("Do you, like the medieval inquisition, fail to understand that diversity is life, and that only death is featureless?" Leon Pinsker wrote that golden sentence in 1861 in a short-lived journal called *Sion*.) But "cultural Zionism" cannot make a contribution to a struggle over the direction of a state that it wishes to obliterate.

The political culture of the Palestinians, by contrast, has so far been, let us say, a stranger to the Enlightenment. I do not say this to offend, or with glee. The happiness of my people depends in part on the philosophical condition of the Palestinian people. In the internecine Palestinian war between democratizing forces and theocratizing forces, we, I mean Jews and Americans, must unflaggingly support the former. "If you believe in equality, how can you create a state which claims members of a certain race, or certain religion, belong to it more than others?" Beinart asked in an interview. He was right. He was referring, of course, only to Israel. But it is, in fact, a perfectly Israeli question. Beinart flatters himself about his moral fineness. Political Zionists and two-staters are plenti-

fully to be found in the ranks of the egalitarians. Why are his professions of this shared belief any more credible than ours? Is his formula really so spotless, so devoid of dangers? Can one injustice be righted by another injustice? The Palestinians have for a long time asked that piercing question, but some of their tribunes should ask it also of themselves.

His interviewer aptly inquired why Beinart's denunciation of sins against equality does not extend also to Muslim countries, which have not exactly covered themselves in glory in this regard; and the question reminded me of my own disgust with the reticence of the left about Syria, Ukraine, Belarus, Myanmar, Hong Kong, Cuba, and the other locations of authoritarian horror. How in good conscience can one march for Palestinians and not for Syrians? "True," Beinart replied, "there are other countries who violate this principle. In my opinion, they need to be reformed." Yes, reform them! But he is not demanding that Israel be reformed. He is demanding that Israel be eliminated. Beinart is breaking new ground in progressive politics: he is cancelling an entire country. I know of no other state whose unjust treatment of others has thoughtful people calling for its erasure. There are concentration camps in China.

The Israeli occupation of the West Bank, which originated in a war for survival, has been transformed by religion and chauvinism into a moral disgrace for a state that calls itself, and largely is, open and lawful; and the unceasing settlement of the West Bank has been perhaps the greatest strategic blunder in Israel's history — a nuisance from the standpoint of security, and utter madness if the Israelis are ever genuinely to coexist with the Palestinians. The Palestinians deserve security, and dignity, and identity; and the attributes of nationhood, which include political ones. But no amount

of sympathy for the Palestinians warrants this amount of antipathy for the Israelis. They, too, deserve security, and dignity, and identity; and the attributes of nationhood, which include political ones. It has long been known that nationalism is an affair of collective subjectivity: one people cannot dictate to another people how they should represent themselves to themselves, or to others.

Brit Shalom was an association of formidable Jewish intellectuals, founded in Jerusalem in 1925, that advocated a binational state of Jews and Arabs in Palestine. Martin Buber was its most famous member, whom Peter Beinart likes to cite as his precursor. In the end nothing came of it, because it found no Arab interlocutors: it was a conversation that Jews were having with themselves. As Arthur Ruppin, the sociologist who was its chairman, remarked in a letter, "what we can get [from the Arabs] we do not need and what we need we cannot get." In 1936, in a volume of essays called *Jews and Arabs in Palestine*, Ben-Gurion made a comment about Brit Shalom that is worth pondering. "We oppose Brit Shalom," he wrote, "not because of its desire for peace with the Arabs, but because of its attempt to obliterate the Jewish truth, and to hide the Jewish flag as a price for peace." There was nothing mystical about his statement, though "the Jewish truth" is a locution that can make a liberal squirm. Its secular meaning is simply that people are fulfilled, as individuals and as groups, in their particularity. Peace is gorgeous but contentless. We seek peace, and the security that is the premise of peace, as the setting for self-fulfillment.

Jewish peoplehood is one of the most ancient facts of recorded history, and Jewish nationalism is the modern interpretation, according to the protocols of modern politics, of Jewish peoplehood. The people called the Jews consti-

tute a primordial and independent element of the world, irreducible to its other elements, converging with them and diverging from them, and through all the convergences and the divergences remaining themselves and no other, changed but the same. Their story is one of the sublime human stories, and it deserves to command the attention and the esteem of all peoples. After they were expelled from their commonwealth and made slaves and subjects and serfs, with self-governance gone, the Jews learned to live in many cultures and many circumstances, and to combine adversity with vitality. To the world they offered a certain vision of God and goodness, but of the world they asked only to be allowed to be themselves. Yet their demand for apartness, their perseverance in their beliefs and their practices, was more than the world was willing to grant, because the insistence upon difference defied the need of other faiths for universal vindication, even by means of coercion. Suffering became a regular feature of the Jewish exile. The suffering never determined the substance of Jewish peoplehood, or of Jewish religion, not even in the worst of times. But the suffering had to stop, and nobody except the Jews themselves was going to stop it. The people that taught the world about the relation between history and redemption chose to act on their own idea, splitting themselves for the sake of saving themselves. Their self-reliance was both a revolution and a restoration. And so one day, long after they were supposed to have disappeared, in the very land from which they had been banished by empire, the wounded and hopeful people raised a flag. Insofar as "the Jewish flag" is the symbol of this saga — of the end of the suffering, of the reversal of the vast misfortune, of the efficacy of the victims against their own victimization, of the failure of misery to crush a civilization, of the beautiful stubbornness of purposeful survival, of

The Exclamation Point

the accession to freedom of the perennially unfree — insofar as the Jewish flag represents all this, then it represents more than statehood, it represents the energies and the potencies of a magnificent people, and it cannot be denied. It has flown over war and over peace, over stirring victories and wise compromises and sordid mistakes. Nobody is without guilt. Power will always be a challenge to wisdom. Introspection is another name for self-rule. Pity the people who need to suppress others to become themselves; pity them and resist them.

387

CONTRIBUTORS

MAMTIMIN ALA was born in East Turkestan in 1971. He is the author of *Worse than Death: Reflections on the Uyghur Genocide.*

RICHARD THOMPSON FORD teaches law at Stanford University and is the author of *The Race Card: How Bluffing About Bias Makes Race Relations Worse.*

MARIO VARGAS LLOSA won the Nobel Prize in literature in 2010. This story was translated from Spanish by Adrian Nathan West.

JAROSLAW ANDERS is the author most recently of *Between Fire and Sleep: Essays on Modern Polish Poetry and Prose.*

SEAN WILENTZ is the George Henry Davis 1886 Professor of American History at Princeton University and the author of *The Rise of Democracy: Jefferson to Lincoln* and *No Property in Man: Slavery and Antislavery at the Nation's Founding.*

ANGE MLINKO teaches English and Creative Writing at the University of Florida. Her new collection of poems, *Venice*, will appear next year.

BENJAMIN MOSER is a writer and translator living in Amsterdam. His most recent book is *Sontag: Her Life and Work.*

JONATHAN ZIMMERMAN is a Professor of History of Education at the University of Pennsylvania. His new book *Free Speech: And Why You Should Give a Damn* was published this year.

LEONARD COHEN, the poet and singer, died in 2016.

CASS R. SUNSTEIN is the Robert Walmsley University Professor at Harvard Law School and the author most recently of *Liars: Falsehoods and Free Speech in the Age of Deception.*

MARK LILLA is Professor of Humanities at Columbia University. He is the author of *The Stillborn God* and *The Once and Future Liberal.*

HELEN VENDLER is the A. Kingsley Porter University Professor Emerita at Harvard University and the author of many books on poetry.

HOLLY BREWER teaches history at the University of Maryland and is the author of *By Birth or Consent: Children, Law, and the Anglo-American Revolution in Authority.*

SHAUL TCHERNIKHOSVKY was a renowned Hebrew poet and translator. He died in Jerusalem in 1943. ROBERT ALTER is professor of Hebrew and Comparative Literature at the University of California at Berkley.

DAVID THOMSON is the author of many books on film, most recently *A Light in the Dark: A History of Movie Directors.*

CELESTE MARCUS is the managing editor of Liberties.

LEON WIESELTIER is the editor of Liberties.

Liberties — A Journal of Culture and Politics is available by annual subscription and by individual purchase from bookstores and online booksellers.

Annual subscriptions, which offer complete digital access to current and previous issues as well as a discount from the individual cover price, can be ordered from libertiesjournal.com. Gift subscriptions are also available.

In addition to the regular subscription discount price, special discounts are available for: active military; faculty, students, and education administrators; government employees; and, those working in the not-for-profit sector at libertiesjournal.com.

Liberties — A Journal of Culture and Politics is distributed to booksellers in the United States by Publishers Group West; in Canada by Publishers Group Canada; and, internationally by Ingram Publisher Services International.

Liberties, a Journal of Culture and Politics, is published quarterly in Fall, Winter, Spring, and Summer by Liberties Journal Foundation.

ISBN 978-1-7357187-4-3
ISSN 2692-3904

Printed in Canada.

The insignia that appears throughout *Liberties* is derived from details in Botticelli's drawings for Dante's *Divine Comedy*, which were executed between 1480 and 1495.

Liberties